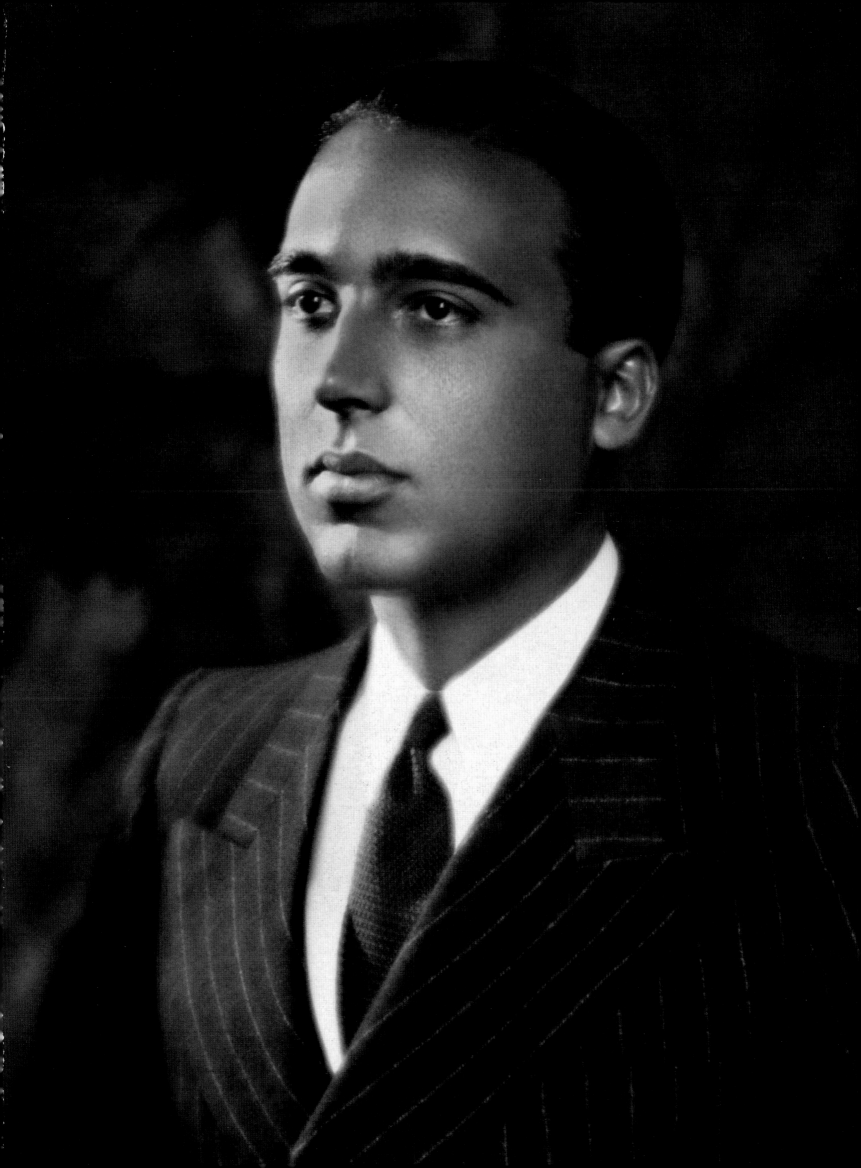

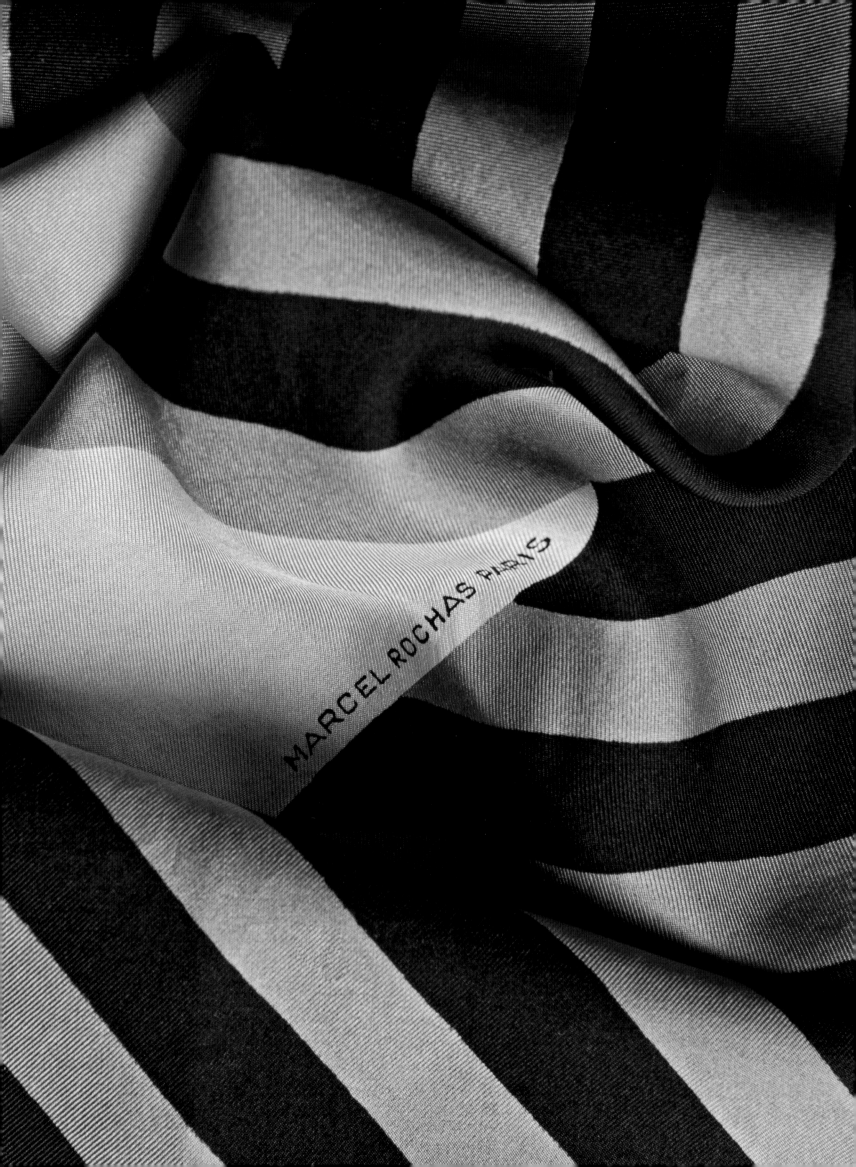

MARCEL ROCHAS

DESIGNING FRENCH GLAMOUR

TEXT SOPHIE ROCHAS
PHOTOGRAPHY FRANCIS HAMMOND

Flammarion

To my children, Gabriel and Sarah,
and my cousins, Kouki and Éric.
SOPHIE ROCHAS

EXECUTIVE DIRECTOR
Suzanne Tise-Isoré
Style & Design Collection

PROJECT EDITOR
Delphine Storelli

EDITORIAL COORDINATION
HOUSE OF ROCHAS
Julia Guillon

EDITORIAL COORDINATION
Sarah Rozelle

EDITORIAL ASSISTANCE
Lucie Lurton and Inès Ferrand

GRAPHIC DESIGN
Bernard Lagacé

TRANSLATED FROM THE FRENCH BY
Alexandra Keens

COPYEDITING
Barbara Mellor

PROOFREADING
Helen Downey and Michael Thomas

PRODUCTION
Angélique Florentin

COLOR SEPARATION
Les Artisans du Regard, Paris

PRINTED BY
Tien Wah Press, Singapore

Simultaneously published in French as
Marcel Rochas, audace et élégance.
© Flammarion S.A., Paris, 2015

English-language edition
© Flammarion S.A., Paris, 2015

Flammarion S.A.
87, quai Panhard et Levassor
75647 Paris Cedex 13

editions.flammarion.com
styleetdesign-flammarion.com

Dépôt légal: 05/2015
15 16 17 3 2 1
ISBN: 978-2-08-020207-9

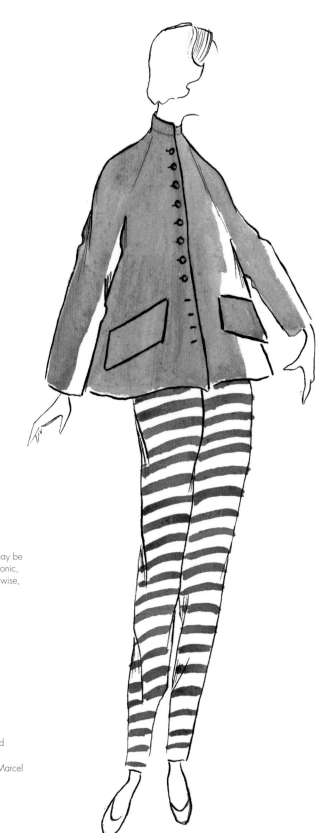

PAGE 1 Marcel Rochas wearing a double-breasted
suit and striped silk tie, 1936.
PAGE 2 The stripes in this silk scarf are typical of Marcel
Rochas's designs. House of Rochas archives.
RIGHT The Mahn, blue-and-white-striped sun top
and pants, toast-colored short coat,
1949 mid-season collection, no. 122.

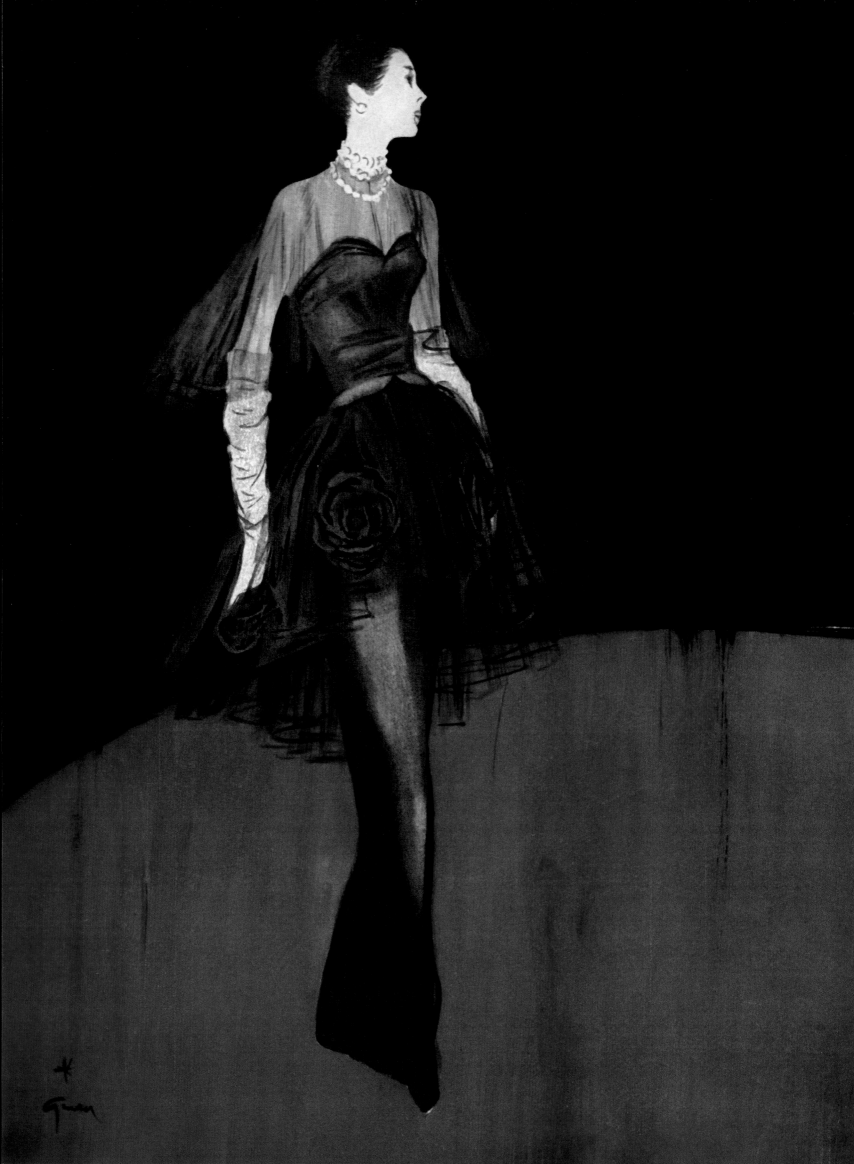

FOREWORD

Marcel Rochas, couturier for women and young people, has gone down in fashion history, in the great tradition of designers who combine talent with discretion, and innovation with originality.

The designs produced in his studios from 1925 displayed a simplicity that was informed by his desire to offer glamorous new forms of elegance to clients who were on the verge of celebrity. It was not just fashions that Marcel Rochas was designing; these were outfits created to showcase and enhance the women he dressed. Considerations that in other hands spawned empty frivolities and fashion-focused fripperies, in the hands of Marcel Rochas constituted a world of social chic.

With its short dresses and long gowns for day and evening wear, shoulder wraps, practical yet superb suits, and protective coats, the Rochas wardrobe was like a beautifying balm for the female silhouette.

The Rochas perfumes complemented this seductive enterprise, a world in which Marcel Rochas excelled through his attention to detail and the extreme care he took with his work—concepts that seem far removed from contemporary preoccupations.

We trust that this book will restore a unique couturier whose style has proved timeless to his rightful place in the history of fashion design.

OLIVIER SAILLARD
Director of the Palais Galliera, Fashion Museum of Paris

FACING PAGE Black evening gown, circa 1947.
Illustration by René Gruau. Inscription
by Marcel Rochas: "Without my famous *Guêpière* that
I designed and launched a year ago, it would have been
impossible for me to express the extreme femininity
of my new collection today."

PREFACE

To create is to imagine. So, biography: fiction or reality? As Jean Cocteau pointed out, it is not easy to admire someone and to express this admiration in writing. It is even more difficult when you are writing about your father, who was moreover a fashion designer, who died when you were still a child. The memories themselves do not die. A couture studio is like a painter's atelier. When you visit it at a young age, the designs, colors, and smells imprint themselves on you. You can simply close your eyes and let your memory wander, to recapture the images and sensations, ever intact. They stay under your skin and in your soul for the rest of your life. Any artist's child will understand what I mean. It's a weighty heritage, both invasive and intoxicating. Forged out of biographical material that stirred my childhood memories, this book gradually took its course, becoming a necessity. I want to pay grateful tribute both to my father, of course, whom alas I knew for such a very short time, and also to the other aspects of this man whose many facets I have been discovering.

It's a burdensome legacy, talent. What is it, exactly? People talk about a couturier's creative talent, but a painter's creative genius. They admire the skill of those "strange *capteurs d'ondes*" (trend detectors), to use Lucien François's picturesque expression,[1] their ability to sense what's in the air, but they find it harder to recognize the "poetry of couture." Coco Chanel was the first to condemn this, vehemently, even though she herself left her mark like an artist's signature on her little suits. Fashion can and must spark enthusiasm, she declared, but "a dress is neither a tragedy, nor a painting; it is a charming and ephemeral creation, not an eternal work of art. Fashion must die, and die fast, so that the trade can live."[2] Is a couturier's genius about the art of capturing the essence of a place, a time, about the ability to see into the future?

Those who have gone behind the scenes of fashion have seen the anguished faces in the wings: "In these graceful ballets, nothing is left to chance, beauty is carefully ordered. Everything is planned and meticulously orchestrated. Behind the art of appearance, there lies a world of passion and courage." Like a bullfighter entering the ring, the couturier—projected onto the stage under the spotlights at the end of every show, groggy from too many sleepless nights—faces the verdict that will seal his fate. The pain of the poet as the words elude him or her is akin to the suffering of a painter before the canvas, when suddenly an image they have glimpsed vanishes beyond the reach of the hand guiding the brush. They must try and try again, a thousand times. The suffering is invisible, lying unseen behind the image of the willowy, diaphanous models with their swan-like necks. How many fittings were there? How many broken threads?

The world of couture is not so different from that of dance. Choreographers expect their dancers to push themselves to the limit. The dancer's body is on the verge of breaking, just as a fabric might tear. To achieve the desired attitude, to capture it at last, to master the dress's movement, you have to constantly start over. A ballet company and

a couture studio are driven by the same love of beauty, which forces its members to surpass themselves, sometimes to the point of exhaustion. What couturier has not been possessed by a fury close to madness, by an urge to slash into strips, to cut into a thousand pieces a dress that was so precious and treasured just a few seconds before? "Here in a few words is the paradoxical fate of a true couturier at the height of his maturity: to burn what he has adored…to adore what he has burned. Each period, each fragment of history tends to embody itself in a figure whose name and marks stay in our memory. Chance plays its role here, as ever, governing our memories and their wanderings and reawakenings. One man will stay alive as a name that gradually becomes a word, and this word engenders a formless crystallization the origin of which gradually fades. Marcel Rochas is in this respect a famous unknown. His name is familiar, his legend remains, but often the impression is vague, uncertain."[3]

One day my father's first name disappeared from the perfume brand. It is a sad fact that Marcel Rochas has even disappeared from dictionaries, and that under entries for the word "guêpière" only the definition of an item of women's lingerie appears, with no mention of the word's inventor, nor of Christian Dior's New Look line, although it originated in the guêpière. A "famous unknown": therein lies a deep injustice that needs to be redressed, and a mystery. My father is numbered among those dead poets whose work has dissolved like footprints in the sand. Yet it was a huge body of work, developed over thirty years, thanks to two couture houses, hundreds of employees, several thousand designs, a cinema department, and thriving accessories and perfume subsidiaries, which gave birth to the legendary fragrance Femme. An impassioned champion of French haute couture, Marcel Rochas was one of the pillars of Parisian elegance, alert to the latest trends, an architect of the ever-renewed line. With his pencil, this man who adored women caressed a thousand feminine forms, from the not-so-boyish garçonne to the goddess-like mermaid. With his insatiable eye, he seized upon the forms and colors transfigured by the artists of his century in order to sculpt a modern woman. Through each of her variations—wide shoulders (the Bali dress), contrasting motifs, the suit, the canadienne (fur-lined jacket), the Mermaid line—the Rochas woman remained ever present. It is time now to explore the sources of his inspiration, and to restore to the Marcel Rochas style the recognition it deserves.

The mix of genres that I have employed in this book reflects the subtle mixture of fabrics and furs, perfume ingredients, colors, and accessories created by my father. He was skilled in the art of structure, of cut, of the right proportions. To recount the life of a family member whom one knew for only ten brief childhood years one must draw as much on historical accounts as on one's own vivid memories. Every evening and every weekend, Marcel Rochas would shed his couturier's garb and became a father and family man. Myriad images of the private man serve to illuminate and soften the portrayal of the public man. Over half a century has passed since my father's sudden death. A single book, published under my mother's guidance, has hitherto preserved the memory of Marcel Rochas, retracing the itinerary of the couturier-perfumer.[4] Memories fade when the desire to perpetuate them dies. That desire has always been with me. "Everything has been said about your father," my mother said to me one day, "everyone knows him." Everything? Really?

This book is, for me, a duty of remembrance. I dedicate it to my children, my grandchildren, and my great-grandchildren, and to the fashion designers of the future. In the course of my work, while I was unraveling the threads, I encountered a good deal of unexpected help along the way, accounts from the rare people who knew my father. I am grateful to them for having supported me in my moments of doubt, as I faced the blank page. I hope that I have faithfully rewarded the trust they put in me. Remember that illustrious forebear, that tireless couturier. This is the story of a not-so-ordinary family, with its own share of poetry and happiness, and of tragedy too. A life story, in short. The story of a man of passions. And what passions!

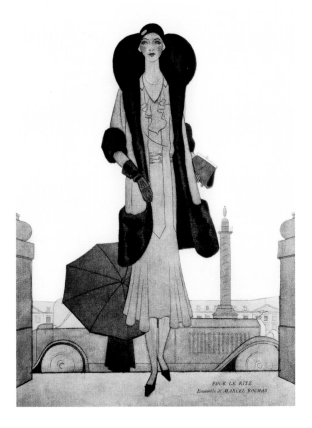

ABOVE Pour le Ritz seven-eights-length trimmed afternoon coat in light green woolen, 1930.

A BORN COUTURIER

1902 | 1925

"TO LOVE BEAUTIFUL THINGS AND TO LOVE ONLY THEM, TO HAVE AN INSTINCTIVE FEEL FOR WHAT'S AUTHENTIC AND WHAT'S FAKE, TO CHOOSE THE BEST AMONG THE WORST, IS A REAL GIFT FROM THE FAIRIES THAT FORTUNATELY FALLS TO THE POOR AS WELL AS TO THE RICH. THERE IS SOMETHING THAT ONE EITHER HAS OR DOESN'T HAVE AND THAT CANNOT BE LEARNED: A SENSE OF PROPORTION…QUALITY AND PROPORTION ARE, TO MY MIND, THE TWO MOST IMPORTANT FACTORS IN DESIGN." MARCEL ROCHAS, 1943.

I doubt my father ever imagined, as a child and teenager, that he would one day be a great couturier. But the family into which he was born and the environment in which he grew up no doubt offered fertile ground. Raised by women, he developed what might be called a feminine sensibility, something that was associated with artists in those days of the early twentieth century; but such a predisposition on the part of a young boy was not then viewed favorably in bourgeois society.

One day in February 1902, after the birth of Suzanne three years earlier,[1] a boy arrived in the Rochas family at last.[2] He was given a fashionable first name, shared by the likes of Achard, Aymé, Carné, Duchamp, Pagnol, and Proust. Marcel would perpetuate the Rochas line, which would have been a source of satisfaction for my grandfather, Alphonse Rochas, and my grandmother, Jeanne Damotte. And all the more so since from birth he was blessed with good looks. As a child he looked almost Indian, with his dark skin and his great dark velvet eyes, full, heart-shaped mouth, and long, curly black hair. He might have been dressed in frilly clothes, with ribbons in his hair, as was customary at the time, but little Marcel would never have been mistaken for a girl.

Alphonse Marius Rochas[3] had been born on March 20, 1873 on rue de Buci in Paris. His father, who came from Valence in Provence, had come to the capital to exercise his profession as a clock- and watchmaker, and his mother was from a family of Parisian property owners. The marriage of Alphonse and Jeanne Henriette Damotte, in 1897, reflected the growing wealth of a generation of craftsmen who joined the ranks of the middle class under the Third Republic. Tall and slim, with light brown hair, hazel eyes, and pale skin, Alphonse sported a fine circumflex-shaped mustache, as was the fashion. My grandmother, Jeanne, whom I never knew, had also been born in Paris. The daughter of property owners from Ménetreux-le-Pitois in Burgundy, near Semur-en-Auxois, she had black eyes, soft brown hair, a mouth with upturned corners (which her three children inherited) and quite distinctive looks, though in complexion she was paler than her children. Her mother, Sophie, built a number of small storehouses on her land in Burgundy for the Pouilly-Fuissé wine from her vineyards, and a café on rue de Ponthieu provided a useful outlet for the wine for a while. Marcel doubtless inherited her enterprising nature.

PAGE 11 Marcel Rochas in 1937.
FACING PAGE Marcel Rochas at the age of four, November 1906.

My grandfather, Alphonse, whom I would like to have known, was a dealer in precious stones, and was more Nordic than Mediterranean in his looks. Where did my father's oriental features come from? He would certainly make the most of them, dressing up as a maharaja at his first fancy-dress parties from early childhood. It is a family mystery, of which there were many in those days when travel to the colonies could produce some surprises. A few years before her death, my aunt Suzanne would speak insistently of Madagascar, hinting that a few drops of mixed blood perhaps ran in the Rochas veins. Whatever their origins, the three children born of the marriage, Suzanne, Marcel, and Perle,[4] would remain close all their lives, and Marcel looked out for the family, his sisters, his nephew Éric, and his niece Kouki.

Our family was characterized by a twin attachment to regional tradition and the artistic professions. No doubt my father's love of excellent wine and good food had their origins in his Burgundian roots, and the long-simmered meat dishes, jugged hare, *boeuf bourguignon, oeufs en meurette* (eggs in red-wine sauce), and other hearty staples of the local cuisine. But becoming a couturier takes time. The many ingredients can't simply be thrown together; it's a subtle recipe that takes patience and practice. It is the art of making them work together that makes a great fashion designer. In the Rochas-Damotte family, the ingredients were not lacking: an archaeologist great-grandfather who took part in excavations on the site of Alesia; a spiritualist great-uncle who was famous in the early twentieth century; a grandfather who was clockmaker to the

BELOW Birth announcement and photographs of Marcel Rochas at various ages. Rochas family album.

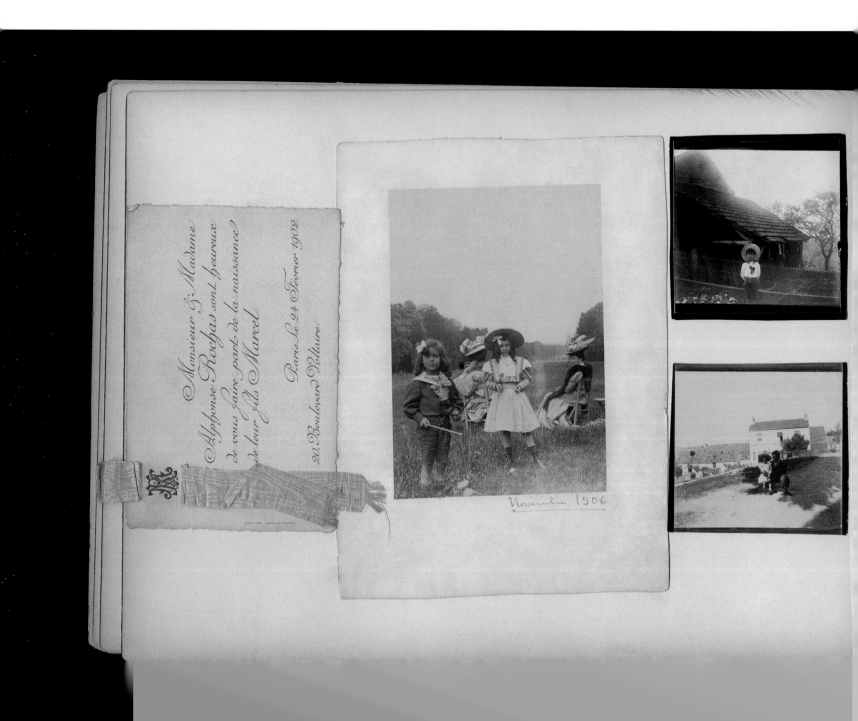

French senate and a freemason. In many families there are figures who were more or less famous in their day but who have been forgotten by posterity.

In this story, it is the boy of the family who would go down in history. All three siblings had artistic gifts, in drawing and painting. But only Marcel would become famous. It is true that few women at the time were able to make a name for themselves. It was easier for them to do so in dressmaking, sewing being part of a girl's education. But it was more unusual for a boy to want to become, say, a dress designer or a dancer; in twentieth-century society, these were seen mostly as women's professions. Being a man and wanting to be a couturier didn't really cut it.

"To make everyone happy, I should say that from a young age I was interested in dolls and dressing up! The reality was quite different! I remember my cries of impatience and cross stamping of feet, and sneaky acts of sabotage, when my mother dragged me around stores looking for fabric, or to the dressmaker's for fittings for her and my older sister. To take my revenge, if I happened to come across a pair of scissors, I would cut up everything I could lay my hands on."[5]

So what were the circumstances that allowed young Marcel's vocation to reveal itself? The Paris salon his mother held every Thursday at his childhood home at 237, boulevard Pereire? My grandfather's jewelry shop was not far away, also in the 17th arrondissement. Alphonse and Jeanne were young and good-looking, and both from families who perpetuated the traditions of the *grande bourgeoisie*, the upper-middle

SUZANNE MARCEL 5 ANS TROUVILLE

MARCEL 17 ANS

SUZANNE GRANDS PARENTS MARCEL

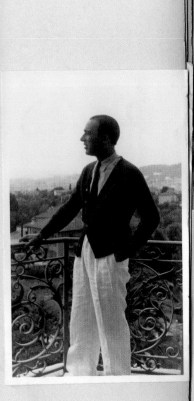

class. Suzanne and Marcel, the oldest of the children, were looked after by a nanny, for their parents often went out in the evening, dining at Maxim's or Prunier. They took great care over their children's education. In addition to traditional schooling, the children also received religious, sports, and artistic tuition, and particular attention was paid to their dress and their appearance in general. When Alphonse and Jeanne requested the children's presence in order to introduce them to adults, they had to look pretty as a picture and speak on cue: "Marcel, say hello, goodbye, thank you," never a word out of place. In middle-class families, it was customary for parents to use the formal *vous* when addressing their children, as the children would in return. One Thursday, when his mother was holding her salon, the five-year-old "petit Marcel" was summoned to greet her visitors. Some of them were clients of the jewelry shop, others perhaps childhood friends from Burgundy. Marcel made his entrance, escorted by the nanny in her white apron. The guests placed their floral-patterned porcelain cups back on their saucers. Standing squarely on both legs, dressed in an impeccably pressed sailor suit, shorts, and pristine long white socks, and not remotely shy, little Marcel faced the guests. He started to greet the ladies present politely, but suddenly froze in front of one of them and refused to say *bonjour*. My grandmother was dismayed at this inconceivable and inexplicable attitude. "*Marcel, qu'est-ce qui vous prend*, what is the matter with you, will you greet Madame de ∗∗∗ immediately?" To no avail. A little embarrassed, the lady in question tried to lighten the atmosphere. "It's of no consequence, Jeanne, the boy must be tired." But Jeanne took a different view; her son had been well brought up and she would show them so. She was mistaken in demanding an explanation, however, for children will always have the last word when confronted. But refusing to beat about the bush, she insisted, with threats, that the impudent boy should behave correctly. Then the small boy's voice broke the stony silence: "I really can't greet that lady, for she is dreadfully badly dressed (*habillée comme une catastrophe*)." Marcel would be punished, but it was the first intimation of the career that was to come. At the time, this was of course some fifteen years in the future, and nobody dreamed of it, not even his father, who wouldn't live long enough to see the talent of his only son.

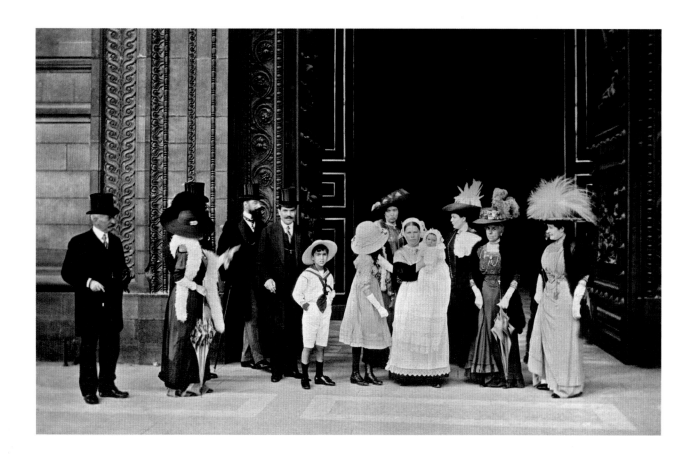

Aside from this childish lapse that came out of the blue, and that the whole family chose to forget after the ensuing punishment, how was it that the vocation of the man who would become the youngest "celebrity couturier" was revealed to him, one night in 1925? Was it something to do with all those beautiful, fashionable ladies, corseted, hatted, gloved, and dripping in jewelry whom he had seen throughout his childhood?

In 1912, after eating a contaminated oyster, Alphonse succumbed to typhoid fever, and Marcel was obliged to take on the role of "head of the family" at the age of ten, thus reigning over three women: his mother and his two sisters. His innate sense of duty helped him take on the responsibility that had fallen to him. Did he truly enjoy much of his youth? It seems unlikely, for his teenage years were marked by this premature loss, followed by four long years of war. All their lives my aunts admired their talented brother who, despite his professional commitments as couturier-perfumer, would always be there for them.

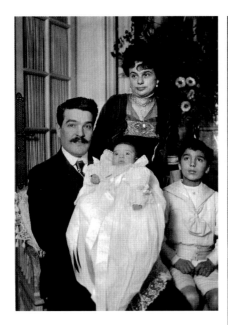

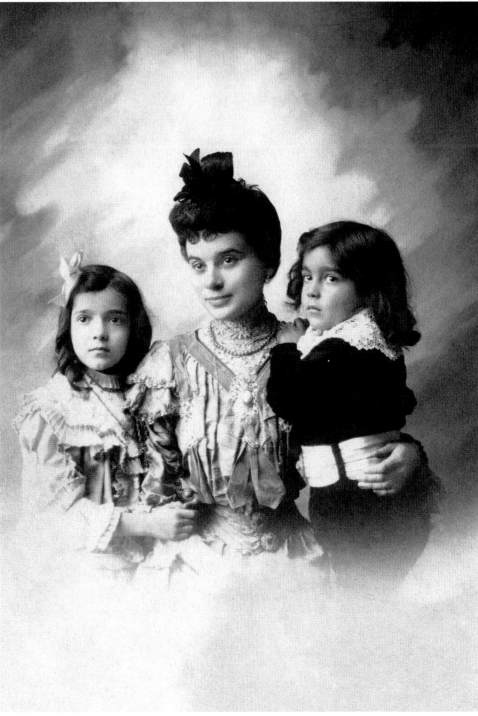

FACING PAGE The christening of Germaine Rochas, Marcel's younger sister, at the church of La Madeleine in Paris, spring 1911. Marcel Rochas, aged nine, wears a sailor suit.
ABOVE Marcel Rochas in 1911, with his parents and baby sister.
RIGHT Marcel Rochas in 1905, with his mother and elder sister, Suzanne.

But for the time being, Marcel was in 7th grade, and his first communion was approaching.[6] The family moved to rue Rouget de l'Isle, a quarter of an hour from the Lycée Condorcet, which my father entered in November 1914. His poor results, except in literature, in which he excelled,[7] no doubt reflect the orphaned teenager's difficulties in adapting to this large high school with thirteen hundred pupils, where life went on despite the mortality rate of the Great War that was taking its toll on families there as elsewhere. He stayed there for just two years, cultivating his sporting abilities—gymnastics and horse riding, among others—outside school, as well as his taste for drawing and painting. His elder sister, Suzanne, was also showing an artistic temperament. Besides her obvious gift for painting, she took photographs and made batik in a workshop. Perle, the youngest, drew figures wearing eccentric outfits. In addition to his drawing lessons, my father started to learn the piano. It came easily to him, and he gave his little sister Perle music lessons. He would sometimes play for fun with the large brass band of his friend Raymond Ventura (uncle of Sacha Distel), but in the national census taken when he was twenty he evidently didn't consider himself a proficient enough musician to declare that he played an instrument.

What was he to do with all these aptitudes? Further his studies, of course. My father's family was demanding, especially of a boy. Girls would get married and have children, but men had to choose a career, whether of a military, scientific, or legal bent. Marcel opted for the law. Once he had gained his *baccalauréat*, he enrolled for a law degree, with a view to becoming a lawyer. "I was a law student, as far as I could be from my true path. I was drawn to literature, to drawing, and to gymnastics. With these three centers of attraction, I could have become a lawyer or a novelist, a painter or a champion boxer. But events and a love affair were to have a much bigger say in the matter than my natural gifts."[8]

BELOW Called up in 1922, Marcel Rochas (standing third from the left) joined the 23rd Regiment de Dragons in Meaux.
FACING PAGE, TOP Marcel Rochas's sister, Perle (Germaine), wearing designs by her brother, 1928–29.
FACING PAGE, BOTTOM Marcel and Suzanne Rochas (standing second and fifth from the right) in Deauville, August 1920.

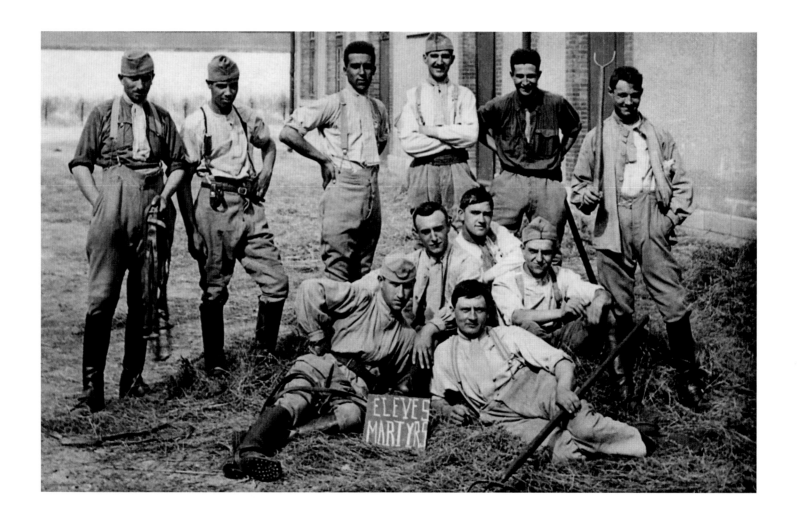

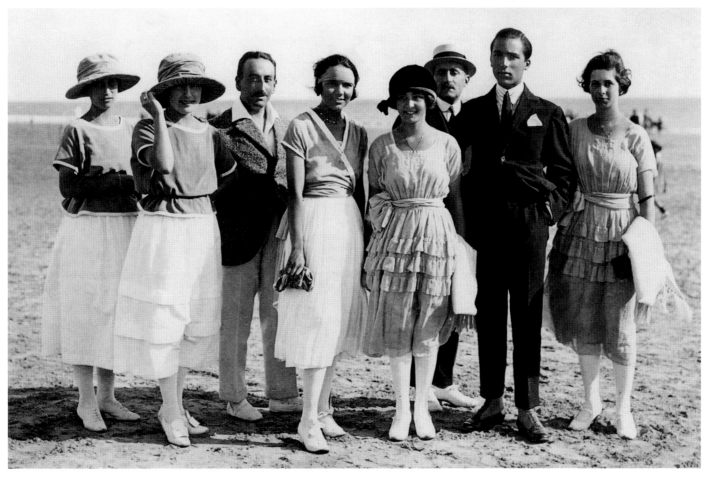

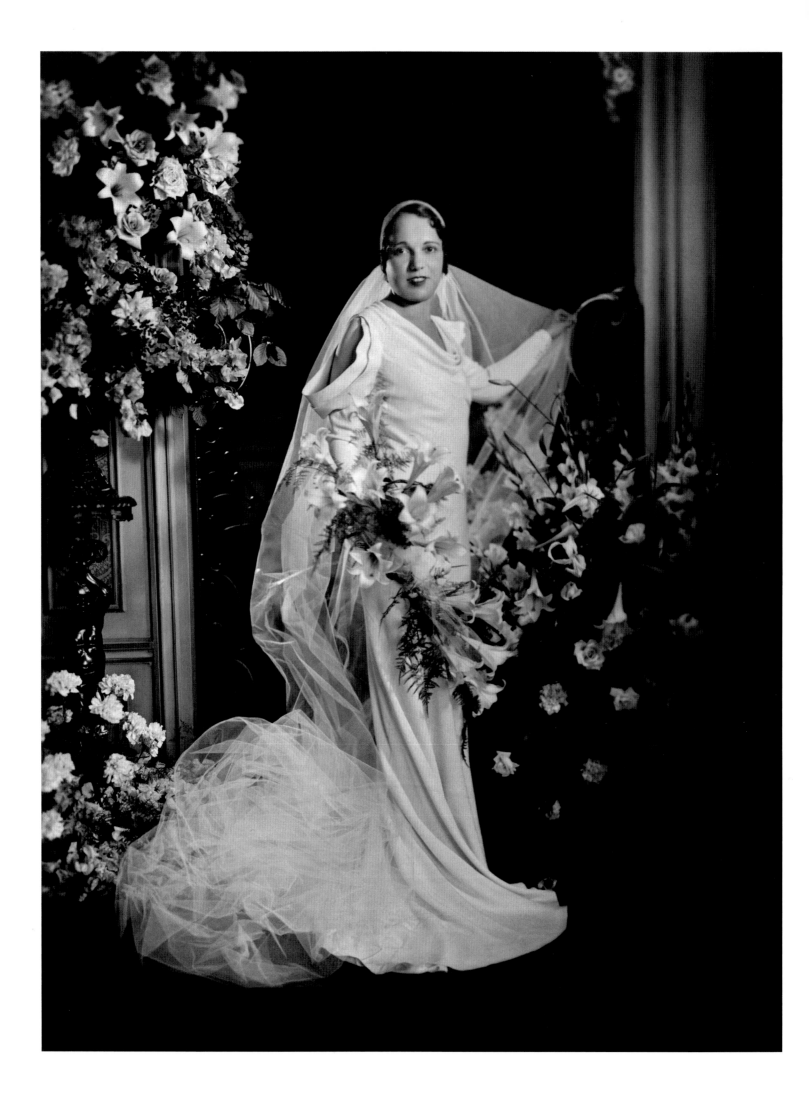

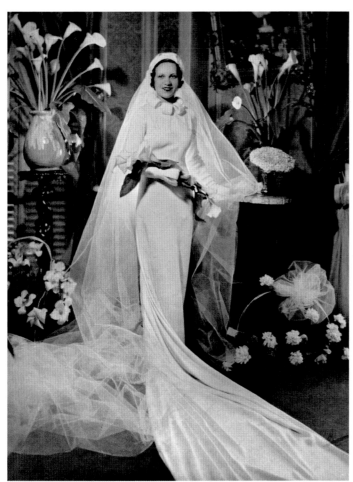

THE REVELATION To pay for his law studies, Marcel got a job as an assistant with a fabric manufacturer: the seeds of good fortune had fallen on fertile ground, and all that was now needed was for someone to nurture those seeds. That person was to be my father's first wife. He was very young, just twenty-two, and she was twenty-four. The daughter of an auctioneer, Yvonne Coutanceau[9] dreamed of fashion, her sights set on getting away from the furniture, paintings, and objects that were the bread and butter of her father's profession. One charming but unconfirmed story has it that the couple met at the Salon d'Automne, where my father was exhibiting a landscape painting.[10] My father held painters in high esteem, and his taste for the arts would remain with him throughout his life. Manet was his favorite artist,[11] for his way of painting women and his sense of color. He would even choose "Manet Blue" for the sofas in the salons of his premises on avenue Matignon, when he had them redecorated in 1950. But this was still the early 1920s. A romantic *coup de foudre*, his meeting with Yvonne reflected the kind of man he was, a little bit crazy, always in a rush, full of energy, and ever youthful. It was love at first sight: *suivez la femme*! Yvonne was a woman of character: she knew what she was doing, and she very soon detected the young Marcel's talent. The decision was taken: he would give up his lawyer's robes—for many other dresses to come. But for now duty called. In May 1922 he was conscripted into the 23rd Regiment de Dragons in Meaux, to carry out his compulsory eighteen months of military service.

When he returned home in November 1923, his certificate of good conduct in his pocket, he could begin to think about his future. The wedding was planned for April 7, 1924.[12] For the budding couturier the challenge was to design the dress that his beautiful blonde bride would wear, the prelude to a long list of wedding dresses: for his older sister, Suzanne, and for Perle in 1934,[13] for high society ladies,[14] and as the climax of his fashion shows. There was the actress Micheline Presle's dress in *Falbalas*, and his

FACING PAGE Suzanne Rochas in her wedding dress designed by Marcel Rochas, July 1933.
ABOVE, LEFT Perle Rochas in her wedding dress designed by Marcel Rochas: white sheath dress in Chantesoie by Colcombet decorated with white feather petals, and diadem with small birds. *L'Officiel de la mode*, no. 153, June 1934.
ABOVE, RIGHT Detail of a wedding dress in white crepe, Marcel Rochas, 1937. Palais Galliera, Fashion Museum of Paris.

finest wedding gowns, several of which are today in store at the Palais Galliera, safely protected from the light. How dazzled I was when I first saw them, in the face of such technique, such purity!

"The young woman to whom I was engaged was naturally the most beautiful and the most elegant woman in the world. This certainty became my strength. My only wealth lay in my youth and my love. And that alone was quite something! I should mention that fashion was very complicated at the time, very tormented … a bit too rich, and too much to the American taste! How much I preferred the kind of blouses worn by my fiancée, her simple sheath dresses, her youthful little *cols Claudine* [Peter Pan collars]! There was such a striking contrast between her style and the other one, I felt so distinctly that it had to be the true one, that I couldn't conceive that other women might dress differently."[15]

While other people may say that as children they always wanted to be a president, pilot, doctor, teacher, fireman, or priest, my father became a couturier not by the grace of God but by the grace of a woman. It was in 1925 that he opened a couture house in his name, Marcel Rochas. He was just twenty-three years old. There was to be no younger couturier until the arrival of Yves Saint Laurent, who was hired by Christian Dior at the age of nineteen, and was twenty-five when he presented his first collection at rue Spontini. In addition to their precocious gifts, the two couturiers also shared a love of the arts: the famous Oiseau (Bird) dress created by Marcel Rochas in 1934 was distantly echoed in Yves Saint Laurent's dress named Hommage à Braque (1988).

BELOW In April 1924 Marcel Rochas married Yvonne Coutanceau, whose wedding dress was designed by her husband.
FACING PAGE Detail of a wedding dress in ivory silk crepe, featuring pearly sequined embroidery with beads in floral motifs, Marcel Rochas, 1936. Palais Galliera, Fashion Museum of Paris.

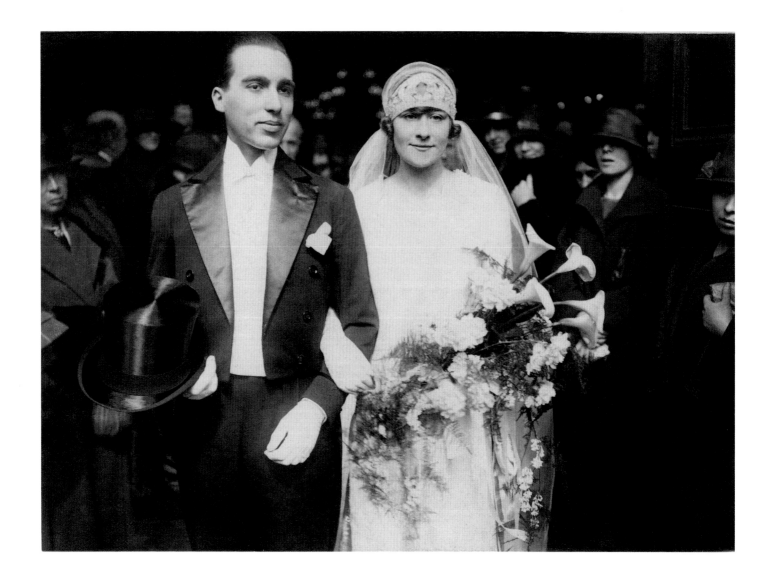

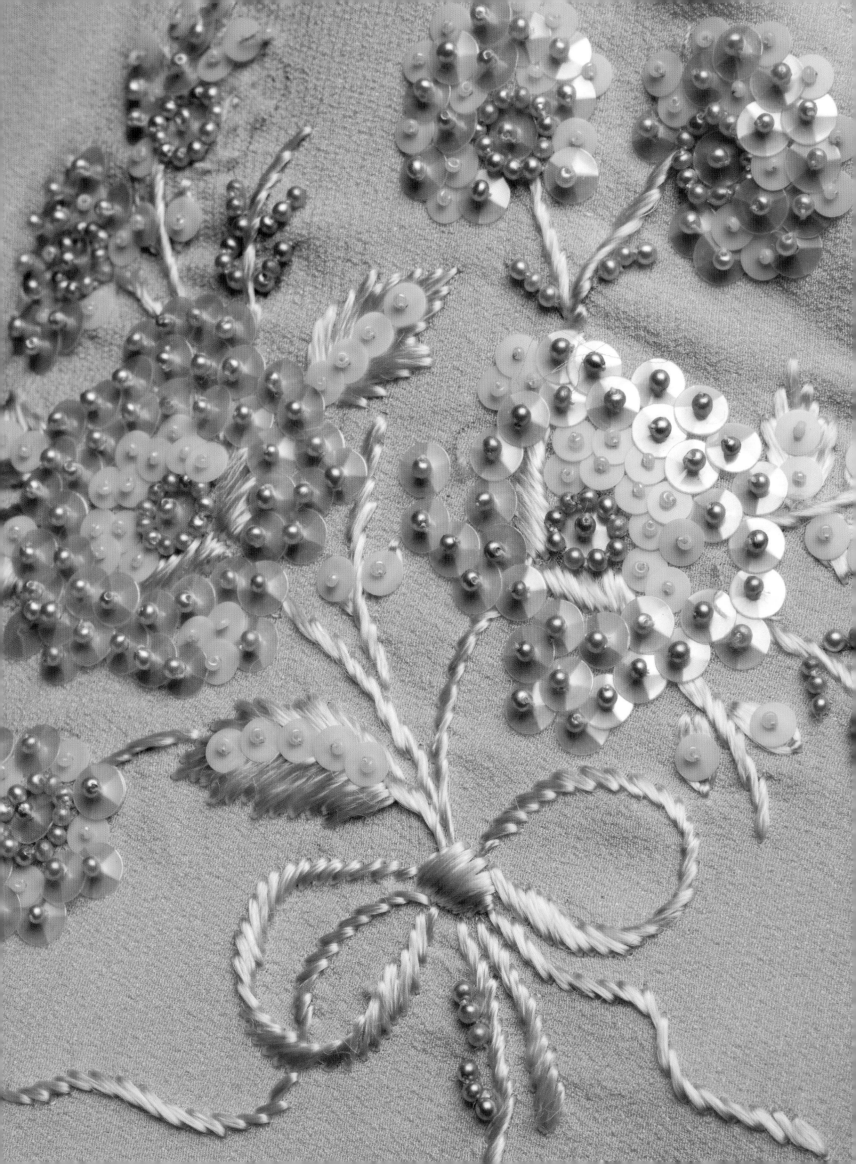

EARLY
DESIGNS

1925 | 1933

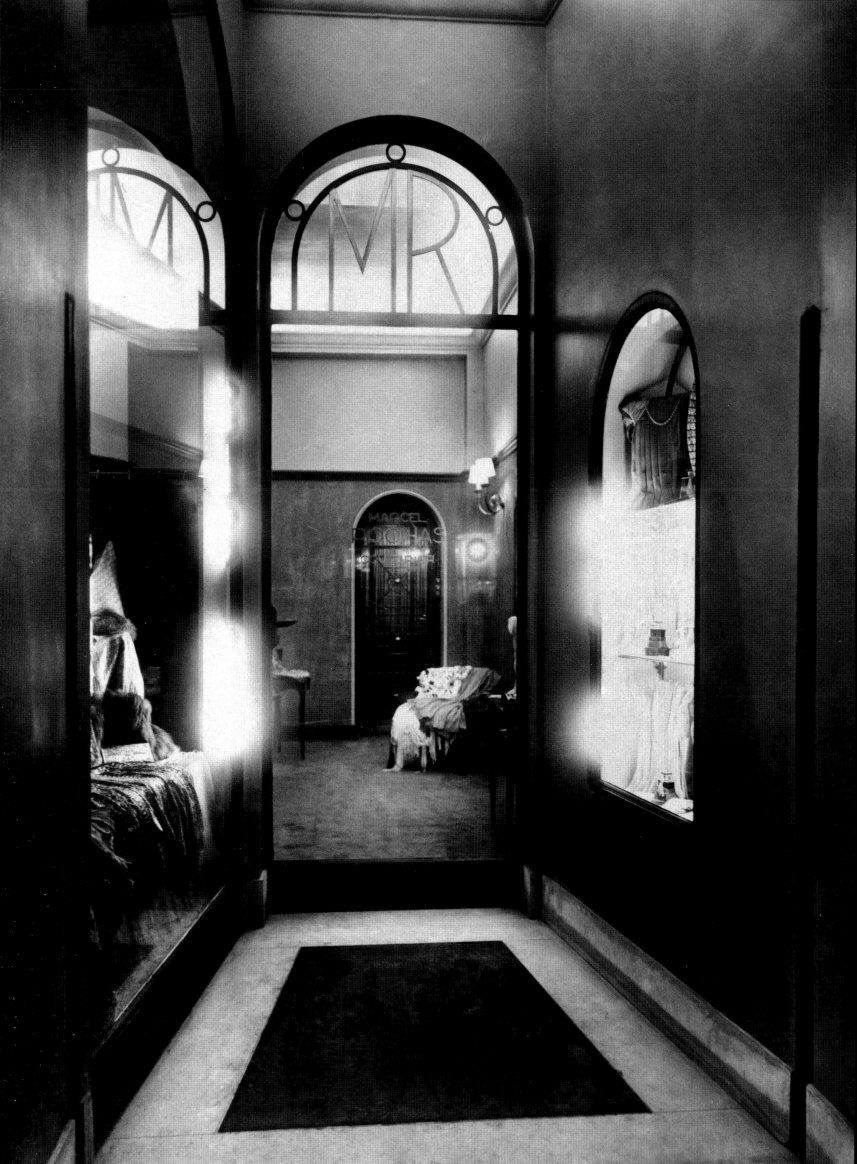

"I WAS MADLY IN LOVE WITH MY YOUNG AND BEAUTIFUL BRIDE BUT OUR MEANS WERE LIMITED. AND SO I CAME SWIFTLY TO THE CONCLUSION THAT THE BEST WAY TO MEET MY BUDGET AND STILL HAVE MY WIFE BEAUTIFULLY DRESSED WAS FOR ME TO BECOME HER COUTURIER. A SOLUTION BOTH SIMPLE AND COMPLICATED AT THE SAME TIME. SIMPLE BECAUSE I WAS IN LOVE; COMPLICATED BECAUSE I POSSESSED ONLY $5000." MARCEL ROCHAS, *TIME*, OCTOBER 4, 1937.

Paris 1925, "the unique theater of fashion, the eternal meeting place of the hand, the material, and the spirit,"[1] the *carré d'or* (golden square) of the luxury industries was the Faubourg Saint-Honoré. It was unthinkable that Marcel and Yvonne Rochas should open their first couture house anywhere else; even if it was small, this was where it had to be. At 100, rue du Faubourg Saint-Honoré, in a modest building on the corner of Place Beauvau and next door to the then Chambre Syndicale de la Haute Couture (Haute Couture Trade Union),[2] the story of Rochas had its beginnings. "Couture, lingerie, and furs, women's and children's general apparel" was the declared vocation of the Marcel Rochas company, with a share capital of 800,000 francs[3] on its registration on August 12, 1925. The young Rochas contributed business assets that he had just acquired from the Société Industrielle des Parures d'Art and the lease for the premises on rue du Faubourg-Saint-Honoré: investments that were refunded him by the new company's shareholders. These numbered ten, selected from the trade and industry sectors, with the exception of the main subscriber, Dr. Marcel Rafinesque, a former intern at the Hôpitaux de Paris. Besides the three hundred shares assigned to him out of the sixteen hundred dividing the capital, a monthly salary of 3,000 francs was granted to Rochas, who was named sole director of his company.[4] At twenty-three, the ambitious couturier of limited means had succeeded in convincing others: with his charisma and talent—which he had yet to demonstrate—he had found the capital he needed to make his dream come true. Among his aristocratic friends, the Arcangues family were part of this madcap adventure. As a token of friendship, the Princesse Murat was a sales assistant for a while in his second couture house, which he opened in 1933 on avenue Matignon. Another member of the original team was the French boxer Georges Carpentier, a friend of my father who had taught him the rudiments of boxing. This virile sport was fashionable at the time: even the Aga Khan boxed. Georges Carpentier's wife would also work as a sales assistant in the Marcel Rochas couture house and store. A smart crowd had come to the aid of the young Parisian couturier.

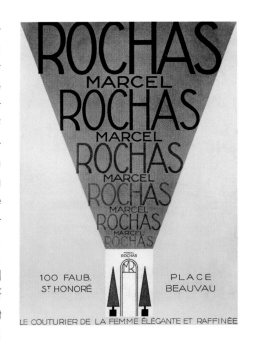

PAGE 25 Entrance to the first house of Rochas, at 100, rue du Faubourg Saint-Honoré, Paris 8th arrondissement.

FACING PAGE The Marcel Rochas label, inside a mini-cape in black velvet with bands of black satin, 1926–28 (see page 95).

ABOVE "Marcel Rochas, couturier to the elegant and sophisticated woman." Advertisement in *Femina*, October 1926.

While they waited for the completion of building work on the premises in rue du Faubourg Saint-Honoré, decorated in the English style,[5] the young couple stayed with Yvonne's parents.[6] Marcel and Yvonne were part of the society set and embraced their bourgeois family lifestyle, often going out in the evening. This was doubtless the best way to foster their public relations. The times lent themselves to partying, in the spirit of *The Great Gatsby*. People danced, drank, and had fun in order to forget the ravages of World War I, mingling with those members of the aristocracy who hadn't been ruined. Everyone was filled with confidence, and the future belonged to those who dared to live their dreams. Couturiers were more than just suppliers; they were acquaintances to be cultivated, sometimes even worshipped. They were part of Parisian life, playing their part in the revolution in style and throwing memorable parties: "It had begun in 1911 when Paul Poiret publicized his Eastern mode with a spectacular oriental extravaganza…the Fête Persane.…He was dressed as a Persian sultan, Madame Poiret as his favourite, wearing a lampshade skirt, harem pants, and imprisoned in an ivory cage."[7] The former law student was passionate and full of ideas, good at speaking, and had the physique of an actor. Slim with a bronzed complexion, slick jet-black hair, and velvet eyes, the "*Valentino de la Couture,*" as he was dubbed, was reputed to have a magnetic charm. The actress Arletty, whom I met at her home in rue Rémusat, which she rarely left by that time as she was almost blind, remembered my father well. Elegant as ever in a cream suit, with a quick and curious mind and Parisian repartee, she still retained—despite the trials she had been through—her inimitable, youthful laugh. "He, at least, wasn't like the others," she remembered. "He truly loved women. And he was as handsome as a model; so handsome that once I followed him in the street."[8]

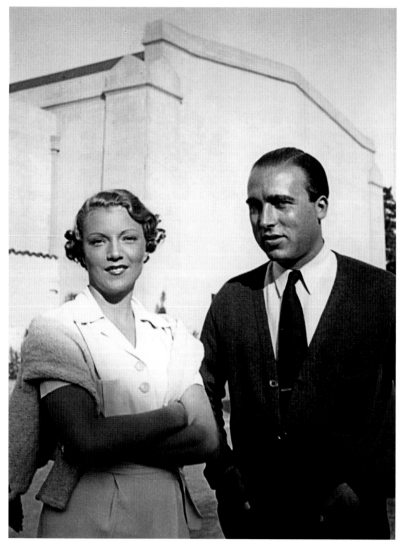

LEFT The actress Annabella with Marcel Rochas during a visit to the United States in the late 1930s.
ABOVE, BOTTOM The couturier and interior designer Paul Poiret (1879–1944), who was a mentor to Marcel Rochas.
ABOVE, TOP Marcel Rochas advertisement, 100, Faubourg Saint-Honoré, Paris (1925–32).
FACING PAGE Wallis Simpson, Duchess of Windsor, wearing Marcel Rochas: cobalt-blue, striped sequined jacket, white dress with a belt to match the jacket, circa 1940.

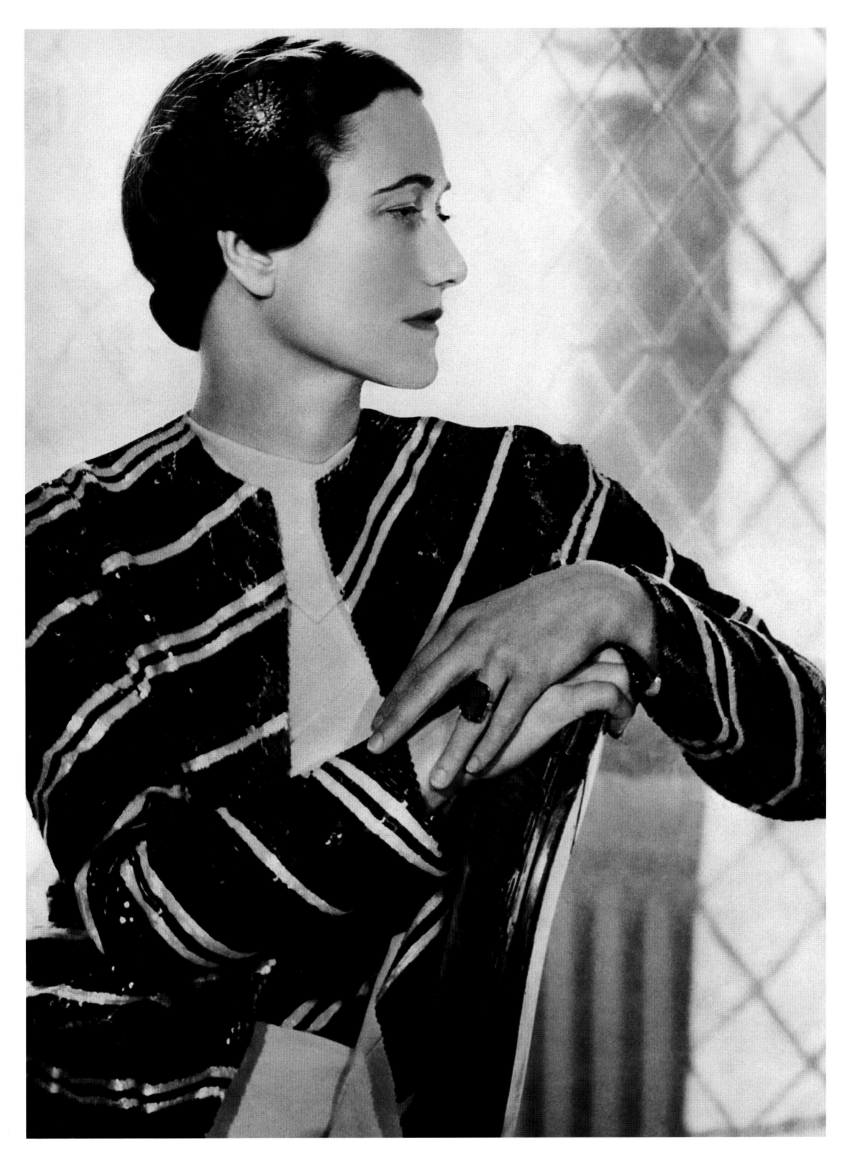

In the early days, Marcel and Yvonne would deliver clothes to their clients together, on a sort of motorized bicycle towing a small cart. They were encouraged by Paul Poiret, known as *"Poiret le Magnifique,"* who lent them a few of his models for their first show, and also by Christian Bérard, Jean Cocteau, Colette, Lise Deharme, Louise de Vilmorin, Élisabeth Toulemont—later Élise Jouhandeau—Braque, Aragon, and Paul Éluard. Over the years, they were joined by many other artists, musicians, painters, writers, dancers, not to mention crowned heads and other illustrious figures including the Aga Khan, the Duke and Duchess of Windsor, the Noailles, Brissac, Montesquiou-Fézensac, Beauvau-Craon, and Croisset families, and wealthy members of the Guinness and Lopez families, as well as patrons Charles de Beistegui, Étienne de Beaumont, and "Le Commandant" Paul-Louis Weiller, among others. Young actresses also took an interest in the new couturier, including Annabella, Simone Simon, Gaby Sylvia, Edwige Feuillère, Suzy Delair, Gaby Morlay, and Madeleine Sologne.

Among my father's early supporters, there is one to whom I should like to pay particular tribute. Besides his talent as a composer, which I discovered much later, I was witness to his great kindness, his unaffected simplicity, and above all his sparkling sense of humor. I recall vividly the timbre of his voice and his delicate touch on the piano keys. This very special person, who stood by my father until his death, was Georges Auric. Three years older than my father, he acted as a protective older brother to this young man who had been deprived of a male role model in the family from an early age. I remember his caring attitude and *joie de vivre*. The two friends shared a taste for good food and wine, cigars, witty conversation, pretty women—not unusual in the world of musicians—and of course music. The Groupe des Six was primarily a group of good friends whose company my father must have enjoyed, who set out to simplify the musical score, clarify musical expression, and bring a breath of humor and light picturesque into music.[9] Georges Auric embodied these ideas perfectly. He introduced Marcel Rochas to Igor Stravinsky, Erik Satie, and Francis Poulenc. With his *Les Fâcheux*, after Molière, created in 1924 for Serge Diaghilev's Ballets Russes, Auric embarked on a series of ballet scores, including a number for the Ida Rubinstein and Daniel Lichine companies. Thanks to him, my father became friends with Serge Diaghilev and Serge Lifar, whom I was fortunate enough to meet in our home when I was a child, though alas I did not see him dance in either *L'Après-midi d'un faune* or *Icare*. Off stage, Lifar's dark and noble beauty, black slicked-back hair like my father's, and rolled "r"s as clipped and precise as his *fouettés*, fascinated me. In the 1920s, the Ballets Russes were a very important part of the Paris art scene. The world of dance no doubt influenced my father's designs, as did painting and cinema.

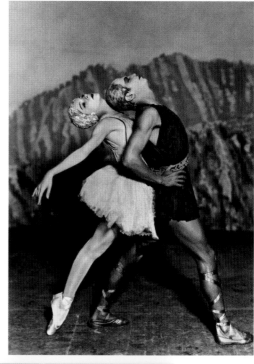

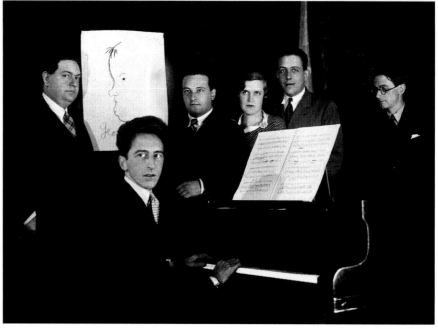

RIGHT, TOP The dancers Alexandra Danilova and Serge Lifar in *Apollon Musagète*, circa 1928.
RIGHT, BOTTOM The Groupe des Six with Jean Cocteau. Left to right: Darius Milhaud, Jean Cocteau, Arthur Honegger, Germaine Tailleferre, Francis Poulenc, and Louis Durey (the absent Georges Auric is depicted in Jean Cocteau's drawing), 1931.
FACING PAGE "Jeunesse" (Youth), Marcel Rochas advertisement by Paul Valentin, circa 1935. The dress suggests the Cambodgienne of 1934, typical of the designs created by Marcel Rochas for the Exposition Coloniale in 1931.

DRESSING PARIS SOCIETY During the carefree period between the wars, members of society watched for the arrival of invitation cards, which were an event in themselves. They were often painted or illustrated by famous artists, and engraved in gold or deep red letters, on ivory or pale gray parchment card. Elegance was everywhere, down to the smallest details, which were designed to reflect the good taste of the smart society set whose members would later fill the pages of the Who's Who. Decked out in their embroidered and beaded dresses, capes trimmed with braid and tassels, feathered boleros, strings of pearls, aigrettes, cigarette holders, and long satin or velvet gloves, fashionable ladies moved from harbor to beach and from beach to racetrack, from cocktail party to dance, and from one theater to the next: the show must go on.

My father was an astute strategist and a keen observer of high society, and soon developed a well-honed understanding of public relations: it was important to be talked about, and there was no such thing as bad publicity! You had to make a strong impression, even if it meant causing a mini-scandal at some fantastically smart soiree. He liked things to move fast, and he relished the unexpected, and one day he decided to take a big gamble in the space of a few hours. That evening, he loaned the same ball gown design to no fewer than eight society beauties: "Imagine eight identical black sheath dresses with a high collar, paired with the same necklace of arum lilies! Two young women, on the verge of a nervous breakdown, went home to change their gowns; two others plucked nervously at the arum lily necklace; the other victims decided to grin and bear it. It was the talk of the town."[10] This memorable event provided a spectacular launch for the haute couture career of the young man who a few years later would become my father. Myth or fact? Although told some twenty years later, the story reflects so well on my father that it would be a shame not to tell it. Did he really dare? Was it in 1925? The description of the dress is more suggestive of the early 1930s: perhaps he planned this coup to mark the opening of his second store? As for the sheath dress, it was significant that it should play a role in this opening story of his career as a couturier: it was to bring him luck, and he adopted it as his talisman.

After presenting himself as the "couturier of the elegant and refined woman,"[11] Marcel Rochas wanted a higher-profile image on the Paris fashion scene: he was twenty-three years old, so naturally he would be couturier to the *jeunesse dorée*, or gilded youth. In 1928, he chose the slogan "*Simplicité et Jeunesse*" ("Simplicity and Youth"), then "*Jeunesse, Simplicité, Personnalité*" ("Youth, Simplicity, Personality"), and two years later "*Jeunesse*" ("Youth") and even "*Toujours plus jeune*" ("Ever More Youthful").[12] When he took stock of his career in 1943 and in 1951, he insisted on a motto that he would adopt retrospectively: "Elegance, Simplicity, Youth." The meticulous care he took with his slogans echoed his sense of graphic design and the logos that gradually built his image through the advertising campaigns published in women's magazines from late 1925. My father was quick to understand the importance of networking through society circles and the press. Keeping his sights set on a young clientele, he appealed to young women, anticipating their desires, and they in turn followed him.

Two ideas boosted his creative potential as a couturier: while the "Marcel Rochas" label, woven on a ribbon, was sewn into the lining of each garment, the house also maintained an aggressive pricing policy. An haute couture dress by Rochas would sell for 800 francs, when it was hard to find a similar dress elsewhere for less than 2,000 francs.[13] Designer dresses at lower prices? In glowing reports, women's magazines such as *Vogue* (1926), *L'Officiel de la mode* (1927), *Le Jardin des modes* (1928), and *Femina* (1929) urged their readers to hurry to Place Beauvau.

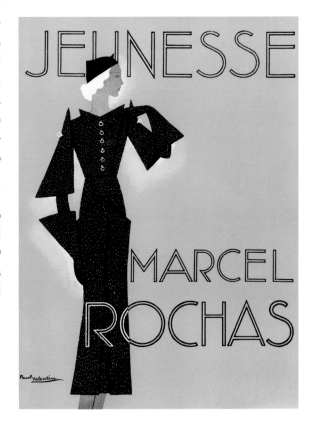

Over time and with growing mastery of his skills, Rochas learned how to cater to changing tastes, and even to anticipate them. For the time being he was in step with contemporary fashions, following in the footsteps of Paul Poiret, who freed women from the torture of the corset and promoted the use of color. While the androgynous *garçonne* style was in vogue, Rochas was shaping his very feminine modern woman of the years 1925–1930.

His gamble had paid off. His mini-scandal got people talking better than any advertising campaign might have done. This young man who had set out to become a lawyer now added his name to the list of leading Parisian haute couture houses such as Agnès, Augustabernard, Beer, Callot Sœurs, Chanel, Dœuillet, Doucet, Jenny, Lanvin, Louiseboulanger, Lucien Lelong, Martial & Armand, Molyneux, Paquin, Jean Patou, Philippe & Gaston, Paul Poiret, Redfern, Madeleine Vionnet, and Worth. They included a good number of women designers, catering to the new aspirations of their sex: "It was the women themselves, like carriers of pollen, who fertilized insatiable Paris fashion; it was the millions of women exchanging constant glances over a cut, a nuance, the set of a sleeve, asking for alterations and hoping for a change, who created fashion; thus did the artists of couture understand what was in their minds."[14] Many French women wore clothing that was made to measure by couture houses, whose turnover was booming. Ranking second in France's foreign trade, couture represented 15 percent of all French exports.[15] In 1930, despite the economic recession, 350,000 people were still working in the couture sector and 150,000 in related activities (glove-making, costume jewelry, lace, and embroidery).

BELOW AND FACING PAGE From 1928, Marcel Rochas focused on the theme of youth. "Toujours plus jeune" (Ever more Youthful) and "Jeunesse" (Youth), advertisements by Paul Valentin, circa 1930 (below, left), Dorland, French *Vogue*, April 1930 (below, right), and Paul Valentin, French *Vogue*, circa 1932 (facing page).

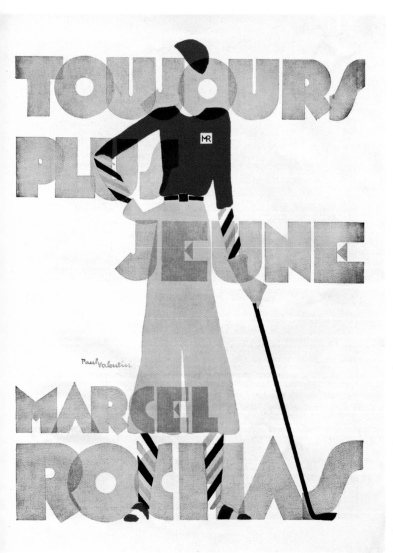

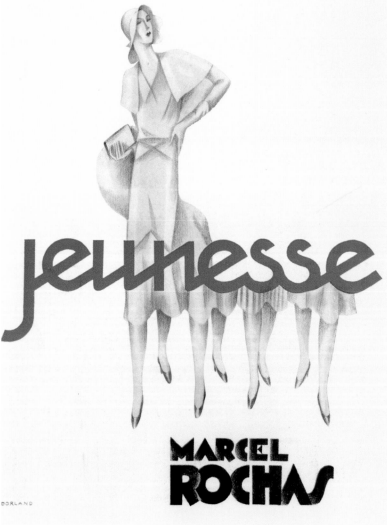

THE ART
OF PROMOTION

Julia Guillon, Heritage Department of the House of Rochas

From the early days, Marcel Rochas embraced innovative communication strategies for his fashion house. During the period 1920–1930, Paul Valentin and Dorland, who were commissioned to do its advertising, created an elegant, modernist graphic design with brief slogans ("Simplicity and Youth," "Youth," "Ever More Youthful"). The colored band or banner, one of the strongest elements of the Rochas's visual identity, was used for both perfumes and couture from around 1935. Initially, the brand name Marcel Rochas Paris, sometimes with the initials M.R. superimposed, stood out in red and white capital letters on a navy background. This new look, common to the three Rochas perfumes at the time, Audace, Air Jeune, and Avenue Matignon, is evocative of the salon interiors at the house of Rochas on avenue Matignon (and later in New York). By extension, the colored band also echoed the house couture design label. A concern for fostering an all-embracing identity thus began to emerge during this period. In the late 1940s, the Rochas band moved away from its original two-color design to take on a range of hues, first with a neutral background and soon with many different colored backgrounds, sometimes matching the bold color combinations that were the house signature.

Earlier, when setting up the Parfums Marcel Rochas company, the couturier-perfumer had started to work with the talented photographer Roger Schall, who took an active part in developing the group's visual identity. In a style that was humorous and elegant, he made the most of the photogenic qualities of lace (Femme and La Rose), using superposition and plays of light and shade partially influenced by Surrealism, and developed the comical, dandy look of the "bonhomme Moustache" with his monocle, top hat, and bow tie.

Marcel Rochas was a pioneer in linking each of his product launches with a cultural event. The launch of Femme, in late 1945, was accompanied by an exhibition entitled, Les Parfums à travers la Mode 1765–1945 (Perfume Through Fashion 1765–1945), in tribute to Paul Poiret, with contributions from Boris Kochno, Louise de Vilmorin, Annie Baumel, and Christian Bérard. In June 1949, La Rose was launched with a promenade concert in the rose garden at L'Haÿ-les-Roses. To promote Moustache, also in 1949, Rochas mounted the exhibition Portraits d'hommes du XVIᵉ siècle à nos jours (Portraits of Men from the 16th Century to the Present Day), with each of the subjects sporting a mustache. The house also threw a ball on the theme "Mouche et Moustache" (Beauty Spots and Mustaches). These initiatives served to reinforce the house's aura of culture and reputation as a host for cultural events.

FACING PAGE Rina Rosselli wearing a moiré day suit with beige top and jacket and black skirt, 1929.

THE ROARING TWENTIES At the end of World War I, women were hungry for emancipation. A wind of freedom was blowing, and it showed in their dress and behavior. Like men, women smoked, went to the races, and drove cars, and they also showed their legs without fear of causing a scandal. They wanted comfortable clothes in which they could work or enjoy their leisure activities. Being slim became the ideal and sporting a suntan was no longer considered an embarrassment. It went with the sporty, sassy, flirty, even immodest look of the *garçonne* with her short hair,[16] which she hid under a cloche hat when she went out. "Short, flat, geometric, quadrangular, women's clothing is based on models after the parallelogram,"[17] deplored Colette. The shirt dress was a conspicuous new addition to women's wardrobes, as were knitted ensembles and sweater-and-skirt sets; corsets, meanwhile, were cast aside. The waistline dropped to define a slim-hipped, androgynous figure, and skirts were shortened to fall above the knee, though they lengthened a little again from 1929. Sportswear was now available for both sexes; swimsuits shrank, and tanned bodies sported loose pants called beach pajamas.

For morning wear, women preferred an understated, comfortable style, sometimes with a discreet ribbon or touch of lace. Asserting their independence, they reinterpreted the masculine look by feminizing it. In town, skirt suits were popular, worn over a blouse with collar and cuffs, as were jackets over wide, high-waisted pants, using accessories such as ties, bowler hats, and canes to play on the feminine-masculine ambiguity. After her morning activities, visits, and shopping, a fashionable woman would change her outfit for her afternoon meetings, the race course or an art exhibition, a tea party or bridge. For these she would need a more elegant dress, in chiffon or crepe perhaps, with a more elaborate cut.

After nightfall, she would opt for a very feminine ensemble in silk, silk velvet, or lace. In the evening, to contrast with her daytime style, the 1920s woman became a true vamp, in something stunning that was also easy to wear. Clean lines, flowing cuts, and black were favored. The famous little black dress, the *"Ford de Chanel,"* made its appearance in 1926. In 1922 and 1923, evening outfits were elegant ensembles of a dress and coat, with the coat lining sometimes matching the dress material. For a cocktail party or soiree, lamé was de rigueur. Designers honed the art of detail: every part of the outfit might be embroidered with sequins or gold and copper metal thread, or covered in silk chiffon or ribbons. Evenings were lavish, and accessories were essential embellishments: tiaras and barrettes; jewels and bead necklaces of onyx, jet, coral, jade, pearls, diamonds, and glass paste; precious and semi precious stones; feather fans, clutch bags, stockings embroidered with sequins, and shoes with heels covered in paste beads. Women's emancipation was reflected in the sleek lines, decorative effects, and play of fabric and light in their clothes.

Women's liberation was even manifested in aviation exploits: "Times have changed. 'Madame gets back, Monsieur is reading his paper.' Penelope has become the husband waiting for his wife to return from her trip. Sometimes, she doesn't return; it's the risk taken by these pioneers of the sky."[18] Rivaling the American women aviators, the first of whom was Amelia Earhart, France also had her "female Mermozes," such as Hélène Boucher and Maryse Bastié, admired in France and throughout the world. "Grace, charm, simplicity, bravery, and stoicism, this is what these women aviators have shown."[19]

The era of record-breaking was also that of the booming maritime and railway companies, and of the birth of passenger airlines. Cultural exchanges grew. In April 1925, the International Exposition of Decorative Arts opened on the Esplanade des Invalides. Seventy-five couturiers were represented, as Didier Grumbach has described.[20] Visitors wandered between the Pavillon de l'Élégance and the forty-odd stalls set up on the Alexandre III bridge, including the Boutique Simultanée opened by Sonia Delaunay with the couturier Jacques Heim, where she presented her woven coats with matching

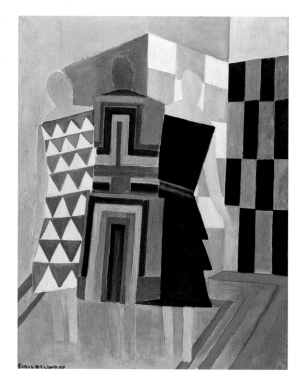

ABOVE Sonia Delaunay-Terk, *Simultaneous Dresses (Three Women, Forms, Colors)*, 1925.
FACING PAGE Photographs of designs patented by Marcel Rochas in 1928.

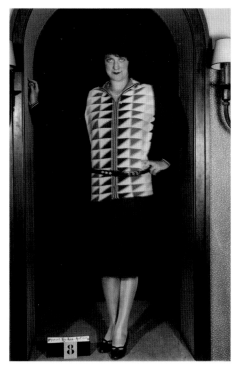
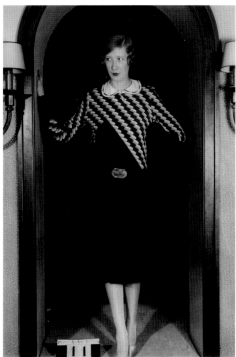
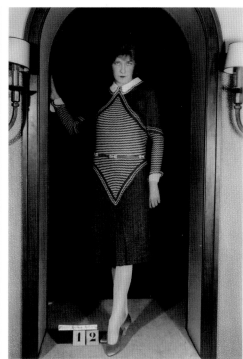

stole and bag. A young man longing for change could not have dreamed of a better opportunity to get an idea of the new formal repertoire that was emerging. Advocates of the clean, pure line were gaining ground over upholders of art nouveau, while the pavilions of the French colonies brought a breath of fresh air from overseas. The haute couture of the 1920s captured this whiff of exoticism. My father was part of the artistic crucible that Paris then was, along with the actress and singer Mistinguett, whom you could see performing at the Casino de Paris music hall or the Moulin Rouge cabaret; Kiki de Montparnasse, Man Ray's *Violon d'Ingres*; Josephine Baker, with her boyish figure and *Revue nègre* show; and from America jazz and the Charleston, the music of Gershwin, and the Dolly Sisters. Everyone went crazy for dance! Other American stars also made the journey to the City of Light, including the graceful dancer Isadora Duncan, killed in her car by her own flowing scarf; the curvaceous actress and dancer Mae West; and Hollywood stars Joan Crawford, Mary Pickford, Greta Garbo, and Gloria Swanson. When the capital wasn't deserted for Deauville, Biarritz, Saint-Jean-de-Luz, or later the Côte d'Azur and winter sports, its giddy social life was played out between Le Bœuf Sur le Toit in Montparnasse, where Jacques Doucet played the piano all night long, and the cabarets, music halls, and dance clubs of Saint-Germain-des-Prés. Artists devoted their creative imagination to legendary balls on historic, exotic, poetic, or Surrealist themes, hosted by the likes of Charles and Marie-Laure de Noailles, the Gramonts, the Faucigny-Lucinges, or Étienne de Beaumont. My father and his wife wouldn't have missed them for the world. When it wasn't a ball it would be a dinner party hosted by Lady Mendl, famed for her interior decoration, or the fabulously wealthy Daisy Fellowes, or the society columnist Elsa Maxwell. In the evening, when the Ballets Russes were performing, people would applaud sets designed by Picasso, Braque, Derain, or Gontcharova, and the music of Stravinsky, Auric, Poulenc, or Satie, or else the work of Picabia with the Swedish Ballets and Erik Satie on the highly Surrealist *Relâche*.[21] The artistic imagination was triumphant. The art and fashion worlds converged and stimulated each other. Great architects and renowned interior decorators designed houses and apartments for high society, and couturiers commissioned them to design their salons.

YOUTH AND SIMPLICITY "All my designs are simple, with a sporty look ... because young women, and my wife and I, cannot conceive of fashion otherwise. Today I no longer like my designs of yesterday, and I already love all those that I will create tomorrow, but I try not to design anything simply for the pleasure of creating something new."[22] In the early days, my father, who created his designs with Yvonne, came up with severe cuts with simple colors and variations on the masculine/feminine line. "He is thinking of the young, active, and elegant Parisienne ... for the morning and for sport, and he shows us jersey and woolen ensembles, in selected tones.... The simple skirts are quite flat behind (they mustn't crease during a car ride), but shaped in front, featuring groups of pleats, etc. Jersey sweaters of all sorts: angora, wools, cashmere, mixed with metal; many horizontally graded stripes."[23] My father's popularity grew thanks to his charming, elegant little Parisian outfits, the forerunners of the suit, which gently broke with the androgynous and quadrangular *garçonne* silhouette. Under sweaters in well-chosen colors, and light-colored, bib-front or pin-tucked blouses, the "young girl" style, with small Peter Pan, pointed, or low-neck collars, brought a contrasting touch of softness and elegance. Marcel Rochas thus moved away from the masculine look of the *garçonne*, which didn't correspond to his vision of femininity. He added flounces and pleats to his first two-piece knitwear ensembles, which spoke of his taste for feminine details, and integrated flat pleats into his cardigan jackets. For evening wear he proposed "very flowing evening gowns, pointed cuts, detached panels, long scarves, very irregular lengths,"[24] noted *L'Officiel* in 1927. Extremely feminine and more sophisticated than day dresses, often in white, light beige, champagne, dark blue, or black, his evening gowns featured long, gored skirts, sometimes trimmed with chiffon flounces. Low hips were emphasized with wide, silky pleated belts complementing the ample godets. The emphasis remained on youth and movement, for dancing was all the rage. High fur collars on evening coats brushed against hair cut short and crimped over bared napes. In place of fox fur, a wide, white collar might drape over the back of a black coat back, the effect accentuated by long, floating two-toned scarves. One of these coats is somewhat reminiscent of the lawyer's gown that my father almost donned. Marcel Rochas enjoyed the ambivalence of borrowing from the male wardrobe in order to heighten a design's femininity by means of contrast. However, while he combined masculine and feminine looks, in keeping with the *garçonne's* emancipation, my father did not lose sight of the fact that, whatever the hour of day or night, and whatever the activity she was engaged in, a woman should remain feminine at all times.

His beach pants, which attracted attention in 1926 in New York,[25] widened at the bottom with insets and box pleats, and beach coats, with a cut inspired by men's coats, responded to the new aspirations of fashionable women. My father's second wife, Rina, looked very chic wearing Marcel Rochas pants in the 1930s on the Deauville boardwalk or the Chambre d'Amour beach in Biarritz.

Sonia Delaunay's textile designs opened up new directions in geometrical forms and color contrasts. Yvonne and Marcel's flowing designs and feminine lines also incorporated broken lines and right angles, as in their Cubist sportswear ensemble of 1927. Superimposed bands, several rows of topstitching, appliqué work, and insets enhanced the lines and structure of Rochas designs. "We are seeing the same versatility and same visually pleasing understanding of modern demands: colorful geometric insets, ribs, godets, seam shaping, etc. The coats, with a pretty line slightly flared from the bottom, feature appliqués and furs."[26] The play of lines extended to the choice of fabrics, striped or spotted, anticipating the fashionable prints of the following decade. At the turn of the 1930s, Marcel Rochas designed a long sheath dress with a bodice motif inspired by the Renault Reinastella radiator.[27]

Rochas continued to develop this style, which would soon flourish, basing one of his advertising campaigns in 1930 on "the two lines,"[28] a play on the dual use of "line" to signify both clothing lines (sportswear or evening wear) and geometric lines

ABOVE The colored band used by Marcel Rochas from 1935, designed as a distinctive house motif.
FACING PAGE, LEFT "Jeunesse, Simplicité, Personnalité" (Youth, Simplicity, Personality), Marcel Rochas advertisement by Marc Real, 1929.
FACING PAGE, RIGHT "This young couturier presents a very complete and balanced collection. He is thinking of the young, active, and elegant Parisienne. For the morning and for sport he shows us jersey and woolen ensembles, in selected tones. The simple skirts are quite flat behind (they mustn't crease during a car ride)." *L'Officiel de la mode,* no. 74, 1927.

(plain or broken). He was quick to take on board the fact that couture houses could not live without advertising, and his keen sense of communication encouraged him to develop a bold strategy in this area. The opening of his store on Place Beauvau established his graphic design identity and developed the brand. In the 1930s, the first Marcel Rochas advertisements appeared. With their subtle play of colors, they signaled the recurrent, familiar presence of the couturier in the everyday lives of modern women and elegant men. From 1945 they appeared everywhere, in the press, in ballet and theater programs, in exhibition catalogs, and on invitation cards. The couturier was implicated in every aspect of Parisian life, a ubiquitous presence, with no dividing line between his professional and private life. A man of his time, he was sensitively attuned to its every new trend. Then he would set about putting what he had captured into words. Language was another asset that he used to further his creative work and commercial strategy: my father loved to use words and even invented some of his own (coining the term *guêpière* for a "waspie" corset, for example). Eclectic in their inspiration, some of them still sound foreign or exotic to our ears. Where did he get this love of words from? Innate or otherwise, it had clearly been fostered during his time at the Lycée Condorcet.

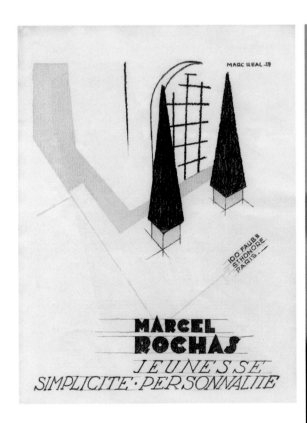

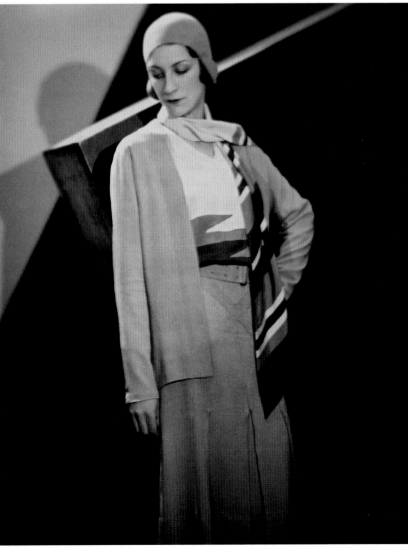

CHIC SPORTSWEAR

As a couturier for young people, and a couturier of his times, Marcel Rochas was bound to cater to the wardrobe of the elegant, sporty woman. His famous "two lines" formed a dichotomy that ran throughout his career: a highly sophisticated evening line contrasting with a more simple and comfortable line for the daytime. In 1925, the first advertisements for Marcel Rochas Couturier focused on "*bonneterie*" (hosiery) along with "dresses, coats, furs" and "luxury perfumes." The demand for *bonneterie*, which included knitted and jersey items as well as socks, stockings, and lingerie, reflected the new popularity of sporting activities after World War I. "Sports dresses" and "closely tailored sports coats" offered the comfort and elegance of jersey and wool ensembles, while demonstrating Rochas's eye for color in their color combinations, and his use of fabrics that kept their shape. Forms and color were at the root of an approach that matched the vitality of the times: "All these colors sing out on the snow and skating rinks sparkling in the sun. One can understand the enthusiasm of the young generation for this life of movement and the open air that renews and revives the deepest forces of our being." (Colette d'Avrily, "La Mode et le Sport," *Les Modes*, January 1934).

The vogue for skiing and the beach endured until the outbreak of World War II, and Marcel Rochas was full of ideas for dressing every moment and every need of this France in which people, as they had in England and Germany, had begun to take care of their physique. For the mountains, Rochas's designs replicated comfortable features of the male wardrobe, including knickerbockers, two-piece suits in black gabardine or dark-green waterproofed fabric, sweaters, gloves, and white or orange wool stockings. For après-ski wear, in 1947 the couturier invented a new concept, the Spahi-Ski: woolen pants that narrowed at the ankle, inspired by the military dress of the Spahis, light cavalry regiments assigned to service in North Africa. Summer mountain and seaside resorts also called for a complete wardrobe, notably the comfortable yet elegant "beach pajamas." Short-sleeved jackets, sweaters, or sleeveless smocks accompanied wide pants that sometimes featured godets. Swimming, as opposed to paddling in the sea, called for innovative textiles, and swimsuits now covered less of the body. Rochas's La Bourrasque swimsuit of 1934, a corset-shaped costume, offered an aerodynamic look that was well-suited to this speed-loving era. In the 1940s and 1950s, cotton beach ensembles, featuring draped elements and the use of looser cuts and softer fabrics from the city wardrobe, continued to reflect these mutual influences between sportswear and couture. **JG**

FACING PAGE Marcel Rochas's "two lines", one straight and sporty for daywear, the other more feminine with flounces for evening wear. Advertisement from the 1930s.

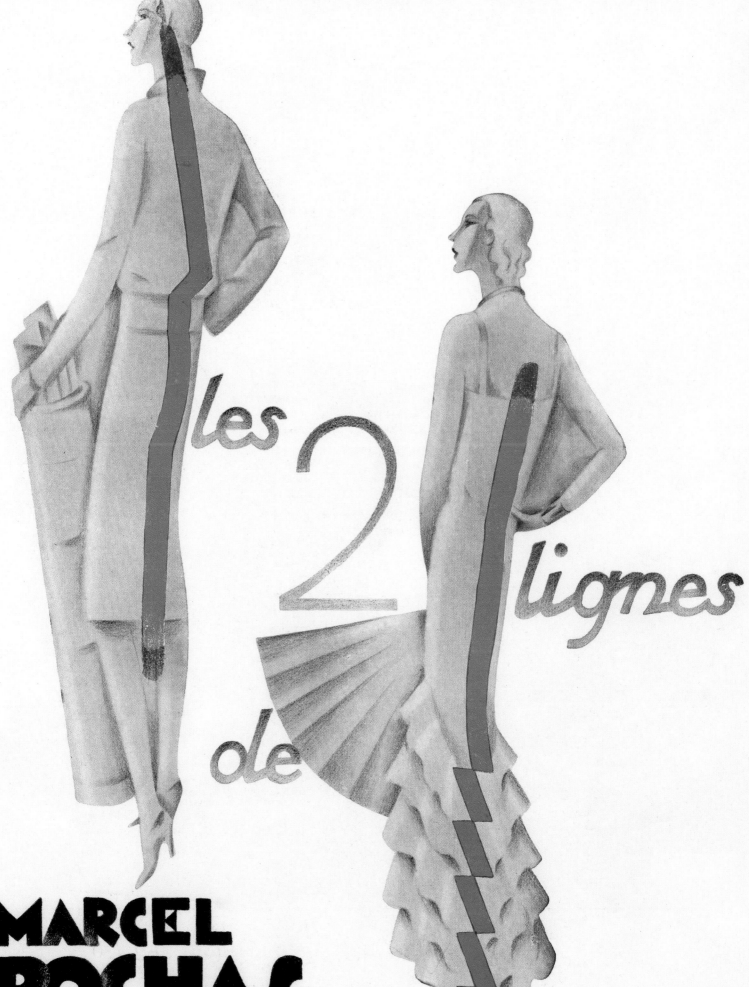

les 2 lignes de

MARCEL
ROCHAS

A GREAT COUTURIER IN THE MAKING

1933 | 1939

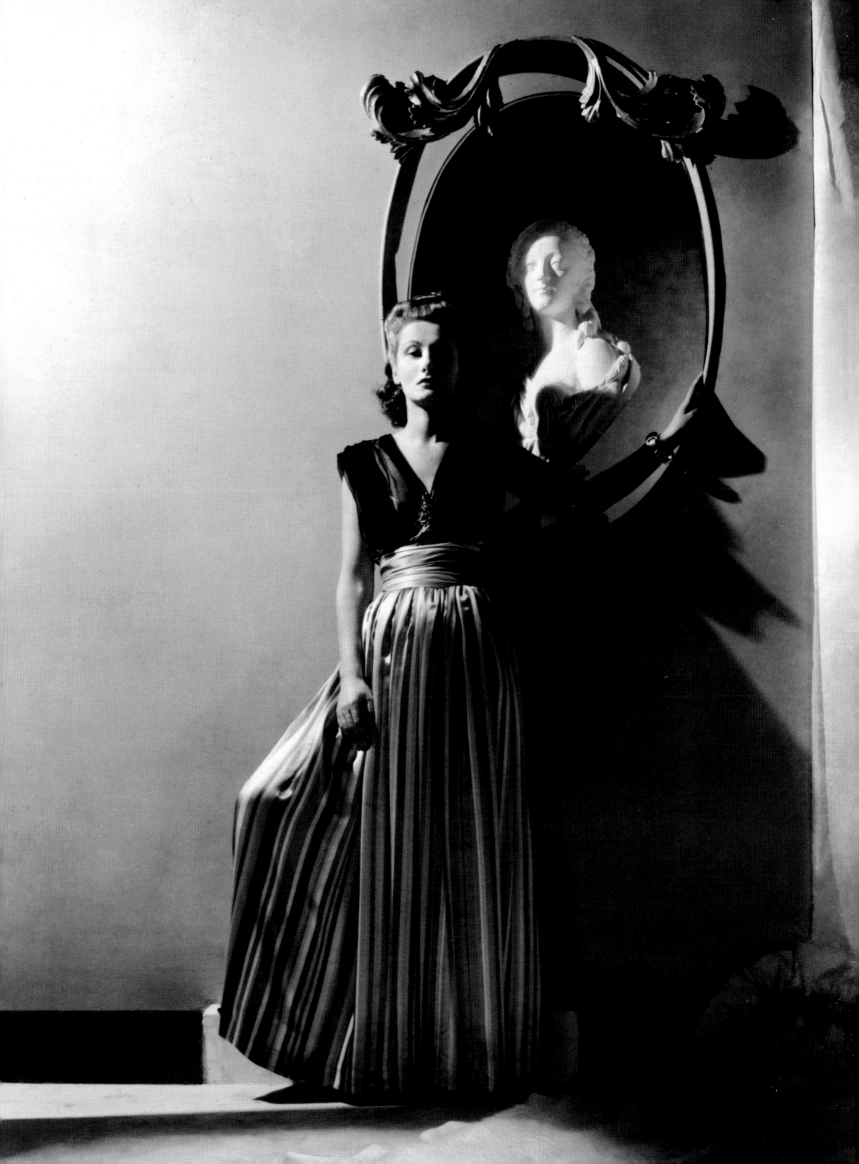

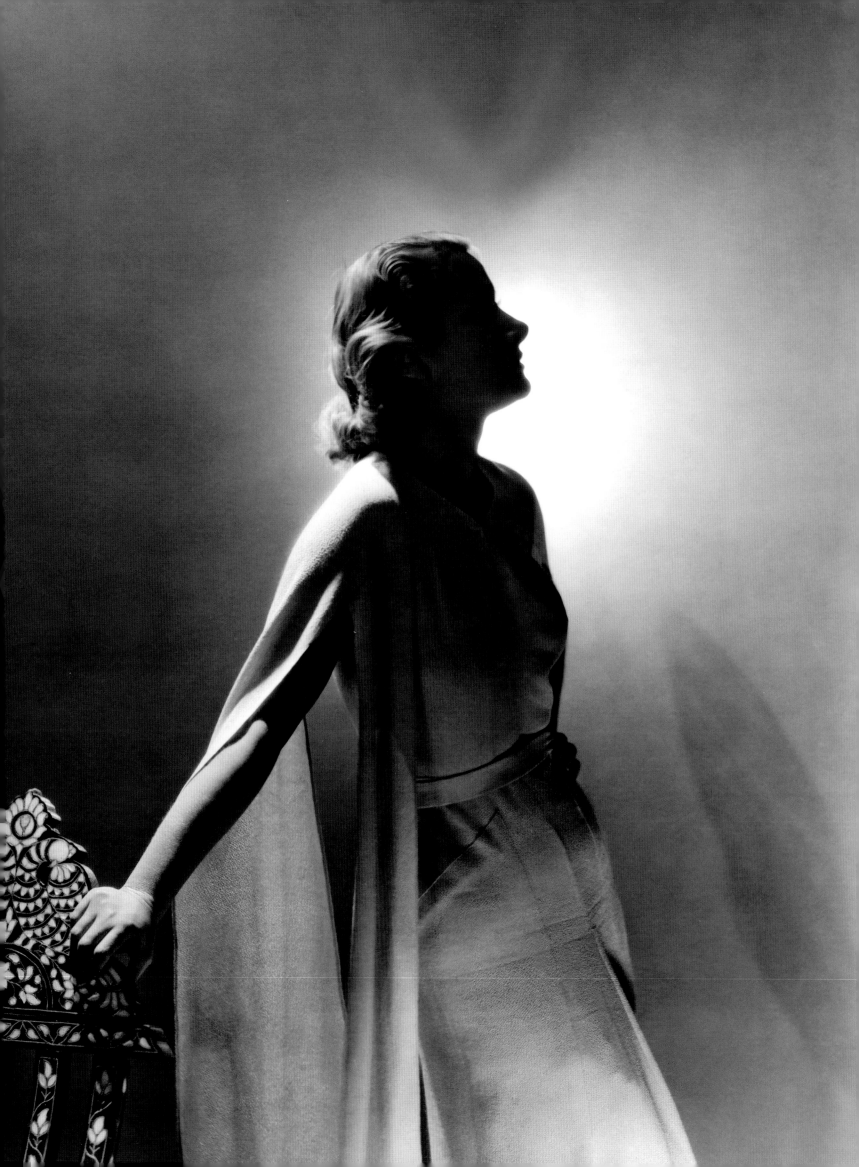

"THEN THERE CAME—INEVITABLE AND LOGICAL, ROMANTIC TO THE POINT OF BRINGING A TEAR TO YOUR EYE, RAVISHINGLY FEMININE, FRAGILE LIKE A HAPPY DREAM—THEN THERE CAME THE REACTION OF 1930. MADAME, HOW PRETTY YOU SUDDENLY WERE IN THAT LONG DRESS!"

COLETTE, "VINGT-CINQ ANS D'ÉLÉGANCE: À PARIS," 1951.

Yvonne and Marcel Rochas were divorced in 1929. They had had no children (other than their couture designs), and they both remarried within the year.[1] The couturier had a new life and would soon have a new address. In 1933, the house of Marcel Rochas moved to 12, avenue Matignon,[2] where my father rented the basement, the store, and the first, second, and seventh floors. After winding up his first house the same year, he founded the new Société Marcel Rochas, with a share capital of 400,000 francs, on February 14, 1934.[3] This time, it was registered as a "couture house." In exchange for his contributions to the new company in the form of capital, a business, a clientele, and leases, as well as his reputation, the couturier obtained seven hundred of the eight hundred shares that divided the capital.

And Rina had now entered my father's life. With Venetian blonde hair and striking looks, Rina Rosselli was practically the same age as Marcel Rochas. She knew how to charm and he was easily ensnared by this liberated woman and artist whom he admired. Born Thérèse Cassin in Italy of an Italian mother, she preferred to use her mellifluous maternal family name, Rosselli, for her work as a painter and interior designer. She included Moïse Kisling and Leonor Fini among her friends, and her well-honed social skills enabled her to mix in the most select society, where she met potential buyers for her paintings. "I thought Rina Rochas was very nice; she has very feminine expressions whose charm is undeniable,"[4] confided Leonor Fini. A woman of character, free-spirited and cultivated, the beautiful Italian adopted a style of androgynous chic that went well with her penchant for sports. She shared with Marcel a love of speed, dogs, the countryside, and travel, as well as music, dance, painting, literature, and cinema. The couple moved to rue de Longchamp in Neuilly,[5] and spent their weekends in the countryside at Béhoust in the Yvelines, where they entertained friends, devised new water sports, and organized country walks and bicycle rides. Draped in Virginia creeper, the country house where they spent these happy times was simply decorated in a rustic, country style—wooden tables, exposed beams—with Parisian notes such as Marcel's beloved stripes. Among their house guests was Leonor Fini, who in spring 1936 painted a portrait of Rina, with whom she had become friendly: "I dined with the Rochas who are truly my benefactors. Julien Levy was there (he wants to hold two

In the 1930s, Rina Rosselli, the second Madame Rochas, embodied the new Marcel Rochas style.
PAGE 43 Rina poses for *Vogue* in a Marcel Rochas dress, October 1937. "Madame Marcel Rochas looks ravishing in this multicolored striped satin and black chiffon dress."
FACING PAGE Rina Rochas wears a "Manet Blue" crepe evening dress for a ballet at the Théâtre des Champs-Élysées, circa 1933.

shows of my paintings now, would you believe it) and two other rather amusing indi-
viduals."[6] The portrait of Rina was exhibited at the Julien Levy Gallery in New York.

Rina liked to draw, and whenever he gave her the opportunity she influenced my
father's designs over the next decade.[7] The salons at avenue Matignon were decorated
with a modern accent, with large spaces, dark furniture against light walls, straight
lines, and fashionable lighting. "There's an air of youth and cheerfulness that strikes
one on entering," wrote a journalist in *Marie Claire* in 1937, "A simple, white house!
Then a short interior flight of stairs, an impeccable entrance hall, bare salons, with
mirrors on the walls enhanced by chrome metal bands, and curious plants. Let's not
forget that the master of the house, a 'Parisian and son of Parisians,' is quite young,
full of original ideas, that he was the first to launch square shoulders, that he has just
opened a house in New York, that Madame Marcel Rochas (Rina, his second wife) is
charming, sporty…that all the dresses designed by her husband seem to have been
made for her, that she wears them charmingly, and that, as if on purpose, all the models
bear a resemblance to her, her youth, her blondness, and that the sales assistants, all
very helpful, are dressed in dark blue with a white collar, like young women in uniform,
and, lastly, that here is a collection in which all of the designs sparkle with imagination,
like champagne."[8] Rina also contributed to the decoration, painting the screens herself,
and commissioned a trompe l'oeil panel from Leonor Fini depicting a seamstress with
the attributes of her profession. This would later hang in the New York store. In the
sumptuous apartment on avenue d'Iéna that they had decorated in the Napoleon III
style,[9] my father set up a studio where Rina could work to her heart's content.

BELOW, LEFT The Marcel Rochas Paris boutique
at 12, avenue Matignon.
BELOW, RIGHT The design of the Marcel Rochas
store in New York was based on the avenue Matignon
boutique. *L'Officiel de la mode*, no. 196, December 1937.
FACING PAGE The Rochas's apartment on avenue d'Iéna,
photographed by Roger Schall, circa 1932.
PAGES 48–49 The avenue Matignon salons, decorated
in the modern style, circa 1933.

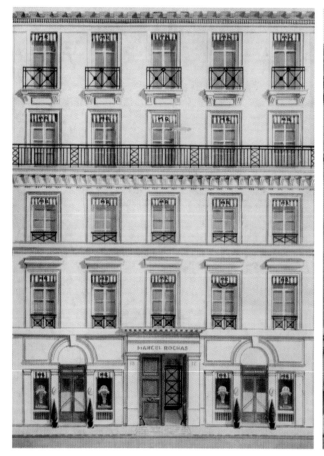
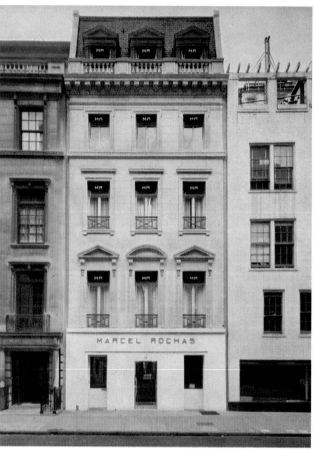

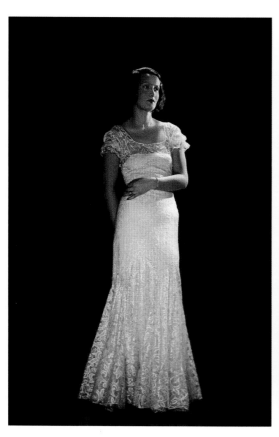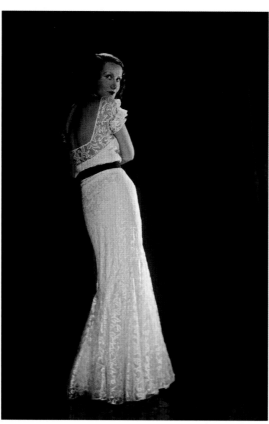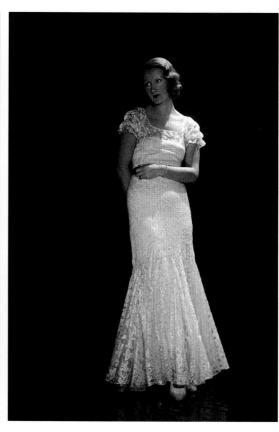

"IF WE HAD ONLY WOMEN LIKE ALIX, BRUYÈRE, LANVIN, OR MAGGY ROUFF, OR ONLY MEN SUCH AS BALENCIAGA, LELONG, PIGUET, OR WORTH, GREAT COUTURE WOULD BE INCOMPLETE… COUTURE BY WOMEN IS CLOSER TO SCULPTURE, WHILE COUTURE BY MEN IS CLOSER TO PAINTING OR ARCHITECTURE." MARCEL ROCHAS, 1943.

ABOVE AND FACING PAGE Rina Rochas in a white lace sheath dress flared at the bottom, with a black belt, circa 1935.
PAGES 52–53 Relaxing at the Rochas's home in Béhoust (Yvelines), circa 1935.

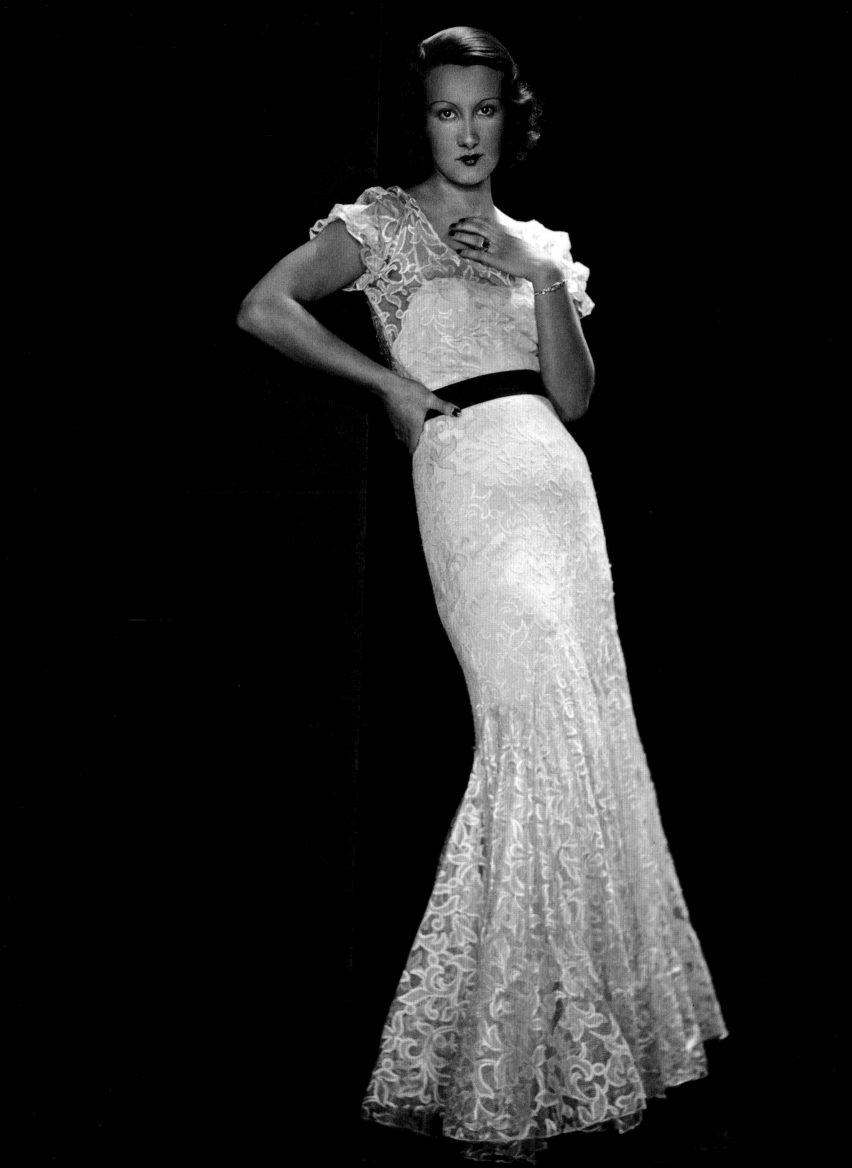

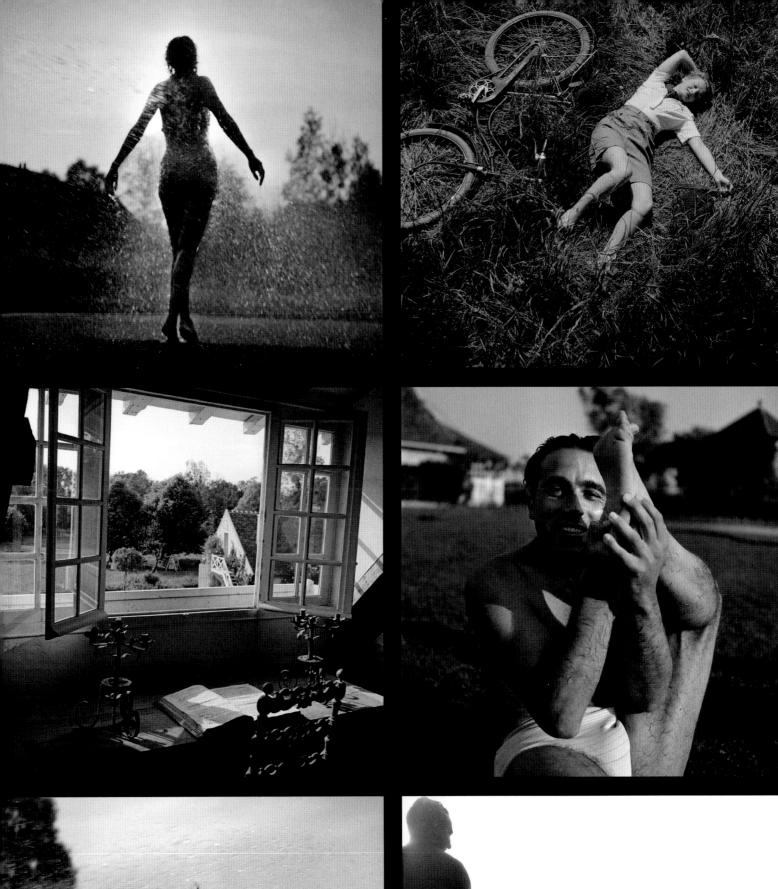

FASHION AFTER THE DEPRESSION Growth, productivity, profit: the Twenties went on roaring until the markets were abruptly brought to their senses by the Wall Street Crash of 1929. The global consequences of the collapse of the stock exchange are well known; recession spread and the fashion market declined. Having been the sixth largest importer of French designs in the late 1920s, the United States now imposed 90 percent customs duties, while quotas were introduced by a number of countries, further reducing outlets for French exports. The economic situation forced many houses to scale back their activity, such as Worth, or to merge or even close down, such as Dœuillet, Doucet, and Jenny. Marcel Rochas adopted a high-price policy (3,000 francs on average for a dress) and targeted a select clientele. With an annual output of some three thousand designs, produced by three dressmaking and two tailoring studios, he maintained his turnover at around 8 to 10 million francs.[10]

A more low-key femininity was now in fashion. Greco-Roman antiquity was an inspiration for the designer Alix Grès, who started out in 1931, draping her garments directly on the model. Augustabernard, Madeleine Vionnet, and even Jeanne Lanvin were not to be outdone and worked flowing, sculptural folds into their long dresses. The girdle, a reincarnation of the corset, was brought back to flatten the stomach and create a harmonious line between a generous bust and curvy hips. Flourishing fashion photography recorded the reshaping of the 1930s woman, with women's magazines adding to the hype: when the superb models were not shown on the beach, they were decked in sportswear or about to step into a car, or portrayed as devoted mothers, accomplished homemakers, or radiant wives, in an angle that had shifted with World War I. In the daytime, women commonly opted for a suit or a day dress, with a straight, loose, simple cut, lightly gathered at the waist by a belt, and falling to mid-calf length once more. Three-dimensional cuts accommodated a woman's shape; the house of Vionnet specialized in bias cuts that lent greater fluidity to the fabric. My father preferred simple dresses and details in the cut, jersey woolens, tops that counteracted

BELOW, LEFT Rina Rochas wearing beach pajamas by Marcel Rochas. The couturier poses jokingly as a chauffeur behind his wife, who poses as a model, 1930.
BELOW, RIGHT A black version of the beach pajamas, with a white spencer, 1930.
FACING PAGE Beach pajamas in white gabardine, fine-knit top in white jersey with blue stripes and jacket in silk shantung, 1930.
PAGES 56–57 Cinched navy blue and white jacket in ottoman, short sleeves with a double flounce, V neckline, white edging, five ceramic buttons, 1939. Palais Galliera, Fashion Museum of Paris.

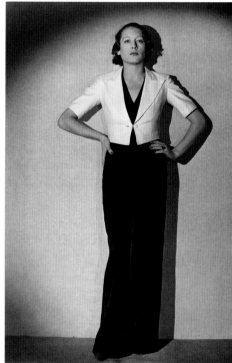

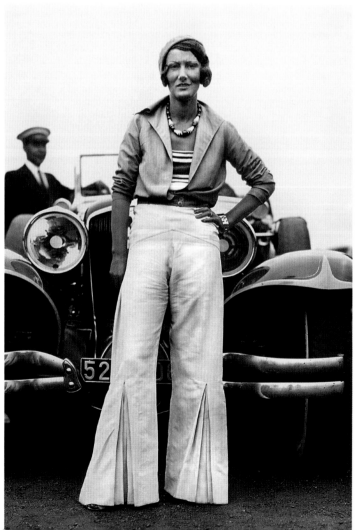

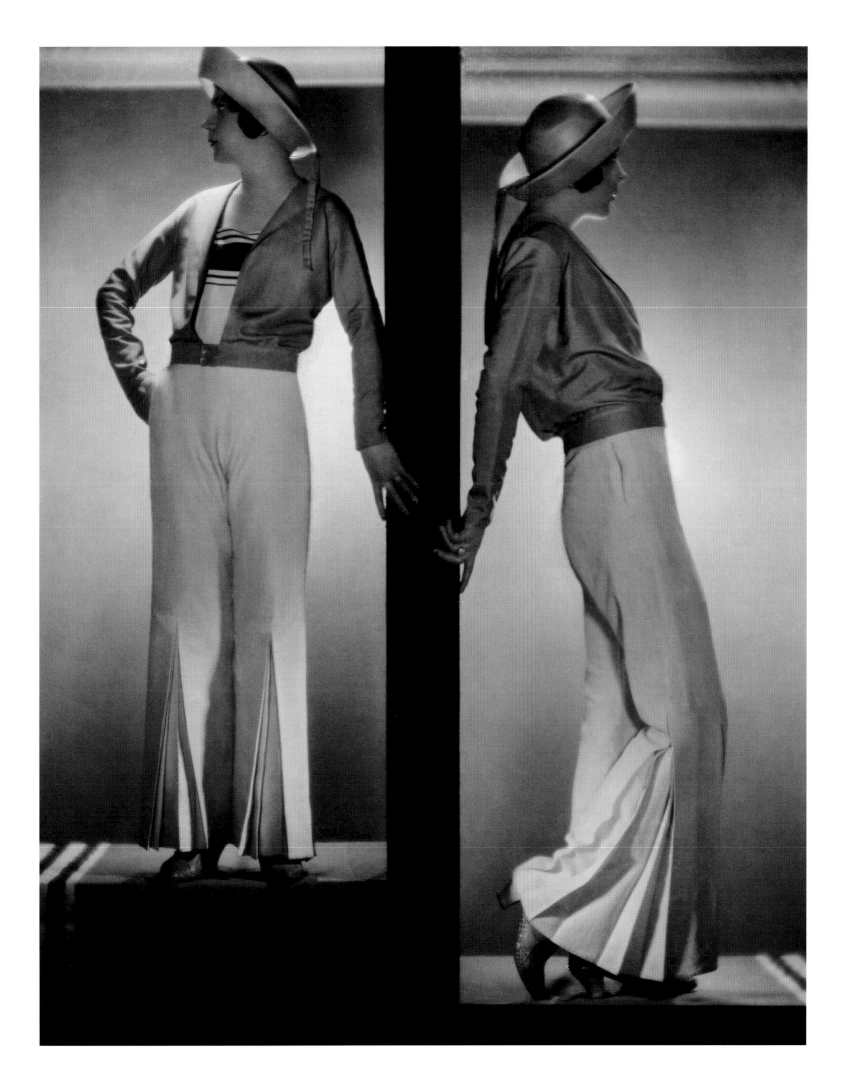

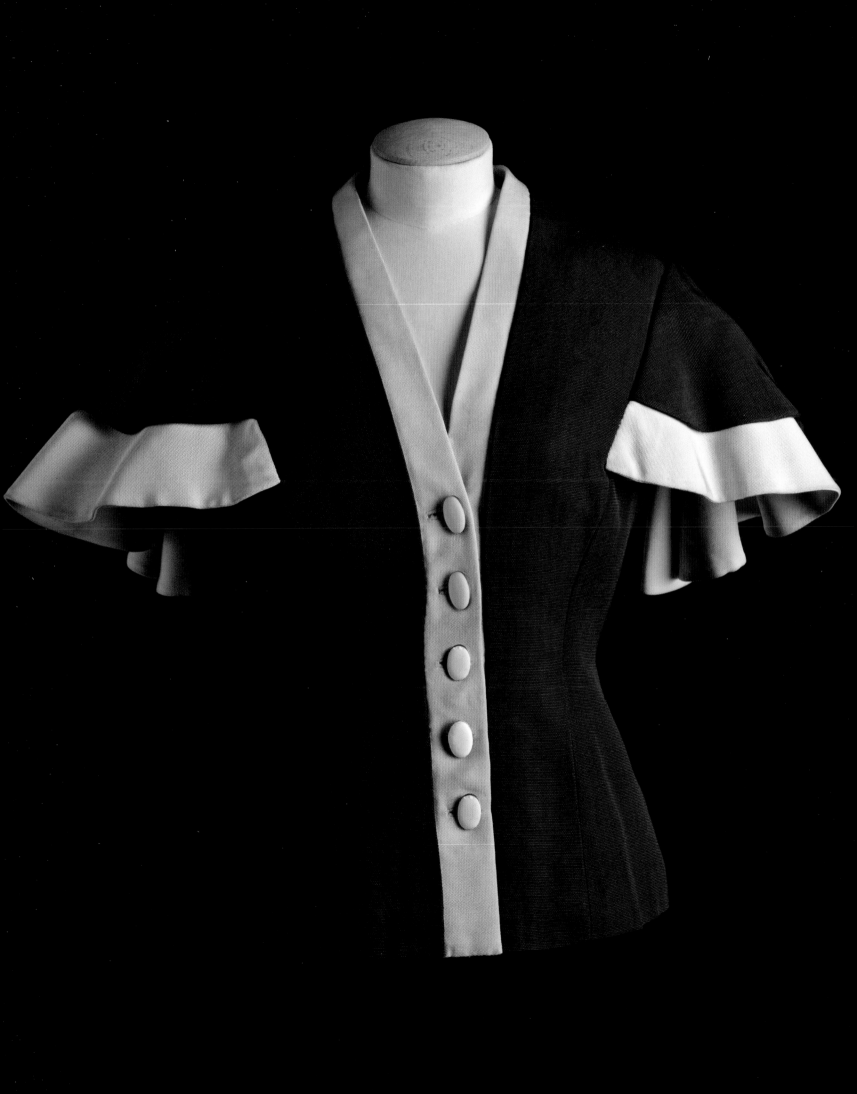

the diagonal stripes, skirts cut on a wide bias, guimpes and cuffs in white crepe. "Marcel Rochas excels in the creation of those simple little dresses of which woman are particularly fond."[11] Designed for the go-getting, traveling woman, the "Rochas suit" was established in those years: a colored semi-sports jacket or a black afternoon suit, always impeccably cut.[12] For rural escapades, from 1936 the couturier came up with sophisticated "country outfits": two-piece suits comprising a jacket in thick colored wool with large buttons over a slim black skirt. My father, who appreciated the "fine legs of American women," revised the length of his skirts in 1935, and used all of his "tenacity to have them rise up to the knees, and all of [his] tenacity to get them accepted wide."[13]

The advent of paid vacations in France in 1936 accelerated the development of sporting activities and comfortable outfits, including shorts and the pareo. With the Anglomania sweeping smart society, women began to wear "slacks," loose canvas pants that were easy to wear on the deck of a yacht or walking on a beach. As a result of his typically middle-class education, my father enjoyed all sports—swimming, skiing, tennis, horse riding, and even boxing. This was reflected in his conception of fashion. Mindful of the development of sea-bathing, which was attracting a growing number of enthusiasts, he promoted the practical qualities of his designs—beach pajamas, swimsuits, and shorts—such as a beach ensemble of a light gray flannel jacket and shorts with black stripes (*Plaisir de France*, 1937), a pink wool beach dress worn over pink wool shorts with garnet-red polka dots (1936), reversible beach-robe-jackets, net bags, and so on. The swimsuit gradually became the one-piece we know today: La Bourrasque was launched in 1934, a swimsuit in "lastex" and Colcombet

BELOW AND FACING PAGE *Variations on Marcel Rochas day ensembles, 1933–35.*

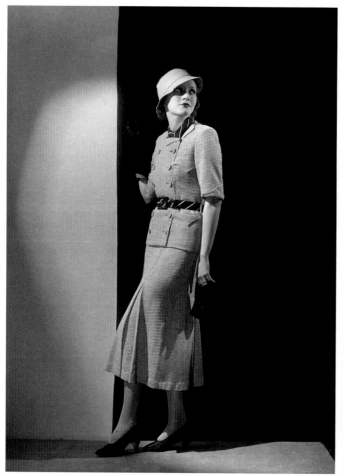 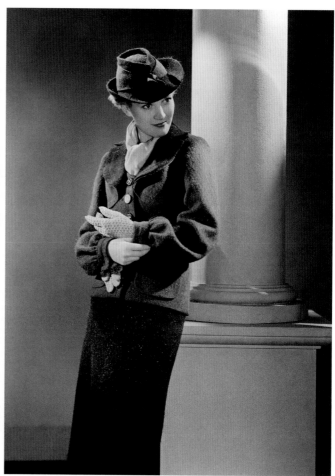

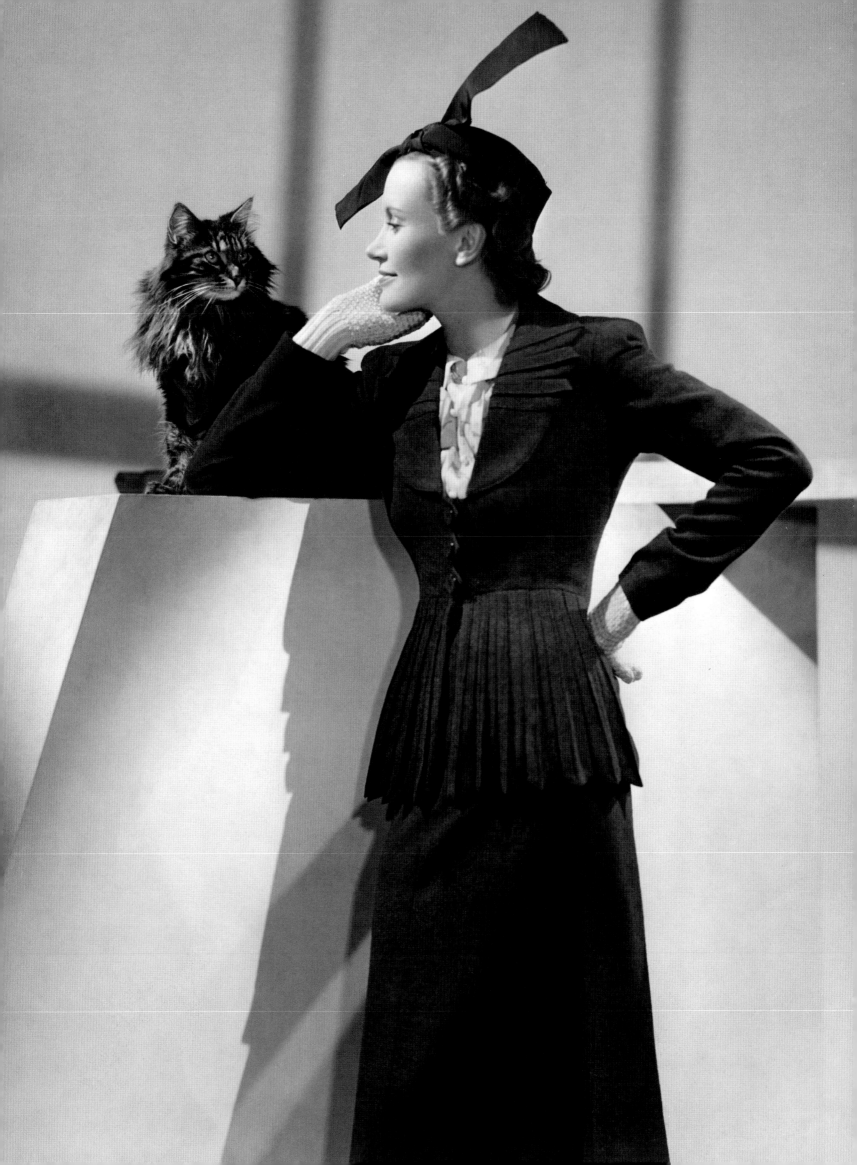

ABOVE Lambswool cape and skirt in "Tchouklap"
by Rodier, worn with a striped sweater matching
the lining and a two-tone scarf, September 1934.
FACING PAGE Cinched fitted jacket in purple velvet,
collar lined with pink satin matching the sash of the
monkey-hair muff bag. Cover illustration by Christian
Bérard for French *Vogue*, November 1936.

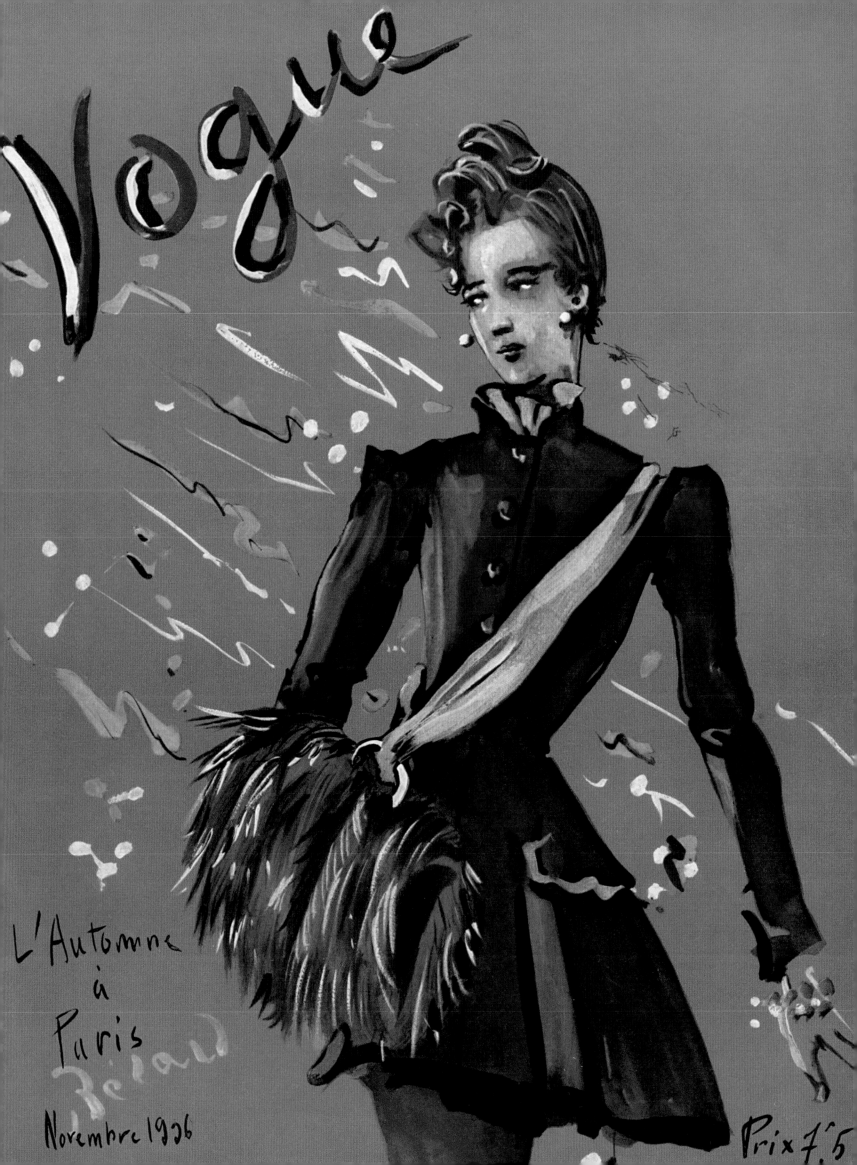

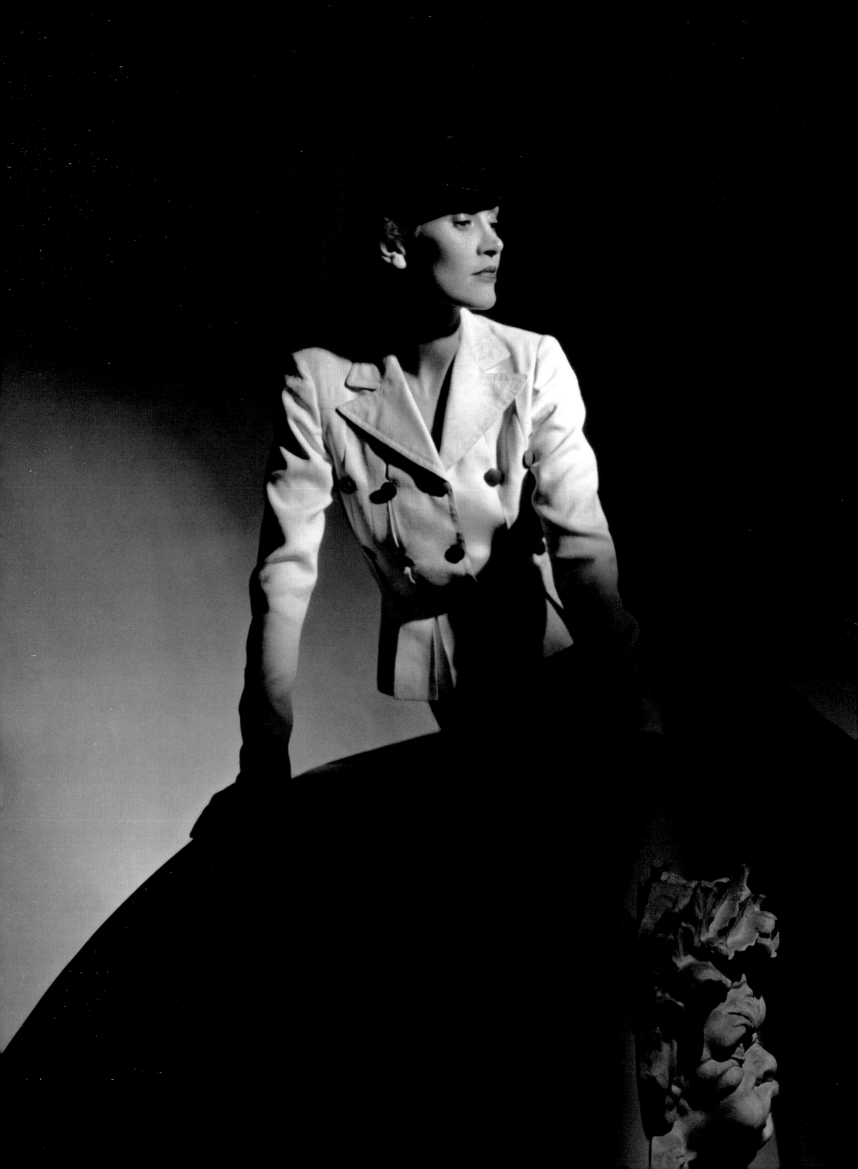

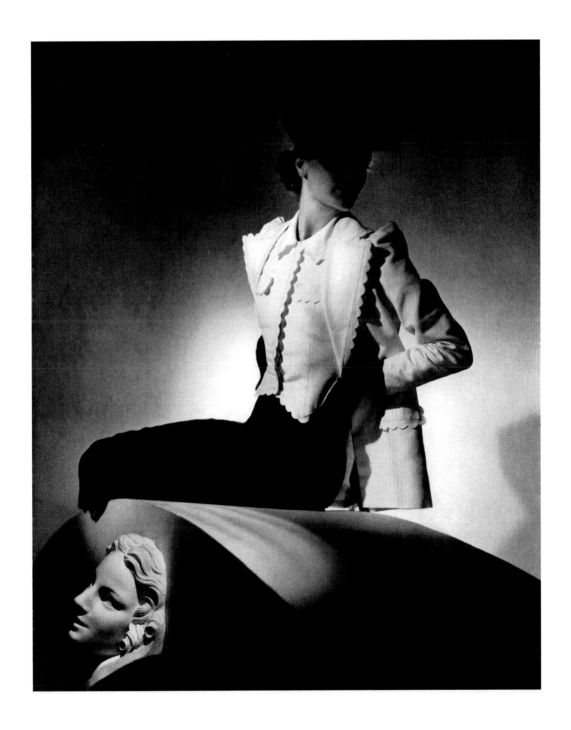

The sculptural lighting effects and neoclassical references
in these photographs by Horst P. Horst bring out
the architectural beauty of Marcel Rochas's designs.
FACING PAGE White silk box-pleated jacket
with leather buttons, black skirt, hat by Maria Guy.
Vogue, March 1936.
ABOVE Short jacket in white piqué with scalloped
edging, box pleats in the back, top with little black
chiffon sleeves, skirt pleated below the hips,
felt hat by Maria Guy. French *Vogue*, March 1936.

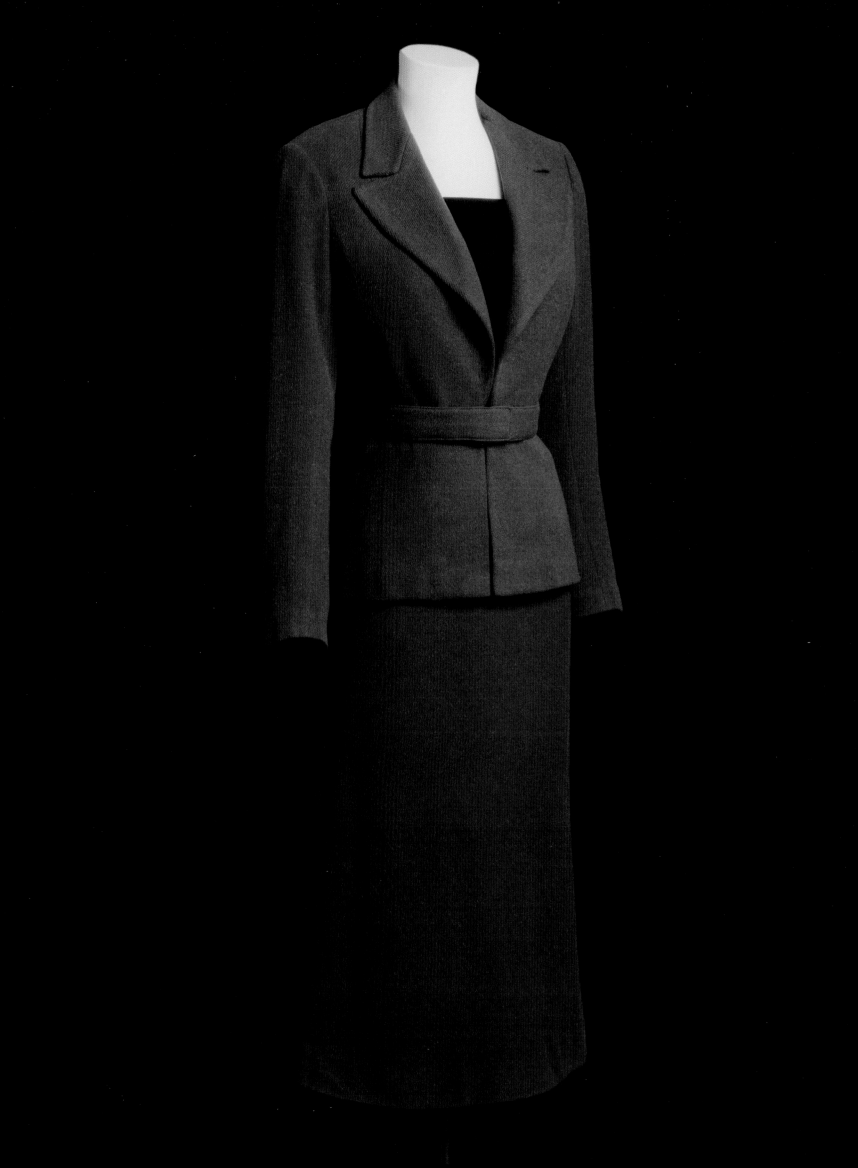

cellophane, "which does not absorb water or become deformed like woolen swim-suits." For cold weather, Rochas created a short Robe de Patineuse (skating dress) (1937) in beige/black and white/red tartan wool with a natural sealskin jacket. He also catered to mountain enthusiasts, with his Davos ski outfit including a fur jacket (1934); hikers (walking coat in Rodier burgyl, 1940), golfers (Putting sports coat in apple-green Carlin scotchel, 1934); and elegant, sporty people in general (Pécari sports coat, 1934). Was he drawing on memories of his mountaineering expeditions with sealskin-covered skis?

With Rina, he continued to frequent all the fashionable vacation spots: at the sea-side, in the mountains, and in the country, as well as the Grand Prix at Longchamp, the Bagatelle Polo Club, and the Racing Club de France, where a cup would be named after him. These fixtures on the society calendar were excuses for an inordinate display of fashionable outfits and rivalries. The leading couturiers were all to be found there. People watched each other while pretending not to do so. Who was dressed by whom? And among these superbly attired ladies, wagers would be placed on one couturier or another as they would on the horses. Fashions go out as fast as they come in, and competition in this sphere has always been as fierce as it gets. Naturally, you'd never go out without your hat, and you'd wear it to the side and on wavy or curly, sometimes dyed, hair, just like the film stars. Marcel Rochas's large hats that graced the heads of fashionable race goers were impeccably matched to his chiffon dresses printed in shimmering colors.

FACING PAGE Day ensemble in wool serge, circa 1930. Philadelphia Museum of Art.
BELOW Four 1936 designs, *L'Officiel de la mode*, no. 175, March 1936, no. 176, April 1936, and no. 177, May 1936.

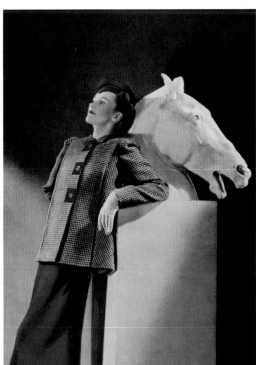

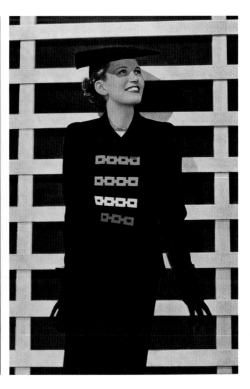

In the evening, these would be changed for long, slinky dresses, sometimes with a train, with well-defined shoulders and a bare back. Lamé, glass paste, and sequins provided sparkle. Photographers captured the image of this sculptural woman on a pedestal. In this ever-greater celebration of femininity, my father was "the author of sumptuous evening dresses that were the absolute epitome of his taste for imposing almost disproportionate silhouettes—but which in truth were only so in their dizzying geometry. These long, full dresses, whose effect was accentuated by sleeves covering the arms to the wrist, seemed to emphasize the bust and enhance the way the lady carried her head. The same went for his sheath dresses, whose body-hugging effect he underscored vigorously with a flouncy spiral, a feather motif, or a double belt at the waist and hips. He was a couturier for young people in his early days and he remained so throughout his career, dressing the times while modeling them to his taste and his dreams. In a certain way, he was the last to do so, for he had an intuitive understanding of this new sensibility and succeeded in mastering it."[14]

This calm elegance that suited the likes of Coco Chanel and the Italian Nina Ricci, who launched her brand in 1932, was shaken up by the turbulent Elsa Schiaparelli. This mischievous and provocative designer opened her fashion house in 1928 on the advice of Paul Poiret and moved to Place Vendôme in 1935. She was known for her knitwear, her sportswear lines, her original use of synthetic materials, her garish colors (notably shocking pink), and her transgressive silhouettes featuring unusual accessories in unconventional ways. Her friendships with Salvador Dalí, Man Ray, Cocteau, and Duchamp led to Surrealist-style designs such as the Tiroirs (Drawers) dress with pockets, inspired by Dalí. Marcel Rochas preferred to temper the excesses of Surrealism in his work.

BELOW, LEFT Halter-top low-back black evening gown, with flounces at the neck and back of the skirt in a double-sided effect. *L'Officiel de la mode*, no. 185, January 1937.
BELOW, RIGHT Pistache evening gown in green wool, wavy flounces around the neck in the same fabric. *L'Officiel de la mode*, no. 138, February 1933.
FACING PAGE The French actress Lili Damita wearing a black velvet dress with an arum lily collar-necklace. *Vanity Fair*, February 1934.

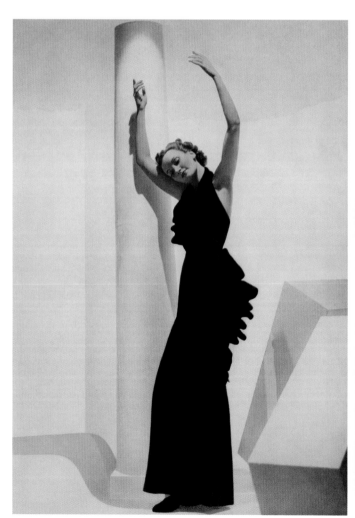

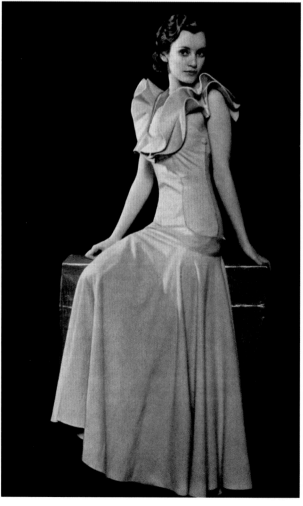

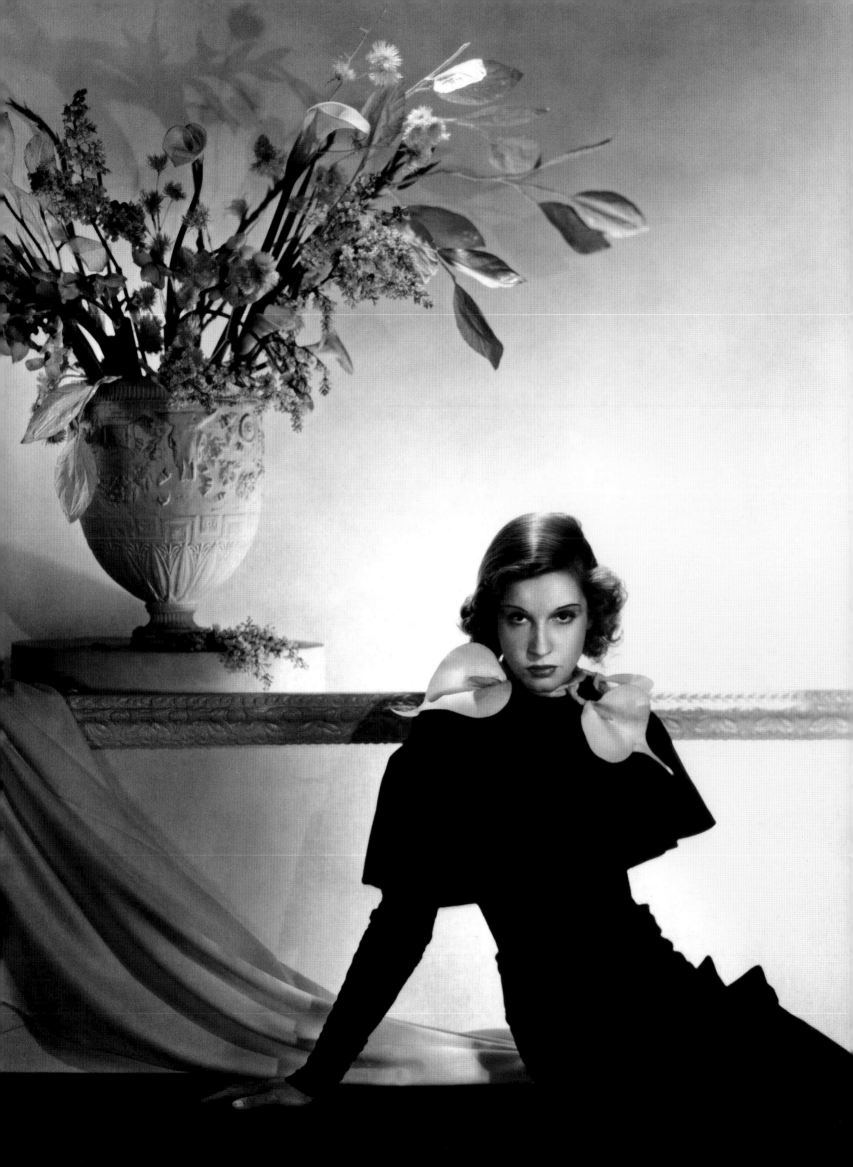

"THERE IS WITHOUT DOUBT AN AVANT-MODE—A PRE-FASHION THAT PRECEDES AND PROPOSES, A FASHION THAT CONSECRATES; AND AN APRÈS-MODE—A POST-FASHION, WHICH, IN ITS VERY EXCESSES, CONDEMNS AND PAVES THE WAY FOR THE ADVENT OF THE FOLLOWING ONE." MARCEL ROCHAS, 1943.

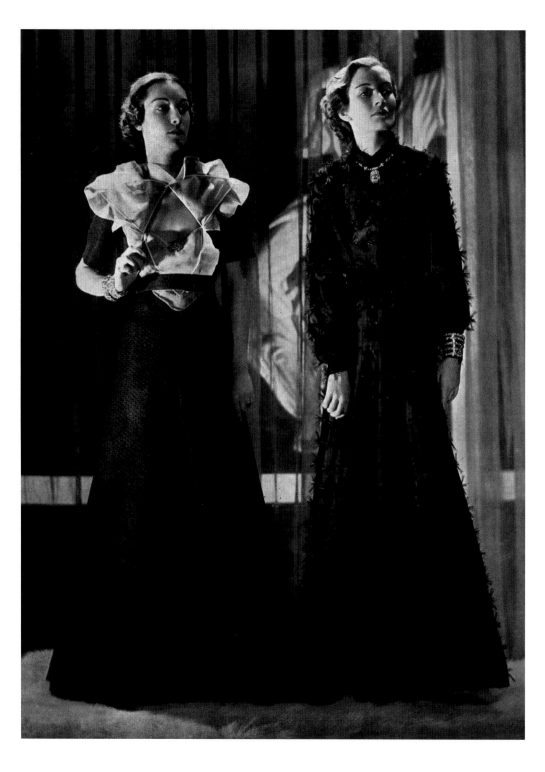

LEFT Two Marcel Rochas cocktail dresses. *Votre Beauté*, September 1934.
FACING PAGE Ball dress in black nylon with metallic-thread embroidery, 1952. From the wardrobe of Mme Jacquinot. Didier Ludot archives, Paris.

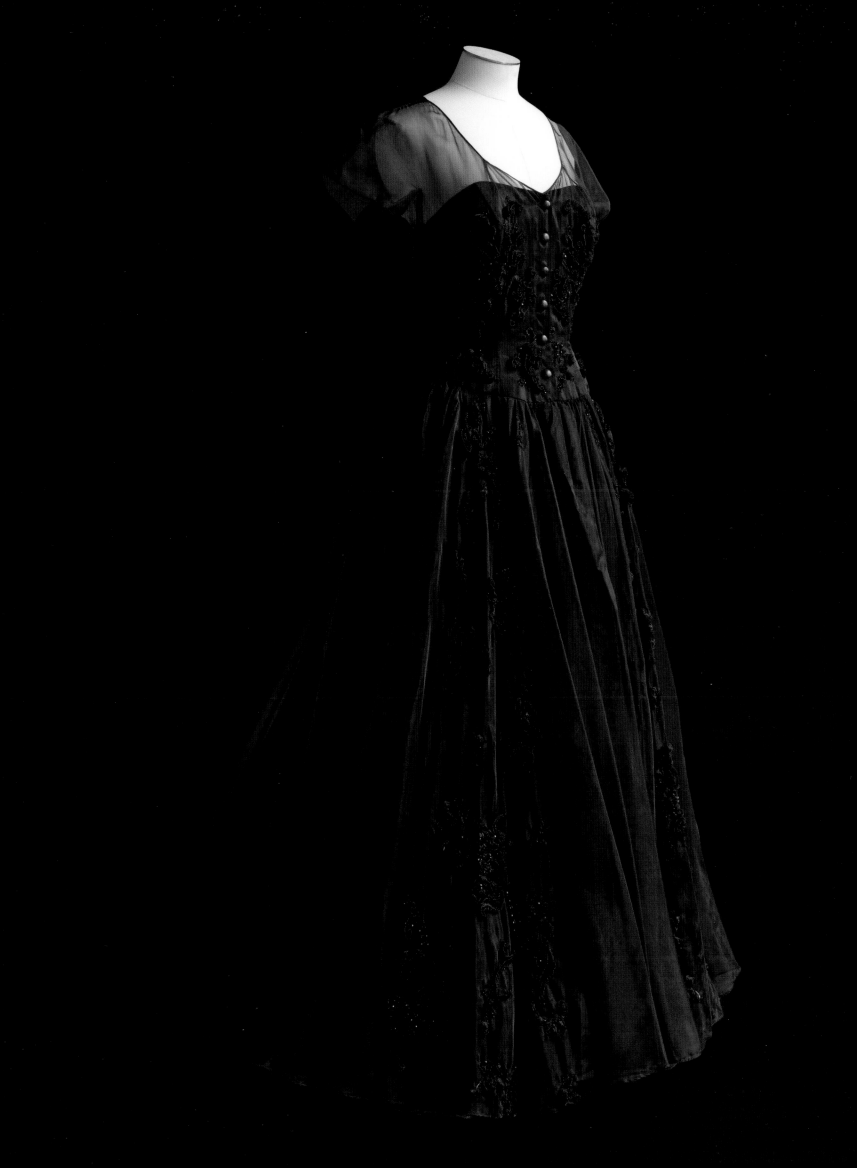

BELOW Loretta dress pictured by Jacques-Henri Lartigue
for the cover of *L'Officiel de la mode* no. 173, 1936.
FACING PAGE Dress in mauve crepe with a half-red,
half-purple top and a scarf lined in these two colors, 1935.

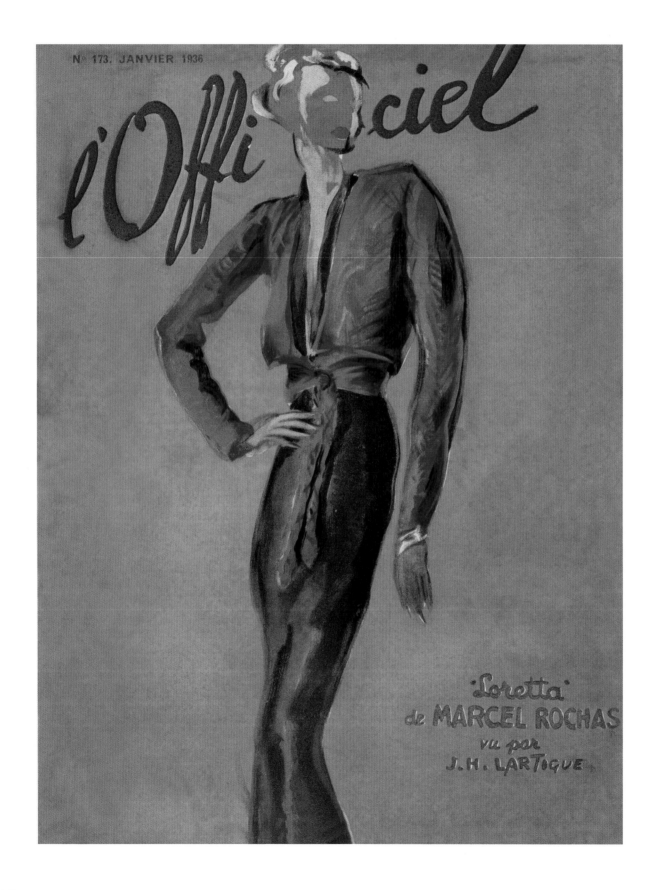

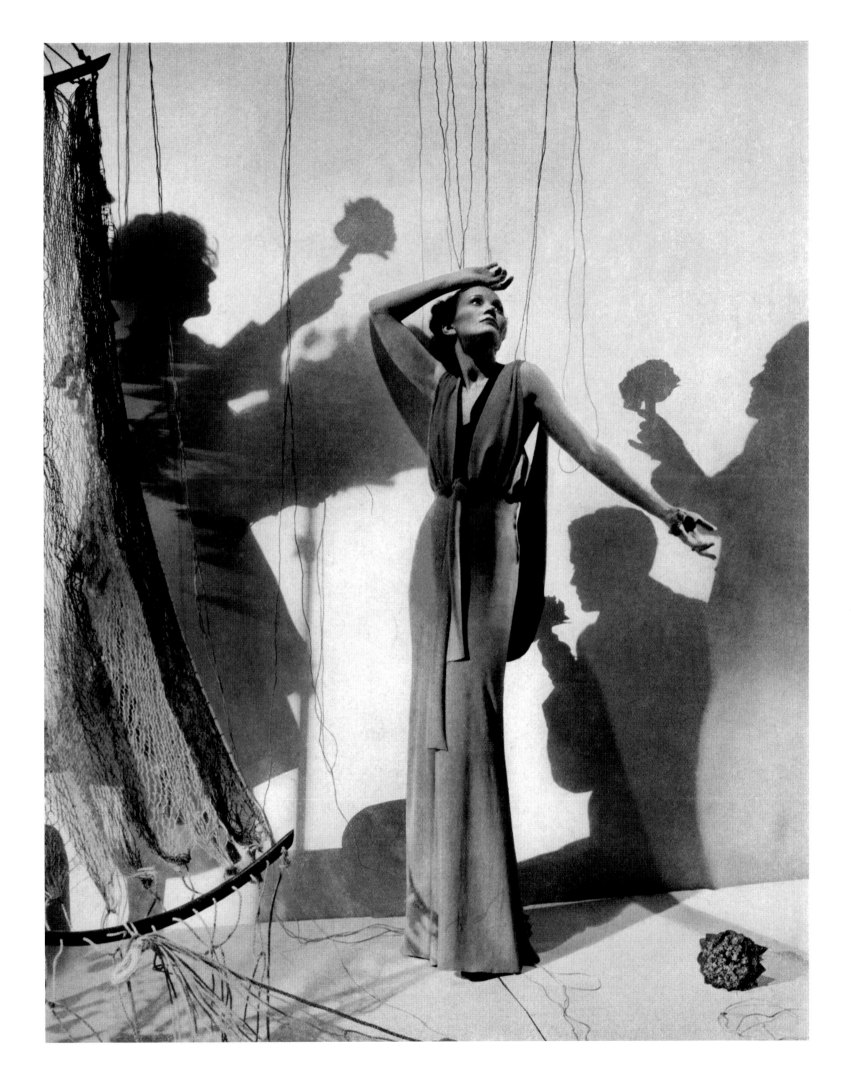

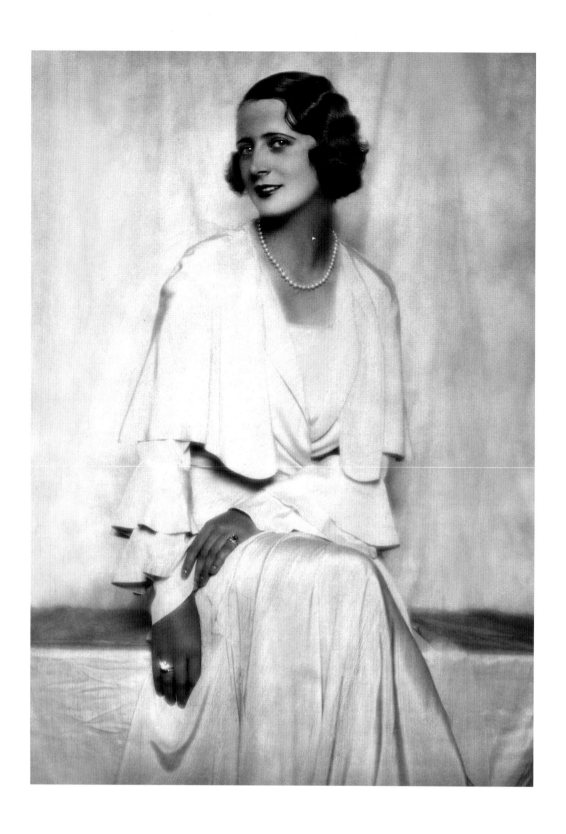

ABOVE Mme Flürschheim wearing
a Moroccan-inspired ensemble, 1930.
FACING PAGE Evening ensemble
with bolero and mermaid dress in faille
and midnight-blue velvet, 1948.
Didier Ludot archives, Paris.

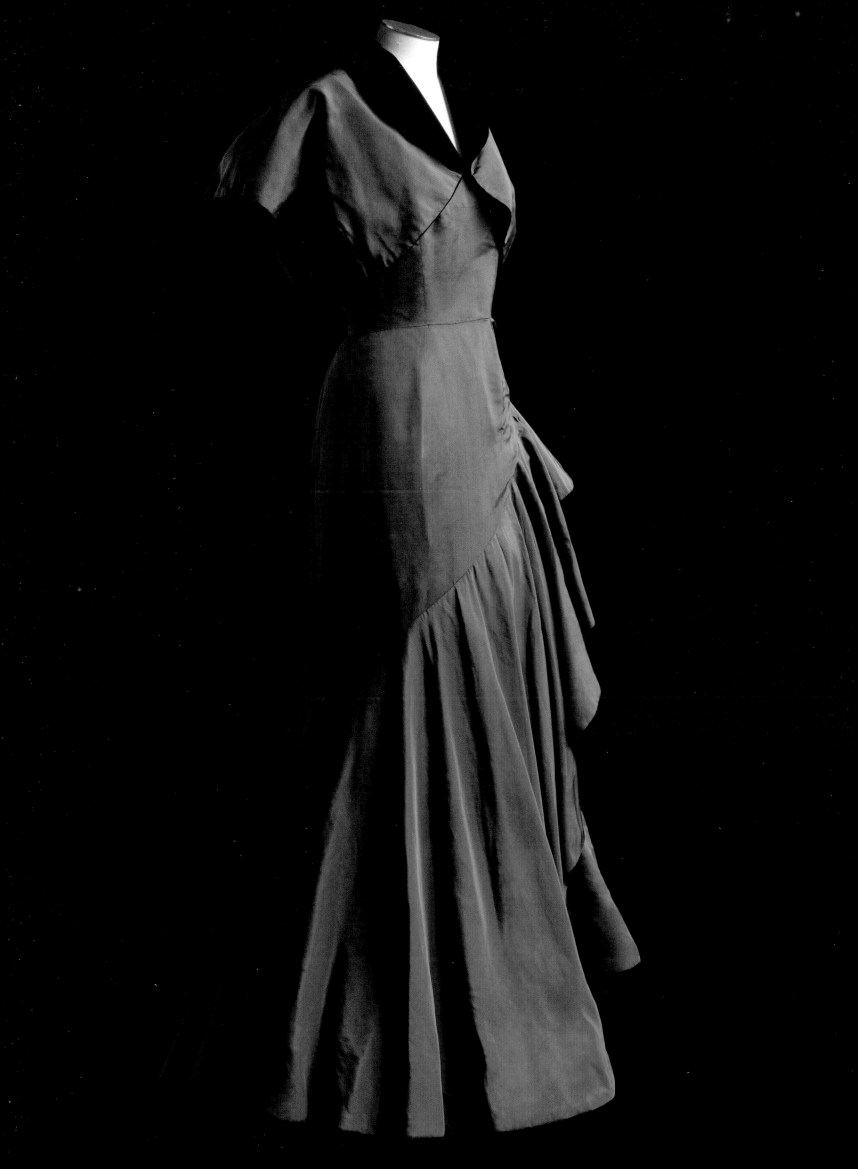

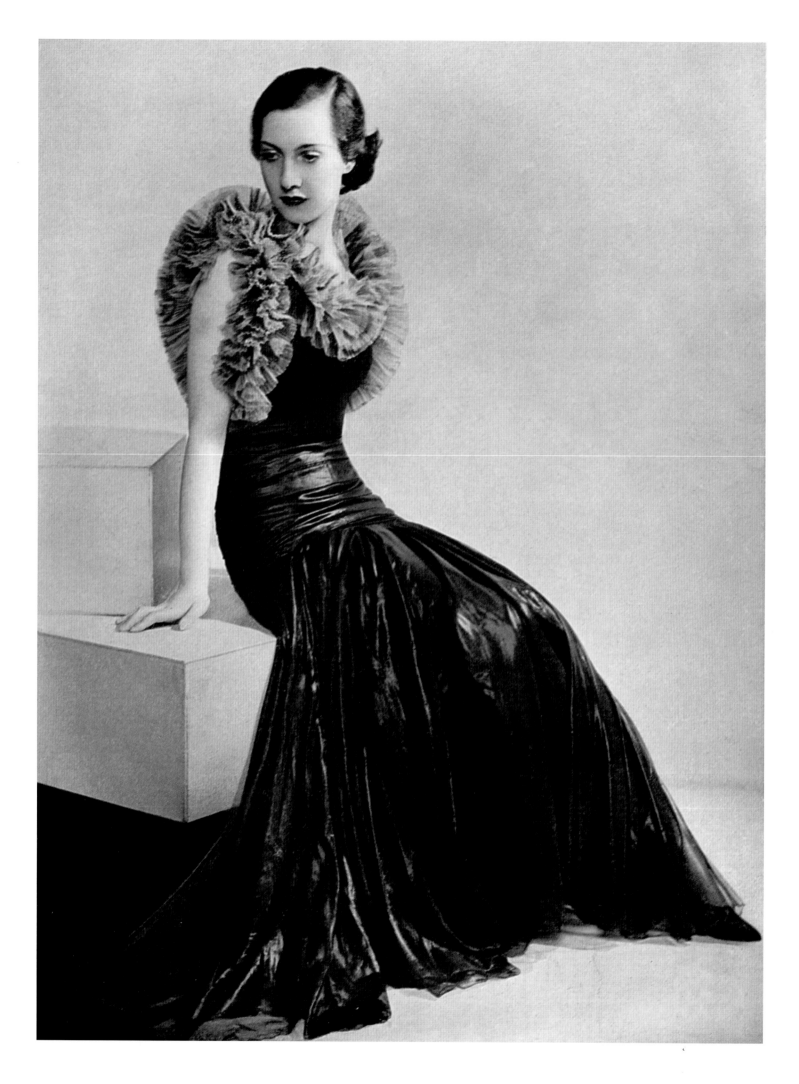

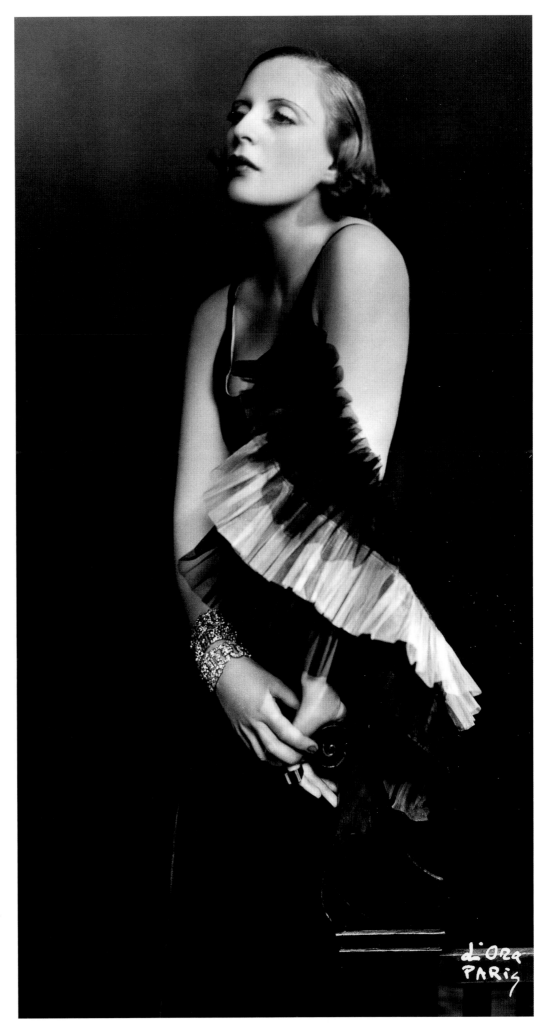

FACING PAGE Tentation evening gown in black lacquered chiffon trimmed with ruffles in black and light-blue tulle. *L'Officiel de la mode*, no. 139, March 1933.

RIGHT Tamara de Lempicka wearing an evening gown with a triple ruffle in black tulle and white organdy, circa 1931.

PAGE 76 Backless evening gown in black velvet with a cascade of white organdy frills, circa 1935.

PAGE 77 Champagne bustier evening gown with broderie anglaise on pink organdy. Broderie anglaise frills gathered at the back of the skirt in the form of a bustle, circa 1947. Sophie Rochas archives.

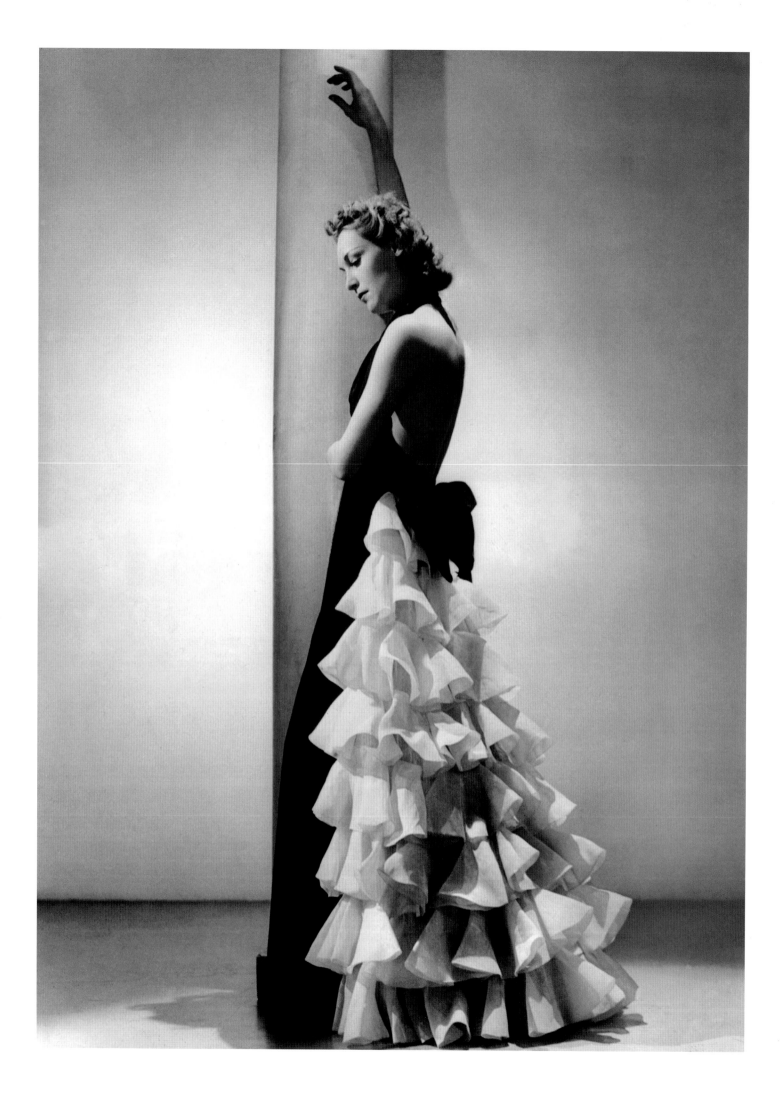

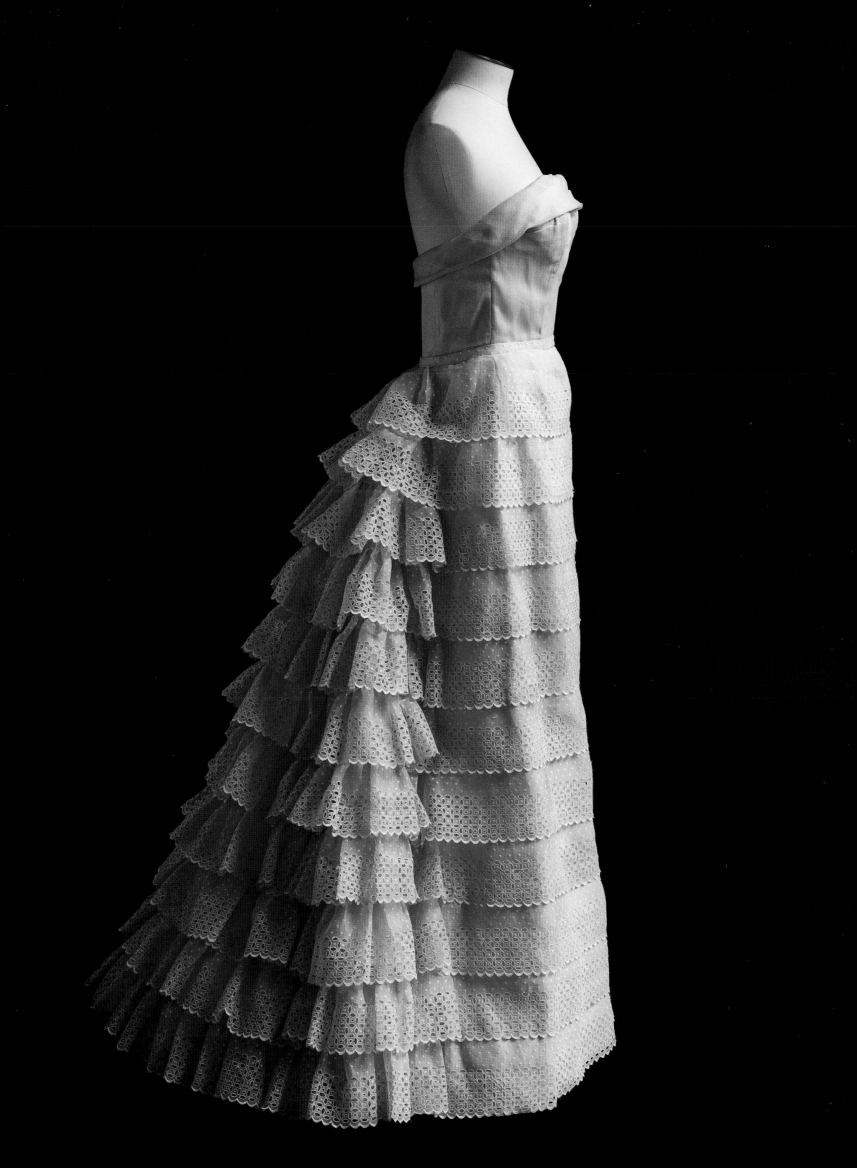

THE BOLD COLORIST My father's many bold strokes, which might be mistaken for eccentricities, were compensated by the precision of a clockmaker, an incredible sense of geometry, and a brilliant use of color. In 1931, he adopted fabrics printed with birds and multicolored flowers, which contrasted with Chanel's black period and Patou's dark blue. *"Le myosotis, et puis la rose, ce sont des fleurs qui disent quelque chose, mais pour aimer les coquelicots et n'aimer que ça... faut être idiot!"*[15] Twenty years before Mouloudji's song, Rochas was adorning his blouses, dresses, and hats with roses and violets, which he sewed into the waist or along a plunging neckline. But no poppies; he left them *"au beau milieu d'un champ de blé"*—in the middle of their wheat field—to make better use of color; as a lover of painting, he liked to put a touch of it everywhere. "With the two hundred colors in a Tertaz by Lesur I bring back color and then the colors themselves. I am in my element, I play with half-tones and juggle with clashing notes. As one of the most copied pre-war couturiers (and I flatter myself for it), I have the supreme joy of being able to recognize a copy at twenty paces, in a difference of tone in the join of a collar, a scarf, or a pocket."[16] As early as 1934, during a trip to Hollywood, he had foreseen the importance of color when films in Technicolor were about to see the light of day. He announced for his forthcoming collections "a violent return to relief and to color, a reaction against all-too-easy black and plain colors... colorful fashions that perhaps will hasten the advent of color on screen, turning fashion conventions in cinema upside down. When it is no longer about appearance, and when you have to work also on the material and the color, then the Hollywood costume designer will become a true couturier."[17] The year 1936 was remarkable in this respect. Unlike Coco Chanel, my father liked black for its practical qualities but he saw the future in more sophisticated colors. To the greens and blues that were popular at the time he added bright pinks and vivid yellows, using color palettes that reflected those of the painters he so admired. "A dress and a coat often form between them wonderful color contrasts, such as bordeaux and light blue, dark blue and amaranth, mustard and brown, green and red, or if the ensemble is in the same color as the lapels, a scarf and bright, unusual buttons liven up the overall harmony."[18] In 1937, his black coats with godets at the back were brightened up with lapel facings in bright blue or red velvet with black arabesques, while his black wool suits had sleeves and lapels with multicolored astrakhan braiding. Always there were mixtures of fabrics and colors. "His admirable sense of color produces almost theatrical surprises. When the jacket is off, there is a moment before the denouement, the last word, when you wonder what is going to appear—you see an unexpected yoke, an unexpected beauty spot, or a blouse in an incredible color."[19] The same year, the Gitane dress lit up the female body in a blazing multicolored wave. It was a huge success. The fashion for bayadère stripes, which made colors shimmer like a kaleidoscope, spread among Parisian couturiers from Lanvin to Maggy Rouff, who presented "dresses inspired more or less by this aesthetic."[20]

Gitane backless evening gown in colorful striped chiffon with a belt in the same fabric, 1937. The couturier cleverly juxtaposed its lines and materials, playing with vertical and horizontal stripes and contrasting a very slim bodice cinched at the waist with a full skirt. The Gitane dress, which was elegant and glamorous as well as modern, was a bestseller for Rochas in both France and the United States.
BELOW Drawing by Jacques Henri Lartigue, *Plaisir de France*, 1937.
FACING PAGE Photograph by Man Ray, *Harper's Bazaar*, 1937.

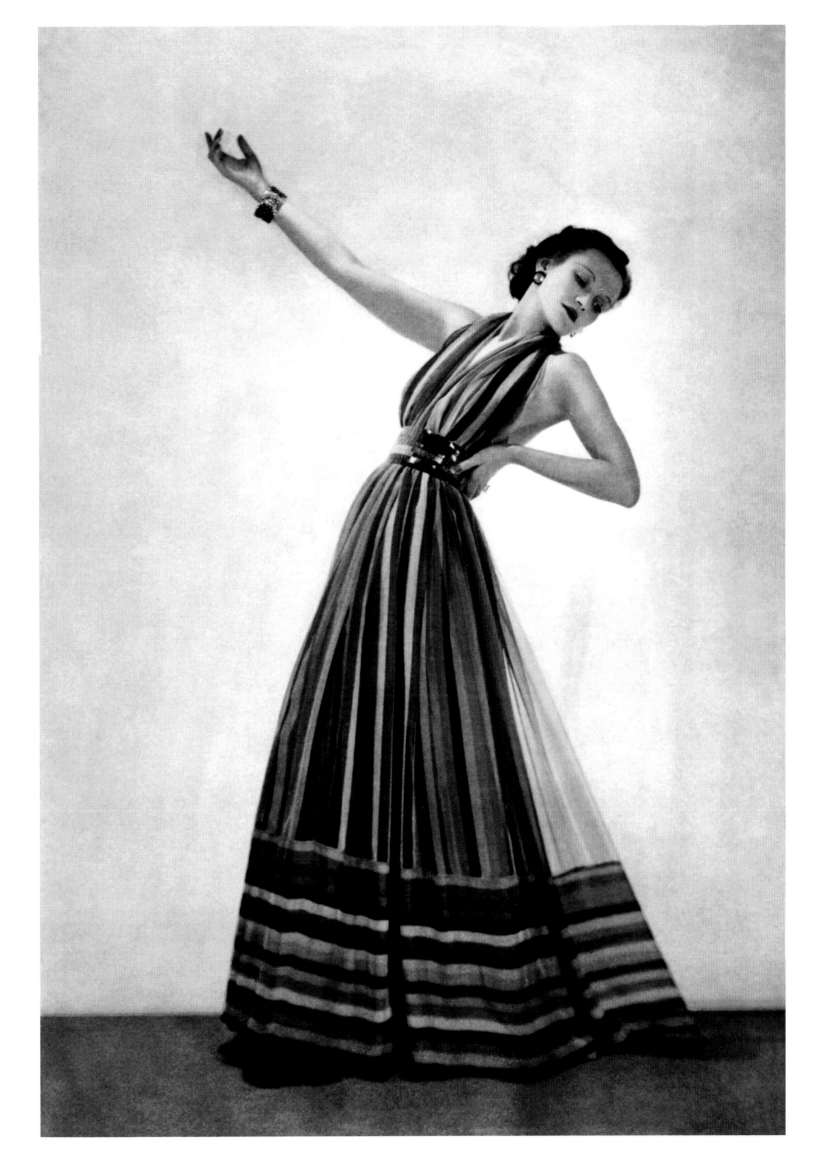

"WHILE I LOVE ALL THINGS NEW, CONVERSELY
I HATE ECCENTRICITY, THE TWIN SISTER OF BAD TASTE. . . .
ECCENTRICITY SOON OVERTAKES NOVELTY,
AND, IN TRANSFORMING IT THROUGH ITS EXCESSES,
INVARIABLY KILLS OFF A FASHION." MARCEL ROCHAS, 1943.

BELOW, LEFT Black velvet sheath dress, train in
two-tone taffeta spreading out under a large bow.
L'Officiel de la mode, no. 183, November 1936.
BELOW, RIGHT Serpentin evening gown in striped chiffon.
L'Officiel de la mode, no. 198, February 1938.
FACING PAGE Evening gown in black velvet, shorter
in front, belt in gold-and-white striped lamé extending
into a train, jewelry by Mauboussin. French *Vogue*,
December 1934.

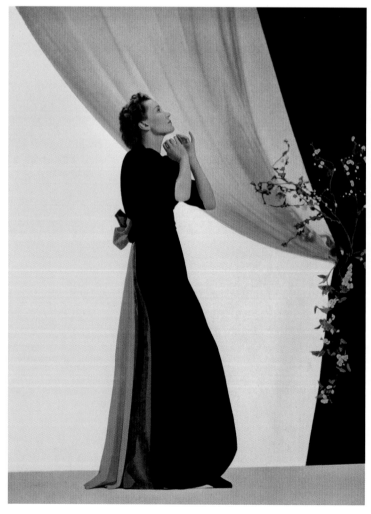
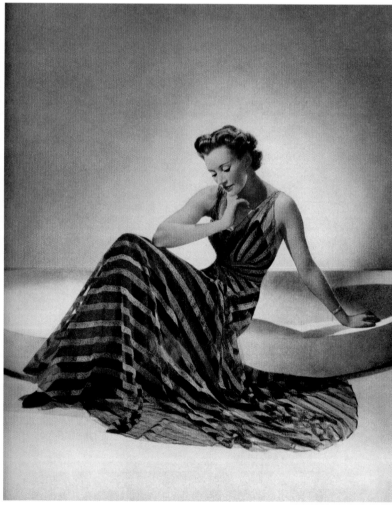

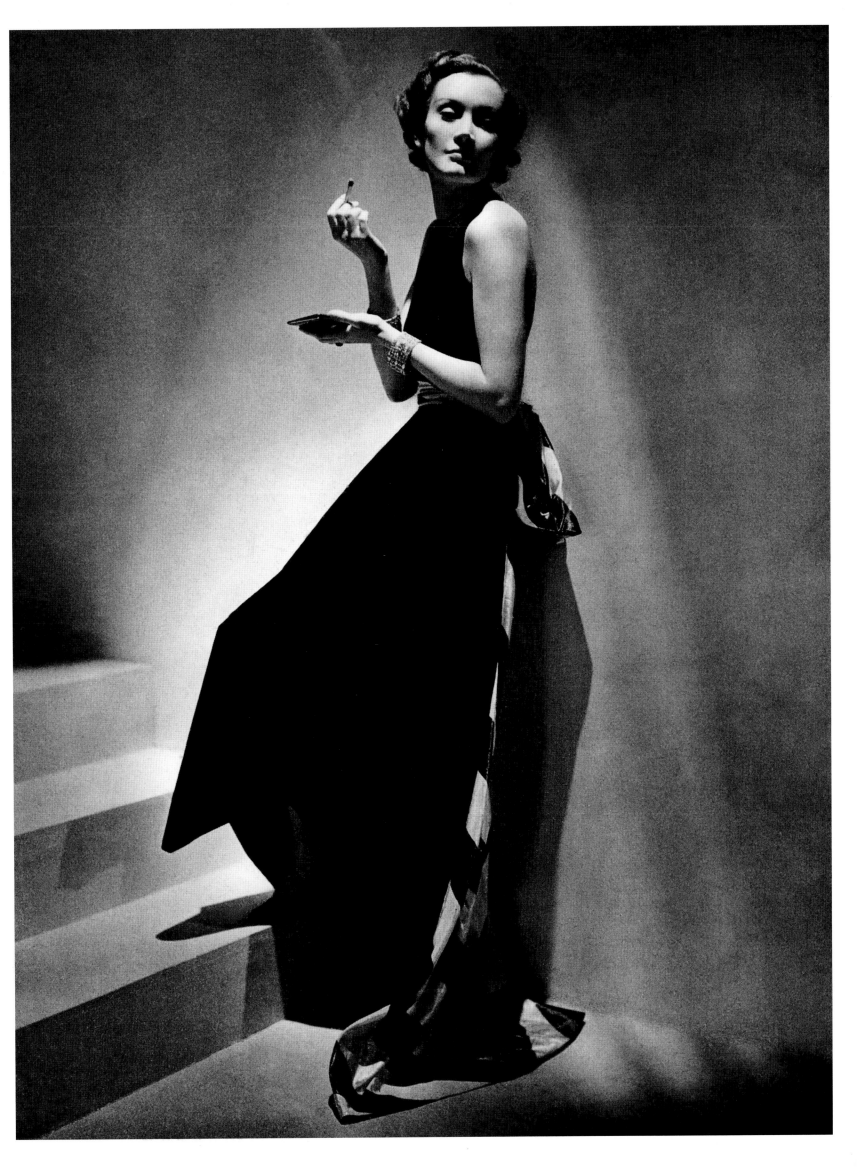

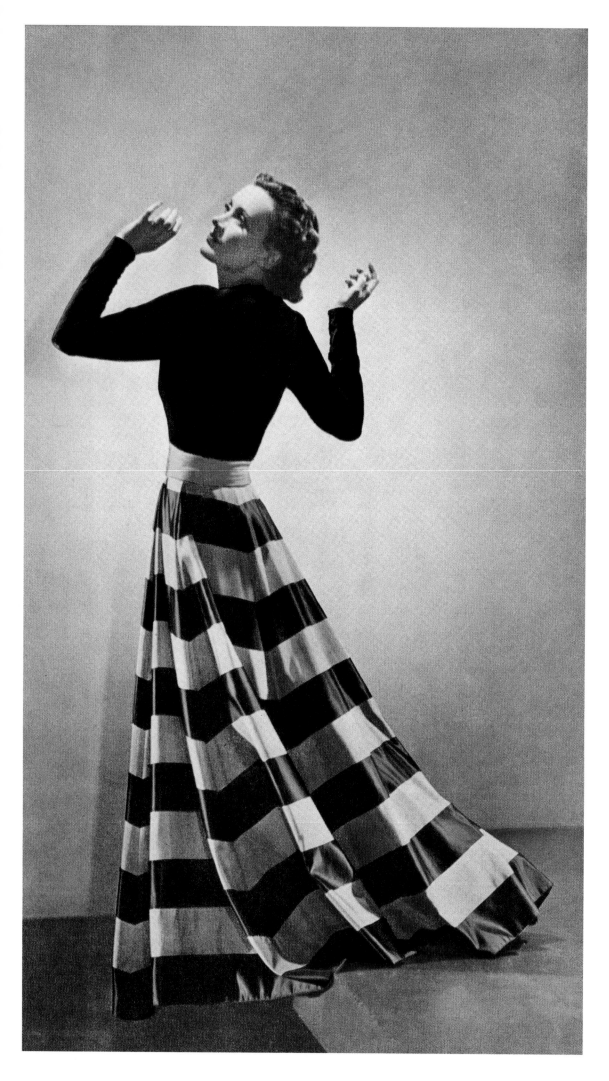

LEFT Olivette evening gown in champagne and purple striped taffeta, flared, floor-length, pointed hem, top in purple silk velvet, wide turquoise blue sash. *L'Officiel de la mode*, no.195, November 1937.
FACING PAGE A variation of the design, with three-quarter-length sleeves and a purple sash, is in the Sophie Rochas archives.

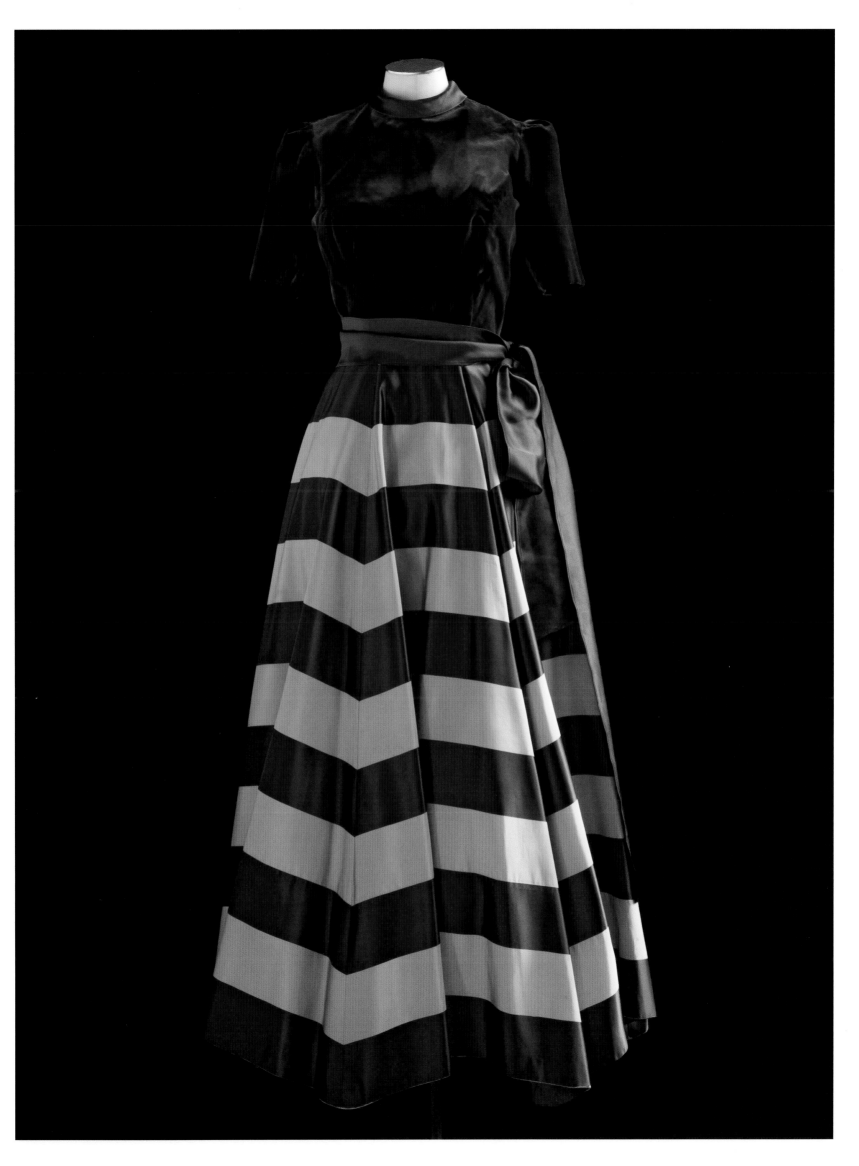

CREATIVE PRINTS

Prints and motifs inspired by different periods and styles became a hallmark of Marcel Rochas's work. Stripes, checks, dots, and flowers, birds, confetti, and globe prints, sometimes in combination, in cloque or draped fabrics, reflected his discerning taste for ornament. He was especially fond of striped motifs, thin or broad, in classic tones or lively colors, frequently associated with sporting and leisure pursuits. The collections he presented in October 1927 featured numerous sweaters "with horizontally shaded stripes," such as the Croisette ensemble, consisting of a sweater with pink and blue graduated stripes and a piqué seam-shaped skirt, and the Fétiche dress in beige crepe de chine with brown and green shaded stripes. Rochas beachwear also sported stripy motifs, as in the Boîte à Matelots beach pajamas (1934) in navy jersey with red and white stripes; the Floride pajamas in beige shantung and navy wool with red and white stripes; suits with shorts in light-colored chalk-striped flannels; and a short smock with cheerful navy, red, white, and green stripes (1950).

"Marcel Rochas is not afraid of juxtaposing two different prints in a single ensemble, and, despite the principles traditionally adhered to in this respect, achieves a highly pleasing effect," observed *L'Officiel* in its issue of March 1936, no. 175. "This modern approach to the use of prints can also be seen in the cut and position of floral motifs, placed at the shoulders, on the hips, or on the bodice." To heighten the effect, when using prints in a design, Rochas would also incorporate a belt with a leather or straw motif reproducing the same print, such as raffia squares or an open book.

Even when he was working with more classical prints, Marcel Rochas retained the fresh, fanciful note his clientele expected of him. The 1935 motifs were "true revelations": "a scattering of bright florets on a light background, trellises, diamond shapes, red stars on white piqué" (*L'Officiel*, no. 165, May 1935); "multicolored confetti prints on taffeta, or tartan prints in vibrant colors on a gray-toned background, light prints, flowers, seaweed, checkerboard, seagulls, masks," and "beach ensembles in linen printed with globes" (*L'Art et la Mode*, nos. 4 and 8, 1935). The famous bird motif that featured on a number of the house designs first appeared in 1934. **JG**

FACING PAGE Floral-print crepe evening gown, maintained at the neck by a braid of plain-colored red, mauve, and yellow materials, *Plaisir de France*, April 1936.

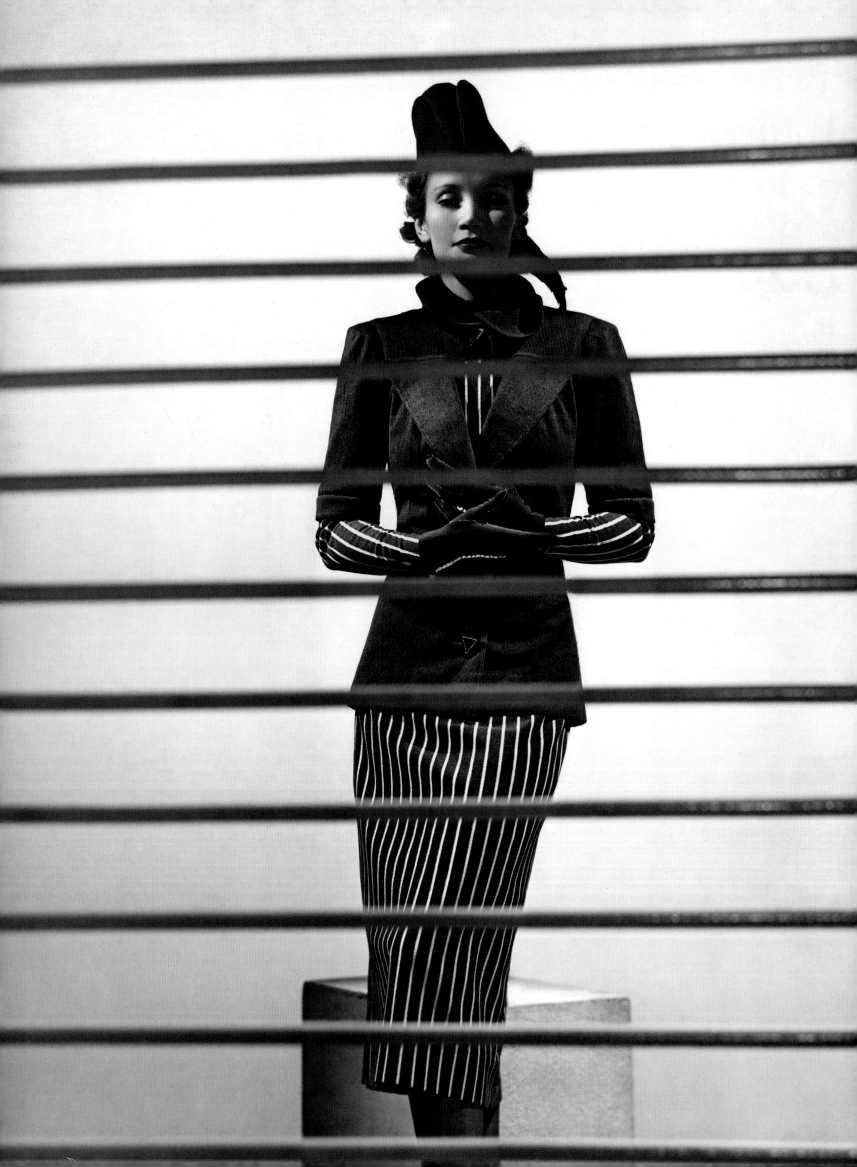

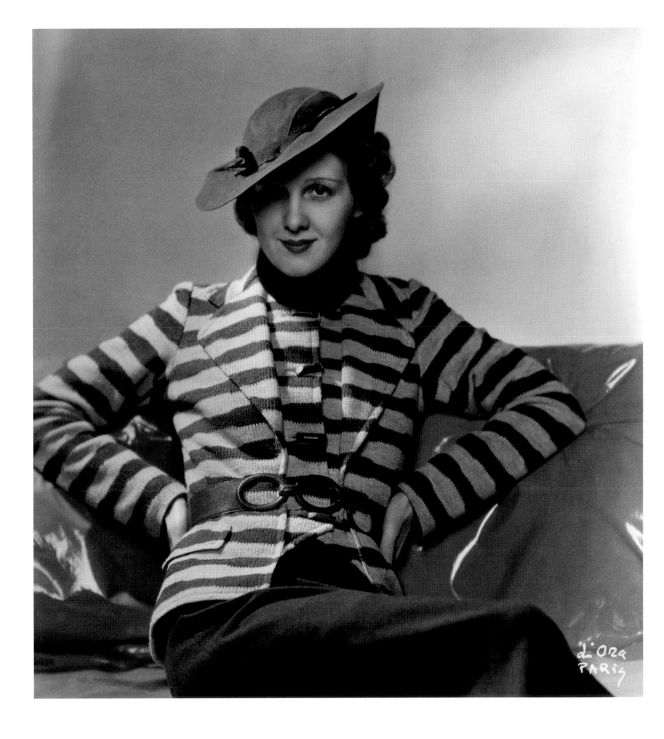

Marcel Rochas was a master at integrating
the play of lines into the architecture of his designs.
FACING PAGE Day ensemble, 1937.
ABOVE Day ensemble, fitted jacket with a front inset
in striped jersey, over a plain-colored skirt, circa 1935.
PAGE 88 Two striped suits by Marcel Rochas, April 1934.
"The spring has brought back the fashion for little
light wool suits, so pleasant for a stroll." The two shown
here are in shades of gray. The one on the right
is in "travers djersondic," a striped iron-gray and
silver-gray jersey; the other is in "djersalissyl"
with gray and fine white stripes. Gray felt hat.
L'Officiel de la mode, no. 151, 1934.
PAGE 89 Gray-and-white-striped jacket and V-shaped
front inset, black trim and braiding, circa 1935.
Sophie Rochas archives.

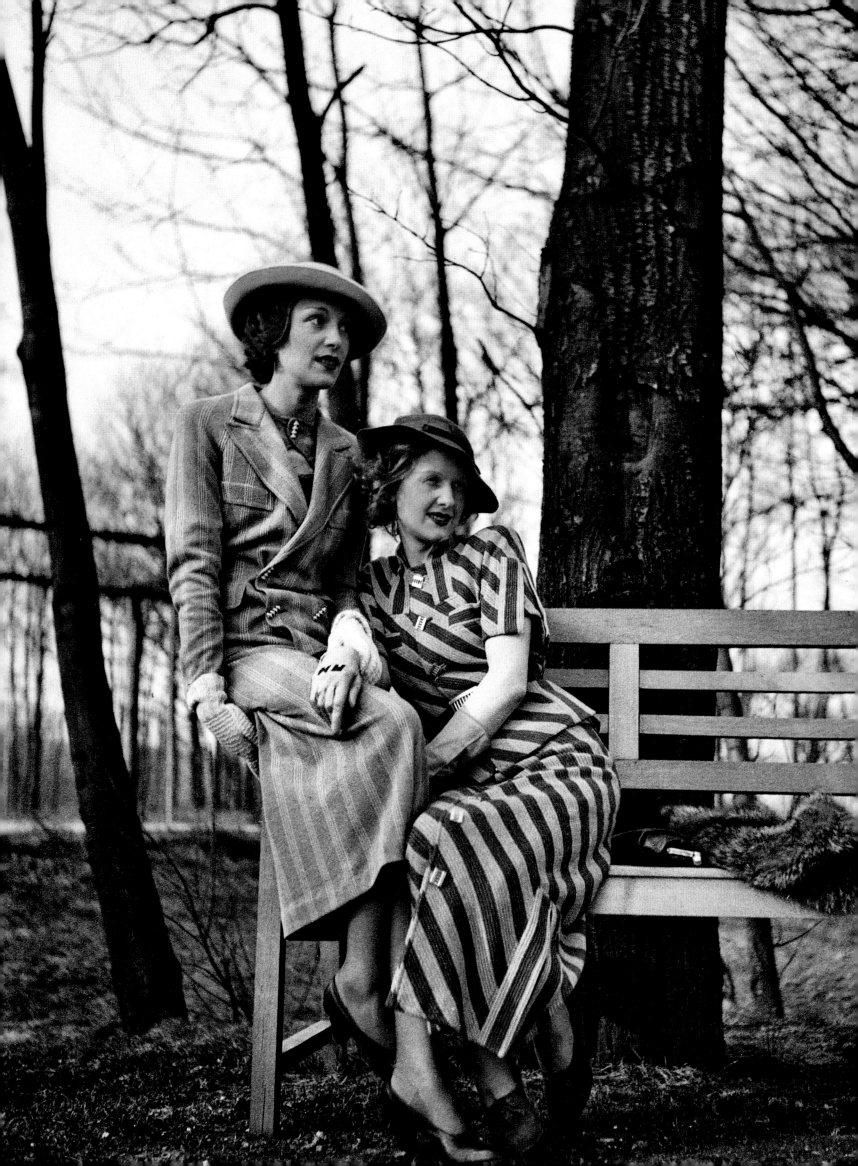

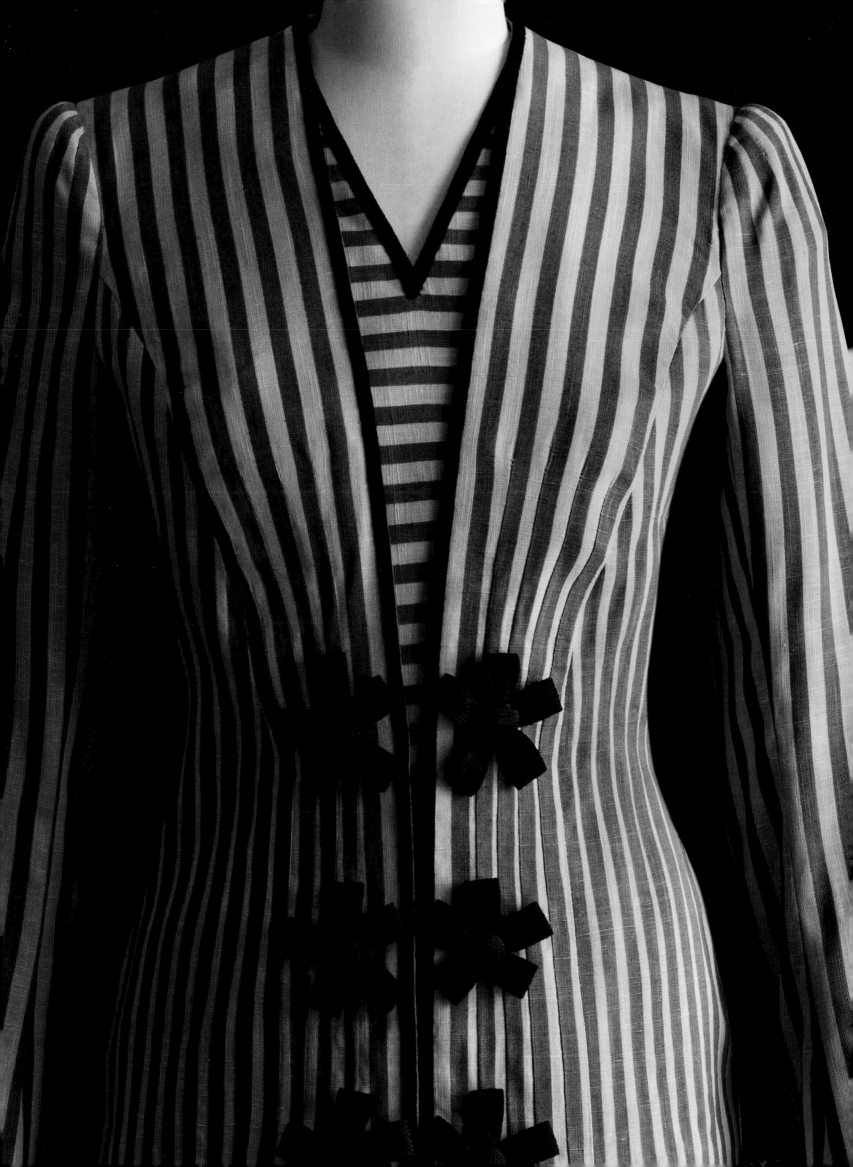

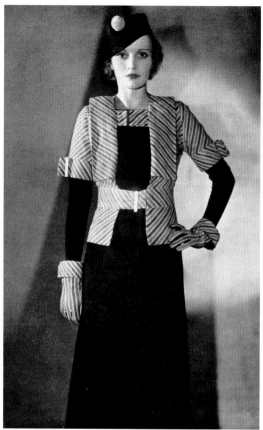

PLAY OF LINES, FEATS OF FABRIC The young couturier liked to integrate the
fabric's grain or motif into the architecture of his models, using stripes, lines, or chev-
rons: "This century's dress is designed, constructed, mechanical, even."[21] Rochas was
noted for his work using optical effects[22] and in "the amazing graphic precision with
which he masters the contrapuntal play of stripes…the graphic effect even verging
on trompe l'oeil in a jacket featuring a brick wall motif."[23] He treated tartans "not like
repetitive surfaces but like functional inserts."[24] My father became a virtuoso of line. He
had the eye of a sculptor, an architect. Moreover, in 1934 he launched his "architect"
coats, incorporating geometrical appliqué work that accentuated their relief, as in the
Voltigeur and Aguicheur coats. His models were based on a highly structured inner
logic, with which he played, in turn masking or revealing it, "with a singularly modern
vigor."[25] Marcel Rochas's unique mastery was an extremely fine balance, which fash-
ion journalists took pains to underline. He juggled with the notions of masculine and
feminine, and brought out womanliness "in the paradoxical play of a virile cut."[26]

It is true that the 1930s lent themselves to this approach. With innumerable dinners
and parties being hosted, fashion designers put all their imagination into beating the
recession. "People dance at Le Ciro's, at the Ritz, everywhere. The victorious Comité
des Saisons de Paris has managed to shake up the moroseness of the recession, that
moroseness that already seems like history, people are so eager to have fun in our
wonderful city…. At Le Ciro's bar before dinner, le Tout Paris awaits le Tout Paris;
pictured here…Mme Georges Levy in a black velvet dress with a feather ruff, the
Duchesse d'Harcourt in velvet, a dress high in the front and very low cut in the back,
Mme Marcel Rochas in a white imitation brocade dress."[27] Given the high cost of raw
materials and people's taste for modernity during this decade, creativity in textiles was
the order of the day. Couturiers were quick to seize the opportunity, my father the first
among them. To meet his needs and develop new processes for the profession, he
started collaborating with fabric manufacturers from 1934. It was a simple matter for
him to use these contacts, having worked for them in the past to pay for his law studies.

ABOVE, LEFT Top in silk organdy with short sleeves
and ruffled cutouts. Hat by Maria Guy.
L'Officiel de la mode, no. 144, 1933.
ABOVE, RIGHT Quatorze Juillet ensemble with a black
jersey wool sheath dress and red, white, and blue
jacket, and matching gloves. Hat by Maria Guy.
L'Officiel de la mode, no. 141, May 1933.
FACING PAGE Afternoon outfit by Marcel Rochas.
Cover design by Léon Benigni
for *Modes & Travaux*, June 1937.

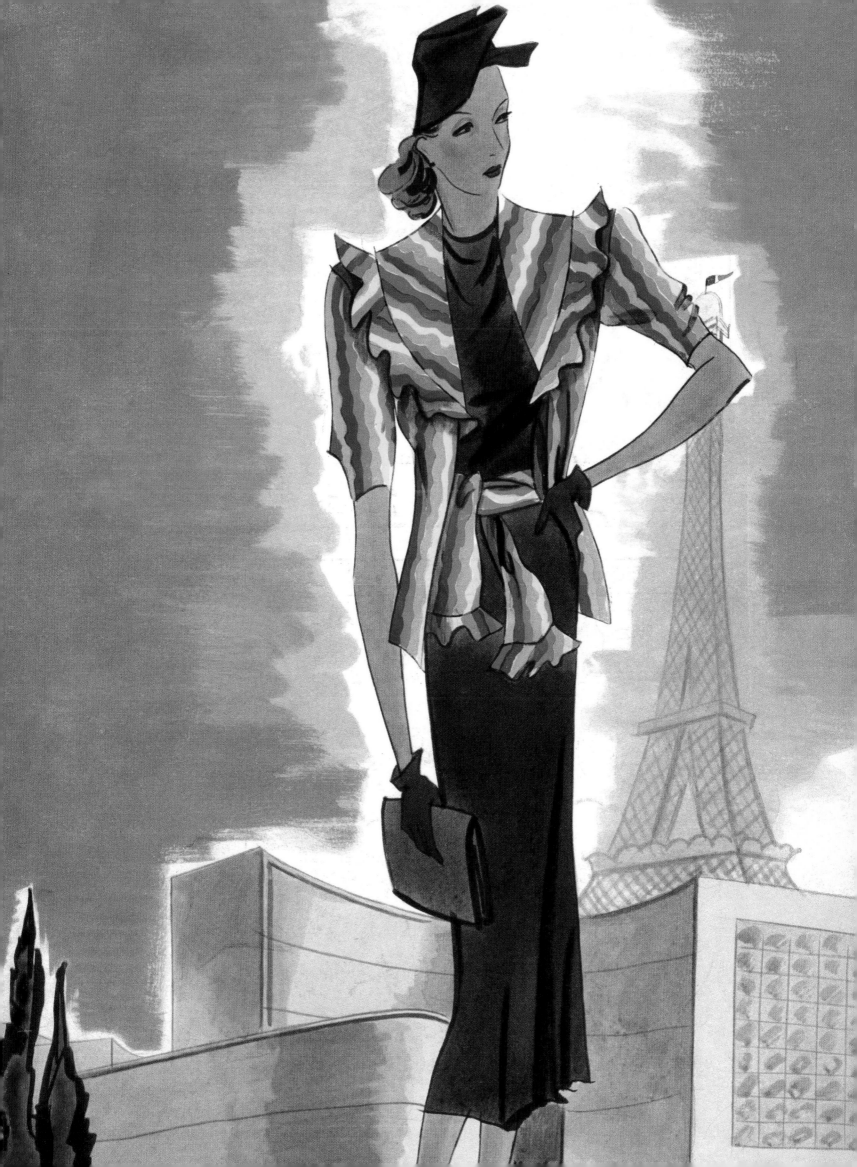

"Four times a year," my father wrote, "I went to Lyon, and in the lofts of Bianchini, Coudurier, Ducharne, and the like, I spent marvelous hours among the references of a century. I triumphantly discovered samples. I communicated my enthusiasm to the manufacturers, who wove splendors for me."[28] Sometimes he ordered plain fabrics (he had Moreau make homespun-type material[29]), sometimes he asked the manufacturer to invent more sophisticated materials for him: Annamite cloque by Coudurier-Fructus, thick Twitchouk by Rodier, "cloque wool and jersey by Rodier [Anthracite]; Dent de Lyon by Riqueur, and woolens by Lesur; Vanitel cellophane woolens, Scotchel by Carlin; Pécari fabric; woolens and printed imitation silks by Roubaudi; shantung, plain and checkered taffetas; gray Tafgah, Rotary, Prince of Wales and printed satins by Coudurier-Fructus-Descher; white Flamenga; taffeta and green lace by Goetz; black lace by Dognin; embroidery in gold cannetille, all in straight lines."[30] He liked to give them evocative names, such as Rosalba, developed with Bianchini Férier in April 1937. Nevertheless, Marcel Rochas "also went back to traditional materials; he reinvented the use of fur, which had been widely abandoned. He did not make it a sign of wealth but explored all its possible combinations with fabrics, woolens, and leather."[31] He clearly seems to have shifted conventions of the time a step ahead of the others. Speed was the key, as ever, in order to surprise and to focus the attention of his contemporaries on him and on his creations.

Always experimenting with new ideas, Marcel Rochas took to mixing fabrics and furs.
BELOW, LEFT Mme Wibaud wearing a black monkey-fur coat by Marcel Rochas, with a matching cap by Le Monnier, 1933.
BELOW, RIGHT Half-length coat in two furs, red fox and black mink, 1930s.
FACING PAGE Cinched jacket in black moiré silk with white satin stripes, V-shaped back inset made up of intersecting bands, circa 1940. Palais Galliera, Fashion Museum of Paris.

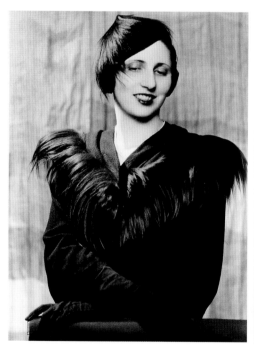

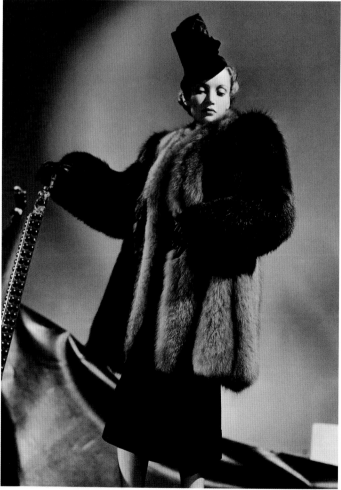

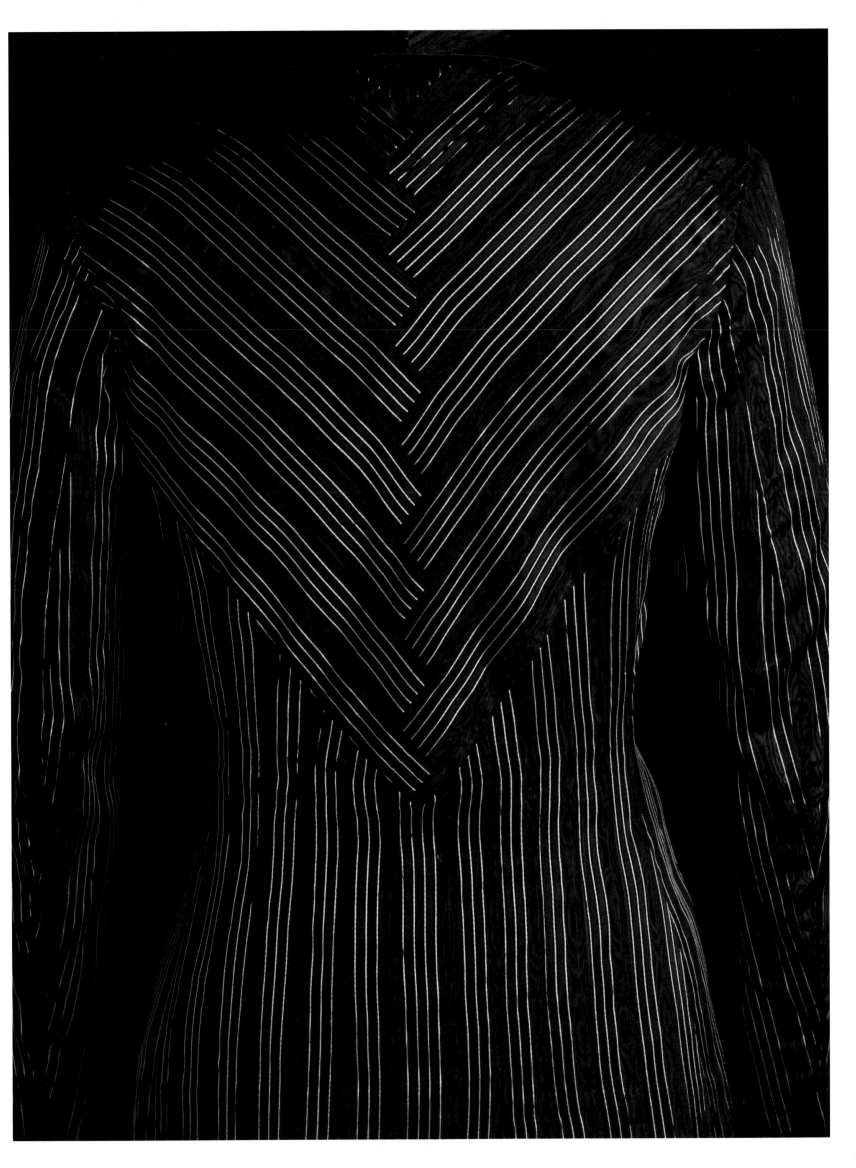

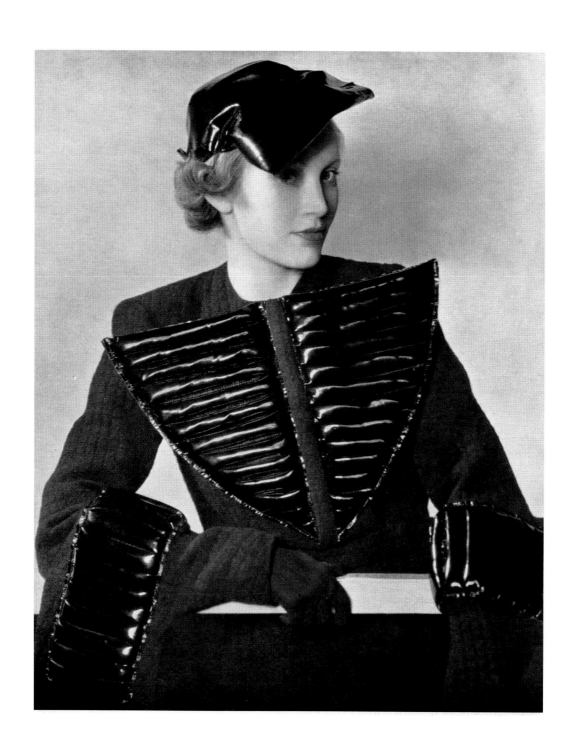

ABOVE 41 coat in Rodier "Cubex," lapels and cuff trims
in black patent leather, green leather hat by Maria Guy.
L'Officiel de la mode, no. 148, December 1933.
FACING PAGE Mini-cape in black velvet with horizontal black
satin bands, edged with a velvet flounce, 1926–28.
Sophie Rochas archives.

GUIDED
BY THE TIMES

Like Jean Patou and Elsa Schiaparelli and other couturiers of his time, Marcel Rochas not only sought out the company of painters and poets, but also drew inspiration from events and motifs in his everyday environment, including architecture (in Paris and elsewhere), exhibitions, cinema, air travel and cars, as well as birds, flowers, and hearts. "The dress of our century is designed, built, mechanical, even; the volume aspect—an utterly new thing—has a role to play," he told Henriette Chandet in fall 1933 (*Rester Jeune*, no. 1, October 1933, p. 21). This was echoed in his winged and square-shouldered silhouettes of the 1930s, elegantly recalling the pagoda roofs of the Colonial Exhibition, and in the coats with architectural reliefs, as well as in the chased old-silver buttons showing the towers of the cathedral of Notre Dame—"a current craze"—and the buckle of the Plan de Paris belt. Cinema was a major communicator of these forms and motifs, as it began to break free from silent and black-and-white films, while America sank into economic depression. During his visit to the Hollywood studios in 1934, when he was working on new designs for photogenic fabrics, Rochas announced "a return to intense relief and color, in reaction to all-too-easy black and plain colors." (*Chantecler Revue*, Hanoi, September 8, 1934).

Marcel Rochas loved color, and he also loved speed. In his Winter 1950 collection, he "names his dresses after famous car marques and opts for waffled, embroidered and blistered materials that make up a rich bodywork" (*L'Officiel*, September 1950). "The 'chassis' is nimble," the report continued, "a soft shoulder line, curving hips, tunics buttoned up the side, feminine scarves"; the swirling flat layers of the Mercédès dress were to become one of the couturier's best-selling models. From the autombile to the airplane, you just had to lift your eyes, travel, take off. The wing symbolism took on a more poetic dimension in the bird theme. Birds were Rochas's inspiration for an entire collection in 1934: a great white seagull perched on the bodice of a black sheath dress, in a design known today as the Bird dress; a small black bird on the Hippocampe dress; two blue parakeets "which seem to have alighted of their own accord on the sleeve of a negligee" (*Femina*, April 1934); and the Petits Oiseaux dress in matte black marocain adorned with multicolored birds (*L'Officiel*, no. 155, 1934). Variations of the bird motif continued to appear over the decades, either in direct formal references or in prints, names, or allusions. In March 1945, every gown in the collection was named after a bird, and in the early 1950s, their wings would evolve into the airy form of the Rochas signature white Peter Pan collar. **JG**

FACING PAGE Cape dress with birds attached to the shoulders. *Vogue*, May 1934 (see page 101).

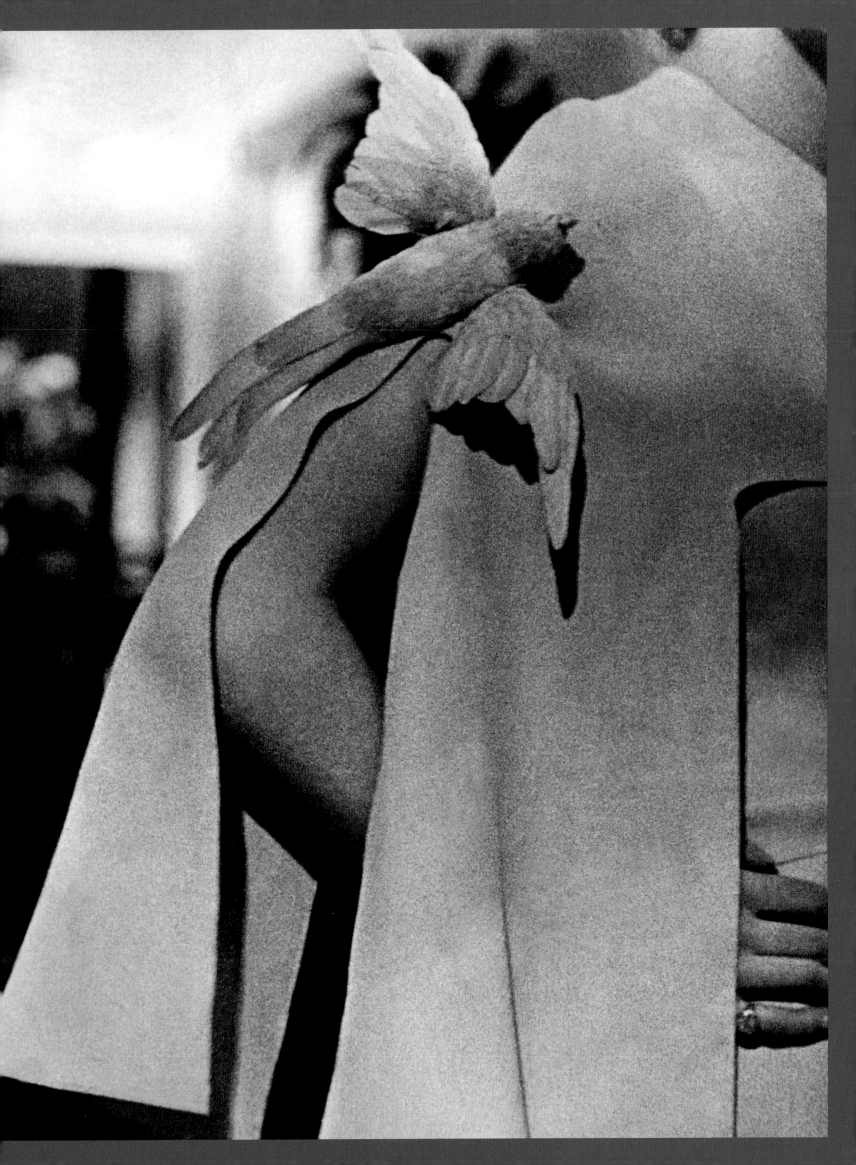

MASTER OF DETAIL While women are every couturier's ambassadors, making connections between the arts also enabled my father to create dresses and perfumes that were never alike. The world of artists was also frequented by their patrons, but when these were lacking, art continued for art's sake. This was a domain in which economics did not rule supreme; talent was its master. In this respect, couture, when it attains perfection, can be considered an art in its own right. Marcel Rochas understood this well; he knew how to challenge the classically elegant with a line, a form, or a reference from elsewhere. An elsewhere that was not necessarily distant. He might come across a detail in the work of his painter friends, Picasso, Braque, Picabia, Max Ernst, Fernand Léger, or Matisse. But he had to know how to garner it and use it in the right place. It might become a Fleurs bolero (1937), or the great white bird of the Oiseau dress (1934). "They have appeared all of a sudden on our spring dresses and we wonder why we waited so long to adorn ourselves with them. It was Marcel Rochas who had the idea of placing a large white gull on a long black silk jersey dress, or a little black bird beating its wing on a shoulder."[32] Worthy of the great artists who inspired it, the legendary Oiseau dress gave rise to numerous variations between 1934 and 1950. Originally a simple stylistic ornament, a miniature, Marcel Rochas's bird underwent a number of metamorphoses: originally a gull, in 1934, it became a black crow on the eve of World War II, then a dove, symbol of freedom, lightheartedness, and newfound peace. Rochas had lived through two wars. Might that explain why this theme returned often to stimulate his imagination, like a beating wing? Over a period of more than fifteen years he created variations of his favorite motif on his long sheath dresses, alternating the bird's black and white colors, sometimes mixing the two with a restrained yet sophisticated elegance. It required highly skilled cutting to create this play of opposites. At the height of his art, Marcel Rochas achieved this alchemy in at least a dozen of his most famous dresses, admired and worn the world over. A hymn to beauty, the Oiseau dress elevated couture to the rank of an art in its own right. This might not have been to the liking of Coco Chanel, who once remarked to Michel Déon: "Now … suppliers are taking themselves for artists. What a farce! Art can do nothing for fashion. If fashion sometimes serves art, that is enough for the glory of fashion."[33]

BELOW, LEFT Georges Braque, *Black Bird and White Bird*, 1960.
BELOW, RIGHT AND FACING PAGE Hippocampe evening gown in black Dent de Lyon, decorated with a black feather bird with a rhinestone beak. *L'Officiel de la mode*, no. 152, April 1934.

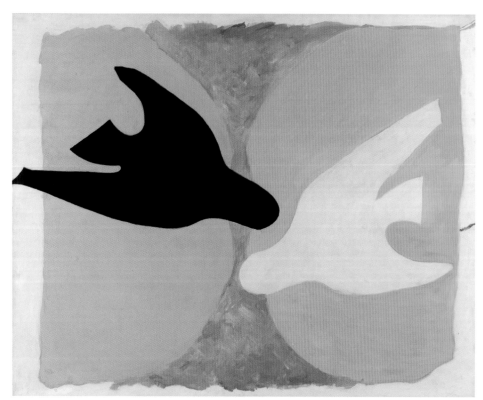

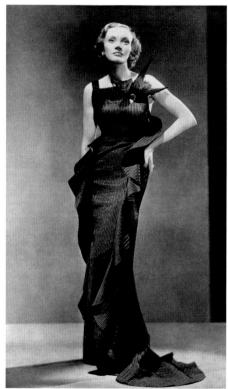

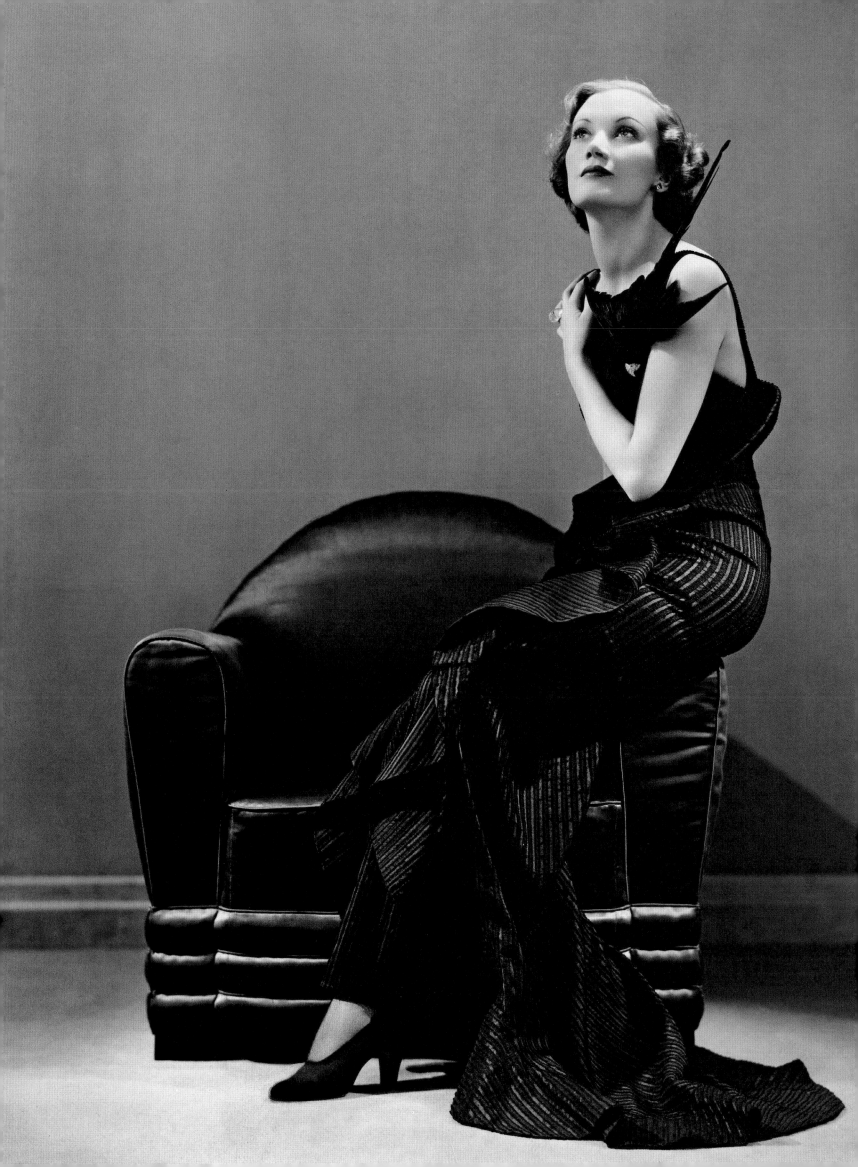

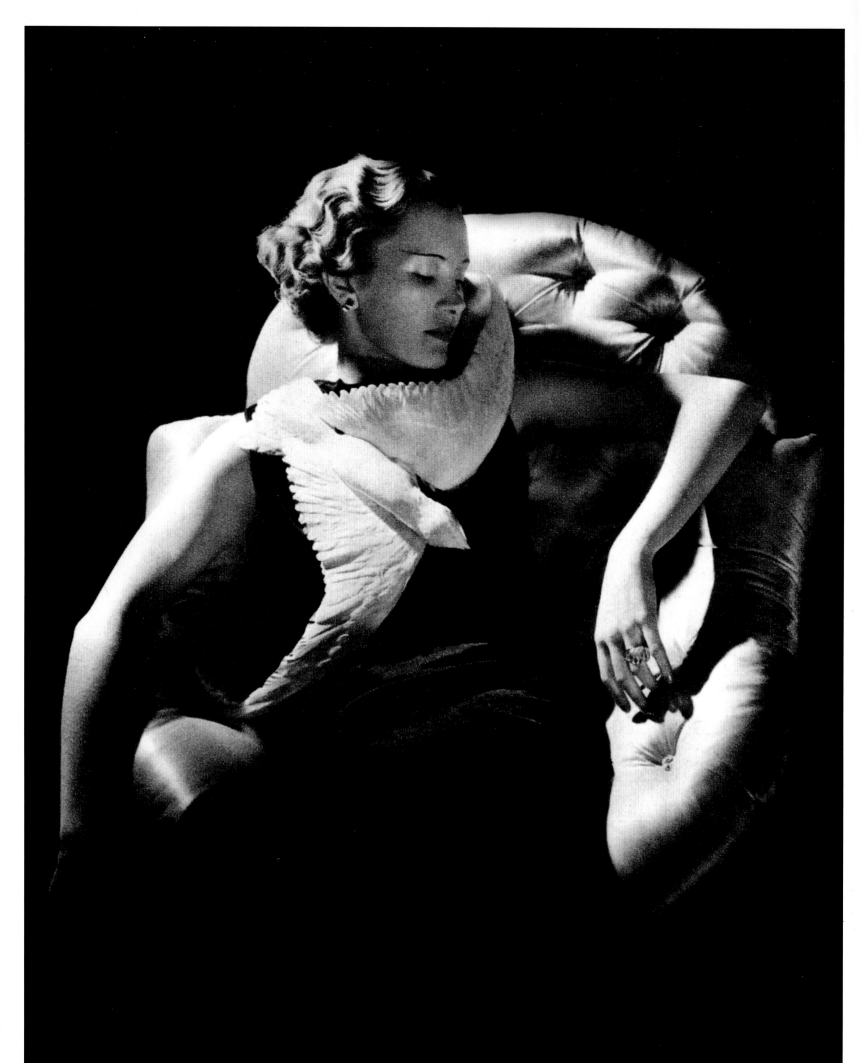

Over fifteen years, Marcel Rochas developed his bird motif. "Birds lend themselves as graceful ornaments on the designs of Marcel Rochas. A white dove spreads its wings over the bodice of a plain black dress, while two blue birds perch on the shoulders of a youthful, pastel-blue evening ensemble." *La Femme de France*, April 1934.
FACING PAGE Oiseau evening gown in black silk jersey, *Harper's Bazaar*, April 1934. The couturier revisited this design ten years later for Hélène Rochas, spreading the bird's wings wider still.
BELOW Square-cut cape with long slit sleeves and bird attached to the shoulder, 1934.

"MY GUIDE WAS MY ERA. MY GENERATION,
THAT OF THE FIRST WORLD WAR, WAS SIMULTANEOUSLY
DISCOVERING SUN, SPEED, AND SPORT:
THE AUTOMOBILE, THE AIRPLANE,
AND THE CAMERA: THESE WERE ITS GODS."
MARCEL ROCHAS, 1951.

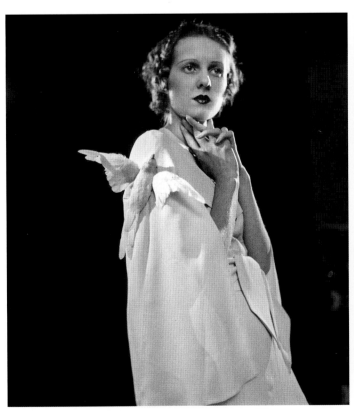
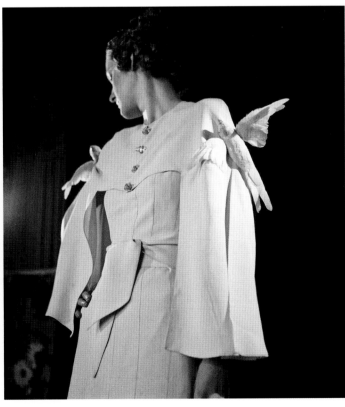

From the sky to the depths of the ocean, the black-feathered bird with a sparkly paste beak also adorned the Hippocampe (Seahorse) evening gown (1934), in black Dent de Lyon.[34] When it wasn't a bird, it was a large heart motif with which the couturier worked, producing the Cœur dress in 1937; or the memory of a musical instrument, a ukulele, which featured on the sleeves of a long, close-fitting evening gown in black velvet (1936). "I would be inspired by anything," remembered my father, "a colonial exhibition, a skyscraper, an automobile, a bird, a flower."[35] The eye captures, the imagination traces.

"Faille in very pale colors, blue-green, or lightly checkered, black on white, with inserts and sleeves in black taffeta. White organdy, with complex pleating framing the face; or black organdy with a mass of large, white daisies on the front of the bodice. Not to mention the buttons and buckles, old-fashioned bouquets nestled at the waist or tucked into a low neckline, and all those many, unusual details that make this collection as much a show of art as something new in couture."[36] From the mid-1930s, the press noted Rochas's ability to enhance a design with a curiosity. Evoking "Marcel Rochas's Surrealism," *Reflets des collections* noted the profusion of amusing details in the couturier's work. They could be found everywhere, on the pockets of his suits, on belts, on gloves. Without attaining the degree of eccentricity to be found in the designs of Schiaparelli, for example, Rochas's accessories would feature unusual objects. "This is not a pipe," Magritte might have observed of a belt featuring a series of colored leather pipes. A bag merged with a leopard-skin glove. In 1939, spectacles took the form of flowers. "Belts in red patent leather on which white butterflies have come to land. Black patent belts fastened with a white plaster lyre, or ending in crossed hands, a treble clef, a stylized ostrich feather."[37] My father was the first to launch symbolic attributes in the form of a brooch or a belt buckle, according to the journal *Les Modes.*[38] He also brought back into fashion cameos, huge metal buttons, and mother-of-pearl or shiny metal buckles. "All these 1850- or 1880-style knickknacks came out of their faded boxes, just like the sparkly diamond barrettes, small hair combs and tiaras that are de rigueur for Mondays at the Opéra."[39] Rochas's taste for antique objects and the Second Empire style was echoed in the apartment he decorated with Rina on avenue d'Iéna, and foreshadowed the one on rue Barbet-de-Jouy on which he worked with Georges Geffroy in the 1940s. Following on from these pre-war accessories would come the "*Frivolités*" (fancy accessories), which he launched in 1948 in his salons on avenue Matignon.[40]

LEFT Mme Henri Gouin wearing daisy sunglasses, Deauville, 1949.
ABOVE AND FACING PAGE Mid-calf-length round-neck dress in black wool with colorful floral insets matching the jacket. February 1936.

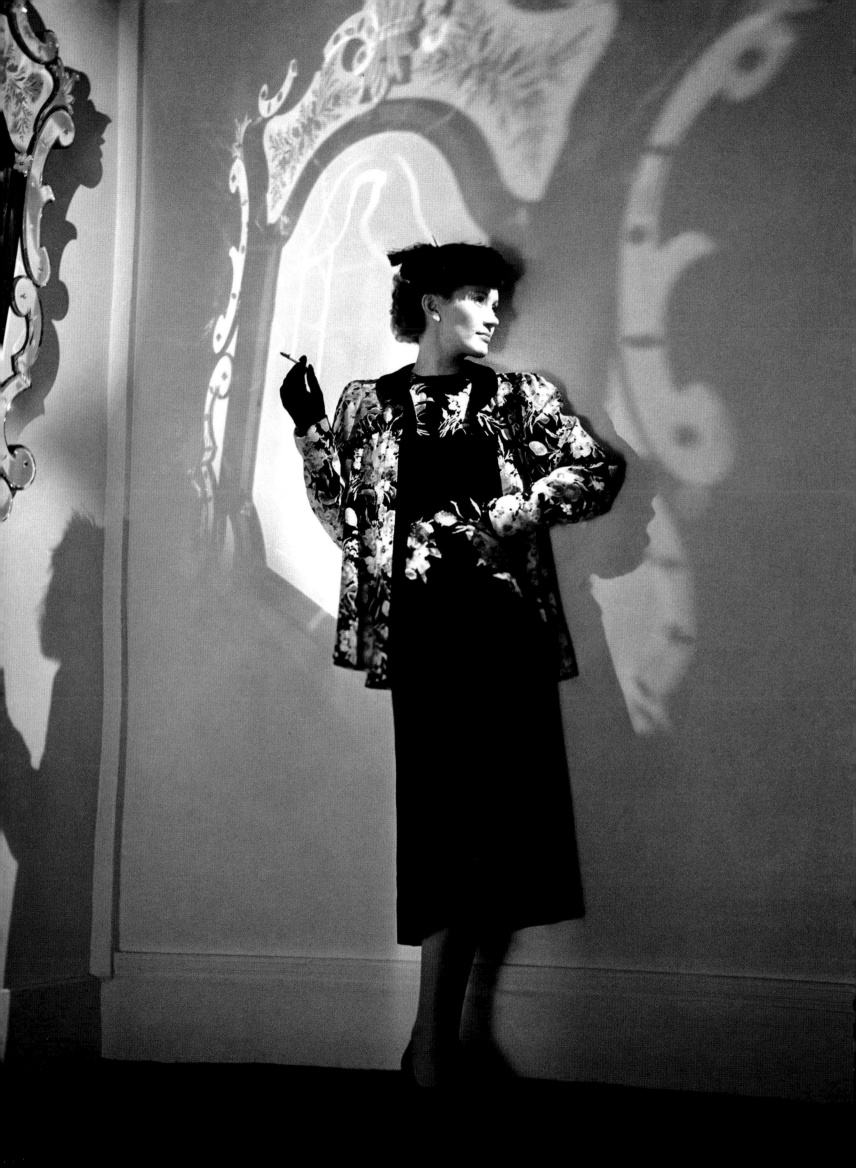

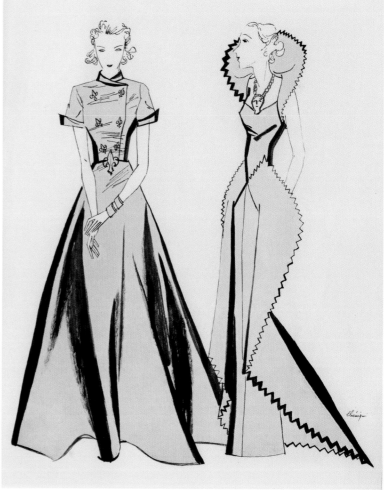

ABOVE, LEFT Mermaid motif on belt and
buttons. *Vogue*, April 1936.
ABOVE, RIGHT The new Orient-inspired
Marcel Rochas line, *L'Officiel de la mode*,
no. 157, September 1934.
FACING PAGE Evening ensemble in a body-hugging
fabric that kept its shape, leaf-shaped
belt buckle, Winter 1934.

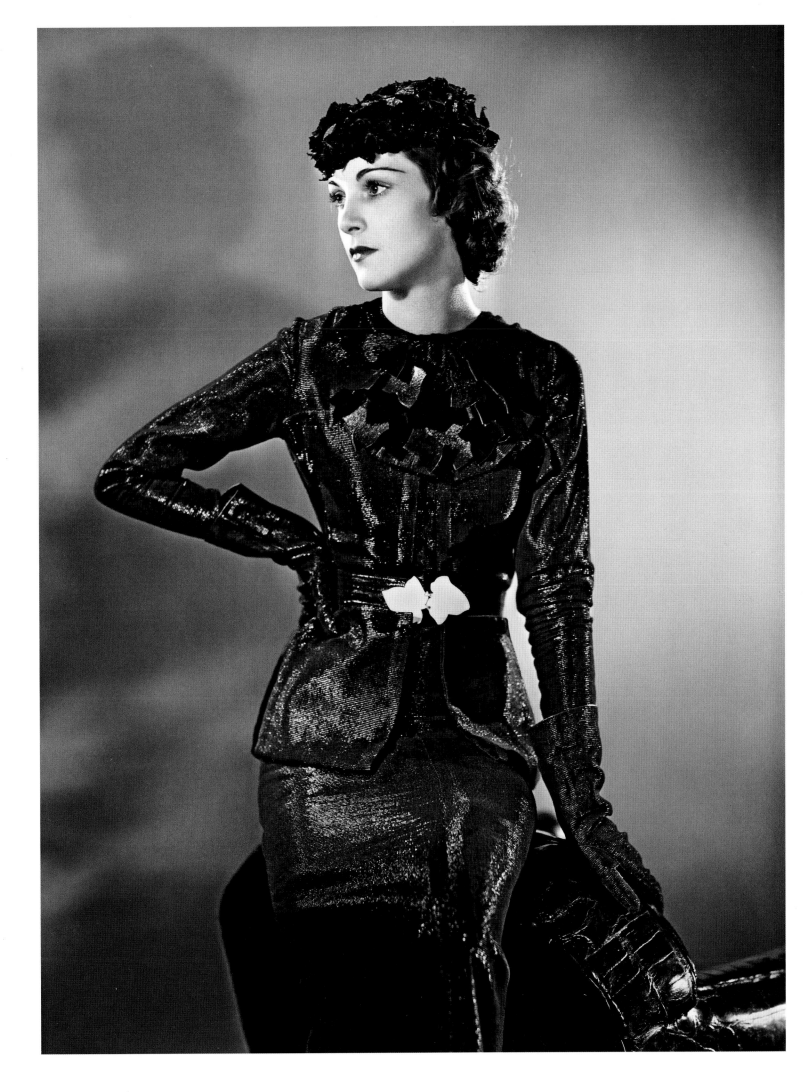

AN INSATIABLE CURIOSITY In 1931, Marcel Rochas's quest for inspiration took him ever farther afield, to the other side of the world and yet so close to Paris; that year, the Exposition Coloniale revived the French taste for exoticism. Go on "a world tour in a day," cried the posters inviting visitors—there would be eight million of them—to admire a France beyond its hexagonal borders, in the Bois de Vincennes. Marcel Rochas drew on the sources that fueled the creativity of Parisian artists. The same year, besides his Colonies ensemble,[41] he presented the Bali dress, with a neckline trimmed with a band of white piqué that brought out the square shoulders, a feature on which he would focus for fifteen years. "There'll be lots of trims in white piqué or lawn, and the most refined touch is giving them the appearance of a simple over- or undergarment: for example, while retaining the 'wide shoulder' line he brought in a year ago, the large flounced collar in piqué on the dress worn Mlle de Beuvoise."[42] Wide shoulders, a new hallmark of the Rochas style, came with geometric yokes, flaps, and large collars, pointed sleeves, and various ornamentations enhancing the bust, above a waist that was back in its natural position, and a considerably longer skirt between 1929 and 1935, a little shorter afterward. "Do you remember the stir caused a little over a year ago by the appearance of a certain lace dress, by Marcel Rochas? Two great wings fixed on the shoulders seemed designed to widen the bust, and that was contrary to the tradition at the time. The deliberate eccentricity of this dress would seem simplicity itself today, for this line is with us now and we have seen a great many variations of it."[43] Appearing three years after the Bali dress, the Angkor coat (1934) also drew on Asian influences.

My father loved Brittany and its wild natural landscape, another form of exoticism, and in 1935 revisited a Breton suit. The jacket with large embroidered black velvet lapels was worn over a fully pleated white silk chiffon blouse, a wide velvet belt accentuated the waist, and a Maria Guy hat added a "very Breton" note. Pleats were a common feature in Marcel Rochas's collections, particularly in the surplices and chasubles that were one of his favorite themes.[44] He used this many times, in a long embroidered evening shirt[45] or coordinated with a day dress or evening gown, such as the Crémaillère dress of 1934.[46]

BELOW, LEFT Bali sheath dress in black silk, shoulders accentuated by a wide rectangular border in white piqué, 1931.
BELOW, CENTER Pouss-Pouss ensemble in white and pink wool by Lesur, with shell buttons and a navy-blue scarf, *L'Officiel de la mode,* no. 151, March 1934.
BELOW, RIGHT Three-quarter-length Angkor coat in black ortie, patent leather belt with silver leather motifs. *L'Officiel de la mode,* no. 153, May 1934.
FACING PAGE Shirred flannel tailcoat over a rayon crepe skirt. *Vogue,* June 1936.

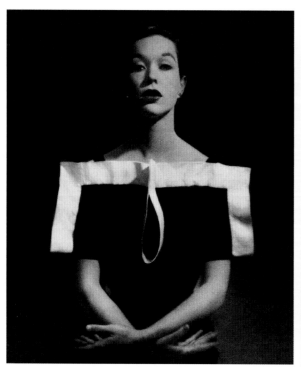

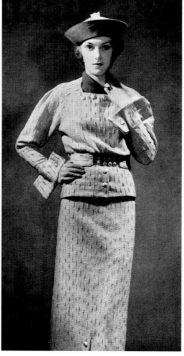

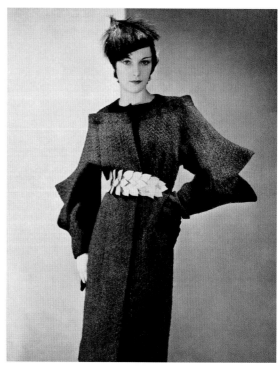

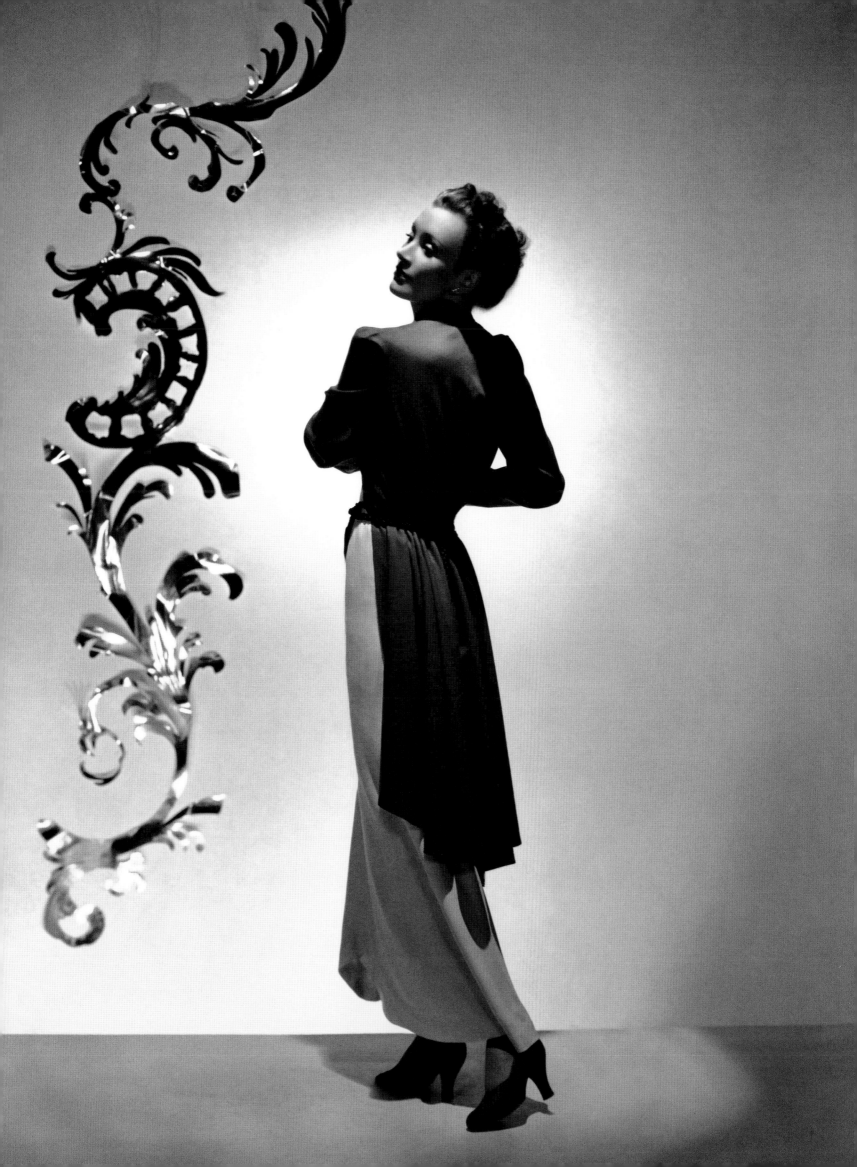

DISTANT
INSPIRATIONS

Marcel Rochas's tendency to exoticism and multicultural inspirations, from Bali to Argentina, were evident even in the names of his face powders, such as Floride, Nil, Tanagra, and Baléares. When he opened his couture house in 1925, all the arts in France were imbued with a fascination for distant shores. These were propitious times for designs featuring new types of clothing (the kimono, the North African burnous and the djellaba, divided skirts, tunics, turbans, traditional embroideries, and so on), and novel fabrics and materials. The Paris Colonial Exhibition of 1931, and the Orient as perceived through Parisian tastes, would together exercise a wide-ranging and enduring influence on Rochas. The names he chose for some of his crepe ensembles, such as Annam et Annamite and Pékin et Tonkinoise, speak for themselves. More striking still was the original form of the Bali dress, which introduced the square shoulders and the winged silhouette that were to form an important new theme in the Rochas look. In 1934, Rochas presented the Pouss-Pouss ensemble, in a woolen fabric with shell buttons, and the Angkor coat in black "Ortie," featuring a belt with silver leather motifs.

At the time of these voyages of the imagination, in the 1930s, Marcel Rochas made a trip to the United States: "And so at last I got to California, such a hugely attractive place; to Hollywood, like a vast and permanent colonial exhibition, like three cities in one, all glitz, artifice, and color." This journey was the inspiration for Rochas's USA beach pajamas design, in an off-white cotton cloth with a loosely fitted jacket and lapels in shantung with a red-and-blue print. Another side to the Rochas take on exoticism could be seen in the regionalist-inspired Breton costumes (1935), with embroidered jackets, lapels, and cuffs. A southern European Latin influence could be seen in the Venise ensemble of 1931 and the Gitane dress, both in its first version of 1932 in black-and-white crepe romaine, and in its 1937 variant, a "Bohemian" gown in colorful striped silk chiffon featuring a wide, metallic-sequined belt. In 1942, "Barcelona was the couturier's inspiration for an evening gown in yellow satin with waffle and repoussé embroidery in jet and black satin" (*Images de France*, no. 89, October 1942).

In the early 1950s, Marcel Rochas looked to South America, where he fostered some special relationships. In Argentina, he regularly designed clothes for Eva Perón. He was also fascinated by Brazil, and borrowed ideas from classic South American costume designs, creating a "Mexican poncho" in red cloth delicately embroidered with white beads (1949), followed by an "Argentinian poncho" with wide blue, green, and pink stripes, "skillfully cut" and "very useful for going out in the blazing sunshine." The burgeoning pleasure-seeking society of the postwar era was eager to adopt the most fanciful combinations of picturesque designs and colorful cottons. **JG**

FACING PAGE Black velvet sheath dress edged with pleats of black, green, beige, and gray taffeta. Winter 1949 collection. Philadelphia Museum of Art.

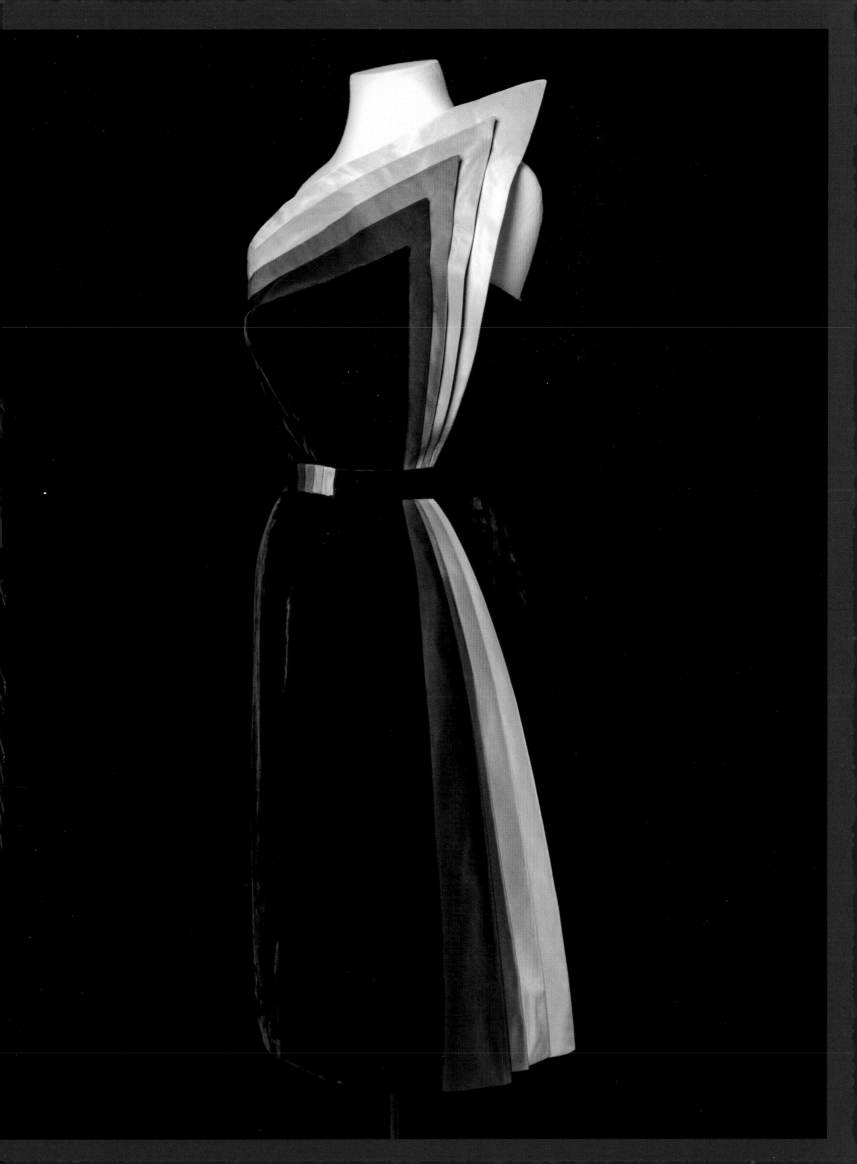

DISCOVERY OF AMERICA His profession left Rochas very little free time. He had to anticipate the changing seasons, detect new trends, keep up his contacts, and travel. The journey to New York, my father's main destination in the 1930s, took over twenty hours. It was a challenge to recover from a transatlantic round trip without delay and head back to the office before all the new ideas he had garnered evaporated. His aim was to observe what was happening on both sides of the Atlantic. The French couture trade union was concerned; with the drop in exports brought about by American protectionist measures and the growing spread of American models by the all-powerful cinema industry, what would become of French models? Were they in danger of losing their influence?

In 1932, Marcel Rochas reflected on the poor reception of his Fall collection in America: being a collection that could "sometimes appear too modern, or too cinema, and consequently appealing to a young and essentially cinematographic audience," it "did not at all appeal to their buyers, who appeared neither to like it nor to understand it."[47] If Hollywood actresses were "knocking out the poor little Parisian actresses with their luxury and elegance" and if Americans in Paris were dressed impeccably, it was because they represented only a small section of the population, the elite. "Where fashion is concerned, I am already certain that the study trip that I intend shortly to make to America will only confirm the impression I have of the way the majority of American women dress: a total absence of taste, judgment, and personality."[48] He made this journey in 1934, when a trip to Hollywood was to leave its mark on the career of a couturier who had decided to go and observe at close quarters the risk of the "Yankee" model affecting the "spread and influence of our old European civilization."[49] After presenting his Summer collection in two shows—one for America on February 7 and the other for Europe on the 8th—he took off for New York with Rina, and this time he took the train to California. Four long days and nights on board those "ingenious sleeping cars" made for a tiring but fascinating journey through the States, with their "desolate landscapes, sparse trees, scorched earth…and always the old Ford, skeletal and yet so charming."[50] On their arrival in Los Angeles, they received a welcome at the largest film studios, where they were shown the sophisticated technical installations and introduced to the costume designers of the stars: at MGM, Adrian,[51] couturier to Greta Garbo; at Paramount, Travis Banton,[52] who dressed Marlene Dietrich and Mae West. "Fashion on the screen tempts me as it has tempted older people than myself in our profession, and if I did not hesitate to undertake this exhausting journey…it was solely in order to acquire a certain cinematographic culture that I had been lacking until that time."[53]

The first consequence of this decisive journey was his immediate preparations to launch the Rochas brand in the United States. "Loretta Young, Jean Harlow, Pat Paterson, Carole Lombard, who is shooting a good deal at the moment, Mae West also, who has become a great pal, were enthusiastic about my dresses, although I had no collection with me other than my wife's own wardrobe. All the stars fell on my white birds from last season, and they appear to be meeting with success in New York."[54] French couturiers not only feared the disappearance of French hegemony but also the pillaging of their designs by American buyers, who returned from Paris with ideas that they transformed into "poor imitations of dressmaking that have none of the finesse of our models."[55] They might as well capture the American clientele and avoid being dispossessed of their creative capital—something that Jean Patou foresaw as early as 1930.[56] Rina and Marcel continued their trips to the United States, where they kept up a network of acquaintances. "Rina, Marcel, and the Pinis have arrived, but they are staying in a magnificent hotel, have a thousand acquaintances, banquets, theaters, boxes, and little time for me,"[57] Leonor Fini complained during their visit to New York in December 1936. After eight voyages, my father opened his first store in New York in September 1937, between Madison and Park Avenues, at 32 East 67th Street.

FACING PAGE Lambswool cape and skirt in "Tchouklap" by Rodier, worn with a striped sweater matching the lining and a two-tone scarf. *Harper's Bazaar*, October 1934.
BELOW Marcel and Rina Rochas in California, 1934.

"What did I go there for? Something very difficult, but very interesting…. Paris really cannot continue to let itself be pillaged and crippled by American buyers…. What I bring to American women is my production of original quality, using original French fabrics."[58] On the other side of the Atlantic, the couturier had re-created the Parisian atmosphere of his couture salons—white walls, mirrors, dark-blue-upholstered chairs, tropical plants—to present his collections (by appointment) and his ranges of accessories and perfumes in the French style. As Lucien Lelong stressed at a conference organized by the Comité des Conseillers du Commerce Extérieur (Foreign Trade Advisors' Committee), in the context of the World's Fair held in Paris that same year, "every book, every dress, every machine, every bottle of perfume, and every ear of wheat that crosses our borders is a piece of the French flag planted abroad!"[59] In December, after a customs seizure, my father was accused of illicit importation of clothing,[60] despite his protestations: the garments were the personal effects of the models, as they would state before the court. In January, an arrest warrant was issued against Marcel Rochas, and the New York salon was shut down in March 1938.[61]

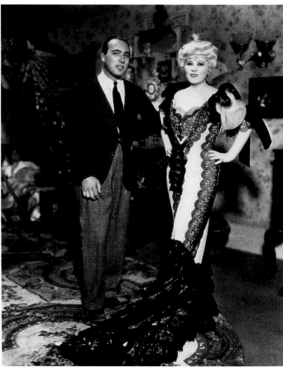

LEFT The American actress Toby Wing wearing a long white dress with ruffled sleeves and hem, with a black belt and straw hat, circa 1935.
ABOVE Marcel Rochas and Mae West, Hollywood, 1934.
FACING PAGE Mae West plays Cleo Borden in Alexander Hall's *Goin' to Town*, 1935.

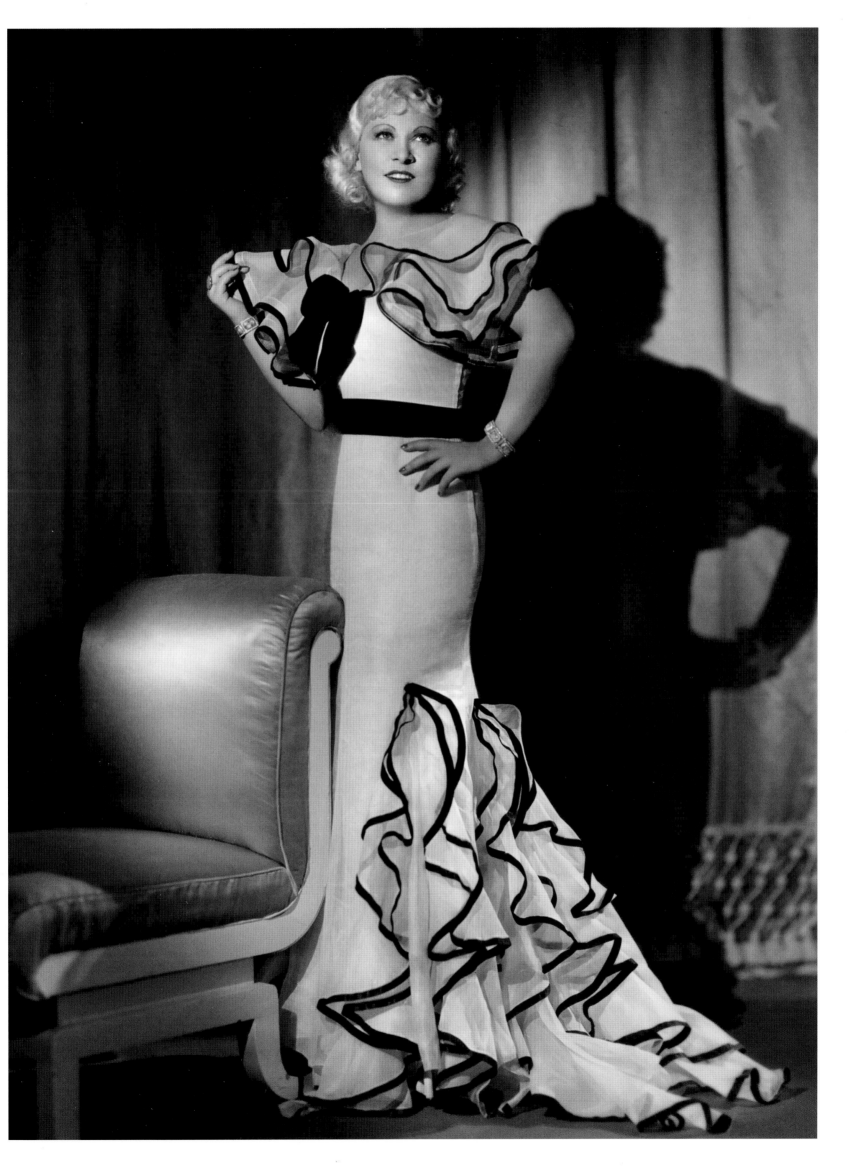

MARCEL ROCHAS AND THE CINEMA The other consequence of his trip to Hollywood was the firm foothold Marcel Rochas gained in a field that had always fascinated him: the cinema. My father recognized that he had been influenced by "cinema and American stars, with [its] smooth-skinned, sophisticated models, and its famous supermodel, Caroline, who represented the most successful type…the Marlene type!"[62] How could he not be drawn to the silver screen, when he had grown up with the smart society set, in luxuriously furnished living rooms with the inevitable grand piano?

From 1933, he made costumes for Simone Simon, the young Brigitte Bardot of the time, for Marc Allégret's film *Lac aux Dames* of 1934. Lake Constance crystallized the loves of several women, focusing on the character played by Jean-Pierre Aumont. Romance, clear water, and expanses of tanned flesh made an ideal setting for the couturier for the young. The production brought together Colette for the screenplay, Georges Auric for the music, and my father for the costumes—a team of friends. I have memories from my teenage years of Simone Simon, who became a family friend. She was the link between my father and the Weisweillers: Alec, who became Simone's partner, and Francine, friend and patron of Jean Cocteau.[63] The poet considered himself as a second father to their daughter, Carole Weisweiller. My father was a little authoritarian and jealous in his role as head of the family, and forbade his sister Perle, who loved the theater and cinema, to accept a role in the film. "Jealous as a tiger,"[64] he reacted in the same way a few years later when Jacques Becker offered my mother the title role in *Casque d'Or*. Out of the question! But one person's loss is sometimes

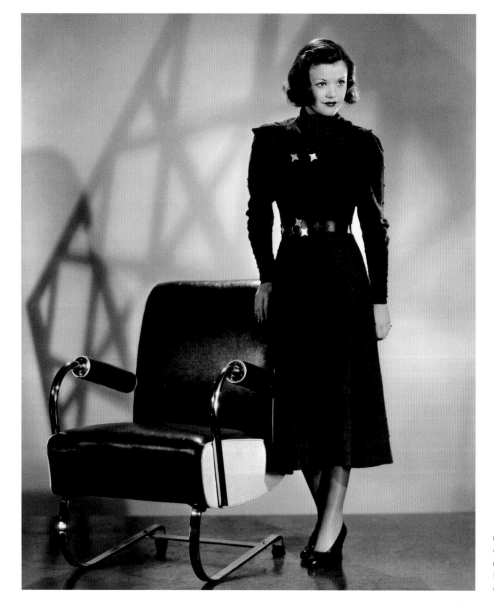

LEFT The French actress Simone Simon wearing an ensemble by Marcel Rochas, 1936.
FACING PAGE Marcel Rochas checks over a white-striped black dress worn by the actress Lili Damita, in the wings of the Fox Europa studios in Joinville, 1934.

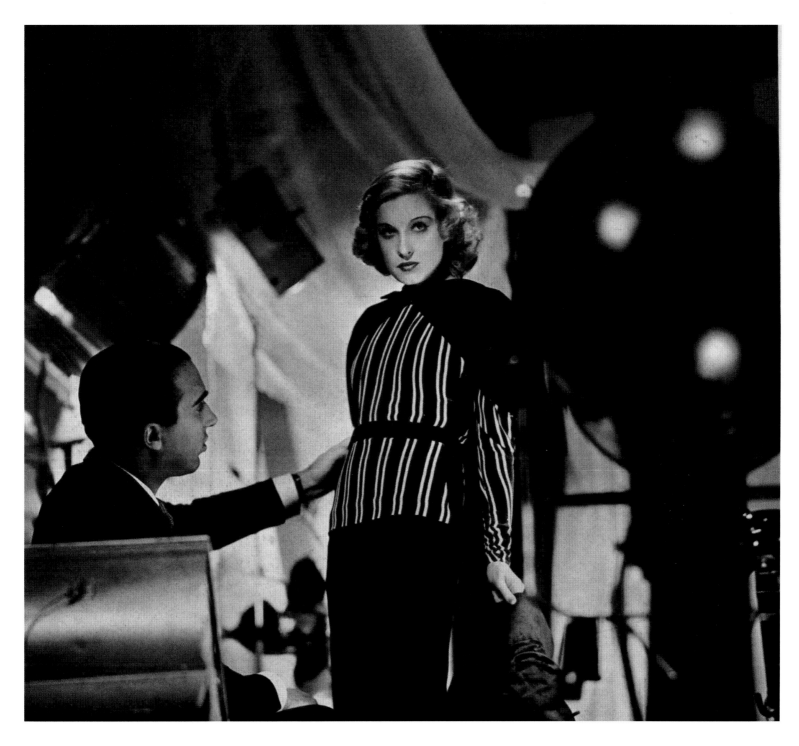

another's gain: it was Simone Signoret who would win our hearts, and that of Serge Reggiani, as they waltzed around and around until they were giddy, gazing into each other's eyes in that famous scene from French cinema. Movie stories, family stories: the small world of cinema is a dream machine. Thirty years later, I was to dress Audrey Hepburn, Albert Finney, and Jacqueline Bisset in *Two For the Road*.[65]

With Jean Patou, Marcel Rochas designed the costumes for Robert Siodmak's *La Vie Parisienne*, a French musical film based on the operetta by Meilhac and Halévy and set in the Belle Époque and the 1930s. Shot in 1935, the film was released in 1936, after my father's trip to Hollywood, where the majors "had created, at tremendous cost, fully-fledged couture houses in their very studios."[66] To the eyes of Marcel Rochas, despite the respect he felt for Hollywood costume designers, their creations had nothing "human" about them. In Hollywood, couture was "subjected to the artificial influence of cinema…. It isn't about dresses for real life, it's dresses for the most photogenic models in the world, and that is an easy job, too easy. I think that before long Hollywood will be obliged to work directly with Paris and to import its creations at any cost."[67]

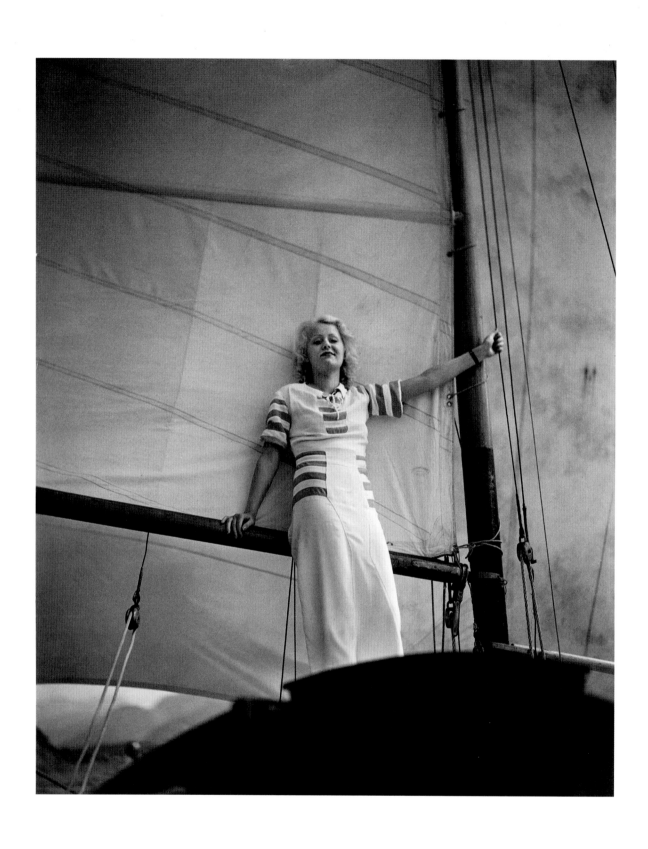

ABOVE AND FACING PAGE Illa Meery (above)
and Simone Simon (facing page),
wearing designs by Marcel Rochas,
in Marc Allégret's *Lac aux Dames*, 1934.

Designed for dream merchants but with a distribution capacity that was unique in the early 1930s, cinema costume design had a dual nature: a confection of artifice on the one hand, and a paragon of style on the other. Marcel Rochas's costumes still retained a theatrical air in *La Vie Parisienne* and even in *L'Éternel Retour*, in which Madeleine Sologne's timeless white drapery displayed strong mythological connotations, but in *Falbalas* they were nothing short of a documentary of fashion and a showcase for the couturier.

In 1941, my father had opened a cinema department in his couture house. By 1943, when it was properly up and running, he was in a position to answer a request from Jean Delannoy, who was looking for a couturier to make the costumes designed by Georges Annenkov for *L'Éternel Retour*, and in particular the dress worn by the "Nathalie la blonde." Jean Cocteau remembered the fitting sessions at the Rochas salon of Yvonne de Bray (who played the treacherous Gertrude Frossin), who "got drunk, tore up all of Annenkov's models, devastated the Rochas house, telephoned me to say she wouldn't shoot the film, and telephoned me the next day to say she would. She was tempestuous. In seconds, Annenkov, who has a reputation as a first-rate set designer, looked like a poor concierge next to her. These small times of tame little follies can't handle larger-than-life characters, of which Yvonne is a classic example."[68] Cocteau succeeded, however, in "releasing this storm in the film" and on March 23 noted in his journal: "Morning, went to see Yvonne de Bray try on her dresses and hats for my film at Rochas."[69] Were Marcel Rochas and Delannoy put in touch by their friend Georges Auric, who composed the music for the film, or by Cocteau, who wrote the screenplay? Whatever the case, they combined their talents for this variation of the legend of Tristan and Isolde, a film of a poetic alchemy that on its release in October 1943 would mark a whole generation. Its stars were the golden couple of cinema Jean Marais and Madeleine Sologne, who embodied a youth, beauty, and love that even

LEFT, ABOVE, AND FACING PAGE In Jean Delannoy's *L'Éternel Retour*, Madeleine Sologne's white dress and Jean Marais's jacquard sweater were made in the Marcel Rochas studio, 1943.

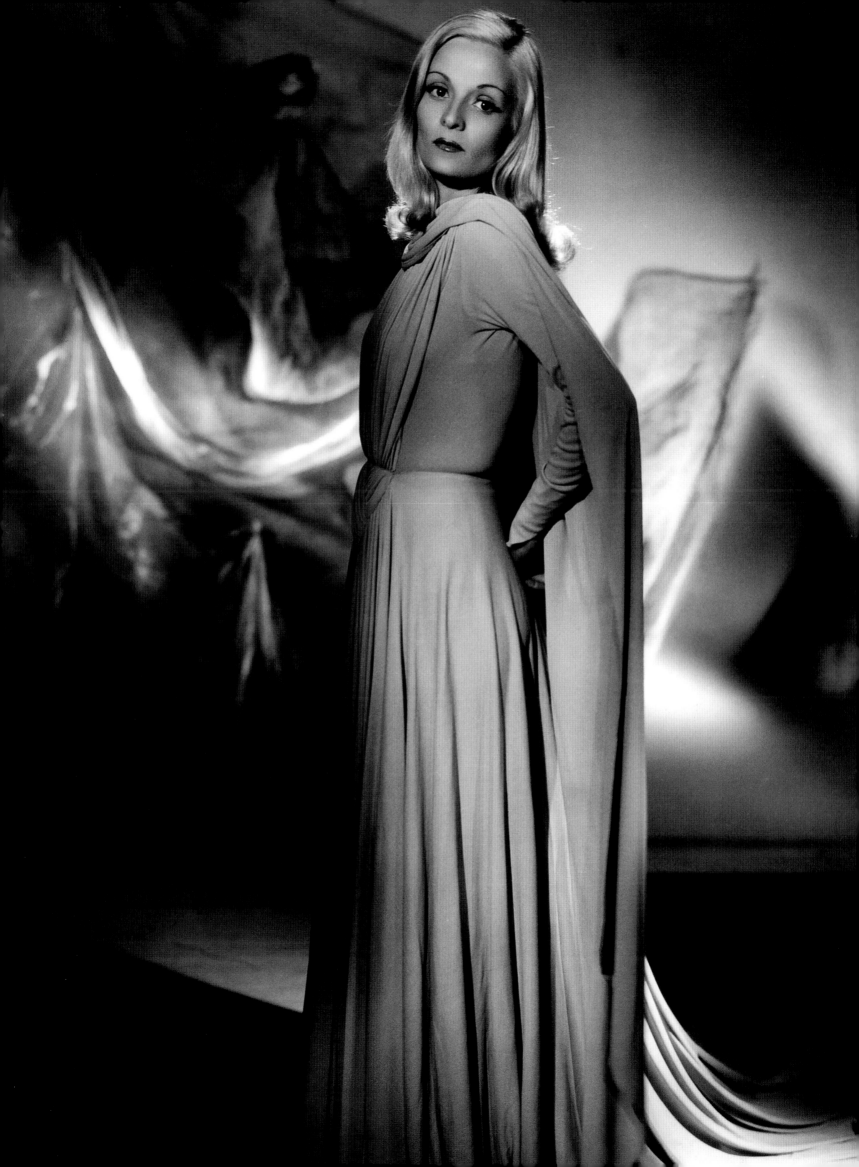

the war could not destroy. The gracefulness and originality of their costumes contributed to the evocative power of their characters. Jean Marais's character wore a jacquard sweater that became to the young people of Occupied Paris what the leather jackets worn by Marlon Brando in *The Wild One* and James Dean in *Rebel Without a Cause* would be to the teenagers of the 1950s. It was a form of osmosis that comes about when a hero or heroine's character converges with the aspirations, dreams, or even tragedies of the audience: it is when cinema meets this unconscious expectation that it deserves to be called the "seventh art." Madeleine Sologne was one of the leading stars of the years 1940–50, and when I knew her in my childhood she was still associated with the pure and romantic young girl, the distant descendant of Isolde.

The year of *L'Éternel Retour* saw Cocteau's significant encounter with Jacques Becker. "Yesterday evening, dinner at the local bistro with Becker. There's a cinema crew being put together that's quite different from the previous one."[70] The filmmaker and his first wife, Geneviève, would soon become friends with my parents. Geneviève even remembers having met "Aragon and Elsa Triolet at the Rochas', who hosted a big dinner party at the time of *Falbalas*."[71] From the Rochas family Jacques Becker picked Marcel, who inspired his main character, the couturier. He asked him to make the costumes for Micheline Presle, who played a virtuous young woman who fascinated this couturier and lady-killer, played by Raymond Rouleau. In the film love and creativity mingle to the point of madness, with salons and couture studios as their backdrop. Becker was subtle in his staging of those dark years, the empty streets and bicycles— and even a Camembert cheese that might have come straight from the black market. The film was shot in eight weeks, from March 1, 1944, in the Pathé-Cinéma studios on rue Francœur, with an additional week shot in the 16th arrondissement for the exteriors. The crew had to cope with shortages resulting from the German Occupation, power cuts, curfews, and restrictions on film, makeup, fabrics, and more. They had to shoot at night, remembers Becker's assistant, "from eleven till morning.... One evening in Francœur, we had come out on the terrace, the chapel had been bombed and the sky was as light as day; it was the most terrible bombing in the Paris region."[72] Paris was liberated in August 1944. The film came out at last on June 20, 1945, the delayed

FACING PAGE The actress Micheline Presle in a Marcel Rochas evening gown, on the shoot of *Falbalas*, with the film's director, Jacques Becker (left), 1944.
RIGHT AND PAGES 122–23 Shot in 1944, Jacques Becker's *Falbalas* could not be released until June 1945. Marcel Rochas designed the costumes.

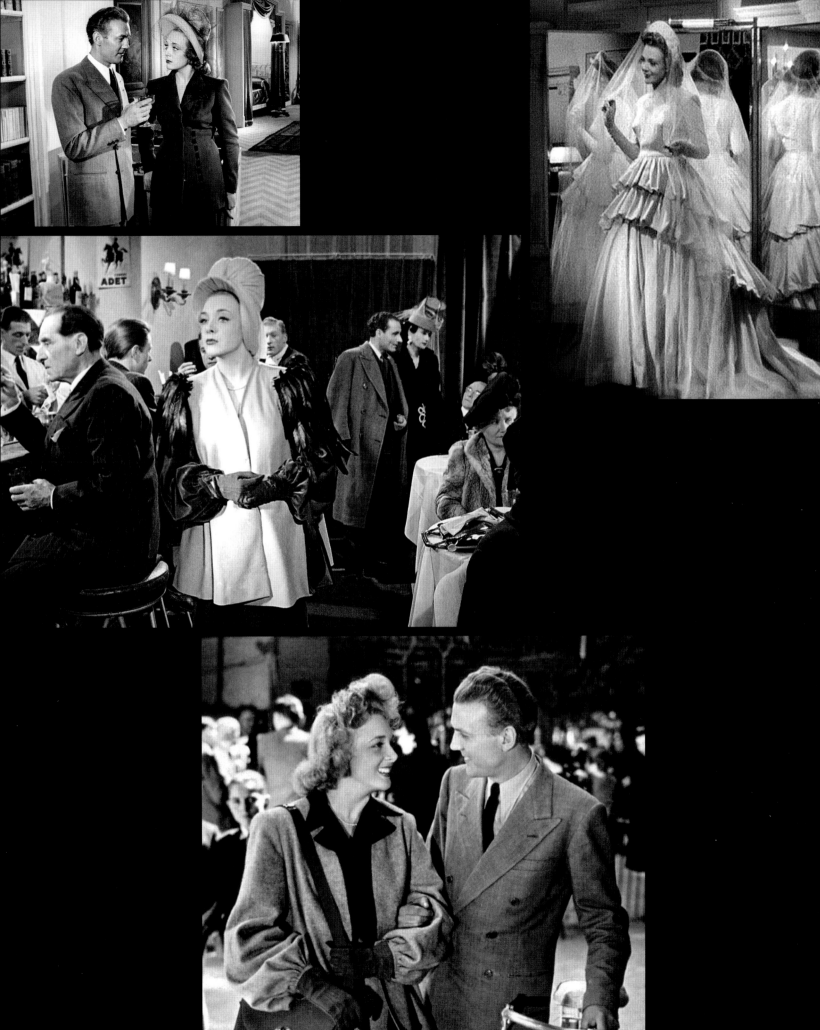

release being due to the changes brought about by the Liberation and the painful work of the "purge committee" as it brought suspected collaborators to trial. In the meantime, the battle for the Liberation of Paris had been documented for the Resistance movement by a team of filmmakers: these first images of Free France had been shown in September 1944 by France Libre Actualités and the Comité de Libération du Cinéma Français (CLCF).[73] The equipment that served to shoot these images appears to have been stored on the set of *Falbalas* and some of the unused footage was incorporated in Becker's editing of the documentary[74]—which goes to show that fancy accessories, frills, and flounces can go hand in hand with the momentous events of history. However, this concurrence also no doubt explains the film's lack of success on its release. The French were more interested in stories of Resistance heroes than the tribulations of a couture designer, however subtly these might be portrayed. Years later, this iconic film of haute couture was to spark the vocation of the young designer Jean Paul Gaultier. Micheline Presle remembers the evening at a restaurant where "Jean Paul Gaultier was dining... with friends. At one point, he stood up and came toward me. He said to me: 'I am Jean Paul Gaultier, I wanted to tell you that it is thanks to you that I am doing this job.'"[75]

After Micheline Presle, my father dressed a star who had achieved fame on both sides of the Atlantic since the late 1930s. Danielle Darrieux approached him for her role in *Au Petit Bonheur*, a film by Marcel L'Herbier released in May 1946, in which she formed a tempestuous couple with François Périer. In another crossing of paths, François Périer and my mother had met at the Cours Simon drama school in the late 1930s.

Marcel Rochas's last two contributions to the film industry involved dressing starlets. Sophie Desmarets, another former Cours Simon student, made her cinema debut during World War II, following in the footsteps of Danielle Darrieux. For her first major role, she found herself playing against a serial killer in Christian Stengel's *Seul dans la Nuit*, released in November 1945, with costumes by Marcel Rochas. He also dressed Dany Robin in Maurice Lehmann's sentimental comedy *Une Jeune Fille Savait*, which came out in March 1948, in which she played opposite François Périer—the same great actor who would appear several times in my life.

Marcel Rochas had a sense of theatricality, sometimes taken to extremes. "Too much" was for him just "not enough." But, human nature being what it is, he also had a feeling for a pared-down, genuine simplicity that few couturiers managed to attain. The dress in *L'Éternel Retour* symbolizes that quest for perfection in beauty that drove both the man and the couturier. This was on display at the Théâtre du Vieux-Colombier on May 27, 1944, at the opening of Jean-Paul Sartre's play *Huis Clos*. Gaby Sylvia, playing Estelle, entered hell in a long, light green dress created by Marcel Rochas: another timeless drapery for a moment of eternity as envisioned by Sartre. At this time, actresses in plays portraying contemporary life dressed according to their own taste and at their own cost. Not all of them had the means, like Mireille Lorane[76] and Marie Déa,[77] to go to the best suppliers, a fact that was deplored by Lucien François in 1944, when he called on theater directors to do more to provide costumes for their actresses: "Theater could fulfill a major role in such circumstances, that of fashion distributor."[78]

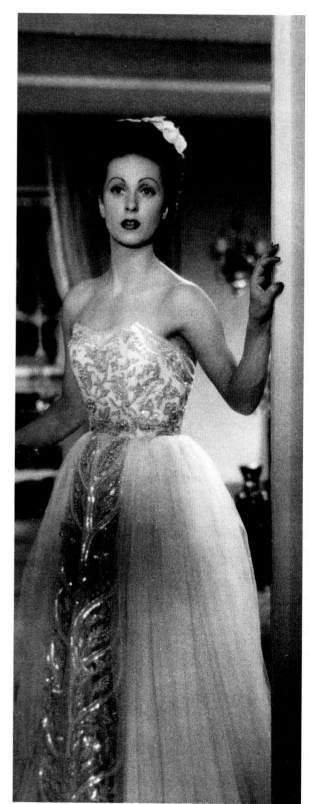

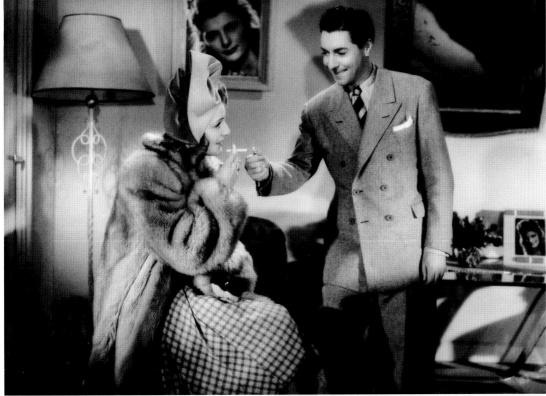

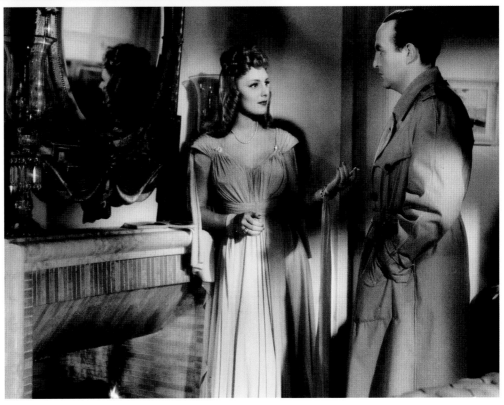

FACING PAGE Danielle Darrieux wearing Marcel Rochas in Marcel L'Herbier's 1946 film *Au Petit Bonheur*.

TOP, CENTER AND RIGHT Conchita Montenegro wearing Marcel Rochas in Robert Siodmak's *La Vie Parisienne*, 1936.

CENTER AND RIGHT Sophie Desmarets, Jacques Pills, and Bernard Blier in Christian Stengel's *Seul dans la Nuit*, 1945. The costumes were designed by Marcel Rochas.

DARKNESS IN THE CITY OF LIGHT

1939 | 1945

"SO MANY TERRIBLE EVENTS,
SO MUCH SUFFERING AND DISTRESS,
SO MANY PAINFUL LESSONS,
AND FOR NOTHING TO CHANGE …
NOT EVEN FASHION! MY REACTION
WAS REFLECTED IMMEDIATELY IN MY FIRST
COLLECTION ON REOPENING, AND IT
WAS A TOTAL FAILURE." MARCEL ROCHAS, 1943.

My father loved hats, those worn by his mother, grandmothers, aunts, and all the women of his childhood. In June 1939, after a "very good collection full of Marcel Rochas's personal ideas evocative of elegance, charm, youth,"[1] Marcel Rochas set aside a space on the upper floor of his avenue Matignon premises for hats and *frivolités* (accessories), in a cushioned decor of crimson velvet trimmed with golden fringes, accessed via a narrow, spiral staircase. "The opening of Marcel Rochas's fashion department was an excuse for a truly Parisian reception, which assembled a highly eclectic gathering at a sumptuous buffet in the elegant avenue Matignon salons, come to show the young master of the house its support and encouragements for his bold initiative. Marcel Rochas's pretty assistants presented with grace and elegance the models that it would be futile to attempt to describe here, as they offer so many new ideas and such varied forms and trimmings. Suffice it to say that the headwear is youthful, the colors gay, the trends highly personal, and that these hats are a match in every way for the couture creations to which Marcel Rochas has accustomed us. It is a very fine success that we are glad to applaud."[2]

August was collections month. The whole world flocked to the capital of fashion to attend the shows in 1939, which already had a military touch, featuring frogging, braided cords, tassels, shakos, and fezzes. "Rarely have we seen such flights of the imagination as in the collection of Marcel Rochas! But these are flights of the imagination that do not preclude perfect elegance and taste—quite the contrary. Rochas dares to venture color mixes and combinations of forms which, were they to be attempted by anyone else, might seem to defy the laws of aesthetics."[3] On September 3, 1939, war became a reality. My father was called up, and "depressed by his failure, his love life, and the divorce proceedings with his wife, thought it best to close down his house for the duration of the conflict, since the design activities could not continue in his absence."[4] While the fashion designers Pierre Balmain, Christian Dior, and Jacques Fath were also called up, and Chanel closed her doors on rue Cambon in December 1940, other couturiers, including Lucien Lelong, rolled up their sleeves and carried out their own form of resistance with their ostensibly innocuous weapons. Their collections would contribute to keeping France on its pedestal as the world capital of fashion. While the war was being waged on all fronts, they would continue to attract fashionable ladies from around the world—and their foreign currency. French women took pride in forming "an army of *insouciantes* whose beauty brings a little gaiety in these grave times."[5] In 1939 Marcel Rochas had no choice, however. He had to leave, much as his sense of responsibility dictated quite a different sense of duty: to stay, and to save his company and all the salaries it generated.[6]

PAGE 127 Nelly Brignole, circa 1940–41.
In November 1942 she became Hélène Rochas.
FACING PAGE Marcel and Hélène Rochas in 1944.

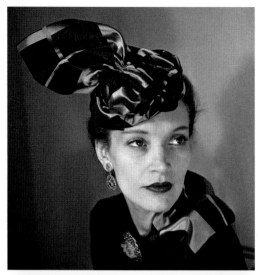
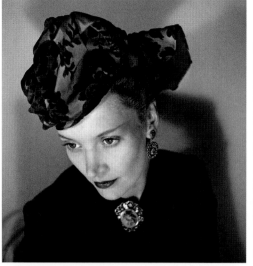
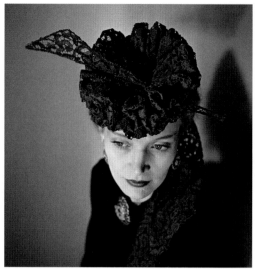
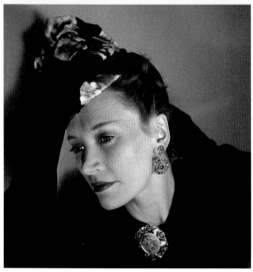
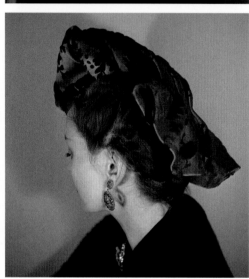

In 1939, Marcel Rochas opened a hat department in the boutique on avenue Matignon. Hats by Marcel Rochas, 1941.

"SINCE MOST WOMEN ARE A LITTLE PETITE—AND SOMETIMES A LITTLE SHORT—FOR THE CURRENT LOOK WHICH CALLS FOR VERY LONG LINES, THEY HAVE COME UP WITH THE HIGH PILLBOX, THE TURBAN ROLLED INTO A CONE, THE MAGICIAN'S HAT, THE PERSIAN TIARA. IT'S A GOOD WAY TO HEIGHTEN A SILHOUETTE WITHOUT MAKING IT HEAVIER; QUITE THE CONTRARY: A POINTED HAT SLIMS THE OVERALL LINE OF THE BODY (IN THE MANNER OF BELL TOWERS AND PEPPERPOTS THAT RAISE THE LINE OF BUILDINGS)."
JOURNAL DE LA FEMME, JANUARY 7, 1938.

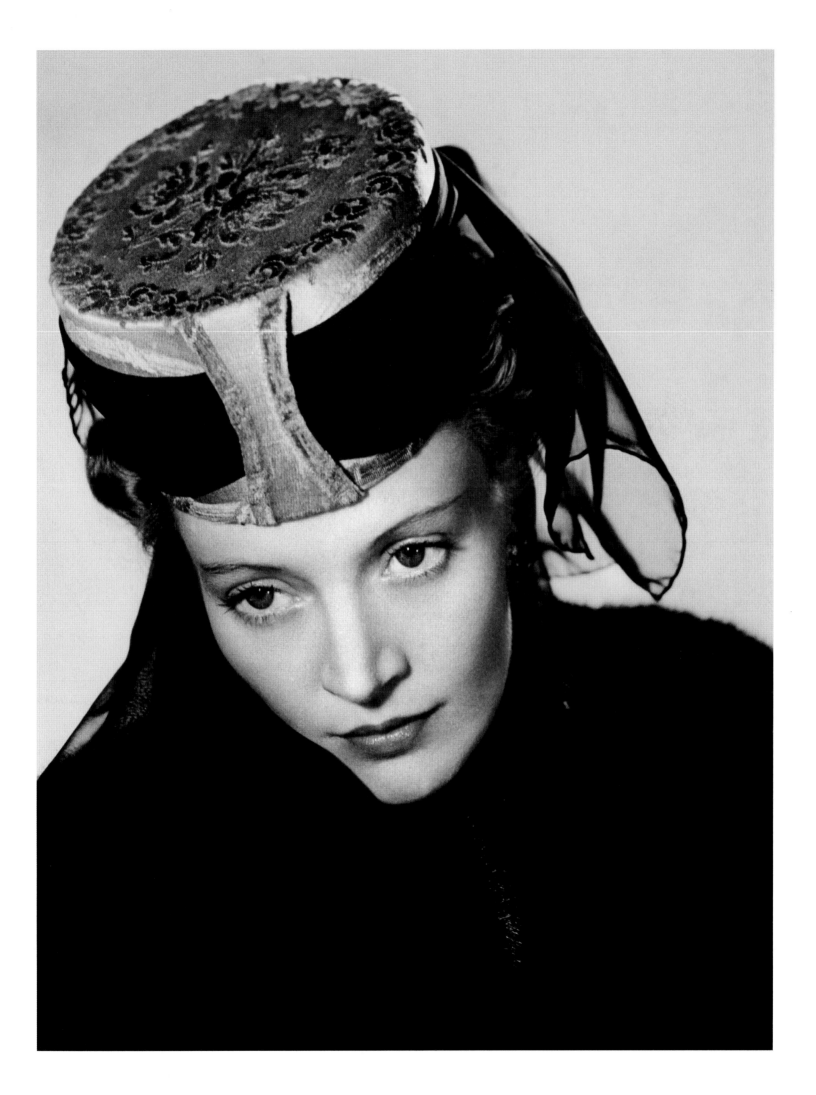

After the Nazi invasion and the defeat of France in June 1940, daily life for French people changed dramatically. The requisitions and rationing imposed in the months and years of Occupation that followed governed all of the Parisians' activities. Clothing ration cards were introduced in July 1941, and supplies of fabrics, skins, and leathers were limited. Women resorted to shoes with thick wooden soles, noisy and uncomfortable, and thought up a host of new ways to make bags and belts using woolen cloth, felt, plastic, cork, wood, and all sorts of unlikely materials. Silk stockings disappeared, and Elizabeth Arden hit on the idea of launching a lotion that tanned women's legs to make it look as though they were wearing stockings. Prices rose, and for the French finding something to wear took its place among their daily struggles. Even the most elegant of Parisiennes made do with an all-purpose suit and a simple printed dress, especially as the fuel shortage forced people to use bicycles and public transportation. "Since the metro is the only means of communication left us, elegance need not be afraid of showing itself there,"[7] announced *L'Art et la Mode* magazine in mid-winter 1941. Women needed clothing that was practical, such as divided skirts. Even evening gowns were shortened, for then they could also be worn on a bicycle, under a raincoat. Sheepskin or fur-lined jackets, which until the war had been recommended by women's magazines for winters in the countryside only, were transformed from items of military clothing to garments that might be worn by the well-dressed city dweller. "Patrols and trench life have also spread the use of the waterproofed canvas jackets, lined with sheepskin, lambskin, or other fur, known as *canadiennes*. A buckled belt cinches them in at the waist. At the neck, a wide band of fur frames the face and protects the chest from the damp and cold."[8] Couturiers including Marcel Rochas seized upon this practical garment and converted it into an elegant jacket.

BELOW *Frivolités* (fancy accessories) department in the Marcel Rochas boutique, avenue Matignon, in the 1940s.
FACING PAGE Marcel Rochas boutique, avenue Matignon, May 1939.

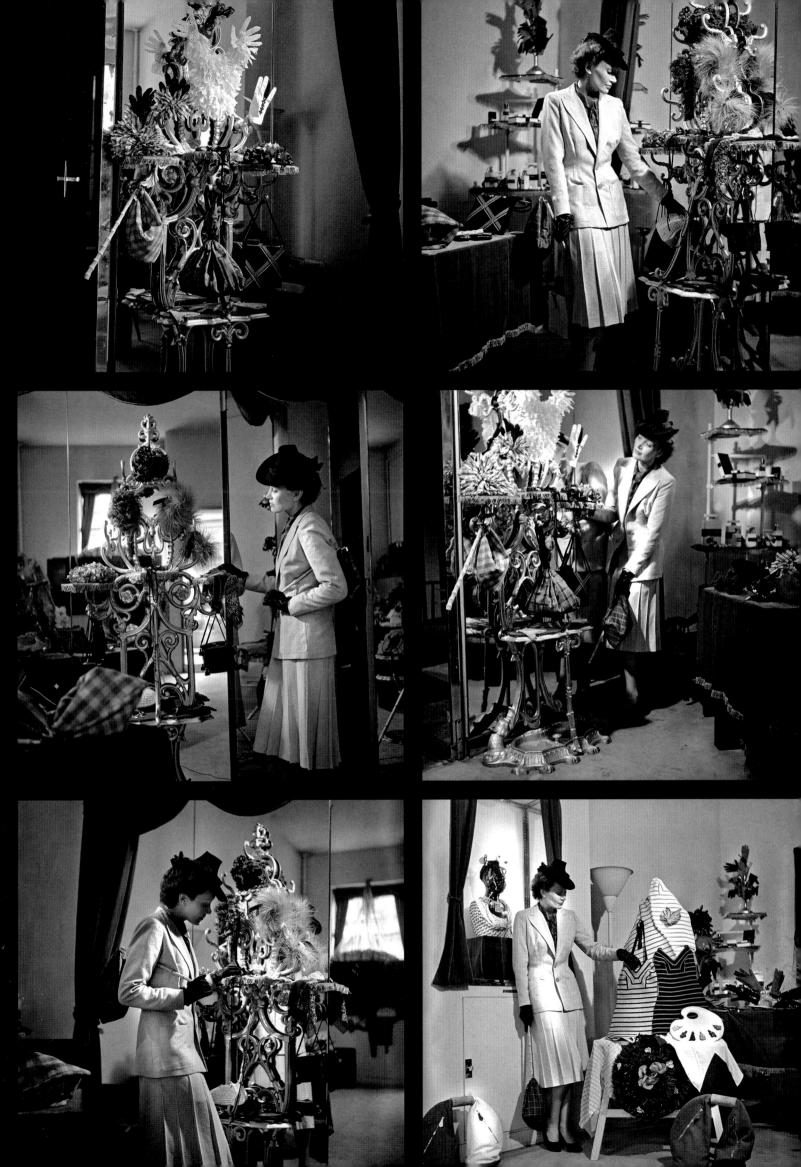

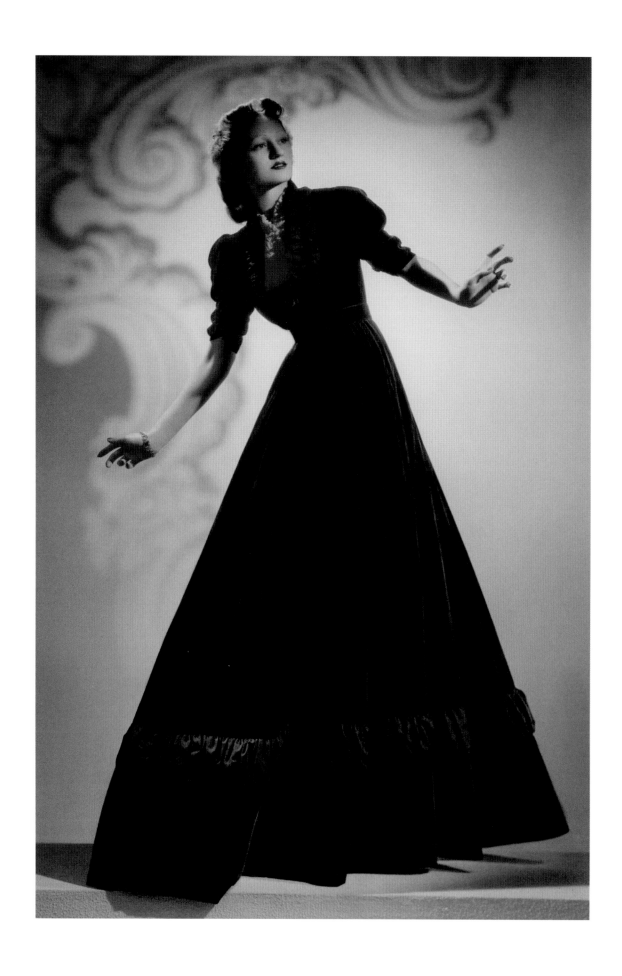

ABOVE Romantic evening gown in silk faille, leg-of-mutton sleeves, circa 1939.
FACING PAGE Romantic evening gown in tartan taffeta, sleeves with flounces, 1939.

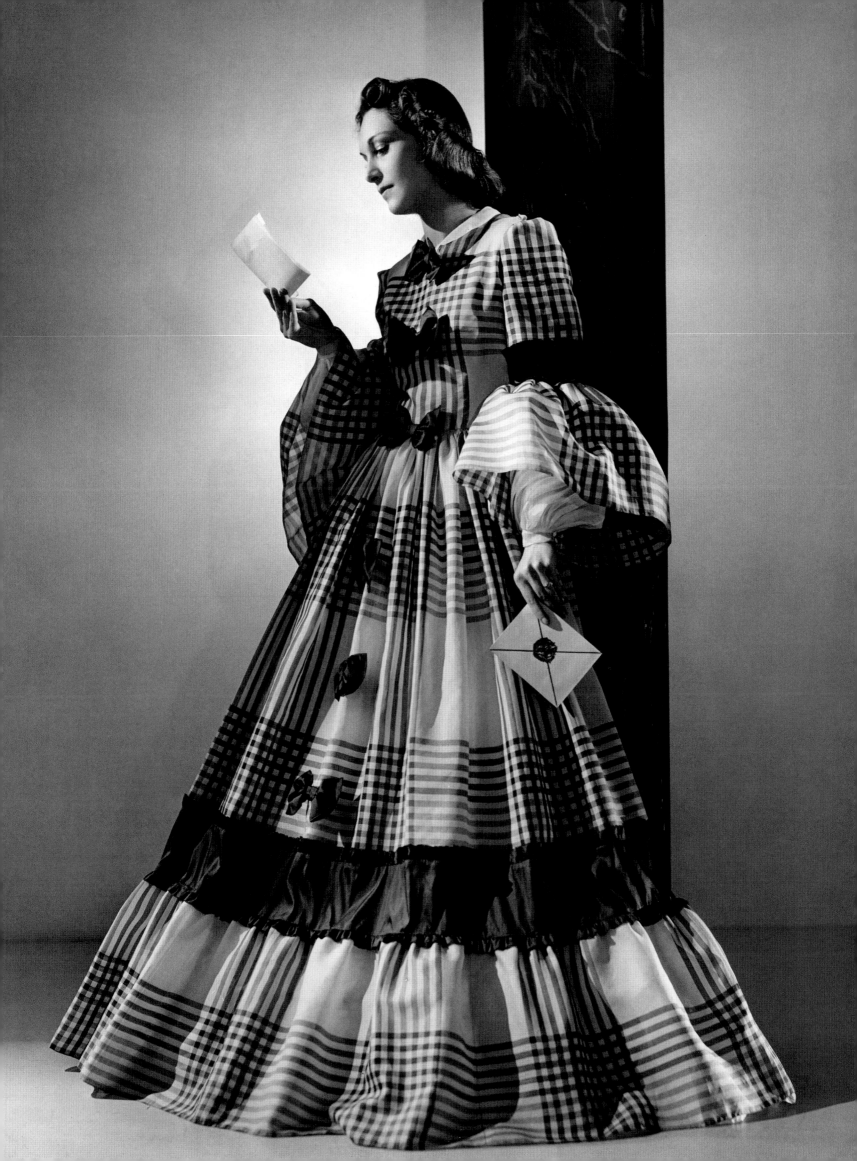

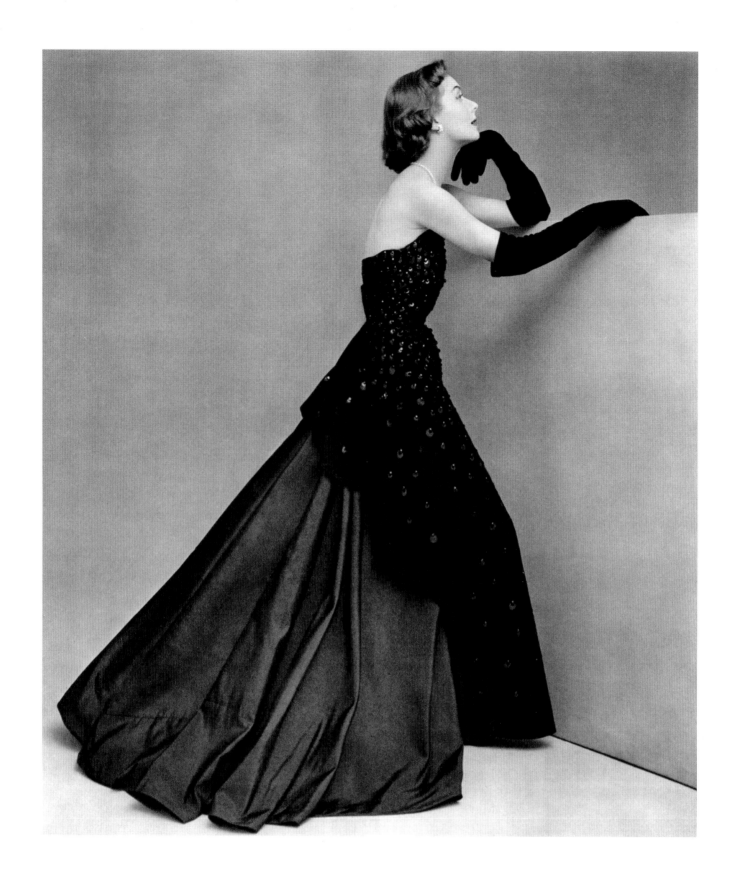

ABOVE "Marcel Rochas cleverly cuts out this delicately embroidered black velvet apron over a full black faille skirt. The jet-sequined silk velvet is by Anfrie." *L'Officiel de la mode*, nos. 345–46, December 1950.

FACING PAGE Black ball gown, circa 1939. The simple V-back top in black velvet constrasts with the long, full silk skirt printed with great sprays of multicolored flowers. The dress is cinched at the waist with a wide, colored satin sash with pointed tips floating down to the floor.

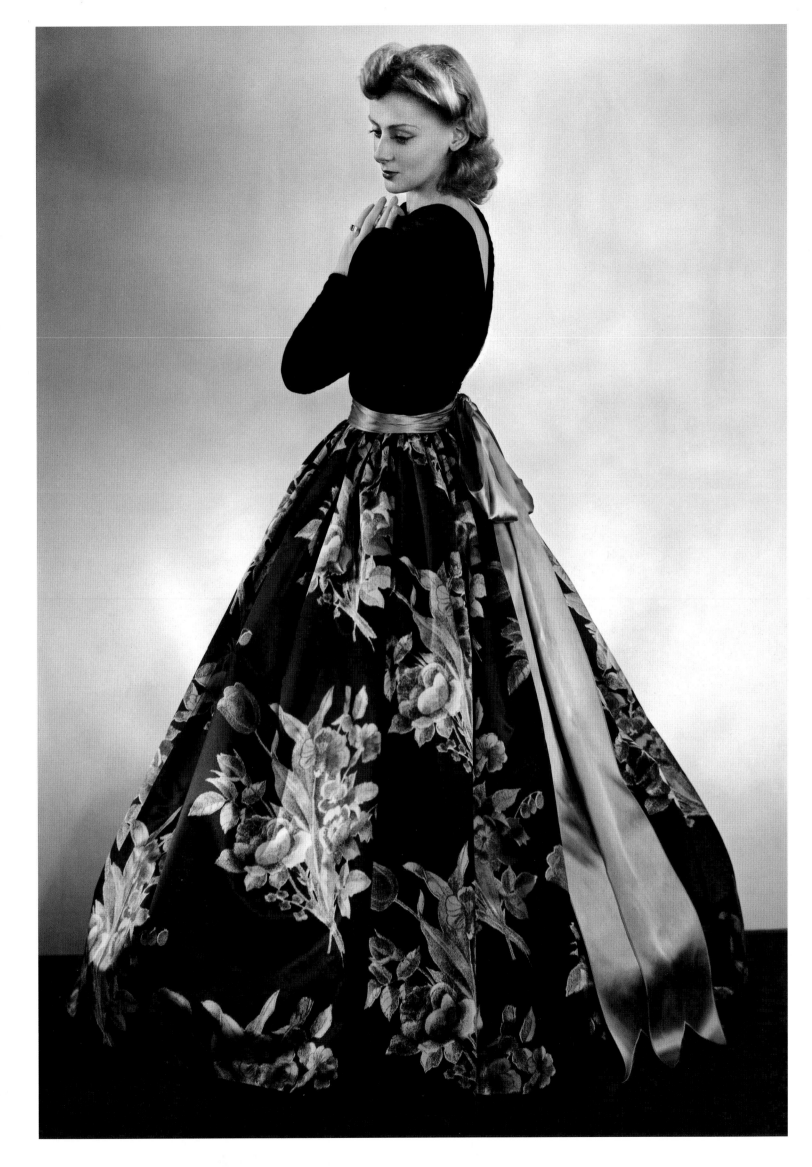

Lucien Lelong and other designers who had remained in Paris, such as Jeanne Lanvin and Nina Ricci, adapted their shows to "create the simple and useful." Collections were inspired by the constraints of Parisian life: Madeleine de Rauch gave her designs the names of metro stations (Mabillon, Solférino, and the like); Schiaparelli brought out scarves printed with the phrase *Lundi : sans viande* (Monday: no meat); and "pajamas" became increasingly popular, with names designed to stave off the cold (including Nina Ricci's indoor tailored coat Douillette [Cozy], Paquin's coat On Lit Mieux Quand On a Chaud [You Read Better When You're Warm], Jeanne Lanvin's indoor jacket Je Remplace le Chauffage Central [I Replace Central Heating]).[9] When it came to fighting the cold, anything went: coats were lined with newspaper, and wooden clogs with straw. In 1942, Jeanne Lanvin brought out a collection echoing the daily grind of life under the Occupation, such as the coat Je Fais la Queue (I Stand in Line).

The German occupying forces meanwhile lent a different face to wartime. As masters of the French capital, the uniformed Germans made the most of the advantageous exchange rate they imposed to buy everything in sight in the luxury boutiques. Irked that Paris should be putting international—and particularly German—couture in the shade, from August 1940 the Occupiers began to consider incorporating Paris haute couture "within a German organization whose head offices would be in Berlin and Vienna."[10] Lucien Lelong, the president of the Couture Trade Union who was preparing to oversee the reorganization of the professional branches ordered by the German occupying forces that same month, resisted as far as he could: "You can impose everything on us by force, but Parisian haute couture cannot be transposed, either en bloc or in its separate elements."[11] He used his diplomatic skills to avoid the forced transfer of labor to Germany, and he managed to obtain special quotas for raw materials, more flexibility in the system of purchase coupons, and a 5 percent limit on labor requisitions, which were severely affecting the French economy. While organizing campaigns to convey the continuing vitality of Parisian fashion, Lelong succeeded by and large in maintaining the independence of the capital's couture houses, by stressing the high added value of their labor in relation to what was, after all, a modest use of raw materials.[12]

In addition to the fruits of Lucien Lelong's efforts, haute couture also benefited from a new clientele who emerged from the climate of opportunism and the openings offered by the black market. These now took their place alongside the society ladies who were determined to return to their couturiers in the spring of 1941, and the smart Parisian artistic and intellectual sets—habitués of the Longchamp racecourse, concerts and gala balls, the cinema and theater, and chic restaurants such as Maxim's or Fouquet's, as well as the salons of couture houses. At a soiree hosted by Jean Luchaire to celebrate the hundredth issue of his newspaper *Les Nouveaux Temps*,[13] his daughter Corinne caused a sensation in a dress by Marcel Rochas, who did not hesitate, as she later wrote, "to create designs that amazed the Germans while safeguarding Paris fashion."[14] This anecdote offers a telling illustration of the ambiguities of the period, and the dubious choices to which it could give rise: a couturier might just as easily find himself selling gowns to a clientele who were hand in glove with the enemy or become part of a film crew working for the Resistance.

BELOW *Réglisse* day ensemble, cinched waist accentuated with seams creating a corset effect, wide shoulders, long puffed sleeves, black bag, hat with a wide red ribbon and fruits or flowers, Summer 1944. **FACING PAGE** An example of Marcel Rochas's famous suits, August 1939.

THE WARTIME COLLECTIONS Haute couture designers who mixed with the wealthy and who had remained in occupied Paris, having obtained special permission from the Germans to pursue their business activities, were accused after the war of being too close to the enemy, and Marcel Rochas was among their number. Couturiers were not only artists and designers, but also businessmen and women, committed to keeping their companies afloat and their employees working. This sometimes came at the price of compromising their principles to a more or less shameful and painful extent, wavering between cowardice, opportunism, and bravery. The number of women workers who were able to keep their jobs during the war thanks to the preservation of these companies has been estimated at twelve thousand.[15] The couturiers, and my father in particular, had to face up to shortages. A new, more modest kind of elegance was invented. Marcel Rochas made the most of what he could find to hand. He combed soft furnishing stores for trimmings that he could adapt to his couture—curtain tassels and tiebacks, cord and braid—and searched bric-a-brac and home decoration stores, performing wonders with the smallest details.

On his demobilization, my father had resumed his former activities. He set up a new company, SAGER,[16] and like Jacques Fath, Jeanne Lanvin, and other designers, presented his Winter collection in Paris in November 1940, then in Lyon in December.[17] Had he designed his collection with a new clientele in mind, since he was among the couturiers whom the Germans wanted to move to Berlin? This was the conclusion of the *New York Times* correspondent on seeing the "'Bruennhilde-figured' manikins, long skirts, puritanical silhouettes," which were so disconcerting that the "spectators kept looking out windows to assure themselves it was really Avenue Matignon, not Unter den Linden."[18] It was a mistake, as my father admitted in 1943: "My reaction was immediately reflected in my first collection on reopening, and it was a total failure."[19] This was because, in the meantime, Lelong had succeeded in preserving couture in Paris. Rochas introduced a change of direction in his next collection. For Summer 1941, the press reported, "Marcel Rochas's classic printed dresses with lapels form the main part of the collection along with linen suits for midsummer. These dresses are delightful, very fresh and youthful in appearance. The skirts are gathered or pleated, with the width starting below the hips. The tops are soft, slightly bloused, with very new, suit-style lapels. The blousy sleeves are still long, gathered at the cuff, which is very often in piqué matching the collar. Square collars in piqué, with a waffled edge, add a cheerful note to these high-summer dresses. The printed motifs are flowery and rather large."[20] In August, Marcel Rochas attended the show put on by his friend

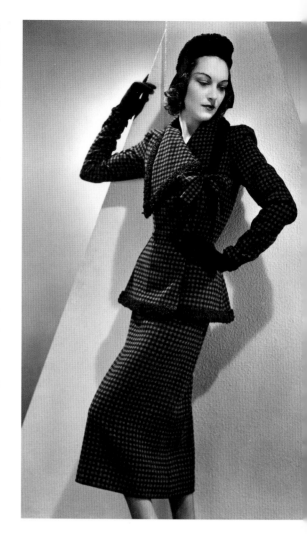

LEFT Marcel Rochas, Jeanne Lanvin, and Jacques Fath in Lyon in 1942.
ABOVE An example of the suits with long jackets, circa 1940.

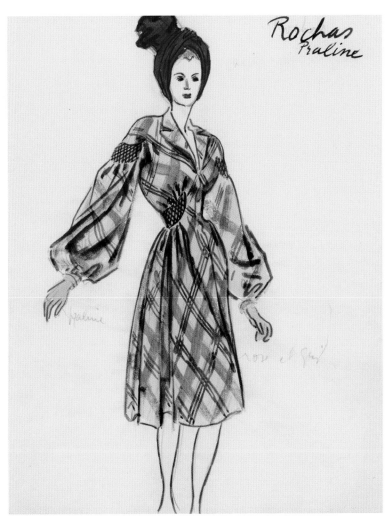

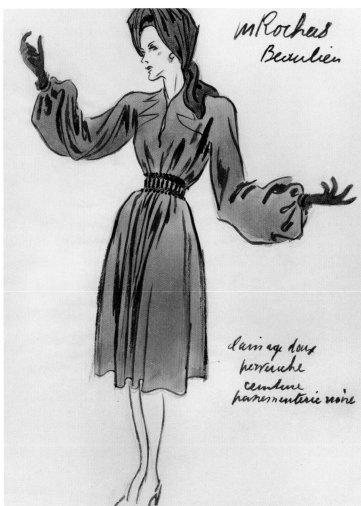

Jacques Fath, who after recapitalizing his company had moved his salons to 48, rue François Ier. "Music accompanied the show. In the audience, the presence of Marcel Rochas was noted. 'This way of supporting an illustrious elder is a…fine gesture of solidarity.'"[21]

In March 1942, for his third collection in Occupied Paris, Marcel Rochas spoke of his intentions to Lucien François. "The suit, Marcel Rochas said to me while busying himself on the other side of avenue Matignon in the lobby, the only room that could be heated in his design studio, where the rayon pieces had frozen solid—the suit is going to have to move toward a freer stye of dressmaking. We no longer have English tweeds that enable us to get the 'strict,' tailored look and we are obliged to do more shaping and cutting. But it is magnificent to work with these new fabrics! Magnificent because it changes everything. This collection is my third since the interruption of war. For the first, I deliberately lengthened my designs and made hats that fitted snugly over the head. The second was characterized by a long chasuble line with a corselet fitted tightly over the waist and wide sleeves. These trends reflected my new way view of the female figure. A new style born of a fresh, barely made-up woman with a natural charm. Real women! Neither androgynous types nor Marlenes. I have put together a whole new stable of models for eighteen-year-old girls. It's for them that I have created little short jackets and almost sentimental dresses this season. For them, or rather for the women on whom I modeled them, because between you and me it's always when a man works for a woman that he truly creates a new kind of fashion."[22] For the new fashion year beginning in fall 1942, *L'Art et la Mode* praised, with "well-deserved" admiration—and a note of patriotism—the work of the couturiers: "Despite the increasing scarcity of fabrics, despite difficulties of all kinds, which indeed seem to stimulate designers' ingenuity, French taste triumphs once more. The collections are masterpieces

ABOVE, LEFT Praline dress in gray and pink tartan, smocking effect at the waist and on the puffed sleeves, 1943.
ABOVE, RIGHT Beaulieu dress in soft periwinkle blue wool, black braid belt, 1943.

of tact and measure. A line lowered here, a sleeve puffed there: the changes are not brusque, but in the nuances, in a detail, which, together, create the 1943 silhouette.... Marcel Rochas has completely abandoned padded shoulders ... the collection is youthful and the cut highly sophisticated, thanks to the absence of shoulder pads."[23] Jackets were longer, waists smaller, and the fur-lined *canadienne* jacket became an haute couture staple, particularly in my father's collections. For the evening, he presented one of the "most sensational novelties of the season,"[24] the bustier dress.

It was at this time that Anne Vernon, who was hoping to interest seamstresses in her children's dress designs, was given the opportunity of entering Marcel Rochas's studio. In her memoirs she left a lively account of my father and the salons of the couture house under the Occupation. "As soon as I arrived, everything seemed miraculous to me: the elegant gray salon, the mixture of English green and Prussian blue in the double curtains, the bored goddess posing before me; I was giggling with happiness! All of a sudden, a handsome man came up and stopped next to me. It was he, M. Rochas! 'Let's see the rest,' he asked. There was something exotic, romantic, suave about him, with his hair slicked back like a Hispanic type. I'd been told he liked women! He had just married La Belle Hélène. 'Well! That's better. Who told you I was going to drop the shoulders?' I looked at him, not understanding. This man in his cinched-in black suit, with a dangerous beauty, considered me and my cool cat look with curiosity: I had long hair, chicken-rings in my ears, ankle socks with pompons, and bitten nails. 'How do you know there'll be no more padded shoulders in the Spring collection? You have only drawn raglans; why?' I hadn't a clue. All the students at Duperré drew dropped shoulders in their fashion illustration lessons."

The future actress was hired by Marcel Rochas to draw designs—and to adapt to the hours of the house, although she wasn't very keen on clocking in "by the concierge's merciless time clock, which made me think of a clock in a station." She was captivated by the house models. "I saw rather drab young women arrive, in old, colorless clothes, with shiny faces, hair pulled back, shopping bag in hand.... It was fascinating to see them shed their mundane looks, to acquire the class they lacked, a strange dignity. It began with a long, cold look in the mirror, a sort of evaluation of the way to go about things. After endless preparations, their makeup finished, their hair done, they rose, like mythical figures of theater. Each of them had a special job! The one with the best physique presented sculptural drapery.... The ingénue was hired for neat little numbers. As for the wedding dress, the grand finale, this was modeled by an awe-inspiring vamp.... Sometimes I saw with pride one of my own designs on a model." Occasionally she helped out on the reception desk. "One day, *quelle horreur!* A gentleman slipped me a coin for his umbrella. It fell out of my hand onto the floor, and one of the very haughty ladies with an aristocratic name who worked at this kind of place picked it up. '*Merci monsieur,*' she said, pointedly, looking at me with indulgence."[25] Anne Vernon was barely nineteen when she brought her sketches to show my father. As soon as she was hired, she was sent to work on the set of *L'Éternel Retour*. She'd be on all fours with her nose in the hem of Madeleine Sologne's dress; or repairing holes made Jean Marais's jacquard sweater by his beloved dog Moulouk. The producers were quick to spot this pretty young woman who walked around, needle in hand, with reels of cotton to match the clothes. This was how the doors of cinema were opened to Anne, thanks to Marcel Rochas.[26] After a few years in the United States, where she shot two films, Jacques Becker gave her the title role in *Édouard et Caroline*, in 1951, and Jacques Demy had her play Catherine Deneuve's mother in *Les Parapluies de Cherbourg* in 1964. Between the two, she appeared in some thirty films and plays. My father was generous in lending dresses to her, which he often did. However, when she borrowed one from another couturier he took it badly. The generosity of Marcel Rochas had its limits.

In spring 1943, as seam-shaped skirts became shorter and "the peasant style appeared to have influenced fashion,"[27] couturiers, ever inventive, indulged in a bit

BELOW Draped chiffon dress in three colors (blue, mauve, and purple) with black dots, circa 1941.
FACING PAGE A garden scene: models wearing Lucien Lelong (left) and Marcel Rochas (right: shirt-dress in white organdy, sleeves with accentuated shoulders, fitted waist, with a white rose), 1942.
PAGE 144 Illustration by René Gruau. Evening gowns by Lucien Lelong (left) and Marcel Rochas (right: collar and white flounces on a navy-blue dress from Soieries et Tissus du Rhône). *L'Officiel de la mode*, nos. 315–16, Summer 1948.
PAGE 145 Black evening gown in silk faille and shirred taffeta, bustier with straps and bows over a crinoline skirt with hoops, 1938. Palais Galliera, Fashion Museum of Paris.
PAGE 146 The Crinoline 45, drawing by Jacques Demachy, circa 1945. Inscription: "Although fashion appears to be moving toward the straight line, some couturiers are still giving us beautiful full dresses for the evening. This one has a full black satin skirt over a crinoline and a peach satin jacket embroidered with motifs in jet. A delicate garland of jet enhances the long shawl collar and very slim waist, while the basque is very wide. Three more layers at the bottom. This is a charming storybook outfit for a pretty young lady."
PAGE 147 Crinoline jacket in gold silk brocaded with a floral motif, collar and basque embroidered with a floral motif in beads and black braid, buttons with a flower motif, circa 1945. House of Rochas archives.

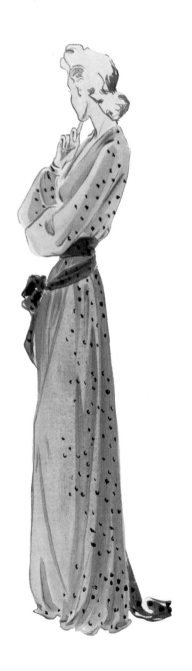

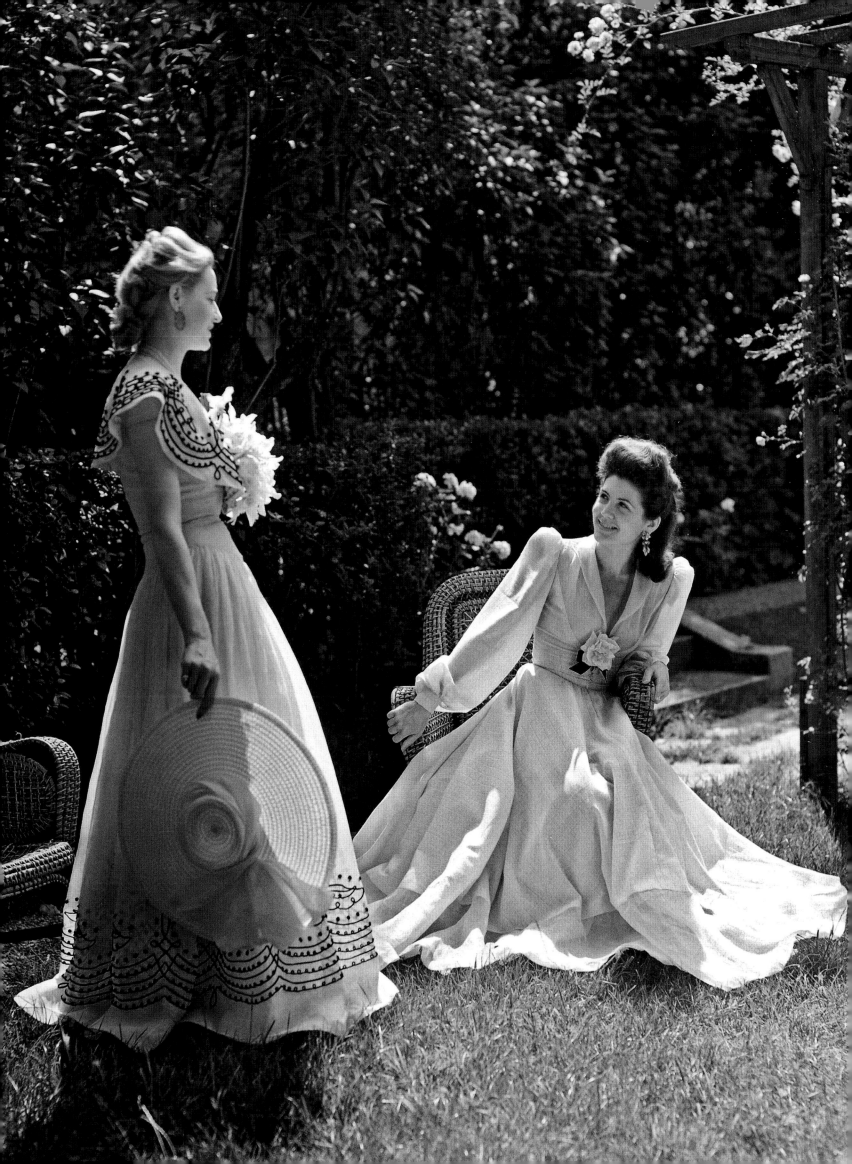

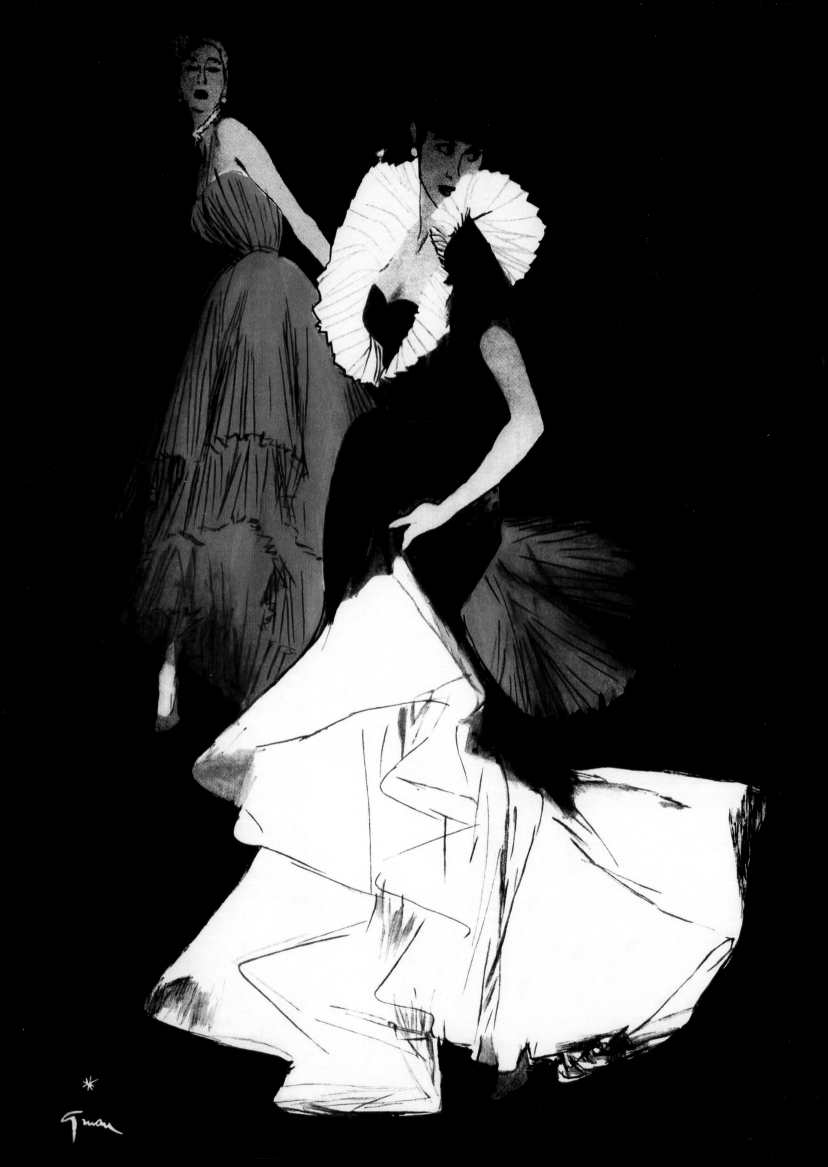

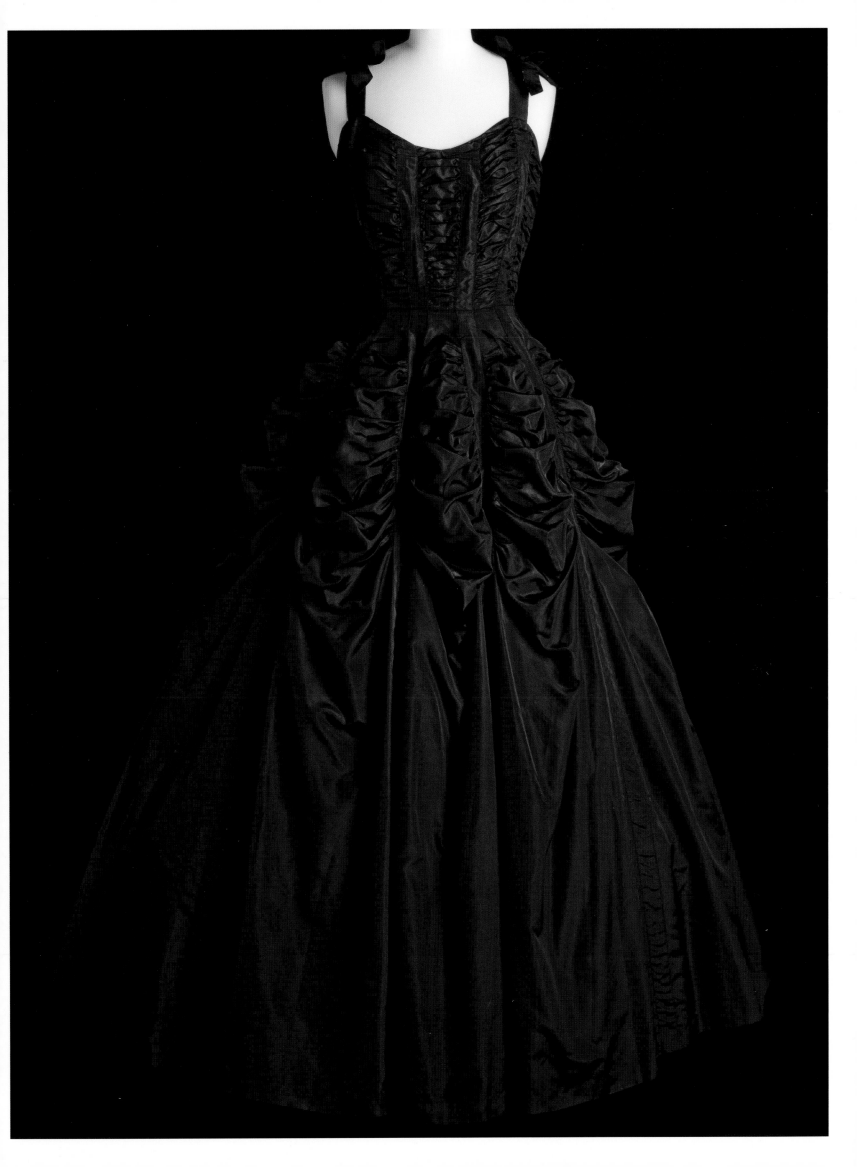

of provocation toward the enemy, with the trompe l'oeil dress. What looked like a suit was in fact a coat. A headscarf turned out to be a drape. In a sleight of hand, the couturier-magician created two-piece effects on a dress that was buttoned down the back but basque-waisted in the front, or a dress coat/redingote in the front opening into a skirt at the back resembling tails. The press noted the Directoire touch—"high waist, short boleros, square-cut necklines,"[28]—that my father gave to his collection. "Marcel Rochas sometimes shifts the waist in a nod to the Directoire style, with short boleros, skirts rising high on the bodices; very slim and lengthening lines; dresses simulating a suit; flounces for evening dresses."[29] Fall 1943 brought "a few notable changes tending to harmonize the female figure to the full, changes that are doubtless inevitable, since couturiers have unanimously adopted more sloping shoulders with lower armholes, well-developed busts, slim waists; extra width, too—a little too much, perhaps, with the current difficulties—in coats and above all in the sleeves, to enormous proportions."[30] With its slim, higher waist, the female figure was sculpted and elongated, "like a figurehead in the wind,"[31] an effect enhanced by thick soles and topped with a hat rising up like whipped cream. Hats took extravagant forms, as if to ward off fate, and featured a host of birds, flowers, and accessories., As sewing and embroidery trimmings were subject to less strict rationing than fabric, milliners such as Caroline Reboux were able to create exuberant decors on hats or turbans, which were very popular town wear. Always on the lookout for novelty, my father also worked on the effects of sleeve volume, as may be seen in Micheline Presle's costumes in *Falbalas*. "And Marcel Rochas you say? What is that bold innovator bringing us? He isn't afraid to load his coats with thick gathers, draped hoods, real or false sailor collars, low-cut basque belts at the back, inset bands creating a bolero effect. His bloused suits, dropped (but padded) kimono shoulders, his gathered, draped, pagoda sleeves, funnel sleeves, shoulder inserts: all this contributes to amplifying the upper part of the body, to filling out the silhouette in a new line."[32]

In 1944–45, the "rustic-elegant" look developed into an emphatically feminine, neoromantic style. Lucien François praised the efforts of the couturiers, who continued to "create despite everything"[33] and France, whose "genius was never more effective" than when faced with obstacles. "Never have the turns and turnovers of the fabrics, the twists and arabesques, the envelopings and moldings been better balanced on a woman's body—in short, that whole architecture of singular perspectives and deceptive viewpoints that enable the feminine form to don forms of artifice that do not betray it." "Natural" behaviors were back, and couturiers understood "that these normal women could no longer be dressed like *garçonnes* nor as faux sportswomen who are slaves to the adolescent aesthetic, nor as Hollywood vamps, export version."[34] As French fashion had survived the war relatively unscathed, it retained its place in the world and gained new forms and textiles. After the war, it became crucial to move on. It was the end for slim waists and thick soles; the way was now open for the New Look, with its longer skirts with full underskirts, and tight tops. Once again, Marcel Rochas anticipated this radical change, lengthening his skirts more than the other couturiers.

FACING PAGE Negligee in pink chiffon with velvet bows.
L'Officiel de la mode, no. 275, August 1944.

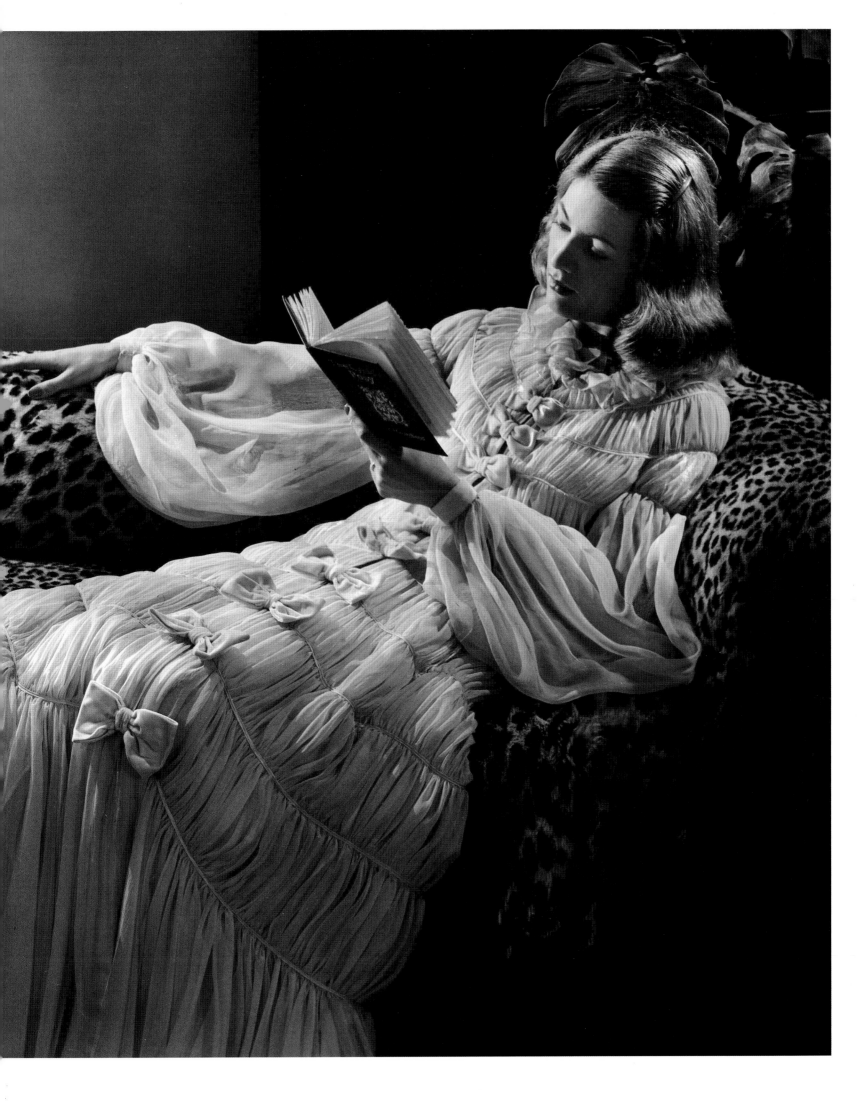

A HEAD FOR HATS Things were not going well between Rina and my father. Their relationship was on the rocks. As early as 1936 they'd reached a turning point; Leonor Fini remembers their arguments at her exhibition at the Julien Levy Gallery in New York. "Rochas is going back [to Paris] on Wednesday, and Rina is staying on. They have quarreled terribly and have also decided to divorce in recent days. It's a shame, because they're very amusing when they're having a row."[35] Ever that need for change, speed, new muses. Nevertheless, their love story had lasted twelve years, from 1929 to 1941, and had produced a baby girl, who died in her first year.[36] After a great to-do over the pronouncement of their divorce in July 1942, Rina continued her activities as portrait painter to the Paris smart set, as noted in 1945 by *L'Officiel*: "In a brocade-lined salon hung with marvelous gilt mirrors, a young woman with a tan-colored mane lives surrounded by strange paintings that recall the precise touch of the Italian Primitives.... She is truly possessed by painting. During the war years, she lived in seclusion in a corner of the Riviera, painting curious heads of young women with tan-colored hair like hers. Currently, she is painting all the Parisiennes. Rina Rosselli is the portraitist of 'le Tout Paris.'"[37]

As for my father, he moved out of avenue d'Iéna and into a bachelor pad on avenue Montaigne. As Rina was fading out of his life, one evening in 1941 (so the story goes) Marcel Rochas saw a beautiful stranger on the last metro and said to her: "Mademoiselle, you have a head for hats."[38] It was the beginning of a modern fairy tale. The girl whom fate had placed in his path had strikingly large aquamarine eyes and a regal posture gained through three years as a ballet dancer at the Opéra de Paris, her "first hard school in life."[39] A connoisseur of feminine beauty, Marcel Rochas suggested an evening at the opera and a meeting at his couture house on avenue Matignon, which he was trying to keep in business with a smaller staff and a reduced stock of fabrics. Nelly, who would call herself Hélène de Brignoles, was twenty years old, nineteen years younger than her admirer.[40] Of her family, she spoke only of her Italian-born father, a World War I hero, and her British-born mother, one of the first female dentists in France. Her brother-in-law Raymond Bernard, married to her half-sister who was fifteen years older than her, had given her a taste for the theater,[41] and she would recount how she was a student at the René Simon drama school when she met Marcel Rochas in the metro.[42] He offered her work in his couture house, but not as a model, for he considered her too young and "not chic enough" to show off

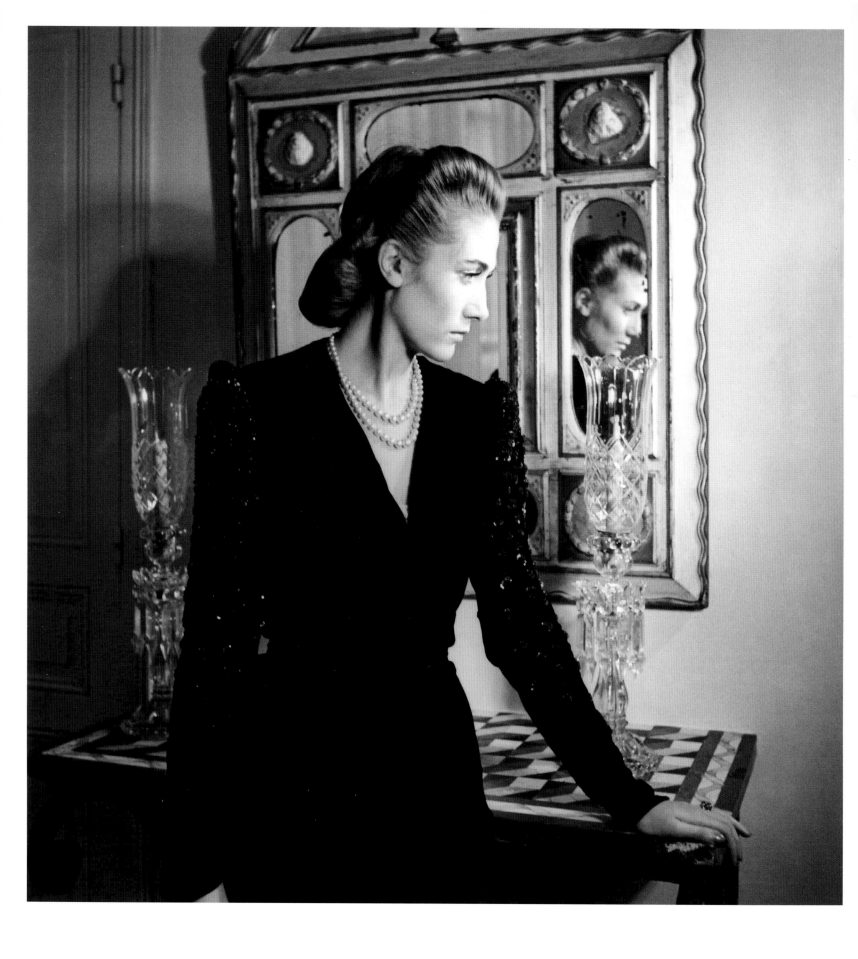

ABOVE Hélène Rochas photographed
by André Ostier, circa 1945.
FACING PAGE Illustration by René Gruau
of a Marcel Rochas dress, *Plaire*, 1945.

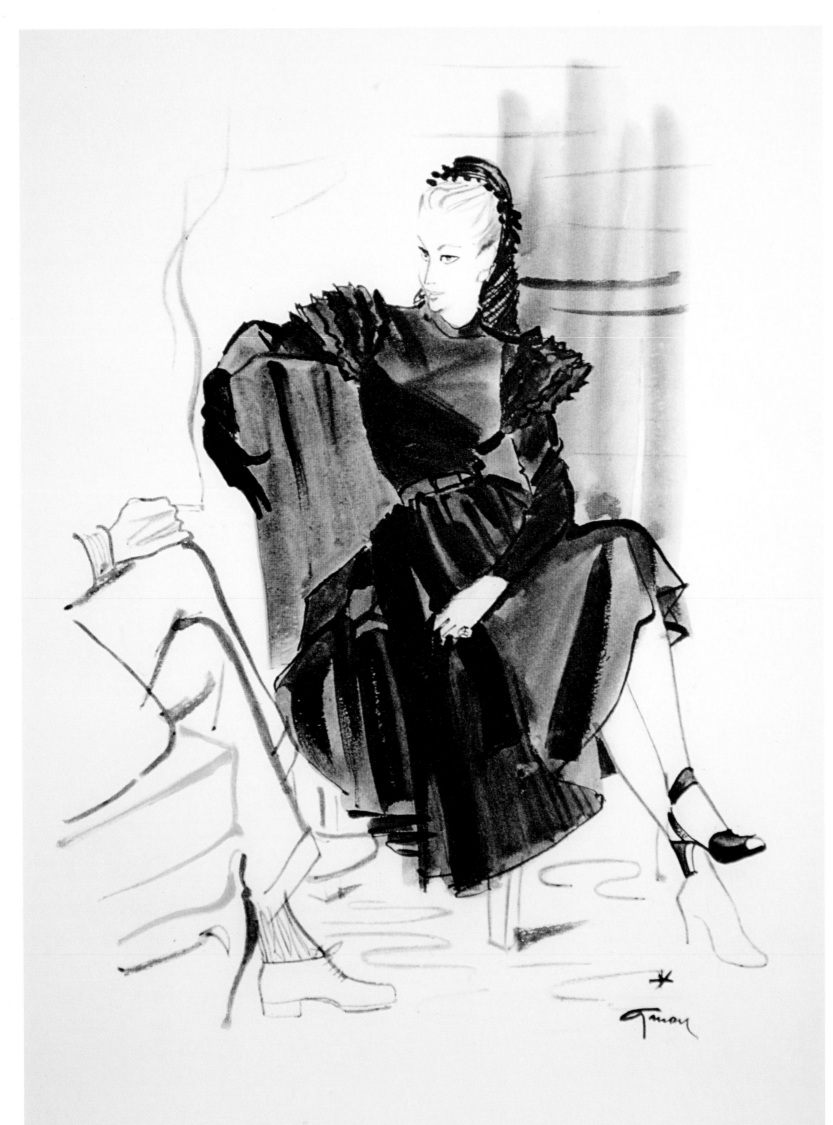

his designs.[43] Hélène had to swallow her disappointment and no doubt worked even harder to be noticed: there was fierce competition among the stable of models to become the couturier's "star model," if not his favorite. Before long, the dancer with regal bearing had cleared all the hurdles in her path. My father became her Pygmalion, and would mold her to his ideal. "I was a good student," my mother would say with a smile, twenty-five years after the death of the man who became her husband. He began by changing her hairstyle, rolling her long, light-brown hair over a slim, flexible horsehair roll, placed like a graceful cushion at the back of her long neck, which was ideal for modeling turbans, berets, flowery hats, and other designs in numerous variations. The first step had been taken. Hélène had a head for hats, and my father had noticed it; but under her hat, the chrysalis Nelly Brignole would become a warrior, a new Helen of Troy for whom some men would have given anything. I think my father allowed himself to fall under her spell. Besides, Hélène looked good; she had modeled for Hermès. Despite her obvious qualities, the perfectionist couturier took his time in bringing out his Galatea. For two years, he allowed her only to model hats. In the end, she outshone all the other models in the Rochas stable. Dressed from head to toe by "Monsieur," she made heads turn for herself just as much as for the haute couture creations she wore. What a stir she must have caused! A couturier who adored women in both public and private was not such a common thing but Rochas was a ladies' man, who charmed his models, his clients, his female friends, and even celebrities. It is said that Eva Perón came to Paris especially to order her incredible wardrobe from him. She was not loyal for long, and soon ordered items from Jacques Fath. But now the couturier was spoken for, and the other girls could only stop dreaming and consider themselves lucky to be part of a great house. It is not difficult to imagine the icy front that must have been put up by the disappointed girls who used to gaze doe-eyed at the talented Marcel. Now he was out of reach, in love with the girl who soon became known as La Belle Hélène.

But Marcel Rochas was thirty-nine and had seen something of life already. He wanted to start a family and have two children—this was the condition imposed on the lucky girl. She would have to give up her own career: being the wife of Marcel Rochas was a full-time job. She had to be beautiful from morning to night, to be a mother (albeit with the help of nannies), and most of all to be a woman, his woman, for whom Paris society would envy him. The contract was agreed. In August 1942 my brother arrived,[44] and two years later I turned up, on June 9, 1944, making my appearance shortly after the legendary perfume Femme, "the best perfume in the world."

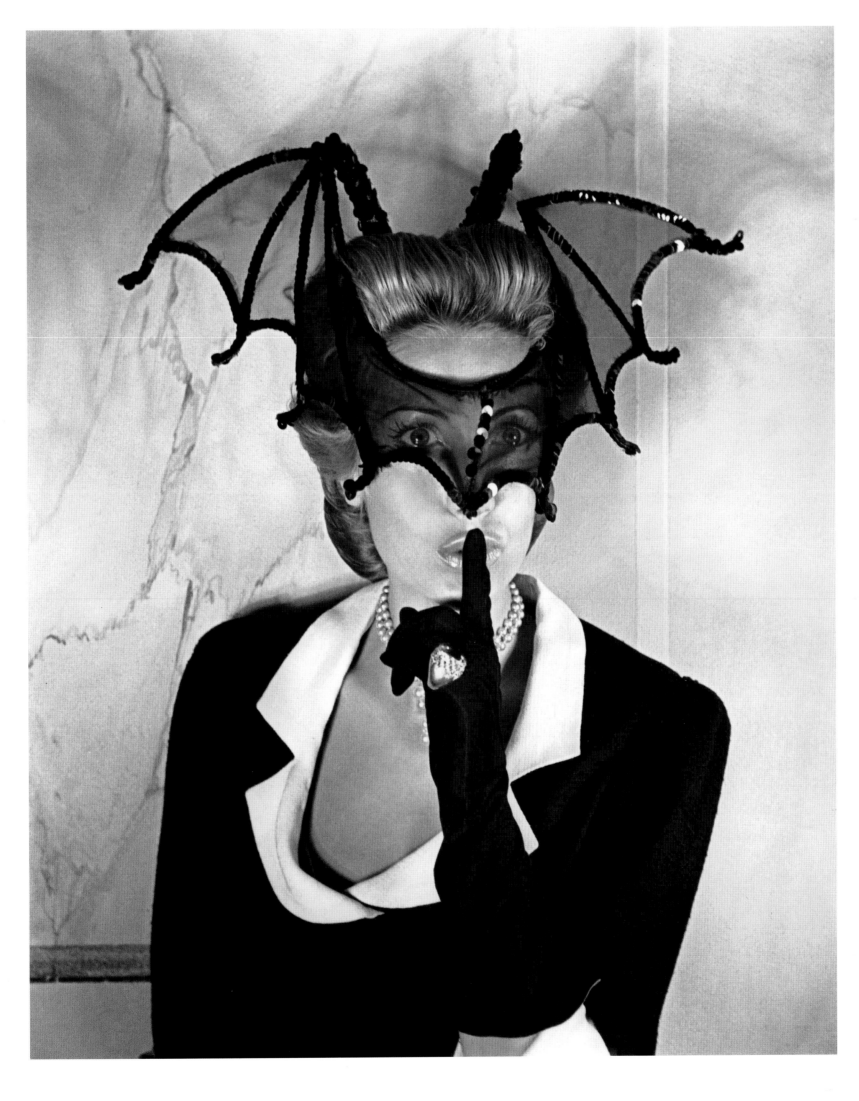

On May 8, 1945, the war in Europe came to an end at last. There were still some restrictions but, as after World War I, life in France soon went back to normal for many people. My mother was in a privileged position, moving in the most fashionable circles. My father created most of his designs to fit her and she wore them in public with panache. For almost a decade, the pupil submitted to the wishes of the master. Appearing at his side, she had her hair styled and was given hats, gloves, jewelry, and ensembles to wear, always designed by her couturier husband, for her every public appearance in the daytime or evening. The wild swan had become the majestic Hélène Rochas, a guest at every reception in the City of Light. Cocktail parties, exhibition openings, races at Longchamp, costume balls, and dinners filled her diary. Her bat mask was a sensation at the Nuit du Pré-Catelan in 1946. In a play of contrasts, the vampire black framed her large forget-me-not-blue eyes, which caught the attention of Paul Éluard, who wrote so beautifully of the expressiveness of eyes, "nocturnal and safe cradle."

When she got home from these society receptions, my mother would take out the stiff horsehair roll and let down her hair to allow it to breathe at last. Morning and evening, she would brush her long, light-brown hair with regular strokes, at least fifty times. My father forbade her to have it trimmed more than a centimeter. One day, however, without asking for permission, she had it all cut shorter: perhaps an early sign of rebellion against her Pygmalion? American cinema, and Ingrid Bergman as Joan of Arc in particular, had set the example. Jacques Fath was the first to give his star model, Bettina, this revolutionary hairstyle known as *la gribouille* in 1949. I can still remember the scene that greeted my mother's initiative. Like the Philippe Clarence character in *Falbalas*, my father would throw sudden loud fits of uncontrollable temper. Usually it was the head seamstresses who bore the brunt of these rages. That day it was my mother's turn. The small cracks in their relationship would gradually widen, imperceptibly spoiling the best years of their lives. In a letter to Hélène, his "*petit chéri*," my father, who signed off "your poor jailer," expressed his love, still intact, and his fear of seeing my mother "tire of the inevitable monotony of happiness."[45]

RIGHT Concours d'élégance for cars in the Bois de Boulogne, Paris, June 23, 1949. Marcel Rochas is at the wheel of a vintage Citroën, with his wife Hélène wearing an ensemble designed by him.
FACING PAGE Dress and bolero in white cotton ottoman, belt in white lambswool, and posy of violets by Guillet, 1950. Didier Ludot archives, Paris.

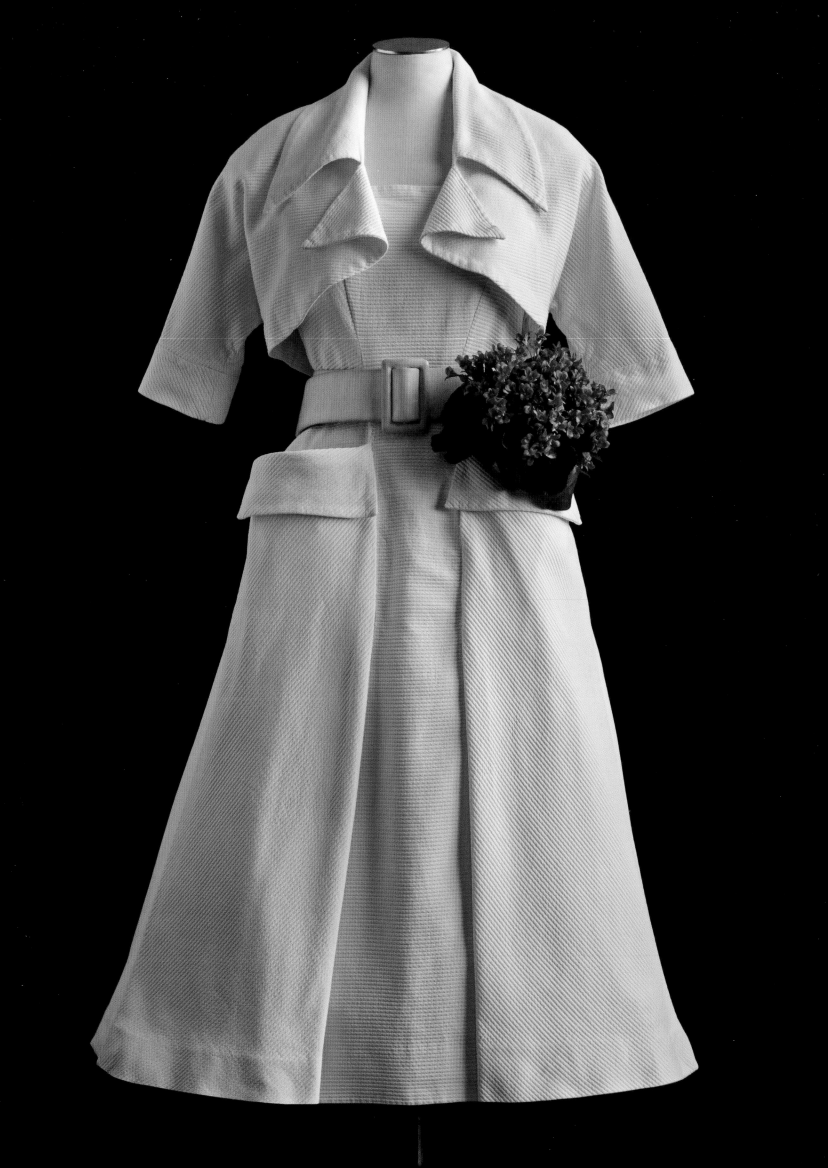

COUTURIER AND PAPA June 9, 1944. While the Allies were landing in Normandy, an ugly duckling landed in Barbizon in the Ile-de-France, in an outhouse of the Hôtellerie du Bas-Bréau inn on the road leading south. It was a near miss: a bomb fell right next to the cellar where my pregnant mother was taking shelter with my brother, François. As a result, I came into the world earlier than planned, with big, bulging eyes and a shock of black hair, as my maternal grandmother told me later. We didn't get off to a very good start! My mother was horrified at the sight of me; for Hélène, one of the most beautiful women in the world, to give birth to such an ugly little girl was unimaginable. Unpredictable little Sophie, whom heaven had landed on her so carelessly, was cocking a snook at her. And her boy was so beautiful. How could I imagine that, from the first second of my life, I should inflict such suffering upon my mother? She might forget the pain of childbirth, but would she ever get over producing a daughter who was less than ideal? Who's to say?

The black hair eventually turned into a more Nordic blond. The bulging eyes became big porcelain-blue saucers, gazing wide-open at life. Curiosity, impetuousness, and mischief were all to come. But nobody saw this in me, except my father, who adored me and wrapped me in the finest things, like a princess. The magician couturier made me dress after dress. I remember yellow, his favorite color, the color of the sun, of joy, of life. I can still see myself wearing a cotton muslin checkered dress with two big bows on the shoulders. In the summer, when we set off for the Riviera, heading to Juan-les-Pins, Antibes, or Bormes-les-Mimosas, it came with me, carefully folded in the cases that my nanny was ordered to fill with as much tissue paper as there were clothes—a real mille-feuille. I was painted wearing another dress, in ice-blue silk covered with white lace flounces with a blue satin sash tied at the back, by Nora Auric, Georges Auric's wife.[46] I was very proud when I was allowed to wear it on special occasions. To complete the picture, my nanny, Mademoiselle Lucienne, had to brush my straight, blond hair, which fell to the small of my back. Then I became Sophie, the perfect little girl my mother had wished for—minus the naughtiness, of course.

BELOW, LEFT Hélène Rochas and her daughter, Sophie, 1945.
BELOW, RIGHT Marcel and Hélène Rochas with their two children, 1944.
FACING PAGE The Rochas family in 1951.

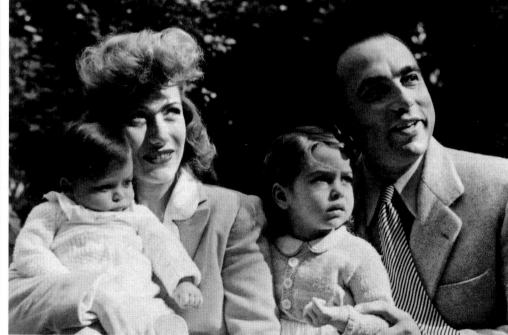

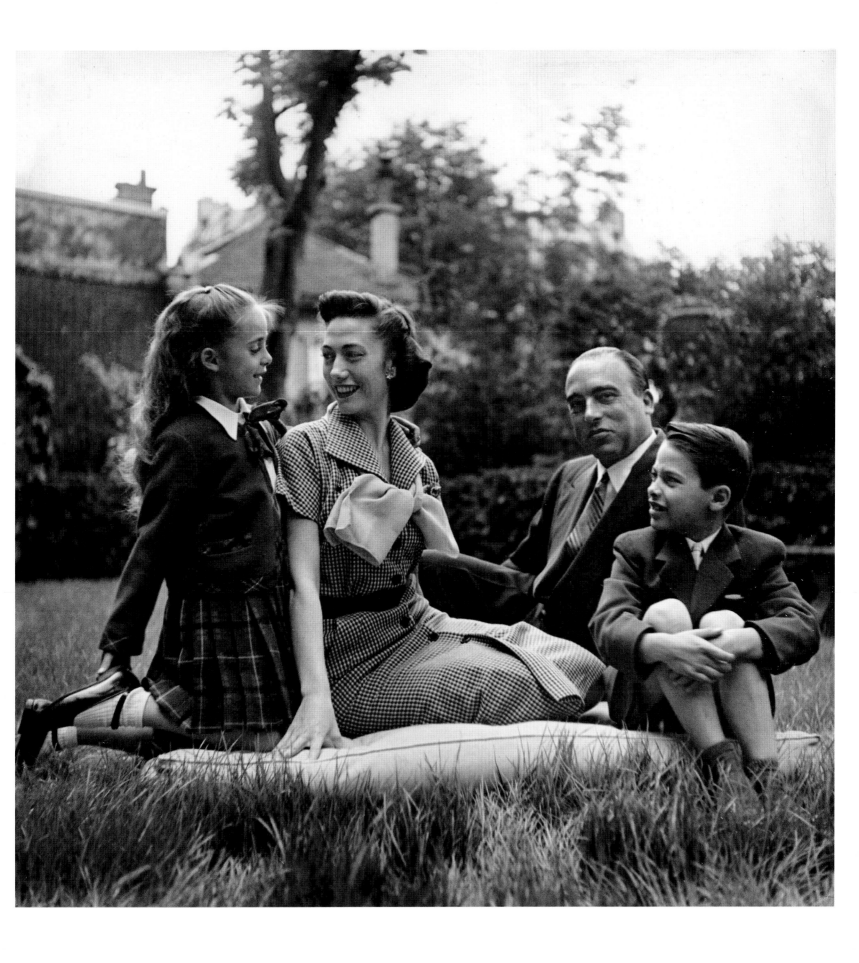

My earliest memories of childhood are imprinted indelibly in my mind. My first dolls' tea set, in Limoges porcelain with pink and white roses, was given to me by Jean-Louis Barrault and Madeleine Renaud, both wonderful actors and friends of my father. I would lay out magnificent table settings for my dolls, very similar to those we had for our family meals. For a tablecloth I would use a carefully ironed white organdy napkin. The *petites madeleines* cakes and Lu biscuits that I carefully arranged on miniature plates would soon disappear into my own mouth. My dolls would go along with the show without protest. Sometimes, I even accused them of being nasty and punished them, mimicking whatever had been said or done to me. In truth, I didn't much like my dolls, except one of them, who had long, curly hair and a very pretty dress. I dragged that one around everywhere, like my twin, like the sister I would have loved to have. A younger sister, naturally, who would have saved me from having my older brother as my only company; he was rather uncommunicative, it has to be said, and as calm and poised as I was lively and inquisitive.

In France in the 1950s, girls and boys did not mix. They were separated at school, at mass, and in many other circumstances—which only sparked even more interest in the other side. All those glances exchanged in the playground and sly looks during an Ave Maria or a Pater Noster were enough to send us straight back to confess those innocent sins, which all too often were treated as some form of perversity by the priest whose face you could barely make out behind the confessional's wooden latticework. In the knowing shadows, the spirit of God, embodied by his servant, would whisper his forgiveness in my ear for the misdemeanors I had to list. After an absolution and the sign of the cross, I was released with a simple "Go in peace, my daughter." Yet what crimes can a child confess? But this was how the Catholic religion was practiced, and my father made no exceptions. There were catechism and mass every Sunday, communions, church weddings, christenings—all rituals that had to be followed. For my first communion, my father chose the prettiest dress a little girl could dream of, a prelude to the wedding dress he promised me. As for the religion inculcated in me in my childhood, it stayed with me only in my fondness for church architecture, images of the Virgin and Child, Pietàs, and the organ cantatas of Johann Sebastian Bach.

BELOW, LEFT Leonor Fini, *Hélène Rochas and Her Children*, 1947.
BELOW, RIGHT Sophie Rochas and her brother, François, 1951.
FACING PAGE Hélène Rochas with her children Sophie and François. Hélène and Sophie are wearing designs by Marcel Rochas. *Vogue*, April 1949.

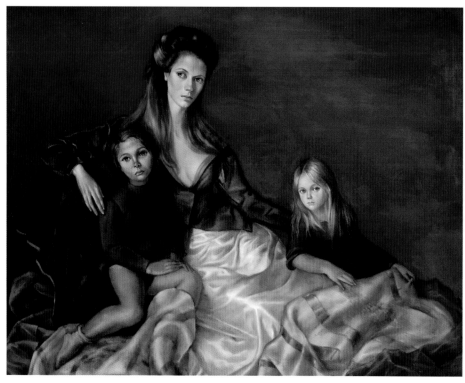

TREASURE CHESTS AND MAGIC CUPBOARDS The religion I favored was the outdoors. I inherited from my father a love of the land, of trees and flowers, as well as a pronounced taste for travel, exoticism, different skin tones, colors, clothing styles, and languages. When my parents set off on a journey, sometimes to far-flung places, I would watch intently as the Hermès and Vuitton trunks were packed with the vast wardrobe designed to show off the beauty of the young Madame Marcel Rochas. Their friends Jacques Fath and his flamboyant wife Geneviève would travel with them in similar style. The women would plan for three changes of outfit a day, with matching shoes, gloves, bags, and jewelry, not to mention underwear, corsets, garter belts, silk stockings, slips, and negligees, nightdresses or silk pajamas. Ah yes! Then there were the full-grain or crocodile leather cases—one for Monsieur and one for Madame—containing toiletries: crystal bottles, ivory-handled brushes, an ebony comb, silver-handled razors, a powder box, a swansdown powder puff, a box of mascara, an eyelash brush, gold scissors, a metal file, glass tubes with silver stoppers containing toothbrushes, an assortment of round, square, or rectangular boxes for soap, imitation beauty spots, and more. These preparations took a day a least, particularly when they were going to New York. The shoe contest between my mother and Geneviève was impressive to see. I remember the copper racks on which my mother's shoes were arranged at home: some with stiletto heels, others in silk encrusted with stones, or in velvet with leather ribbons, or with tiny buttons or fringed laces, in every color, round-toed, pointed, or square-toed, by Mancini or Roger Vivier, often made to measure. My mother had the ideal slim foot for shoes.

When my father returned from a trip there was a joyous atmosphere at home, even when he was jet-lagged after a long flight. With childish impatience, we would watch for the arrival of those trunks and cases. They would always contain lots of wonderful objects brought back from far-off countries—it was all part of the ritual. But we had to wait for my father to wake up before Nanny would allow us to enter our parents' room. She would be ordered not to disturb them, and she always obeyed, like a soldier. It was annoying but I had to comply, otherwise there would be punishments: no dessert, or even worse no Sunday outing with my father. I remember the Sunday outings to the Jardin d'Acclimatation in the *petit train*, rides on the "enchanted river," candy floss sticking to our fingers, and above all cuddling up to my father. At those times, I felt inundated with love. Nothing bad could ever happen to me. He was there to calm my fears.

Now at last we were allowed to join him in his room. We would smother him in kisses, our eyes already on the treasure trunk. What was inside? It was a moment of delicious excitement, a second Christmas, a foray into Aladdin's cave. At those magical times, the couturier-perfumer who belonged to everybody became a papa like any other once more.

And a father he was, despite his work that took up so much of his time. At forty, he was an older father, attentive and anxious at the same time. When he was at home, he was intensely, physically present. His absences were all the more cruel. In the morning, he would often look into our room. It was connected to his office by a long corridor lined with mahogany wardrobes, from which he would choose his suit for the day and all that went with it. There were piles of folded shirts, cufflinks, racks of ties, belts rolled up, pairs of socks turned inside out, polished shoes, brushed hats, gloves, scarves, flannels, silks, cashmere, velvet; an abundance of colors and textures. And always the woody scent of his ambergris perfume mingled with a musky whiff of brilliantine. His smell. In the bathroom that adjoined his room, he would be busy getting ready to leave for the couture house. I listened out for the sound of taps, of water running into his curved enamel bath. I imagined him using his shaving brush to cover his face with Moustache shaving foam, then scraping it off with that long, cut-throat razor blade. The foam made me laugh; it looked as if he'd had a custard pie pushed in his face, like in a Buster Keaton film. But the razor scared me. What if the blade slipped? Sometimes a small red spot on his cheekbone or at the top of his neck made me anxious.

FACING PAGE Hélène and Sophie Rochas wearing identical designs by Marcel Rochas, in the garden of the house on rue Barbet-de-Jouy, 1953.

RIGHT The bedroom of Hélène and Marcel Rochas,
decorated by Georges Geffroy.
House & Garden, September 1950.

Where did that underlying worry about my father come from? Too much love, which made me dread his absence? In their first ten years, children don't ask themselves such questions. In fact, in the 1950s children didn't ask their parents any questions at all. Our father simply told us that his journeys lasted a whole night and part of the day, so passengers had beds like at home. What a way to foster a taste for travel. Without knowing it, my father was whisking me away on a flying carpet. I meticulously filed away his postcards from the places he visited in a green folder. Skyscrapers, the pampas in Argentina, the Sugar Loaf Mountain in Rio de Janeiro, gauchos in their long leather skirts, tango dancers—it all fueled my imagination, and the pictures and objects he brought home kindled my interest. What I didn't know at the time—how could I have known?—was that my father regularly traveled overseas to take his designs abroad, to England, America, Sweden, countries where fashion was thriving.

Was my mother there? I don't see her. She was so beautiful, but she didn't seem made of flesh and blood. She didn't hold me in her arms often enough, although I had such a craving for warmth and contact. Our nanny wasn't the type with whom I might have found refuge, either; she did what she was told, and that was all. Birds of a feather, perhaps; in any case, she stayed on in my mother's service well after we children had left home. So there was my mother, with her outfits and veils, her long gloves, her imitation beauty spots, her hair with the roll in it that went so well with her hats. She gave the impression at the time of being at the beck and call of her lord and master. It is true that my father was very controlling in everything. He decided not only how her hair should look and what she would wear, but also how everything concerning the house should be, the food, the wine, the tablecloths, the tableware, the flowers. It must have been stifling for a young woman who was not without a will of her own, as her life after my father's death would show. During the twelve years of their marriage, once the passion of their early years was spent, my mother played her role with elegance and detachment.

The distance she put between the two of us has ensured that a whiff of Femme is the only part of her that has stayed with me. I try to get over the barrier between us by thinking back to those evenings when, before they went out, she would lean over my bed, the scent of her perfume replacing motherly love. I would sometimes sneak into her bathroom when she left it open, to hungrily breathe in the heavenly fragrances that mingled with the steam. But the love that hung in the air of this windowless den was a narcissistic one, and nothing like the cocoon I longed for. My mother was shy and reserved. On the rare occasions when I caught a glimpse of her undressed, she would quickly conceal herself in her long, pink Porthault robe, embroidered with the initials H.R. I was fascinated by the bottles of oils around her tub, the perfumes and pots of face powder and mascara that filled the shelves. I would watch as she applied a layer of inky mascara to her long eyelashes. Then her look changed: she became "Femme," another woman, so beautiful and remote and mysterious that I no longer recognized her. Once she was dressed, with her hair done and her hat and gloves on, I could no longer approach her; she belonged to another world, the world of beautiful people, and it wasn't mine. And those wardrobes you could hide in were so hard to resist! That long, dark room filled with a thousand and one outfits: how many times did I explore it in secret, my heart pounding, scared of being discovered by our dragon of a nanny? Whenever my mother called Nanny to help her zip up a dress, or to bring her gloves or bag, or a muslin handkerchief, I would try to catch a glimpse of her through the half-open door. In the cheval glass I would see the elusive reflection of the fairy Hélène Rochas, and I would yearn to slip off that second skin that encased her, and that prevented me from reaching my mummy's heart.

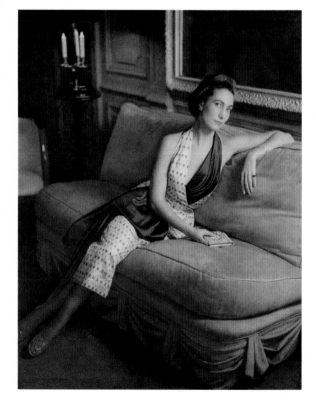

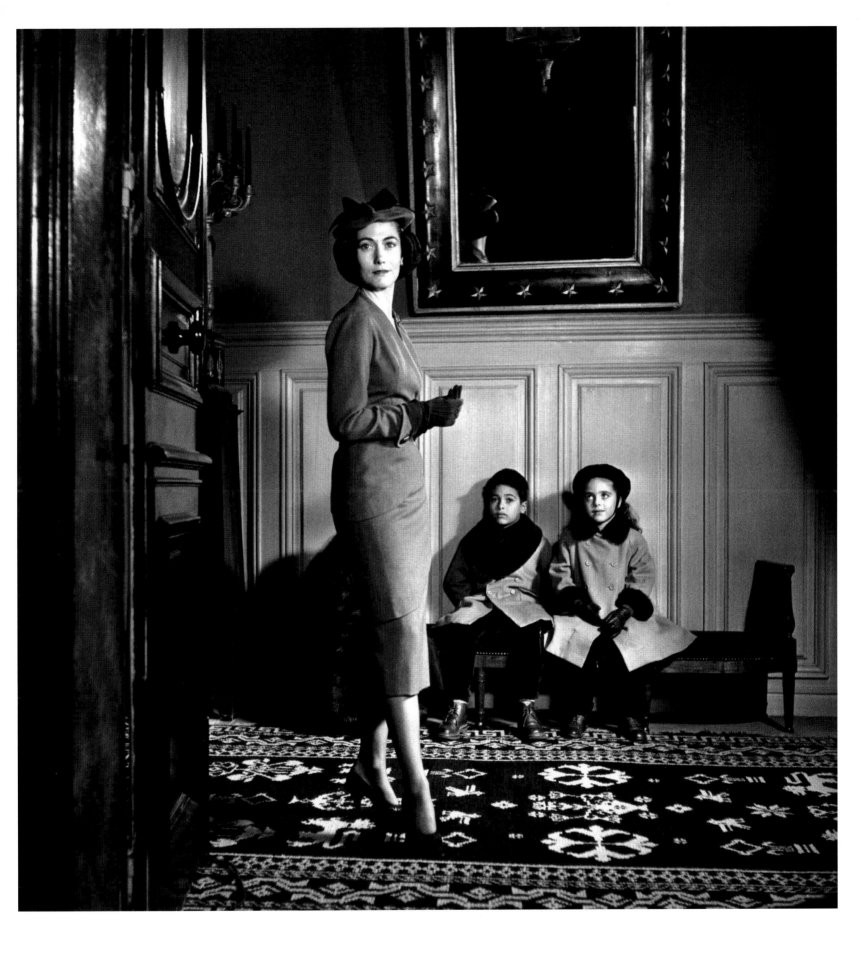

HAPPY HOLIDAYS The road that led to paradise, to my haven of peace, to freedom with my father, my mother, the dogs, the cat, the magpie, was the long road that took us westward out of Paris, over the Saint-Cloud bridge. Whenever he could, my father would take us to La Tuilerie, our country house near Villennes-sur-Seine, for the weekend. Leaving Paris, we would drive through a landscape of fields and villages. I suffered from car sickness, but after an hour we would spot our house at the end of a deserted lane: "a pretty cottage…draped in foliage and wisteria"[47] is how it was described in an article published in *L'Officiel* in spring 1949. I can't remember any neighbors; the house stood on a path that smelled of hazelnut, the point of departure for our bike rides. When we heard the baker honking the horn on his van, we'd dash outside, after our Saint Bernard dog Xérès, to catch a hunk of warm bread. Sometimes our Parisian cat, Mouche, a magnificent Angora Persian with silvery fur and amber yellow eyes, would fall asleep between the dog's paws, and the magpie would come and sit on its head—until the day when the cheeky bird glided down to Xérès's food bowl and was snapped up without further ado. The walnut tree at the bottom of the vegetable patch, which stained my stealing hands, the plump orangey cherries that we'd compete for with the blackbirds in the big garden, the weeping willow hanging over the swimming pool, the mass of tri-colored roses climbing up to the top of the well: how I loved those earthy roots, discovering them anew like treasures rescued from the tidal wave of the city. My father loved nature, bicycle rides, picnics, and the wild places between rocks and the sea. As the same article noted approvingly, he was a "tender-hearted father, who pays attention to the education of his little girl, Sophie, and his young son, initiating them himself into country life."[48] He appreciated authenticity and simplicity, and enjoyed restaurants with a warm, family atmosphere just as much as the sophisticated Eden Rock in Cap d'Antibes, the Carlton in Cannes, the Hôtel du Palais in Biarritz, the Normandie in Deauville, and the grand Hôtel St. Moritz, not forgetting our ritual first stopover on the way to the south of France, the Hôtellerie du Bas-Bréau coaching inn in Barbizon.

In summer, when vacation time came and when Nanny took her annual leave, we would head south. Our summer holidays were spent in Provence, in my father's native Valence. We would arrive in Les Baux-de-Provence, which in those days was a rural haven of peace, scents, and tastes. The huge, rugged rocks, cathedrals of stone, and the plays of light and shade made a dramatic sight in the heart of Les Alpilles. This was where I experienced the happiness of having my father entirely to myself. The Marcel Rochas of the city turned into a man of the fields and the countryside. And here in the garrigue, my mother, lightly and elegantly dressed in shorts, swimsuits, and sun dresses, became a flesh-and-blood person. Real bare arms with soft, fine skin would come to rest on me, like a gull on wet sand. She would hand me a towel to dry myself, hold me close, or embrace me. A fleeting, ephemeral warmth, so quickly snatched away again. Adults forget the importance of these gestures that come so easily to children. Then we would drive off again down the Nationale 7, to the Riviera and its beaches and grand hotels, the last stops before the villa La Reine-Jeanne, where "Le Commandant" Paul-Louis Weiller was waiting for us. The mother I rediscovered in the summer at the seaside was someone quite different, more cheerful, sometimes playful even, on those brief family holidays together—my father, my mother, my brother, and me. Without all the layers of clothing, she seemed lighter, less stiff, less chilly. Sometimes we opted for the Brittany coast instead of the southern heat. Our holidays in Port Manech, in the company of the actors Henri Vidal and Michèle Morgan, were my best ones. I remember the happy group the four of them would make as they linked arms together: two legendary couples joined in life—and in death. It was Henri Vidal who was to bring my father's body back home on that dark night of March 14, 1955; and it was my mother who was to lend Michèle her mourning coat four years later. The men's tennis matches, the women's bicycle rides, the games of *pétanque*, the meals

TOP Marcel Rochas and his children on the boardwalk at Deauville, summer 1948.
BOTTOM Sophie Rochas and her brother François in Saint Moritz. Photograph by André Ostier, 1950.

taken all together, and the big platters of seafood were part of the ritual. Not forgetting the dips in the sea—quick ones, because my mother found the water cold, but for us children it was healthier than the Mediterranean heat. And in Port Manech I would hear my mother laughing, sometimes even collapsing in fits of giggles, as my father, who loved dressing up, would get the two couples up in traditional Breton costumes. What a mad escapade it all seemed, away from the public eye. Michèle was so beautiful, so natural, and so funny, with her tall Bigouden lace headdress, towering like a lighthouse over her long wave of golden blonde hair, which swayed as she walked. Her blue eyes, famous since the film *Quai des Brumes*, seemed even more translucent in the sunlight, and set off by her apricot-colored skin. And when it came to eyes, my mother's were certainly a match for Michèle's. Along with Henri's, my brother's, and mine, their eyes seemed to contain so many different shades of blue, so many nuances, in contrast with my father's black eyes. These happy interludes immersed us in our own, private world, which we would leave behind with reluctance. My parents had to get back to their professional and social obligations, and that was the end of our peaceful time together as a family. Soon life in the smartest quarters of Paris would swallow us up once more.

ABOVE, LEFT Pierre Balmain, Marcel Rochas, and Jacques Fath, Cannes, 1947.
ABOVE, TOP RIGHT Marcel Rochas walking with his dog in Béhoust, circa 1935.
ABOVE, BOTTOM RIGHT Marcel on summer vacation in Port-Manech with his friends Henri Vidal and Michèle Morgan, wearing Breton costumes.

LE THÉÂTRE DE LA MODE In the immediate aftermath of the war, people weren't able to go on vacation, and Paris couture needed to find a new direction that would restore it to its former prestige. In fall 1944, Lucien Lelong, president of the Chambre Syndicale de la Couture Parisienne and a tireless champion of the cause, as we have seen, launched a scheme aimed at restoring the luster to the image of haute couture. The Allied landings and the liberation of the capital had given hope to France, despite one of the harshest winters of the war. Rationing, which was ever more severe, was even harder to put up with in icy cold weather. This was the difficult background against which Lelong listened carefully to the proposal put to him by the journalist Paul Caldaguès and by Robert Ricci, son of Nina and vice-president of the couture trade union at the time, who would be the driving forces throughout this operation, in a sector that was traditionally mistrustful of competition. The project would also serve to raise funds for war victims, through the association L'Entr'aide Française. Their idea was to present French couture on scale models on a series of different sets, in the manner of a miniature theater. While the concept of showing new fashions on small-scale models was not new, Lucien Lelong had the wisdom to revive and support this clever idea. A twenty-year-old illustrator, Éliane Bonabel, was commissioned to sketch the miniature models that would be dressed by fifty-two designers, including Lucien Lelong, Carven, Molyneux, Jacques Fath, and Marcel Rochas. Jean Saint-Martin and the Catalan sculptor Joan Rebull transformed her drawings into three-dimensional figurines, with white plaster faces and arms and legs made of wire. To bring them to life, Christian Bérard, painter, interior and costume designer, was asked to oversee the visual backdrops. Artists loved this larger-than-life figure, who "represented the phenomenon—rare in Paris— of a man who was as well known in aristocratic circles as he was in the most bohemian of artistic coteries. But whatever the company in which he found himself, he was always the same: bearded and unkempt, surprising, mischievous, amiable, generous, with a genius that was the quintessence of Parisian taste."[49] Henri Sauguet created the "musical settings" for this venture, christened Le Théâtre de la Mode. It featured thirteen scenes of Parisian life, designed by artists as diverse as Boris Kochno (for the lighting and staging), Jean Cocteau, André Beaurepaire, Louis Touchagues, Georges Geffroy, Igor Wakhevitch, and Emilio Terry. In one of the showcases, created by Jean Cocteau

BELOW, LEFT Marcel Rochas and one of his figurines for the Théâtre de la Mode, Paris, 1945.
BELOW, RIGHT Marcel Rochas by the entrance to the Théâtre de la Mode, Paris, 1945.
FACING PAGE Poster for the Théâtre de la Mode in New York. Drawing by Christian Bérard.

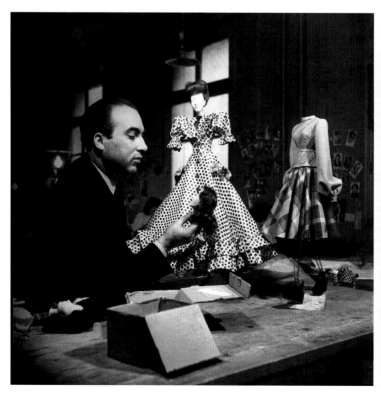

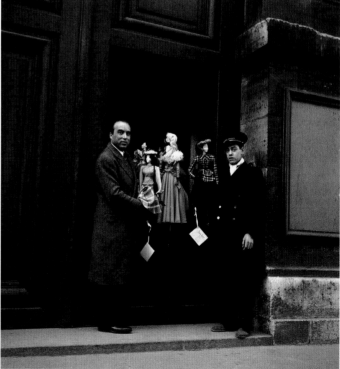

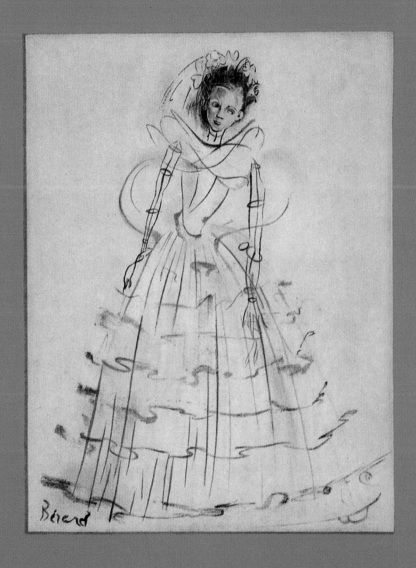

MAY-JUNE 1946

LE

THÉÂTRE
DE LA
MODE

EXHIBITION OF ART AND FASHION
CREATED BY FRENCH ARTISTS AND DESIGNERS
ORGANISED BY THE "CHAMBRE SYNDICALE DE LA COUTURE PARISIENNE"

PRESENTED BY "AMERICAN RELIEF FOR FRANCE"
AT THE BENEFICE OF ENTR'AIDE FRANÇAISE

451 MADISON AVENUE

DAILY : FROM 11 A.M. TO 10 P.M.
SUNDAY : FROM 12 A.M. TO 6 P.M.
ADMISSION 1 s 20 (taxe included)

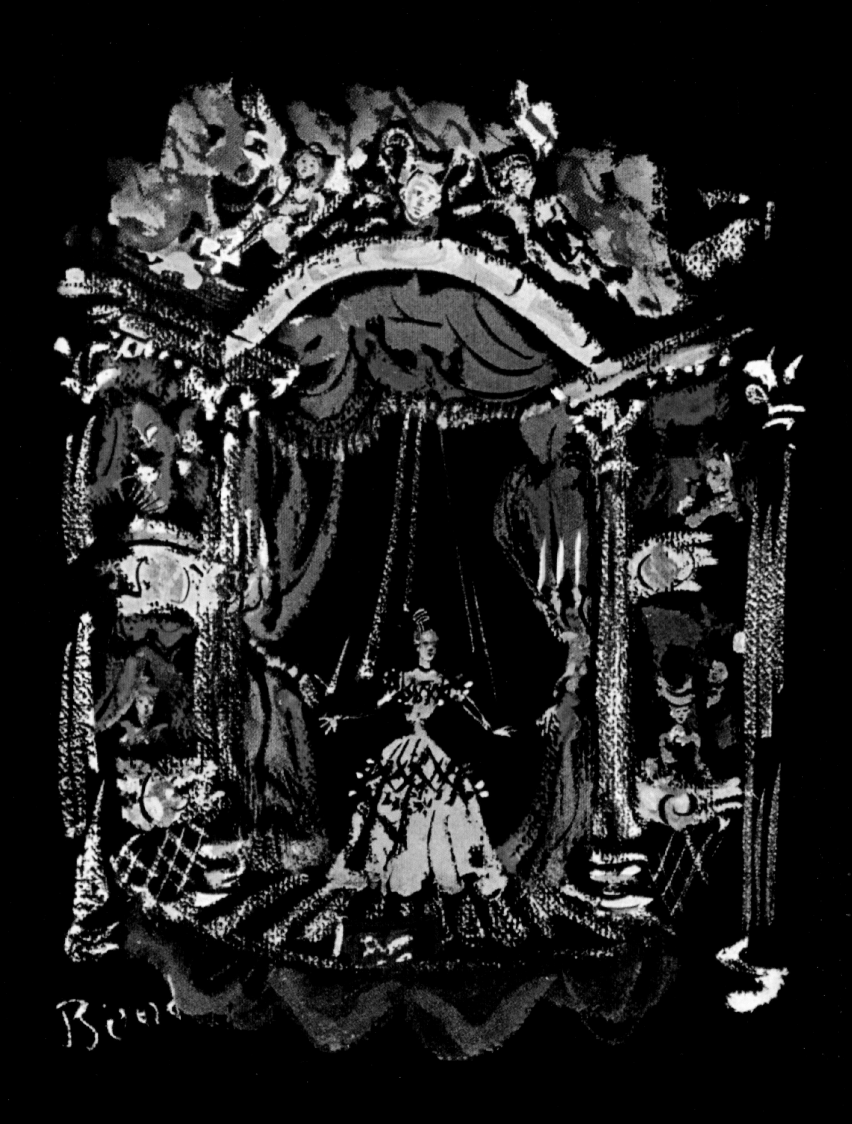

and inspired by the film *I Married a Witch*, Marcel Rochas dressed the bride in a gown that was the most spectacular of the four designs he contributed to the Théâtre de la Mode. As close friends, the Riccis, the Rochas, and the Faths threw themselves enthusiastically into this venture, into which Robert Ricci had brought his wife, Raymonde, who had been my wet nurse.[50] After all the collection shows, Christmas and New Year were celebrated at the Rochas home, with Jean Cocteau as an extra guest.[51]

In a time of severe shortages of fabrics and materials, the Théâtre de la Mode revived a world of luxury and offered a glimpse of a new world after all the privations and sufferings of the war years. After "three months of unimaginable efforts on the part of a prestigious team crippled daily by the lack or scarcity of means,"[52] the two hundred or so dolls, dressed, shod, gloved, hatted, and bejeweled with valuable accessories, just like real models, became the global ambassadors of haute couture. Their mission was to win back the international clientele that had been lost during the war, and to restore Paris to its role as the capital of fashion. Accompanied by a catalog,[53] the exhibition opened on March 28, 1945 at the Musée des Arts Décoratifs, in the Pavillon de Marsan at the Louvre, and drew just over 100,000 visitors. "The dresses, exquisite compositions, 'suit' these silhouettes and faces so well, gracing every ambience with the assurance of a '*femme*' who is aware of the attention she enjoys. Elegance and Paris: inseparable! This 'theater of fashion' is Paris in all its faces! Its smile, spirit, wit, and charm, its eternal soul, and all its comebacks. This is Paris! Glorious in all of its small individual acts and emerging from its present difficulties with so much brio that they've made of a show of it that has a grandeur of its own."[54] After its first showing, the exhibition took Parisian chic throughout Europe: to London,[55] Leeds, Barcelona, Stockholm, Copenhagen, and Vienna. Then in 1946 it was mounted in New York—the figurines being dressed with models from the Spring–Summer 1946 collection, in which early signs of the New Look appeared—before moving on to the west coast. The last venue in the tour was the M.H. de Young Memorial Museum in San Francisco. The figurines remained there, and in 1952, with the consent of the Chambre Syndicale de la Couture, were transferred to the Maryhill Museum in Washington for storage. Several decades later, they were restored and put on show in Paris in 1990,[56] after which they began a new tour to New York and Chicago, where I went to see them with the eyes of the child who had been too young to catch more than a glimpse of them in their earlier incarnation.

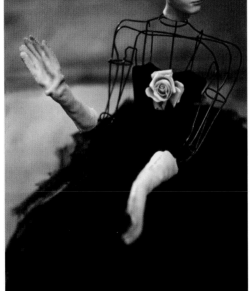

FACING PAGE Drawing by Christian Bérard
for the catalog of the Théâtre de la Mode,
Paris, 1945.
RIGHT Figurines for the Théâtre de la Mode, 1946.
Far right: black Rodier wool dress,
notched collar, front buttoning, and tucked waist,
straight skirt with three asymmetrical tiers,
toque by Legroux. Right: black velvet strapless
bodice with pink satin rose, full skirt
in black tulle over black faille petticoat.
PAGE 175 Hélène Rochas, February 1947.

COUTURE
AND
PERFUME

1945│1955

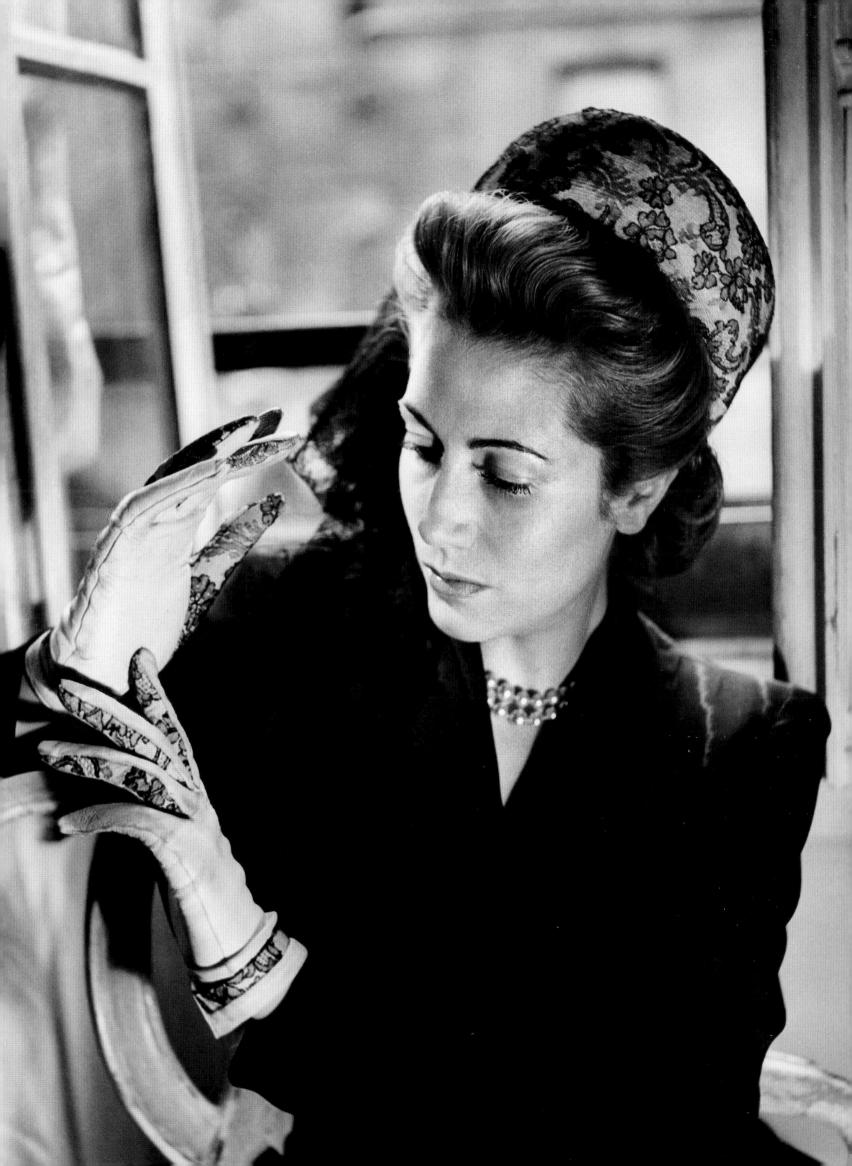

PARFUM
AUDACE

PARFUM
AVENUE MATIGNON

ROCHAS

MARCEL

PARFUM
AIR JEU

PARFUM
AUDACE

MARCEL ROCHAS
PARIS

"HOW I ADORE, DEAR INDOLENT,
YOUR LOVELY BODY, WHEN
LIKE SILKEN CLOTH IT SHIMMERS—
YOUR SLEEK AND GLIMMERING SKIN!
WITHIN THE OCEAN OF YOUR HAIR,
ALL PUNGENT WITH PERFUMES,
A FRAGRANT AND A WAYWARD SEA
OF WAVES OF BROWNS AND BLUES,
LIKE A BRAVE SHIP AWAKENING
TO WINDS AT BREAK OF DAY,
MY DREAMY SOUL SETS FORTH ON COURSE
FOR SKIES SO FAR AWAY."

CHARLES BAUDELAIRE, "THE DANCING SERPENT," *THE FLOWERS OF EVIL*, 1857.

The year 1944, the year of my birth, the year of *Falbalas*, and the year of the Liberation of Paris, also gave my father an opportunity to pay vibrant homage to his mentor, Paul Poiret, while starting on his future path as a perfumer. For my father, the idea of couture without perfume was inconceivable. And just as any artist has a master whom he admires more than others, Marcel Rochas was greatly influenced by Paul Poiret. They had the same way of draping live models in the studio. They shared the same taste for bright colors, costumes, embroidered capes and trimmings, the same love of parties and pomp, pushed to the brink of bankruptcy. It was Poiret who launched the stylish line Les Parfums de Rosine (named after his eldest daughter), which made a lasting mark on the profession. Thirty-six perfumes were added to the collection between 1911 and 1929. In the early twentieth century, it was the couture houses that developed luxury perfumery. After all, they had a thorough knowledge of their female clientele, and had won women's trust through their ability to meet their needs in matters of clothing—the art in this lying in knowing how to create those needs. Who better than a couturier to satisfy a woman's expectations? The rules of this game that was played between client and supplier, friend and confessor, fueled a climate of desire and frustration that the shrewd couturier would endeavor to extend to the field of perfumes and accessories. This proved to be a not inconsiderable source of income that would help balance the accounts, and the share represented by perfume at Marcel Rochas grew after 1945. It was a direction that had been taken after World War I by Chanel (1924), Lucien Lelong (1924), Patou (1925), Lanvin (1928), and Molyneux. The new perfumery business was characterized by its brand focus, and it conquered markets worldwide.[1]

FACING PAGE AND ABOVE Audace, Air Jeune, and Avenue Matignon, Marcel Rochas's first three perfumes, circa 1936–39. Rectangular opaque white glass bottles featuring the blue Rochas band, with matching tubes of lipstick. House of Rochas archives. "The same originality characterizing the designs of Marcel Rochas, the young avant-garde couturier, is to be found in the new perfumes he has brought out for his elegant clientele…. They are bound to be a hit with every sophisticated woman. The packaging is worthy of the delicious fragrances within: imagine crisply cut square bottles in a white, opaque material distinctly reminiscent of Sèvres biscuit porcelain…. It's chic and it's new." *L'Art et la Mode* no. 11, November 1936.

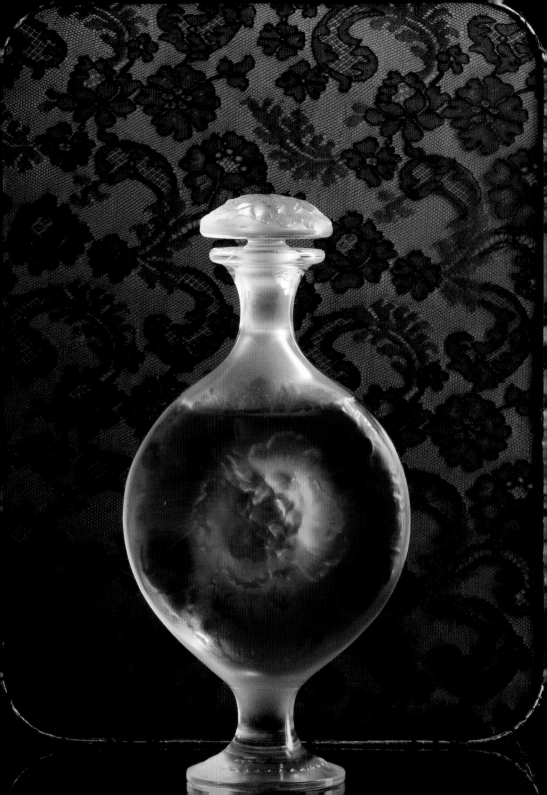

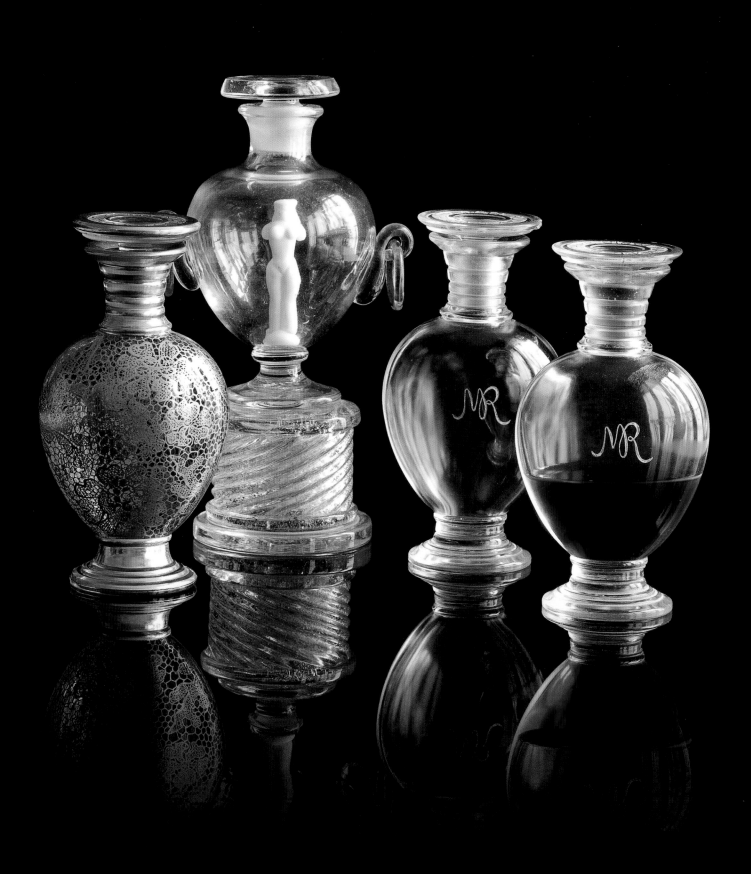

Fête de
nuit

PAGES 178–79 Amphora bottle in crystal with a large engraved flower,
designed by Lalique for Femme, with its satin box clad
in black Chantilly lace. House of Rochas archives.

FACING PAGE Amphora bottles designed by Lalique for the perfume
Femme, circa 1945–50, one of them featuring a gold lace motif.
At the back, a glass amphora bottle containing the statuette
of a woman said to have inspired the Femme bottle,
first half of the twentieth century. House of Rochas archives
and Laurent Gosset collection.

ABOVE Femme evening gown. Drawing by Jacques Demachy,
published in *Couture*, June 1946.

PAGE 182 Femme evening gown. Illustration by René Gruau, 1946.

PAGE 183 Stopper of a Femme bottle, stamped Marcel Rochas Paris,
circa 1945–50. House of Rochas archives.

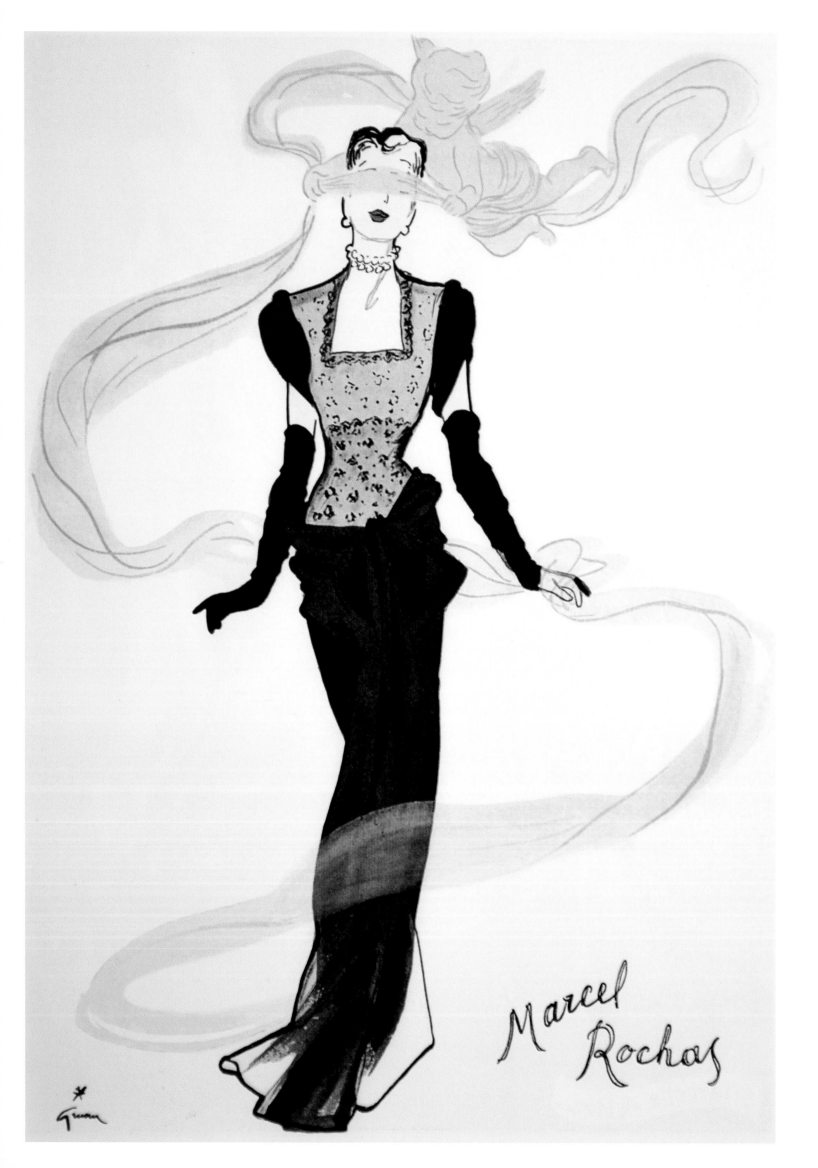

Marcel Rochas

Femme

PARFUMS ROCHAS

PARIS

MARCEL ROCHAS

FLACON-VOYAGE
Femme
RCEL ROCHAS

My father entered the arena in 1936. Why not add a second line of fame to his renown as a couturier? His first perfumes were named Air Jeune, Avenue Matignon, and Audace, and were accompanied by a range of lipsticks and face powders. All that remains of these creations today is a collection of white glass-paste bottles in a wide range of shapes and sizes,[2] reminiscent of the simple lines of Chanel N° 5. Their very 1930s design was underscored by a dark blue Marcel Rochas band with white and red lettering, and the rectangular stopper engraved with the monogram MR had a very modern look. The war put a stop to the career of these early perfumes, whose recipes have been lost, alas, as has the name of the nose behind them. My father had to wait eight long years for the launch of Femme, marketed as "the best perfume in the world." In the meantime, he developed his first perfumery lines, along with the hats and accessories he called *frivolités*: gloves, jewelry, bags, belts, and so on. The opening of a dedicated space for these in 1939 was a prelude to the specialist companies he would set up in the following decade.

When you have enveloped the female body in so many fabrics, it is only natural to want to add a fragrance: "All I had to do was to symbolize the essence of all women in a single and unique perfume." This would be Femme. How to capture charm in a bottle? Marcel knew how to create charm, but he needed a partner. He could see that the future of couture houses lay in developing product ranges alongside their clothing lines, and he also knew that in order to do this he would need to bring in new skills. These he found in Albert Gosset,[3] who brought with him his experience in perfumery at Balenciaga and Renoir. Gosset proposed that he and my father should go into partnership. The perfect balance between Marcel Rochas's artistic talent and Albert Gosset's commercial and marketing expertise, combined with the genius of the future great perfume designer Edmond Roudnitska (1905–1996), was to produce some of the greatest perfumes of the twentieth century. Before Parfums Marcel Rochas was even set up as a company, in early 1945,[4] with its factory in the Parisian outskirts at Asnières, the two partners went to visit the Grasse-based "perfume-composer," as Roudnitska styled himself. He remembers meeting my father "during the Occupation. He was a leading figure of French haute couture at the time, and he wanted to return to a more feminine style. He was looking for a perfume, in harmony with this desire…I presented them with a perfume that I had composed and that would become Femme. It was accepted without the slightest discussion, without the slightest alteration, in November 1943."[5] Given the lack of raw materials available, a limited but subtly harmonized selection of ingredients went into the composition of this chypre fruity fragrance: fresh ylang-ylang, white jasmine, and rose; woody notes of oakmoss; notes of preserved peach and plum; and warm amber and musk. "At the time, I was bound to be influenced by everything that had been done between 1900 and 1930…F[emme], although creating a new accord…was conceived, it has to be said, following the framework and techniques of the old perfumers of the first quarter of the century."[6]

PAGES 184–85 Femme, Mouche, and Mousseline boxed set, printed with black Chantilly lace, circa 1950. Femme travel bottles. At the back, Femme bottles, circa 1965–70. House of Rochas archives.
BELOW Detail of Femme bottles stamped Marcel Rochas Paris, circa 1945–50. House of Rochas archives.
FACING PAGE Femme satin evening gown with Chantilly lace and embroidered with sequins, worn by Anne Vernon. *L'Officiel de la mode*, nos. 289–90, March 1946.

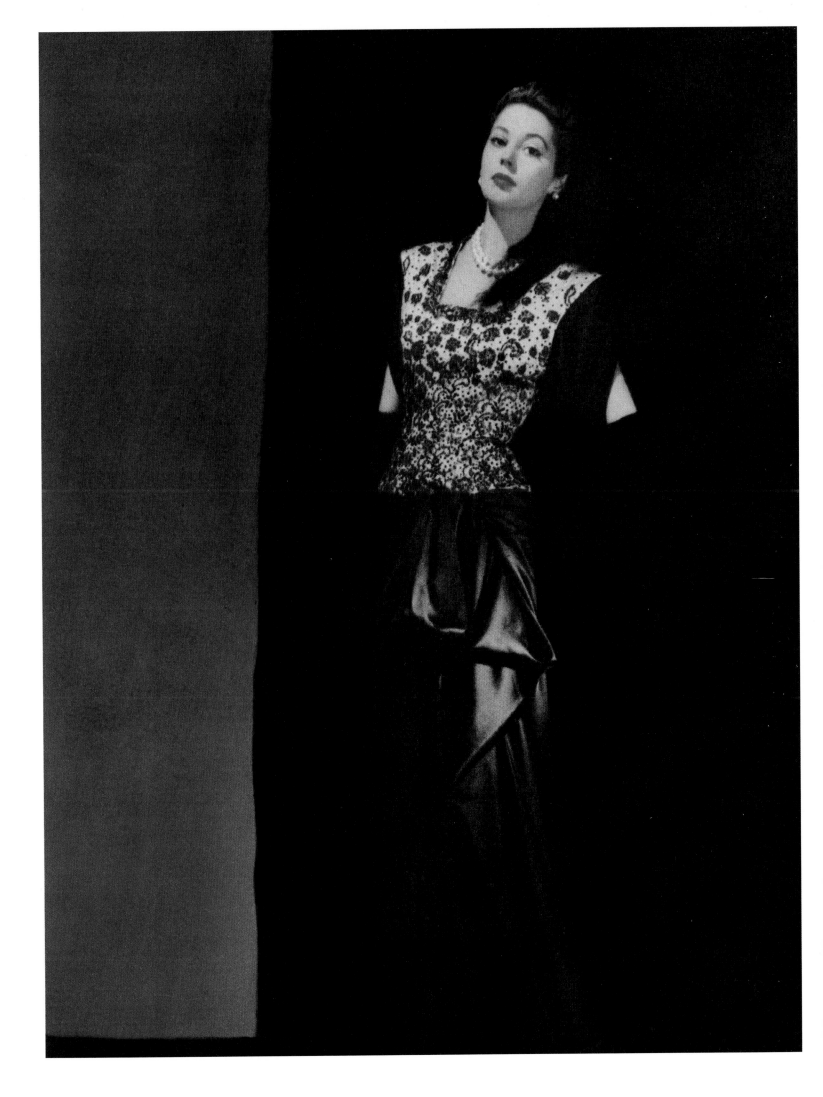

Edmond Roudnitska devoted sixty-five years of his life to perfume, serving it with unfailing passion and high standards. At the age of twenty-two, he had learned his profession on his own, working in every sector, including quality control, composition, sales, and public relations, and getting to know the North American, Latin American, and Far Eastern markets. It was a hands-on apprenticeship for a self-taught man whose original ambition was to be an opera singer rather than a perfumer. His meeting with Marcel Rochas in 1943 and the launch of Femme brought Roudnitska—who had never himself served under a master—the status of master perfumer. He would create five perfumes for my father, whom he held in esteem and affection, he told me. He was always grateful to him for having given him that first chance. His partnership with Christian Dior was to be equally decisive; the two men soon found common ground, as Diorissimo and Eau Sauvage continue to show today. "How not to be humble in the face of success," mused the perfumer-composer; "it costs too much to be exhilarating."[7]

But Edmond Roudnitska's first great perfume was Femme, a scent that evokes memories all over the world, seventy years after its creation. Much thought went into the design of the bottle, and even the young Anne Vernon contributed to it: "To encourage me, one day [Marcel Rochas] asked me to design a bottle for a new perfume. Dressed in black Chantilly lace, the simple little bottle, labeled Femme, was a worldwide success. I worked on a tall form with a very stylized look, a glass steed like a rearing horse. To my mind the object had to fit in the hand like a piece from a game. As a name for my design, I'd come up with nothing better than Échec [chess or check—but it also means failure]."[8] It was Lalique's pinkish-white crystal bottle in the shape of an amphora and clad in black Chantilly lace that gave material form to the extreme femininity my father was looking for. It was apparently designed after a bottle that Albert Gosset—who knew his partner's taste for vintage artifacts—found in an antiques shop.[9] Suggesting the soft curves of a woman's body, it embodied the male fantasy of an alluring woman in a long sequined sheath dress, conjuring up the image of a generously endowed seductress-actress in her boudoir: a reminder of his trip to America in 1934 and the lace gowns worn by the curvaceous Mae West, perhaps? The perfume was launched in 1944 on a modest budget. In the latter years of the war, perfumers could not afford major investments. But its quality and originality were enough to catch the attention of the fashion world and Paris society circles. As the only luxury perfume to be launched right after the war, Femme soon became popular among Parisian women.[10] "Paris's rich and famous received an invitation one morning to subscribe to the luxury edition of the perfume 'Femme,' in a numbered crystal bottle by Lalique…a limited edition like a book, in a luxury 'binding,' all in black Chantilly lace. Fashionable figures were enthusiastic: the Duchess of Windsor, Princess Marina of Greece, the Vicomtesse de Noailles, Madeleine Renaud, Arletty, Michèle Morgan, Danielle Darrieux, Edwige Feuillère, Gaby Sylvia, etc."[11] It proved very popular in Latin countries, though less so in English-speaking countries. Following his instinct, Marcel Rochas brought out a complementary line of scented cosmetics, and created for my mother the dress named Femme, with a bodice of black and white lace, embroidered with motifs overlaid on a black satin skirt. The headpiece was a black bird topped with a long aigrette.

ABOVE Bronze Femme powder compact, engraved on both sides with a Chantilly lace motif. Sophie Rochas archives.
FACING PAGE Travel box for Femme in black moiré with a velvet band. Baccarat crystal atomizer engraved with a Chantilly lace motif. Escale pump by Marcel Franck, circa 1948. House of Rochas archives.
PAGE 190 Advertisement for the Femme atomizer.
PAGE 191 Femme and Moustache atomizers, circa 1955. House of Rochas archives.

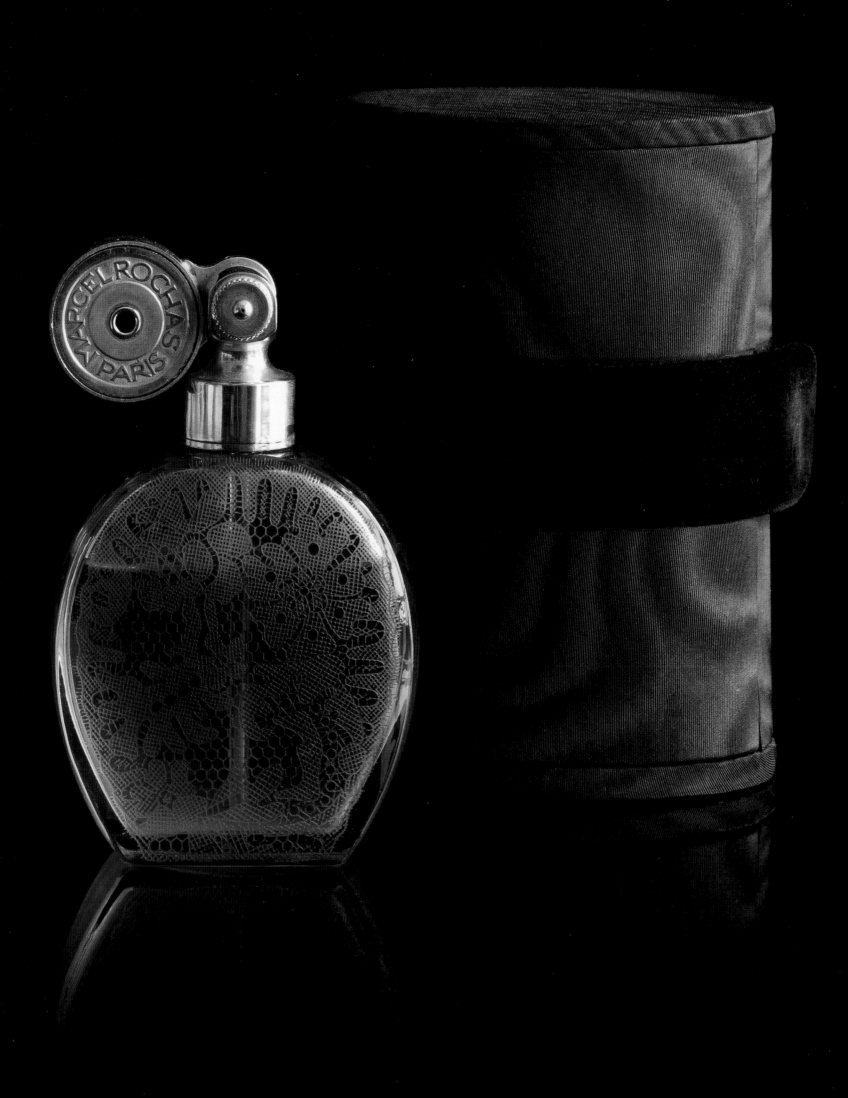

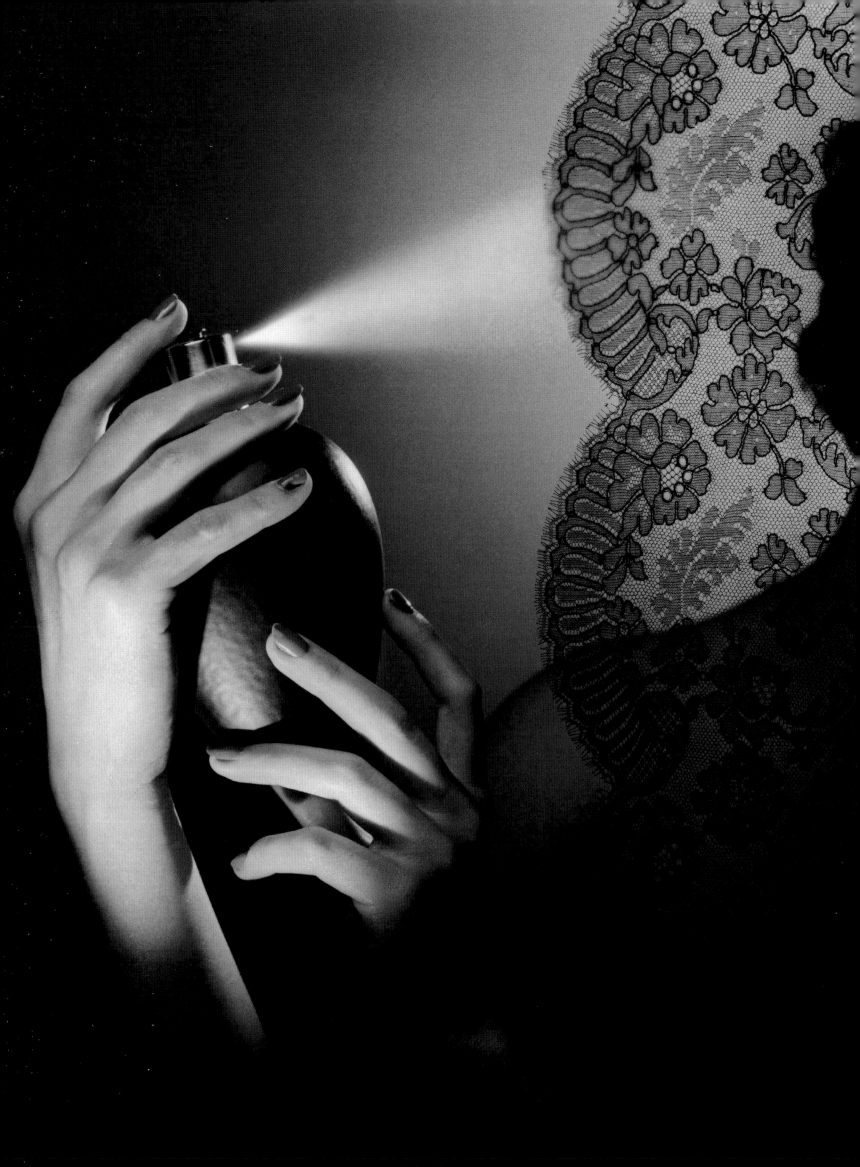

EAU DE COLOGNE
"MOUSTACHE"
MARCEL ROCHAS

EAU DE COLOGNE
"FEMME"
MARCEL ROCHAS

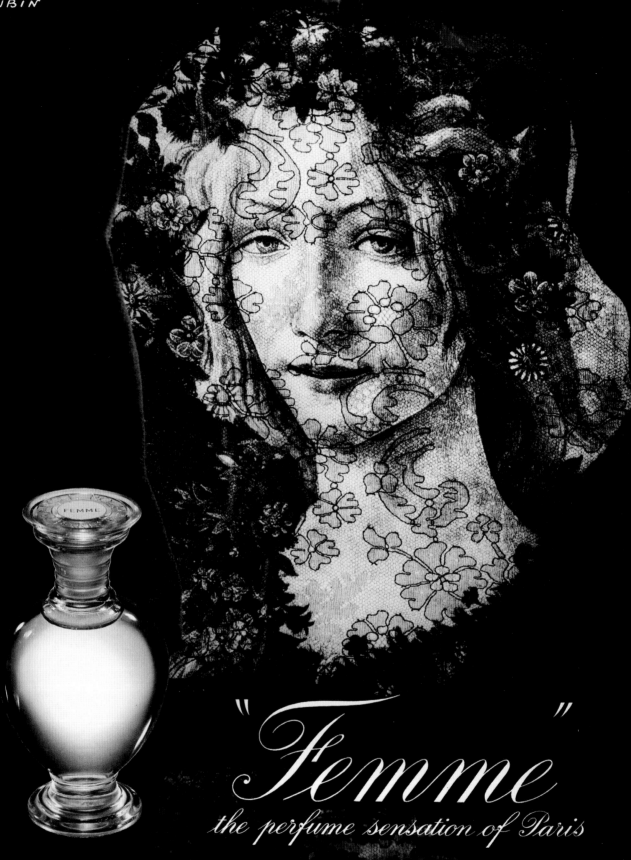

"An incredibly feminine symphony. A *bateau ivre* of travelers of the mind watching over an adorable sleeper, exhausted in her lace before a gala evening."[12] Thus was Femme born in 1944. My father dedicated it to his third wife, his muse, my mother, while offering it to the women of the world as a sign of his love, in tribute to their beauty. *Futilités, frivolités, froufrous* [frivolity and frills], and *Falbalas* were all words that went with Femme. Articles in the press at the time spoke of "a perfume with vibrant notes symbolizing a woman who is sure of herself, alluring and seductive."[13] Femme would soon find its place among timeless perfumes such as Chanel's Nº 5 and Jeanne Lanvin's Arpège.

In fall 1945, the war in Europe was over. It was time to think of a large-scale public launch. An invitation card was designed, in the form of a huge butterfly on a sky-blue background, bordered with black lace. In late 1945, a select clientele was invited to the opening of an exhibition entitled Les Parfums à travers la Mode (Perfume Through Fashion), under the artistic direction of Annie Baumel, who made the window displays at the Hermès store in Paris famous worldwide. The exhibition ran for one month at the avenue Matignon store, where the salons were filled with showcases designed and decorated by Christian Bérard, the famous "Bébé." It was no surprise to find Bébé's companion, Boris Kochno, as artistic director of the exhibition catalog, which Marcel Rochas dedicated to Paul Poiret, "the extraordinary precursor" who turned "Couture into an Art, when it had only ever been a profession."[14] The "prodigious driving force" had died a year earlier amid general indifference; his "passing, which went almost unnoticed, left remorse in our soul and the bitter taste of ingratitude on our lips."[15] The talented illustrator Georges Lepape, who worked closely with Poiret, was asked to design the catalog's frontispiece. It was no coincidence that Marcel Rochas should choose an illustration with stripes as its main theme. To create a historical setting for Femme, the show presented important clothing and accessory designs, jewelry, precious furniture, pots for cream and boxes for imitation beauty spots, makeup, fancy containers, bottles, shagreen cases, and toiletry sets, from private collections or loaned by prestigious houses such as Cartier, Lalique, Mellerio, and Boucheron. The display cleverly celebrated the new Femme alongside Marie-Antoinette's Eau à la Coquette Flatteuse, Yvette Guilbert's 1900 boudoir reconstructed by Jacques Damiot, and a sumptuous toiletry set, on loan from Hermès, that had once belonged to a Mexican emperor.

To promote "the best perfume in the world" and celebrate the tenth anniversary of Femme, in early December 1954 my father held a private reception at Maxim's restaurant. Everyone who was anyone in Paris vied for an invitation. Once again, as in the early days of 1925, the designer created a bold tableau that caused a stir. The few photographers who had been given access to the event crowded around a ravishing model who was draped in a black lace veil that hugged the curves of her naked body and enveloped her face up to her eyes, which were hidden behind a swallow mask. It caused a sensation. On display for the guests was a form of elegance tinged with a new kind of sex appeal. The motionless model held the Chantilly-lace-covered oval box containing the precious bottle against her body. The only touches of white, reminiscent of the makeup worn by the mime artist Marcel Marceau, were the top of the young woman's very white forehead, accentuated by her shoulder-length black hair, a double row of pearls, and, of course, the vaporous halo of white tulle arranged inside the box. The young woman's long fingers emerged from fingerless lace gloves. The guests were spellbound by the sensuality exuding from both the perfume and the model. Looking regal, my mother wore a black taffeta dress with a swan's-neck collar rising up to the chin and long sleeves breaking over her slim wrists. The almost monastic dress, contrasting with the unnerving transparency of the lace, was accompanied by a white swan jewelry piece placed in the famous coiffure with the horsehair roll. Between black swan and white swan, her dancer's grace dazzled not only her husband and mentor but also the whole crowd present. People admired her magnificent dress, of course, but her wickedly beautiful eyes—always those eyes—were devastating.

FACING PAGE Advertisement for Femme reproduced in *Vingt-cinq ans d'élégance à Paris, 1925–1950*.
ABOVE Presentation box in cardboard and lace containing the copper powder compact. Sophie Rochas archives.
PAGES 194–95 The Mousseline (left) and Mouche (right) perfume and beauty care lines. House of Rochas archives.

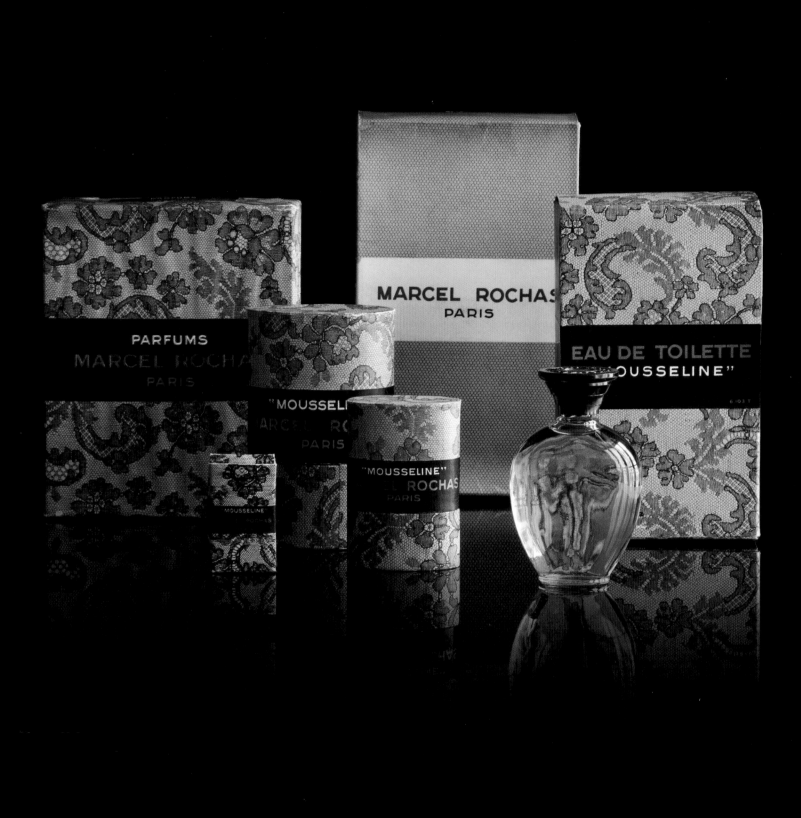

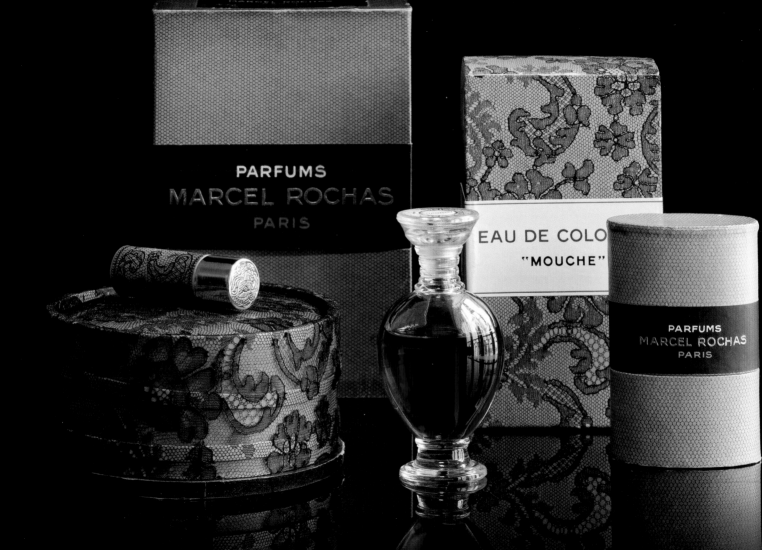

PERFUME AND FANCY ACCESSORIES

The ingenious links that the house of Rochas developed between couture and perfume are powerful illustrations of its dual heritage. Marcel Rochas apparently sought to develop a brand environment from the start, from 1925, selling luxury perfumes alongside dresses, coats, furs, and hosiery. While the decision was probably commercially motivated, the presence of perfumes in the Rochas store reflected their growing role in the fashion world at this time, recalling the approach adopted by Rochas's inspiration Paul Poiret, whose perfumes he would describe as "the irresistible complement" to his couture designs. From 1936, the Rochas perfumes Audace, Air Jeune, and Avenue Matignon went on sale in the boutique at 12, avenue Matignon, their three names summing up the spirit and "the charm of all of the fashion designs" (Constance d'Heigny, *Femme de France*, April 1, 1937).

From 1944, this combination of fragrance and elegance took on a new dimension with the perfume Femme. Marcel Rochas lent a couture accent to the amphora-shaped bottle, wrapping it in black Chantilly lace—which became one of the brand's stylistic themes—and setting it in a satin-lined box: "I in turn created my own perfume, Femme, in the curvaceous, feminine style of my couture creations. In its precious amphora swathed in lace tulle, the prestigiously named Femme earned, in just a few seasons, the coveted title of 'the best perfume in the world.'" Femme was launched at a time when fashion was seeing a "return to femininity," and it reflected a stronger partnership between couture and perfume.

This principle of association led Rochas to come up with other products related to his perfumes, such as lipsticks, face powders, stockings, diaries, Chantilly-lace-printed suede, kid or doblis calfskin gloves, handkerchiefs in lace-printed lawn, silk scarves, and handbags. These articles were available at the Parfums et Frivolités (perfume and fancy accessories) store that opened on avenue Matignon in the late 1940s. Marcel Rochas even associated his men's fragrance, Moustache, with this interplay between perfume and couture. Launched in 1949, Moustache was packaged in a taupe-gray corduroy-lined box of a "virility that contrasts with the silk and Chantilly lace." Yet corduroy was also used in items targeting the brand's female clientele, in the form of gloves or a Moustache dickey. The introduction of the "Moustache spirit" in the Rochas couture collections added a touch of humor and male/female reversal. When asked which he thought was the most humorous of his fancy accessories, Marcel Rochas replied, "My Moustache collar in starched piqué with a tie whose points are like the tips of a mustache." **JG**

LES BAS "*Femme*"

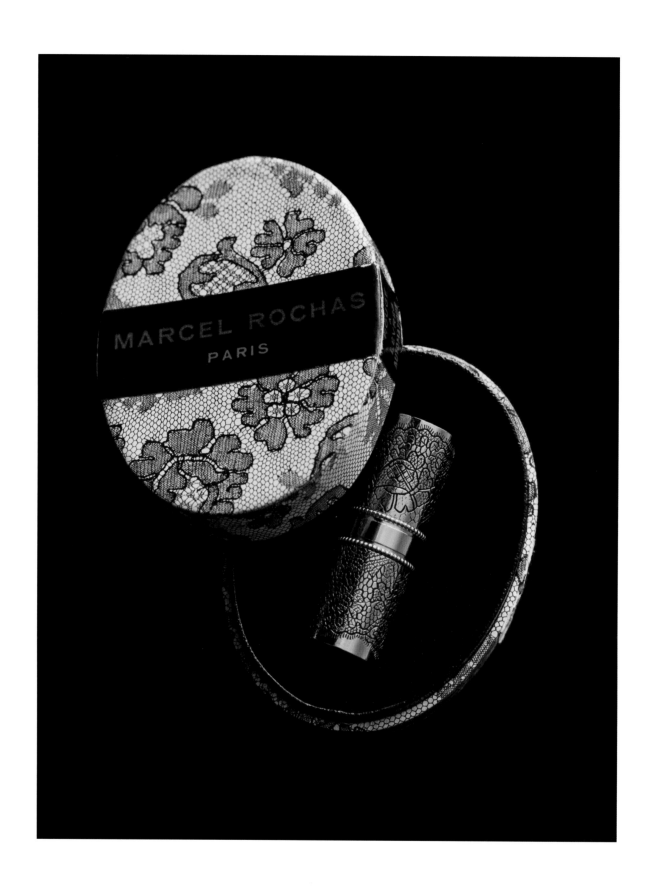

ABOVE Femme silver lipstick tube in its original lace box,
1940s. House of Rochas archives.
FACING PAGE Femme handkerchiefs in their original box.
Sophie Rochas archives.

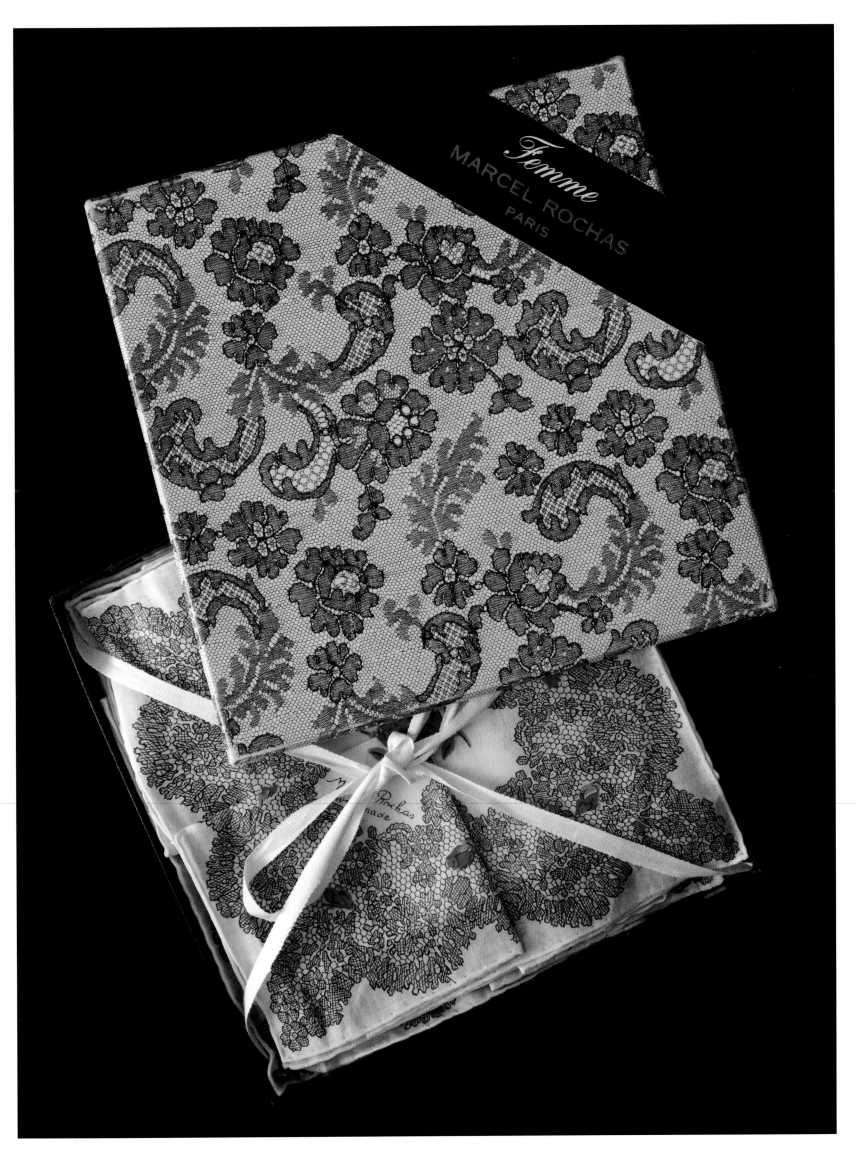

HOMMAGE A PAUL POIRET

LES PARFUMS
A TRAVERS LA MODE

Retrospective de 1765 à nos jours

CHEZ MARCEL ROCHAS
12, Avenue Matignon, Paris

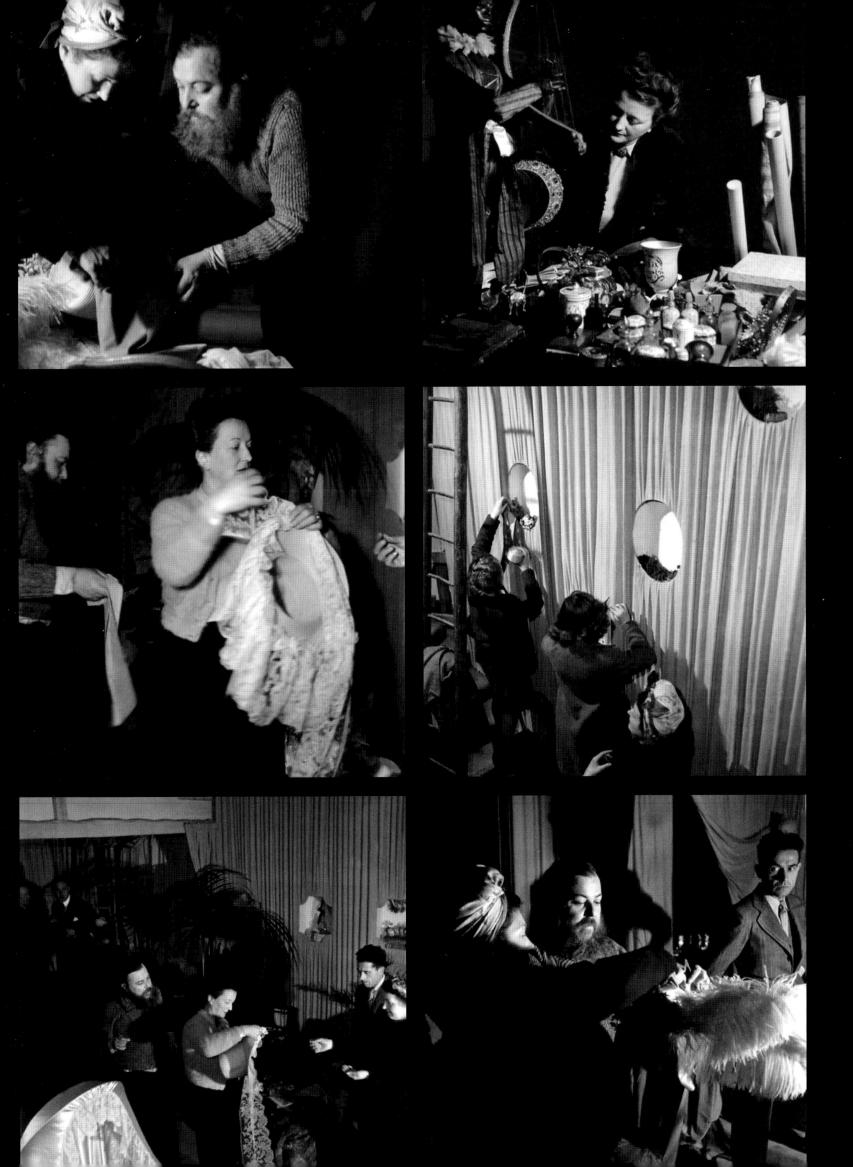

Five years later, my father created a male pendant for Femme. The masculine confidence and elegance of Moustache contrasted with the feminine voluptuousness of its counterpart. Based mostly on moss, woody essences, and rare fruits, the skillful accords of this "*parfum piquant*" were composed once more by Edmond Roudnitska. "Although floral with marjoram, wild thyme, and rosemary, it is the harvests of a torrid land that this scent conjures up: lavender, yew, thick moss, and fast-ripening fruit. Jays flying up out of the juniper. Blue rabbits sitting in a circle on a carpet of thyme. The saps of rosewood and peeling birch have been added to this magic potion, a distillation like Alphonse Daudet's Provençal windmill."[16] Moustache was the first men's perfume to come with a complete line of toiletries, including aftershave, eau de toilette, eau de parfum, soap, shaving foam, and bath oil. In early 1949, my father created two companies with Albert Gosset, who was a shrewd businessman: Produits de Beauté Marcel Rochas[17] and For-Men Parfumerie.[18] The previous year, they had founded Société Frivolités Marcel Rochas,[19] which would develop accessories. Haute couture was losing ground, weakened by repeated assaults from the clothing industry that were given constant publicity by women's magazines. Copies of haute couture models, sold illicitly at a lower price, brought further competition to a profession in decline. While women were gaining freedom from the traditional wearing of hats, gloves, and stockings, which had disappeared during the war, American "ready-to-wear" offered the French women's clothing industry the attractive model of *prêt-à-porter* from 1955.[20] With the exception of a privileged few, postwar women gradually turned to this new development, which developed rapidly: in 1955, 40 percent of French women were already dressing in ready-to-wear (compared to 95 percent in the United States).[21] My father was worried. He could see the direction in which couture was going: the only profession

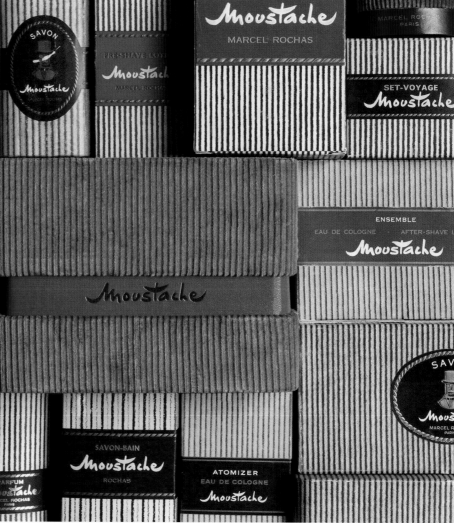

PAGES 200–201 Launch of the perfume Femme. Exhibition catalog *Les Parfums à travers la mode*, Paris, Marcel Rochas salons, 1946. Boris Kochno and Annie Baumel designed the exhibition and showcases.
ABOVE The perfume Moustache, with a bottle and scarves from the line.
RIGHT AND FACING PAGE Moustache packaging and bottle range. House of Rochas archives.

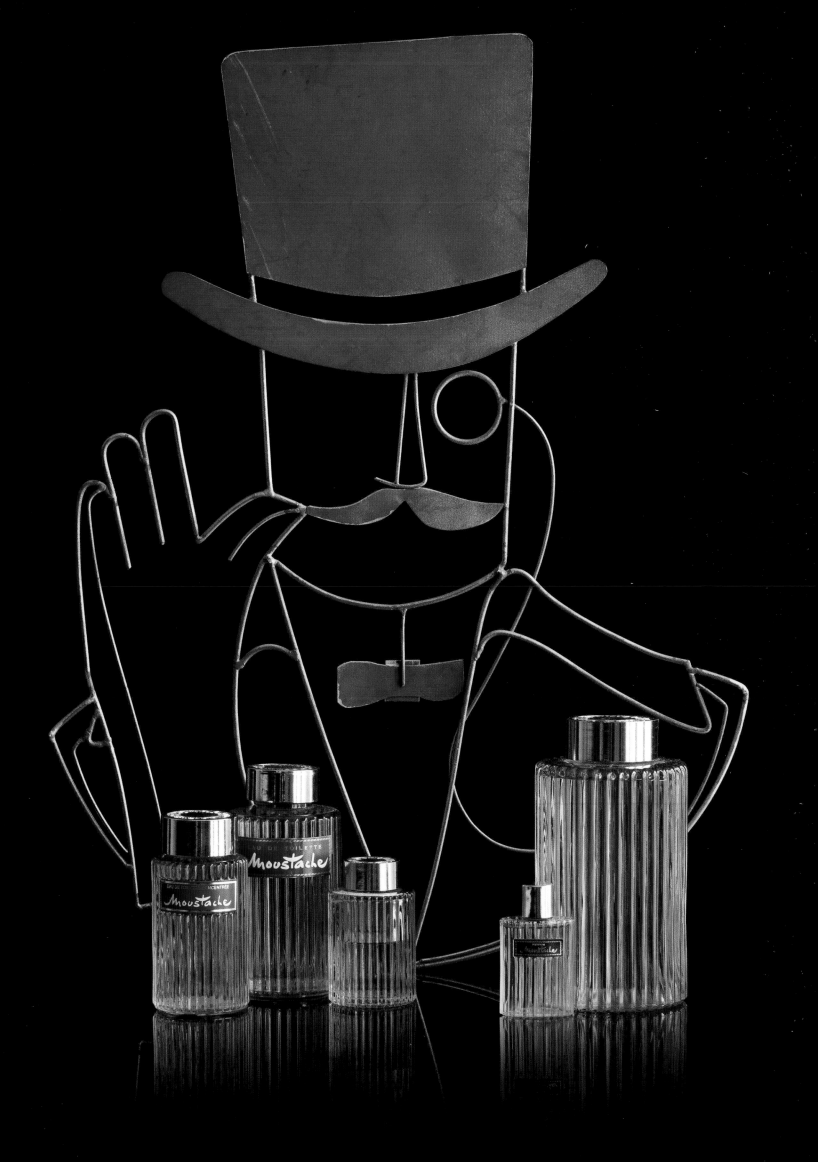

he loved, and the only one he knew. He urgently needed to find new outlets. In its first year, For-Men launched the perfume that was to anchor the brand among its male clientele. "Marcel Rochas perfumes men," observed *L'Officiel*. Part of the success of Moustache, which evoked the Belle Époque, was down to Parisian women. Rochas had spent a long time trying to find the name for this perfume. No name of a flower, bird, or animal name seemed right, and he had begun to despair, when one evening his cat Mouche came into his office and looked at him. At the sight of its glossy whiskers, he cried: 'That's it, Moustache, I'll call the perfume Moustache!"[22] Unlike the gentle curves of the Femme bottle, the fluted glass cylinder of Moustache had a self-assured, virile look, with a playful touch in the mustache-shaped cross stroke of the "t" on its label. It was a success. "What would Jean-Louis do without Moustache!" exclaimed the actress Madeleine Renaud, referring to the great actor Jean-Louis Barrault.[23] For the launch of his new baby, my father commissioned Waldemar-George to mount an exhibition of portraits of men sporting mustaches, from the sixteenth century to the present, to be held from December 16, 1949 to January 7, 1950. On the day of its opening, his friend Pierre Brasseur, a talented actor and colorful character who was not always completely sober, was said to have spilt a large glass of something, possibly champagne, over one of the portraits. Held in the newly decorated salons at avenue Matignon, in aid of *Le Figaro*'s student grant scheme, the exhibition Moustache. Portraits d'hommes du XVIe siècle à nos jours was accompanied by a catalog featuring texts by Waldemar-George and James de Coquet, and quoted Maupassant's declaration that "There is no love without a mustache."

ABOVE, LEFT Launch of the perfume Moustache. Marcel Rochas and Hélène Rochas on either side of Georges Geffroy at the exhibition Moustache. Portraits d'hommes du XVIe siècle à nos jours, Marcel Rochas salons, December 1949. On the right is Charles de Beistegui and on the left the composer Henri Sauguet.
ABOVE, RIGHT Advertisement for Moustache.
FACING PAGE Bottle and packaging range for the Moustache perfume and beauty care line. House of Rochas archives.

In the meantime, Edmond Roudnitska had created not only two more colognes but also three more perfumes for Rochas:[24] Mousseline (1946), Mouche (1948), and La Rose (1948). Mousseline came in the same voluptuously curved bottle as Femme with its black lace box, this time on a lime-yellow background. "I was of course inspired for this perfume by Chypre de Coty, but I wanted to extrapolate something original from it, as crepe de chine had done in its time and genre.[25] 'Mousseline' was composed on a base of moss and crystals, with an extremely floral and fresh head note, heightened with green notes. Linking the extremes were natural essences enveloped by a heady methyl ionone."[26] The 1953 advertising slogan for Mousseline, "the second perfume by Marcel Rochas," said much about Rochas's fame. It was no longer necessary to describe the perfume in eulogistic terms: it sufficed to say that it was Marcel Rochas's second perfume. Mousseline acquired its name by accident, so to speak. My father had chosen Chiffon, but had to change it a year after the perfume's launch because it had already been registered in South America. So it was called Mousseline, a better name it would now seem, although the change proved disruptive to the launch.[27]

"A swath of mink slips from a heaving bosom. Is it the fault of the champagne, the dancing, or words that would never have been uttered without the daring that nighttime brings? The fur mantle heightens the scent that hangs in the air, whose amber-tinged musk brings out the nonchalant tuberose and mystical sandalwood. A provocative scent like a satin beauty spot, provocatively placed at the corner of a narrowed eye."[28] To coincide with the launch of the perfume Mouche in 1948, my father also revived the fashion for wearing a *mouche*, or imitation beauty spot. As we have seen, Mouche was also the name of the family cat (who could have come straight out of a Leonor Fini portrait), and *Les Mouches* was the title of Jean-Paul Sartre's tragedy first performed in 1943. Roudnitska found this name "debatable" and believed that "Marcel the couturier was thinking primarily of the beauty spots worn by fashionable women."[29] My father retained the same instantly recognizable presentation theme for Mouche, this time in periwinkle blue. Roudnitska described how the perfume evolved: "I started with the rather bold idea of combining in strong proportions two natural base notes, each with a very marked personality, which would create a clash and a heaviness. The solution then came from the choice of intermediary notes, rather particular floral notes that contributed to a harmonious development and which, being quite tenacious in themselves, mingled with the final duo (warm and amber-tinged) to lighten it and constitute a very personal and well-rounded blend that appealed to all those who smelled it."[30]

A range of accessories accompanied the launch of Mouche: gloves, small hats, beaded velvet bags, along with a boxed set of the three women's perfumes. Chiffon scarves bordered with Chantilly lace in matching colors added a further touch of refinement to these carefully developed ranges. "This perfume, which had proved wildly desirable to both men and women who smelled it while I was working on it, might have had a great career had it not been for an accident in its manufacturing process." The introduction of an "undesirable note" by an unscrupulous supplier altered the fragrance and tarnished the image of Mouche: "A shame, it was a very rich note."[31] Whatever the case, I loved beauty spots in my childhood. I tried them on in secret, until the day when I was at last allowed to wear my first one for a fancy-dress tea party. I was dressed as Columbine, my brother as Harlequin. In a photograph taken that spring afternoon in 1950, I am sporting a broad smile, looking radiant and mischievous; of course, I was the only one who knew about my secret relationship with beauty spots. My black Columbine tricorn hat, balanced precariously on my head, contrasted with my long, ash-blonde hair.

BELOW Detail of a rose on the Femme travel spray (see pages 184–85).
FACING PAGE Launch of the perfume La Rose. Marcel and Hélène Rochas arrive at the rose garden at L'Haÿ-les-Roses for a promenade concert on June 10, 1949 (top, left). The couturier with his daughter Sophie, who wears a dress chosen by her father (bottom, right). Among the guests was the actress Simone Simon (center). Advertisement for the perfume La Rose de Rochas, "le plus beau parfum," circa 1948 (top, right).

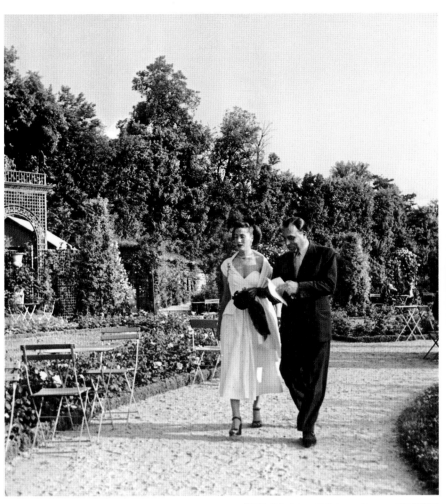

"La Rose de Rochas"

MARCEL ROCHAS
PARIS

Will the fragrance La Rose, natural daughter of Femme, be revived one day? According to Edmond Roudnitska, it was Marcel Rochas's most fully developed perfume, *"le plus beau parfum,"* as it was advertised, "a high achievement" for the perfumer-composer. Developed from rare and choice "Hadley" roses, La Rose remained in development for five years, in the greatest secrecy—a wonderfully fragrant secret with its origins in the roses of Cabris near Grasse and a garden on Mont Valérien outside Paris, where Roudnitska had set up his "first and modest laboratory during the Occupation. I smelled a red rose with a full, deep, extraordinary fragrance. That is the one I used as my first model…I was staying in a hotel…where I perfumed the lobby by spraying it with my test compositions—to everyone's astonishment, as perfume was at odds with the shortages of the time. Describing it was simple. Red roses are among the most fragrant and the most beautiful of all. This was one of the headiest, with a fresh and fruity top note, a light and green development, and all the qualities of a complete perfume, caressing the nose as silk does the eye and the hand. To me that perfume was satiny and opulent."[32] This flower-perfume was packaged in the same bottle and the same black lace as Femme and Mouche, but this time with a pink background. Matching chiffon scarves (in an intense pink, naturally) accompanied it. Brought out in late 1948, the perfume was launched on June 10, 1949, the month of roses, the month of my birth. It was one of the great festive events of the Paris season: "Marcel Rochas organized a brilliant concert-promenade among the flowering roses in L'Haÿ-les-Roses, and his guests enjoyed a wonderful musical program while admiring the beauty of the rose garden."[33] Besides music by Schubert, Weber, César Franck, and Tchaikovsky, guests heard a mini-opera on the theme of the rose, composed for the occasion by Henri Sauguet. I remember the dress my father made for me for the occasion, and the exquisite fragrance of all those roses along the beautifully laid-out paths.

After Femme, the perfumes Mousseline, Mouche, and La Rose met with only fleeting success. Perhaps my father was a victim of his own prolific creativity. Was it possible for four women's perfumes in five years to live together under the same brand name, "especially in the shadow of a success like that of Femme"?[34]

BELOW Labels for Marcel Rochas perfumes.
FACING PAGE Evening gown in white tulle from Dognin over a blue silk skirt, bodice embroidered with rhinestones and beads, Marcel Rochas (left). Evening gown in green Chantilly lace, bodice extending into a short cape, Jeanne Lafaurie (right). *L'Officiel de la mode,* nos. 329–30, July 1949.

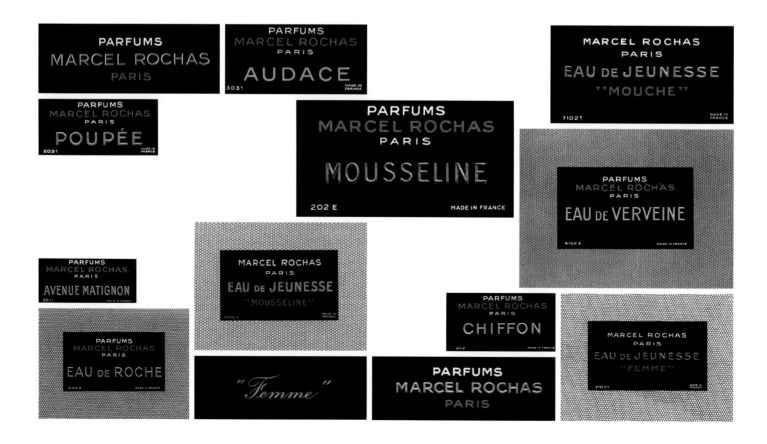

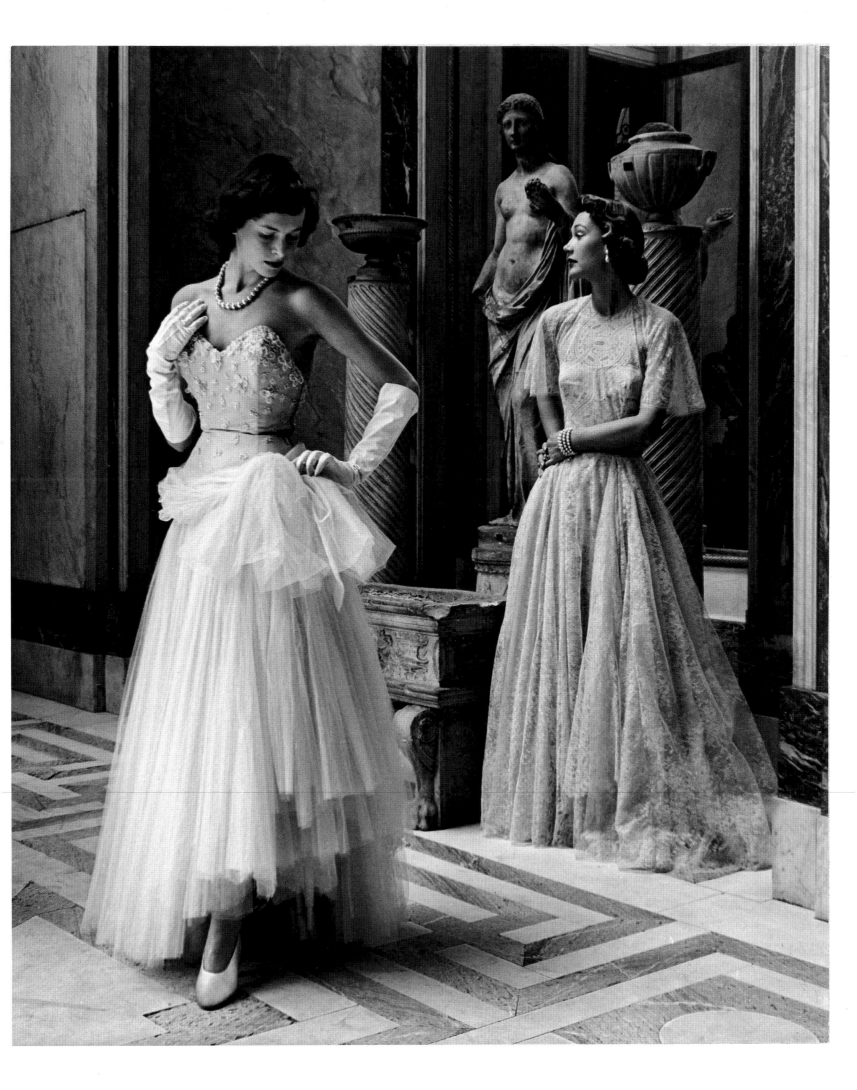

A LASTING SILLAGE

Jean-Michel Duriez, Perfumer of the House of Rochas

The first perfumes brought out by Marcel Rochas were the blue-and-white tri-logy Air Jeune, Audace, and Avenue Matignon, in 1936. What impresses me is the extent to which the vision encapsulated by the young, bold, and Parisian spirit of this trilogy remains a deeply inspirational guideline for the House. Rochas's meeting with Albert Gosset was decisive in entrepreneurial terms; but on an artistic level, his encounter with Edmond Roudnitska proved fundamental. Marcel Rochas had a "nose" for talent. His long and loyal collaboration with Roudnitska contributed several masterpieces to the French perfume industry, including Femme, La Rose, and Moustache, which, to me, are exceptional creative phenomena. Edmond Roudnitska acted throughout those years as the house perfumer, eventually setting up his own perfume design firm, Art et Parfum; the company exists to this day and is run by his son, Michel.

The Marcel Rochas years were prolific ones for perfumery. In the postwar period, couturiers began to take an interest in perfume, realizing how a concern for detail in fashion designs for men and women could extend to creating their fragrant sillage. When Marcel Rochas said that he liked to "breathe" a woman before seeing her, he meant that the sense of smell goes hand in hand with sight, and even enhances it. The ideal combination of couture and perfume that emerged in the early twentieth century was developed through the 1940s, spearheaded by Marcel Rochas, whose interest in perfume dated back to 1936.

Marcel Rochas and Edmond Roudnitska's mutual understanding yielded bold fragrances that were rich in fine ingredients. Femme is one of the original ultra-sensual "gourmand" perfumes; it is a classic floral scent with fruity and spicy notes built on an oakmoss accord (the "chypre" family). Its lingering scent is echoed in many modern perfumes. I used part of this accord in Secret de Rochas, in a kind of tribute to Marcel Rochas and Edmond Roudnitska, combining fruit, flowers, and spices on a chypre base of oakmoss. When I breathe in Femme, I understand how this gourmand fragrance was avant-garde in its irrepressible and incredibly chic sensuality. Wearing it today conveys a pure, but not extravert, femininity—the fashion for gourmand fragrances in the 1990s having sparked a new interest in this perfectly balanced, sumptuous masterpiece.

Marcel Rochas's perfumes have an elegant, sophisticated style that's in keeping with his vision of fashion and his deep love and respect for women. His spirit is still our best guide, helping us reinvent the House from generation to generation. When I became Rochas's in-house perfumer in 2008, I discovered the House's rich and inspirational heritage. It helped me find my creative path and ensure a certain continuity—while, naturally, remaining firmly oriented towards modernity.

FACING PAGE
Advertisement for the perfume Femme.

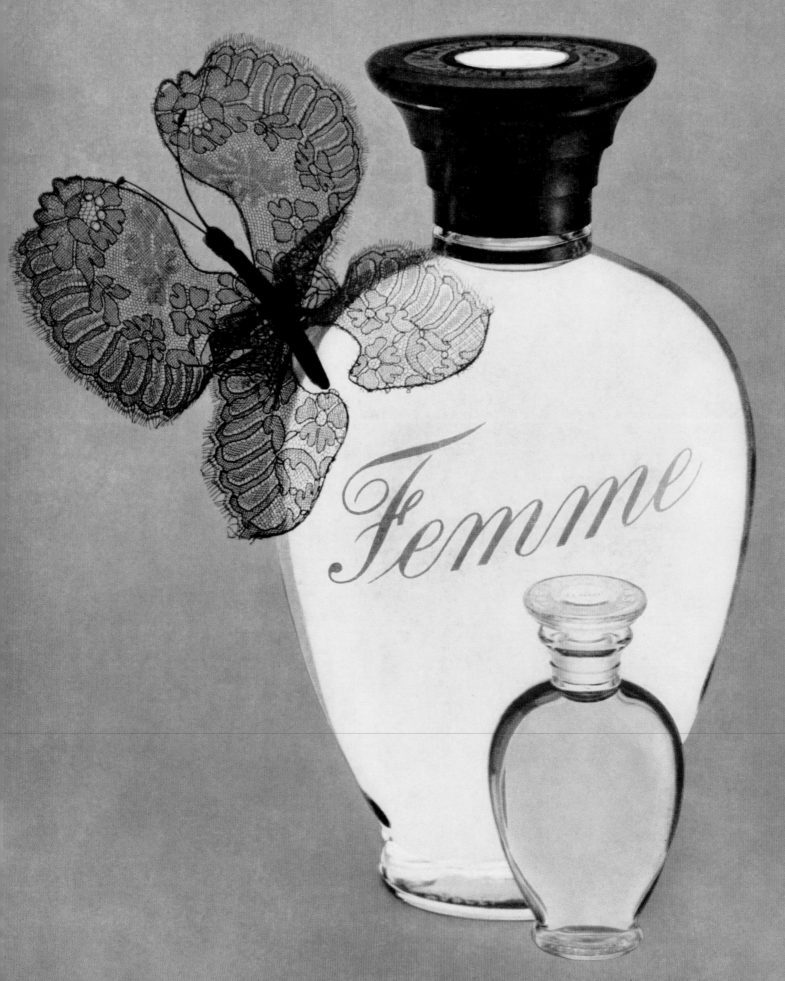

Femme

PARFUM · EAU DE TOILETTE · EAU DE COLOGNE · ATOMIZERS · ROUGE A LÈVRES · POUDRE · HUILE POUR BAIN · TALC · SAVON

MARCEL ROCHAS

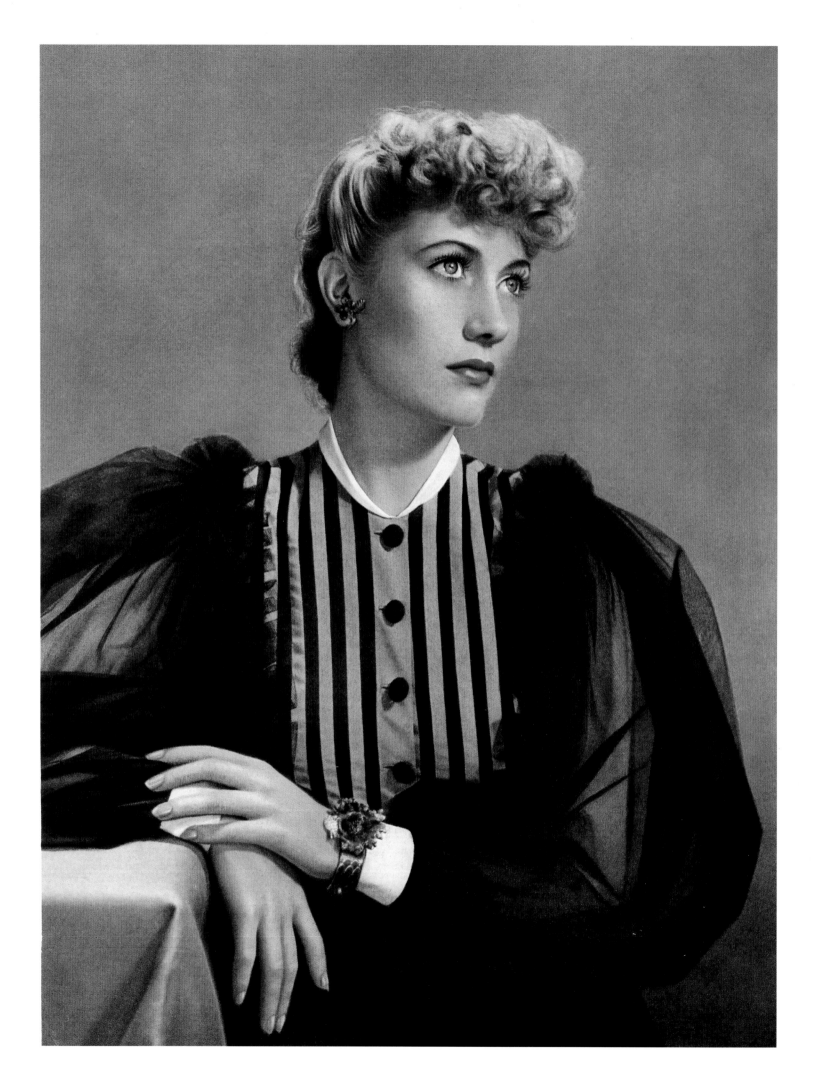

FLOUNCES AND BASQUES: FEMININE ATTRIBUTES These exciting perfume ventures did not stop Marcel Rochas thinking about the future of couture. As a young father and newly married man, at the end of the war he was also one of the great couturiers of his generation. At the age of forty-three, he was a leading figure in his profession. Women's magazines noted few significant changes in the collections of Summer 1945, still confined by the economic situation: "An overall impression of youth, femininity, lively cheerfulness; full, short skirts swirl around, puff sleeves blow up and away. The waist is slim, the bust short, the legs long. It is something of a grown-up doll or little-girl line—a schoolgirl, even, when the bodice is flat and modestly buttoned. But the shoulders are still very wide and a military *je ne sais quoi* in the design of the coats and jackets reminds us that we are still in the year '45."[35] Marcel Rochas skirts remained relatively long, and "composed of slightly shaped flounces." They were worn with tunic tops with wide sleeves that were narrow on the wrist. The couturier liked short, often free-moving basques, boleros, tartans, and "above-the-ankle dancing dresses; for the evening, lots of crinolines."[36] The reworked "Rochas suit" heralded the New Look: an ever-longer below-the-knee skirt, a buttoned jacket tightly fitted at the waist, over more or less full basques, and pockets set at an angle or patch pockets applied to the front and on the chest.

In the fall, "people need to feel peace as one might feel enthusiasm or anger.... Our frayed and tested human nerves yearn for a kind of sentimental peace, just as we might expect a telephone at home, a water supply on every floor, an absence of noise, and a visit from the chimney sweep. The world is a dwelling like any other."[37] The Fall collections were presented under the auspices of the Théâtre de la Mode, which had closed in Paris after enjoying considerable success with the public, and was preparing to open again across the Channel. Are we ready to resume our place? asked "Le Chasseur d'images" in *L'Officiel*, recalling in his introduction to the collection reports of the importance of Lucien Lelong's initiative in getting French couture back on track. This "propaganda tool ... needed to demonstrate in good faith to all of our competitors that it had not only upheld but also amplified the taste and ingenuity that made it so rightly famous."[38]

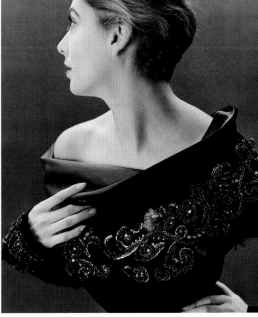

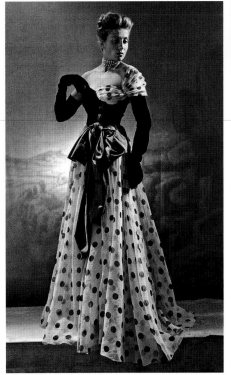

FACING PAGE Hélène Rochas wearing a dress of soft, silken fabrics, 1942.
LEFT Evening gown with a long printed chiffon skirt, cinched at the waist with a large bow. Print motif repeated on the shoulder over a lacquered satin bustier, 1947.
ABOVE Draped dress with a cowl-neck, in black velvet from Combier lined with light-green satin, bodice embroidered with shimmering arabesques. *L'Officiel de la mode*, nos. 333–34, November 1949.
PAGE 214 Evening gown in crepe from G. Pétillault, with an Astrakan bolero. Illustration by René Gruau.
PAGE 215 Evening gown in straw-yellow satin brocaded in bands imitating black Chantilly lace, black velvet, embroidery with black sequins, Fall–Winter 1946. Palais Galliera, Fashion Museum of Paris.

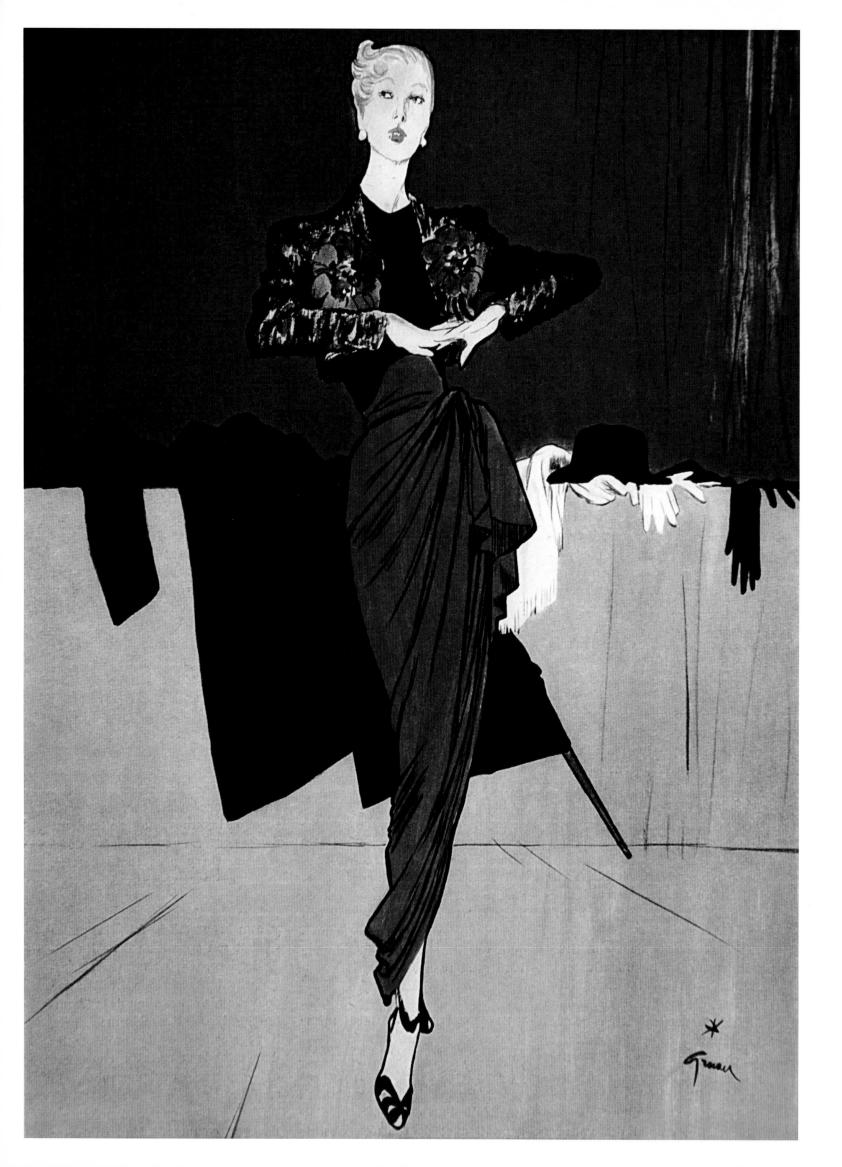

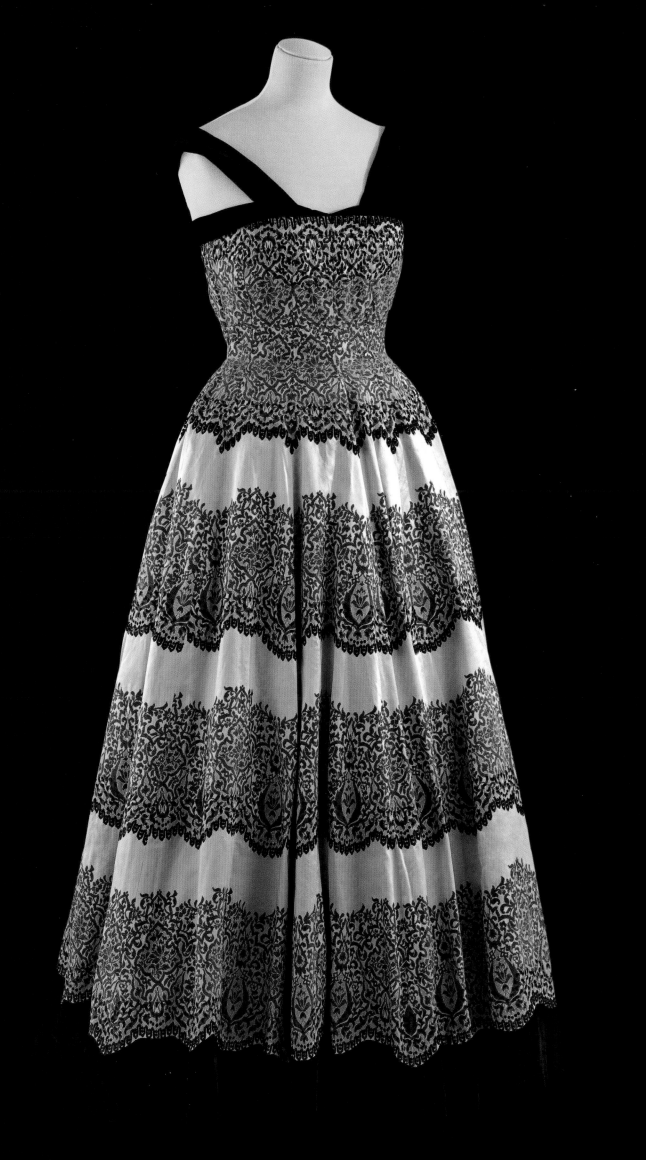

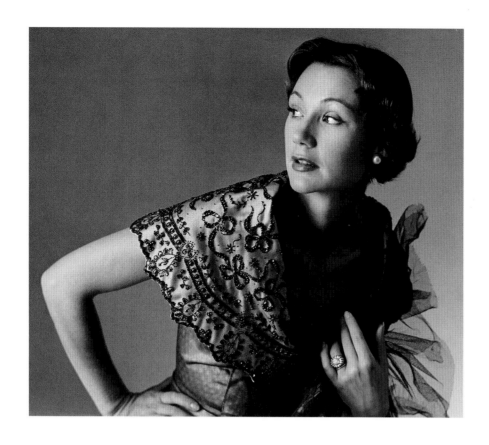

"IN THIS FIRST 'LIBERATED' SPRING COLLECTION, I HAVE GIVEN EXPRESSION TO THE NEW CLIMATE CREATED BY PEACE ON THE HORIZON! WE CANNOT IMAGINE OUR PRISONERS AND SOLDIERS RETURNING TO WOMEN DRESSED LIKE MEN… AND THAT IS WHY FOR THIS WINTER AND SPRING I HAVE RELAUNCHED THE FASHION FOR FLOUNCES, WHICH, IN CONTRAST, SEEM SO CHARACTERISTIC OF FEMININITY TODAY. I WANTED TO CREATE A NEW SILHOUETTE, ONE THAT WAS ESSENTIALLY YOUNG AND FEMININE, TOWARD WHICH ALL THOSE MASCULINE DESIRES HAVE ALREADY BEGUN TO FLY." MARCEL ROCHAS, *PLAIRE*, 1945.

ABOVE Sophie Litvak wearing a dress in tortoiseshell tulle over a white skirt, low-necked bertha collar enhanced with delicate brown rhinestone embroidery.
L'Officiel de la mode, nos. 331–32, September 1949.
FACING PAGE Shawl in emerald-green lace from Brivet, draped over a gossamer evening gown.
L'Officiel de la mode, nos. 333–34, November 1949.

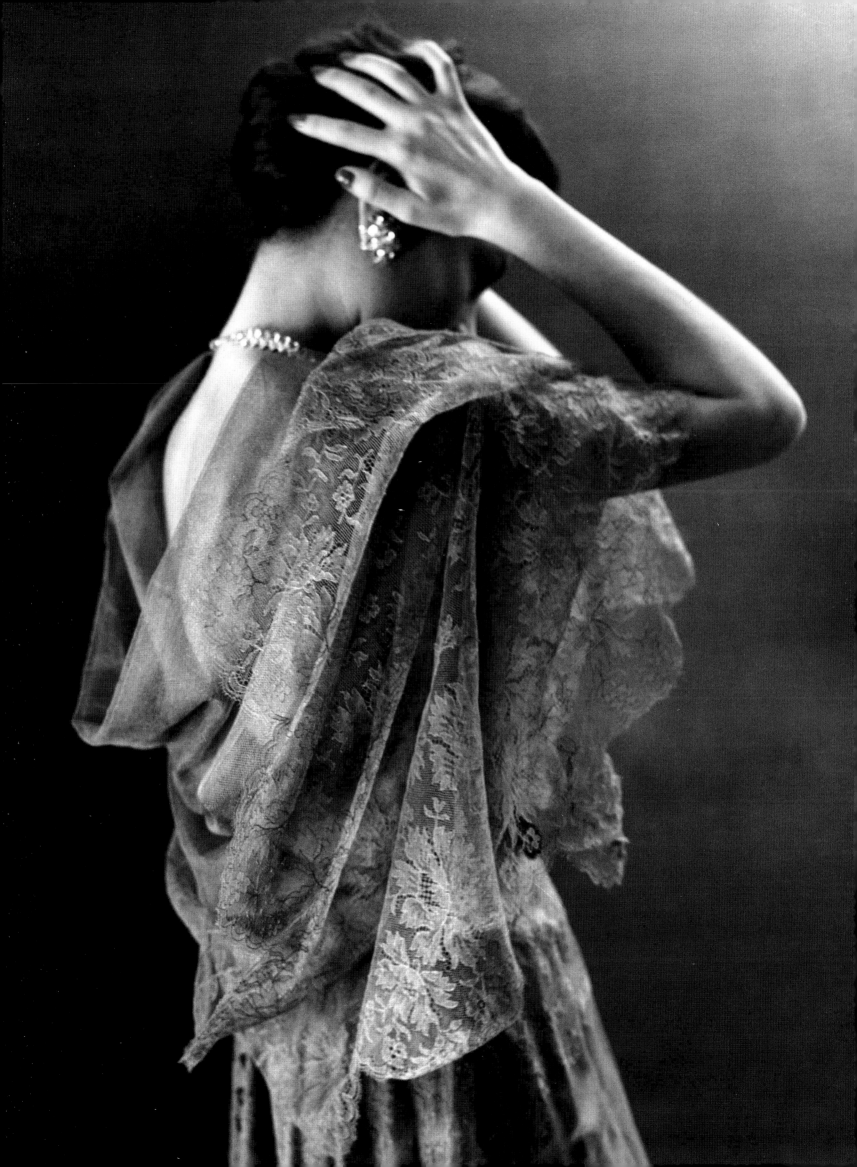

At avenue Matignon, "flounces remain dear to Marcel Rochas, who uses them on coats or on sleeves, on collars and on basques, far more than on skirts. Marcel Rochas dresses us like good little girls, with tartans and braid, tassels and pompons, deliciously 1945."[39] Worn at any time of day, for afternoon bridge or for the evening, velvet in every form—cotton and silk velvet, panne velvet, corduroy, chiseled and crushed—made a strong comeback with the first cold weather: "Never as much as now, perhaps, has velvet enjoyed so much attention from couturiers, nor such popularity among women who appreciate the luxury of a fox-trimmed coat, the cut of a comfortable sheepskin-lined jacket, or the delicious and elegant sobriety of an afternoon suit."[40]

In winter 1945–46, haute couture had been saved from extinction thanks to special ration coupons for fabrics; shortages were becoming less acute, and the means for achieving elegance were within reach once more. Couturiers gave their jackets and coats a degree of fullness again, often trimming them with fur or accompanying them with flowing, intermingled, evanescent scarves. They brought back the spirit of the Belle Époque with "flounces, bustles, ruffles, drapes, and gathers, and tightly cinched waists." It is no coincidence, as the astute Lucien François noted in *L'Art et la Mode*, that we call happy images to mind, the better to ward off the memories of hard times: "For sometimes we dream of a dinner in a private room with some fairy creature with absinthe-green eyes, some beautiful, otherworldly spirit, some princess of love, some devil woman, as they used to say in the fin de siècle, before the atomic bomb or the tax collector.… Hence the most inexhaustible source for fashion is our wistful nostalgia for the last time we knew happiness."[41] Caught up, like the whole of his profession, in the remembrance of things past, my father redefined the female silhouette, while Christian Dior opened his own salons at last in avenue Montaigne,[42] preparing his own small revolution in turn. "A wind of change with the freshness of a Parisian morning is blowing at Marcel Rochas. His collection is largely given over to two-piece suits, with seam-shaped basques in an irregular cut or slightly draped, all perfectly designed. Folds and ribs run over his many models. His tartan skirts, gathered and folded behind, are worn with light-colored jackets and, for a more glamorous time of day, black suit jackets are bordered with lace or a white lingerie trim."[43]

BELOW, LEFT Suit in a very fine gray check by Rodier, draped bustle-style at the back. *L'Officiel de la mode*, nos. 301–2, March 1947.
BELOW, CENTER, AND RIGHT Variations on the suits typical of the Marcel Rochas style, 1946–47.
FACING PAGE Model in front of the Rochas store wearing a simple black suit with pared-down features.

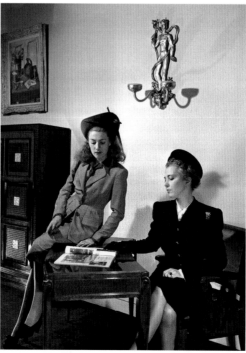
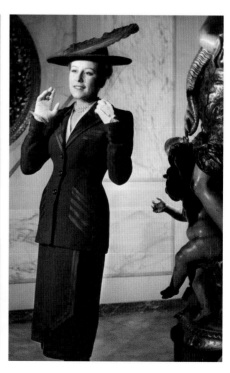

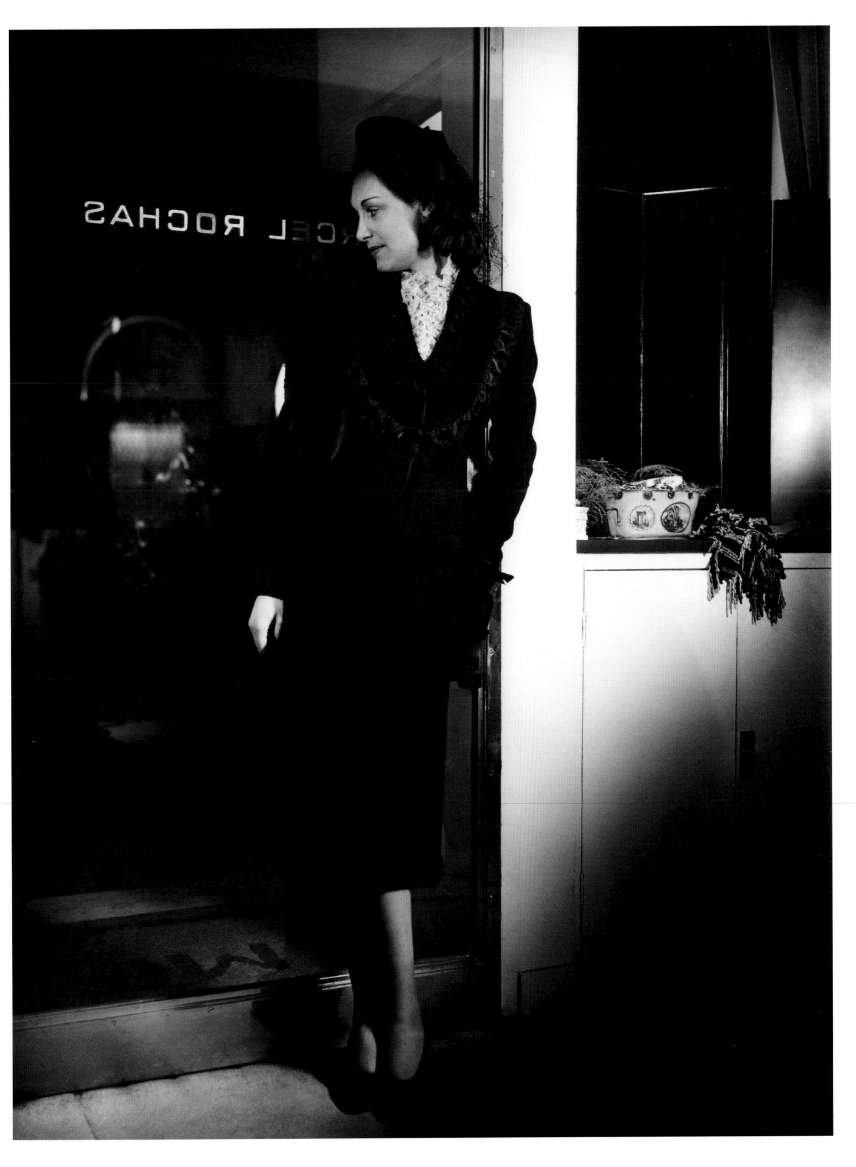

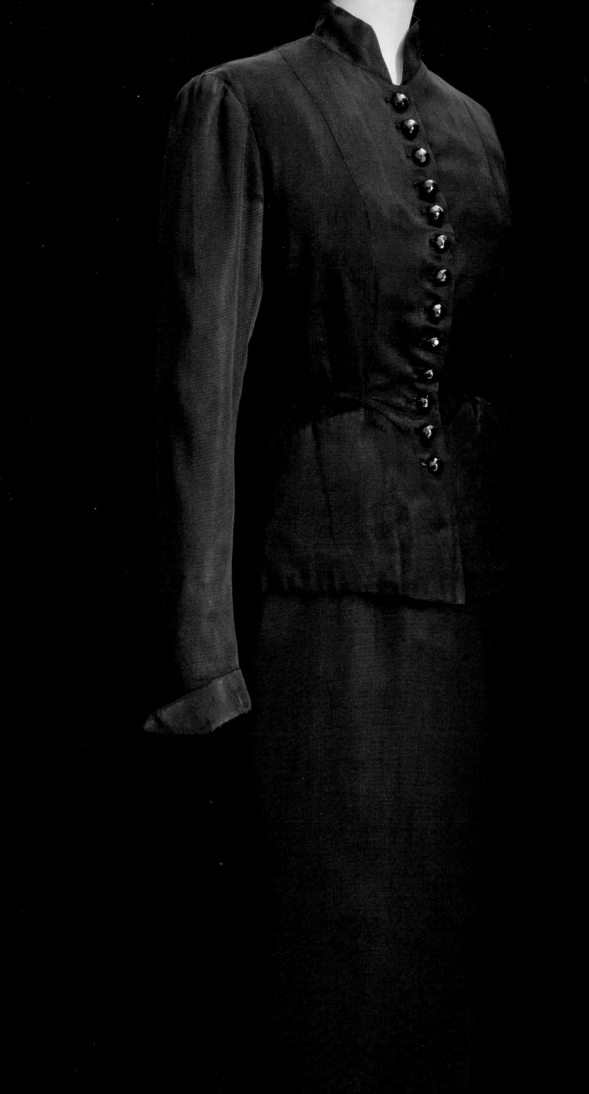

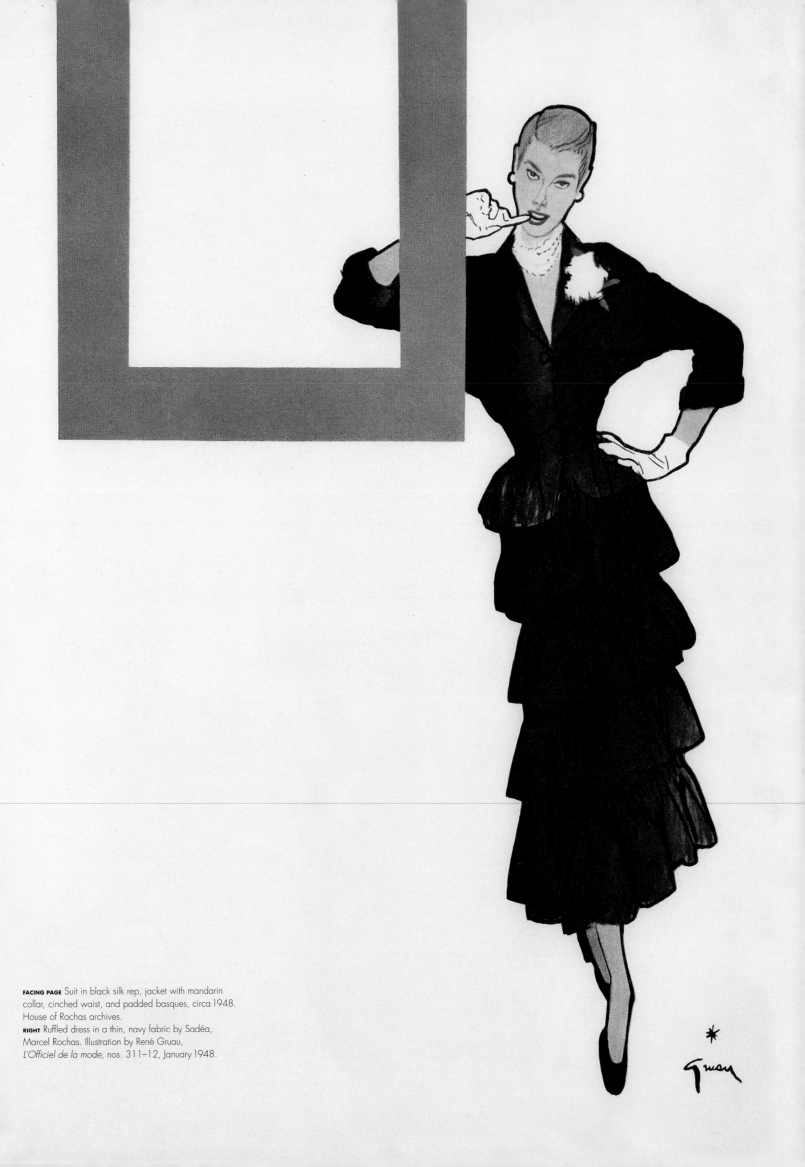

FACING PAGE Suit in black silk rep, jacket with mandarin
collar, cinched waist, and padded basques, circa 1948.
House of Rochas archives.
RIGHT Ruffled dress in a thin, navy fabric by Sadéa,
Marcel Rochas. Illustration by René Gruau,
L'Officiel de la mode, nos. 311–12, January 1948.

Life gradually went back to normal in France. The project to launch a great international film festival, which had had to be aborted in 1939, finally saw the light of day in Cannes in fall 1946. In October, my father entertained the Parisian beau monde at the Palm Beach. "At the first ball in the gardens of the grand hotel, every evening gown was more exquisite than the next; the British cocktail party on the Carlton terrace brought together members of London's high society, while Marcel Rochas's dinner at the Palm Beach drew 'le Tout Paris.'"[44] It was a good way to announce his new collections, which he had presented in the avenue Matignon salons earlier the same month: "A large crowd gathered at the entrance to the salons, which were packed and filled

FACING PAGE A Marcel Rochas wedding dress. Illustration by René Gruau, 1945.
ABOVE Marcel Rochas in his office at avenue Matignon, daydreaming of wedding dresses, 1950.

with cigarette smoke. The collection was inspired by the 'conference' [the 1946 Paris Peace Conference]; is this why it has that elegant Parisian and cosmopolitan look of the prewar collections? Primroses and green plants added a fresh note to the decor."[45] Marcel Rochas had resolutely turned his back on the dark wartime years. Fashion is a sociological phenomenon, sometimes marking a somber period, and sometimes echoing a new reality in which people can once more give free reign to their dreams.

Paris resumed its parties and celebrations of former times, including Mardi Gras; the Mi-Carême carnival on the third Thursday of Lent, when beauty queens dressed up in exotic costumes; and St. Catherine's Day. Every year on November 25, particularly in the couture houses, it was the custom for employees who were still unmarried at the age of twenty-five, whether they were seamstresses, junior sewing hands, models, or sales assistants, to make the most of their freedom. The "catherinettes" gave full rein to their imagination, often taking their inspiration from a recent film or some other event for the design their traditional hats, generally in shades of yellow and green. Who cared if they verged on the ridiculous: being laughed at never killed anyone, especially after two world wars. The girls would even come down from their studios to parade in the streets. In 1946, my father was one of the rare couturiers to let an engaged catherinette take part; an exception to a strict rule! For that day, the whole couture house belonged to them, and the few clients who came would be invited to join in the fun. The high spirits that reigned were all the more heady for the newfound atmosphere of freedom. Beauty and the Beast, Minnie Mouse, or Madame Butterfly might all be seen in the midst of a bed of cloth flowers— forget-me-nots, roses, violets, and poppies. On these special, relaxed days, a festive spirit filled the house and champagne flowed freely. With my nose on a level with the buffets—since my eyes were not on a level with the hats—and my hand in my father's, I can still see the faces of those catherinettes, especially a laughing brunette with dimples. And when I was taken into the couture atelier, the multicolored reels lined up side by side like rows of Caran d'Ache pencils would fascinate me—as did the kaleidoscopes that I loved to play with. I saw in them all of the mysteries of the universe, of the earth's creation, stars, planets, spheres, cubes, prisms—it all fueled my curiosity and imagination. I remember as if it were yesterday the face of Dame Marguerite, the première d'atelier or head seamstress, who remained loyally devoted to my father despite his tyrannical approach. For a few hours I was privileged to enter the inner sanctum, and on one occasion—supreme joy!—I was allowed to embroider a few flowers on an evening bustier-dress, a white tulle ball gown embroidered with sky-blue guipure lace flowers. Concentrating hard, and watched over by Marguerite, I sewed a few flowers onto that dress that in the show would carry the number forty-four among the other models of the collection. How many pricked fingers and tear-filled eyes were there when the results didn't precisely match, down to the tiniest stitch, the sketch that was pinned to the wall like a butterfly in a display case? The mastery of Marcel Rochas was executed painfully, but above all with a pride in work well done. The inspections of "Monsieur"—as couturiers were addressed, like medical consultants—were feared and fearful ordeals. Colette's sharp pen was not always kind to couturiers, whom she accused of being "petty tyrants." The quest for perfection sometimes brought with it an appearance of dictatorship. But nothing in the world would have persuaded the petites mains and première d'atelier to give up their jobs. In the present century still, haute couture seamstresses continue to love their work, and the tradition continues to withstand economic crises.

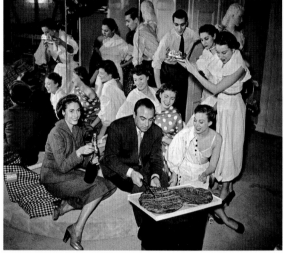

ABOVE, TOP Day of the show, 1950.
ABOVE, BOTTOM The traditional *galette des rois* (a pastry eaten at Epiphany) with Marcel and Hélène Rochas.
FACING PAGE Satin suit, cut-out olive green silk over black silk jacket. Winter 1949 collection. Philadelphia Museum of Art.
PAGES 226–27 Evening gown in silk faille and black tulle with an asymmetrical skirt. The bodice and hem are decorated with appliquéd floral bouquets and embroidered with beads and rhinestones, 1950. Provenance Nina Mdivani (daughter-in-law of Sir Arthur Conan Doyle). House of Rochas archives.

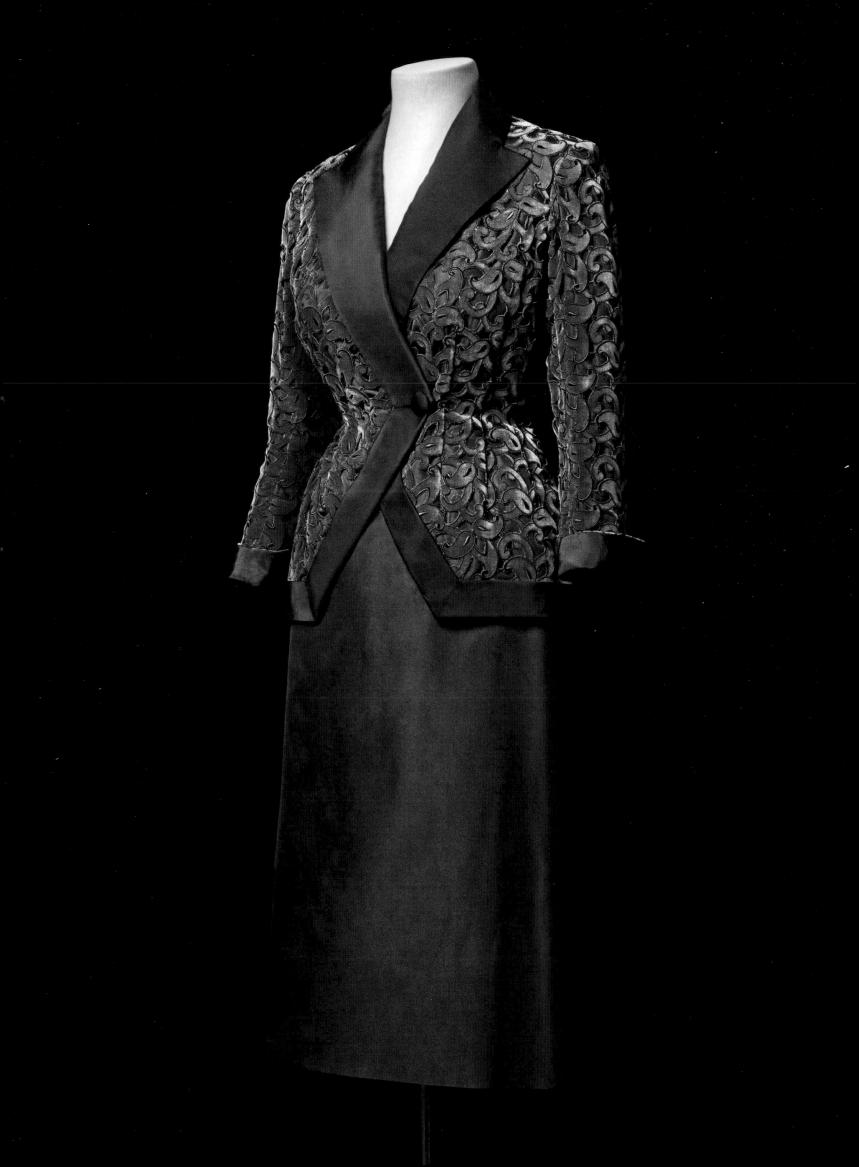

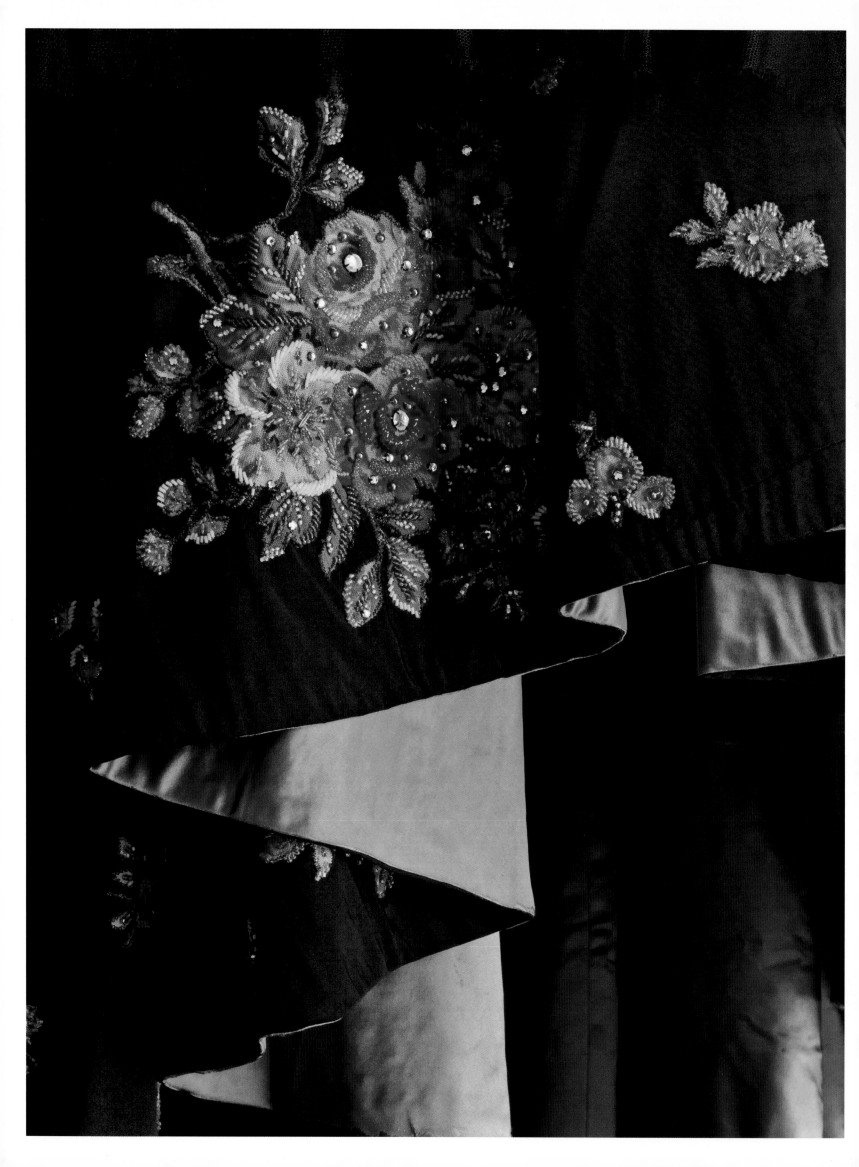

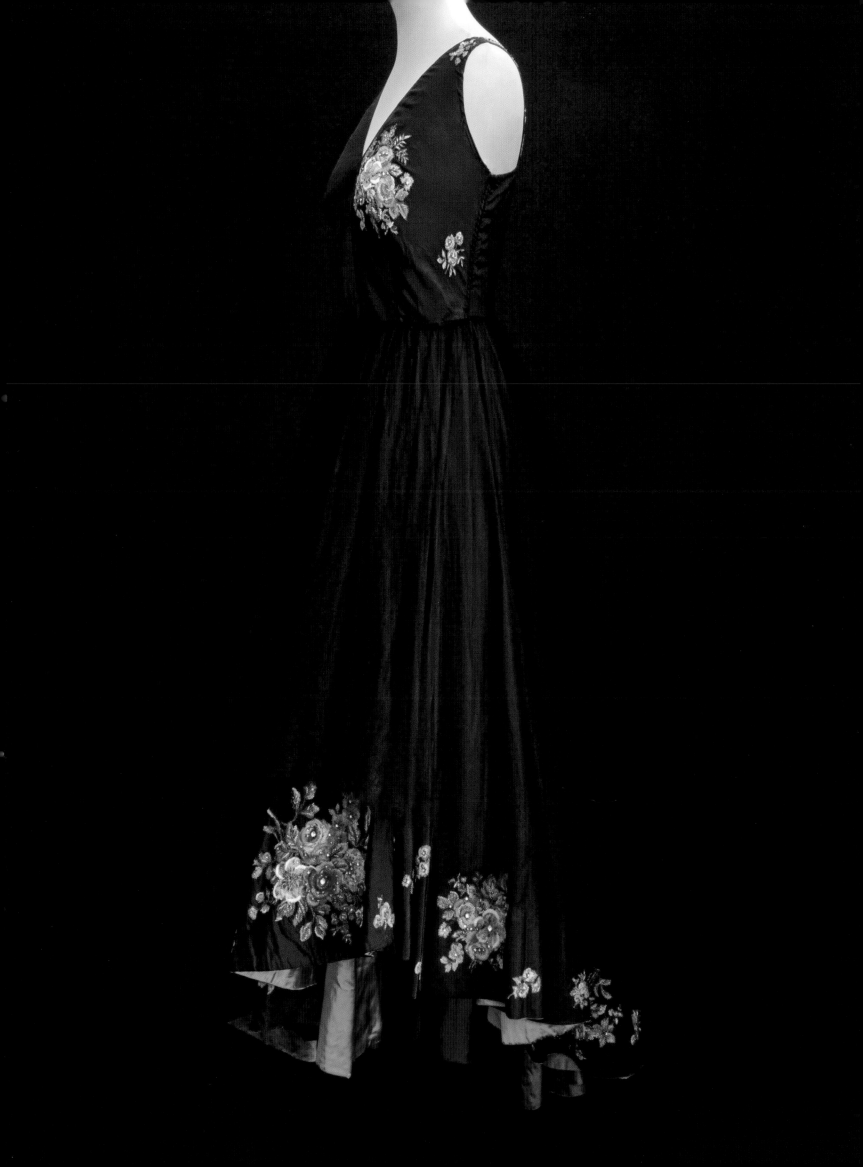

THE AMPHORA LINE As I wandered through the salons at the couture house I would also encounter the models, who spoke with affection to Monsieur's daughter in order to please him. My father's female ideal encompassed many different feminine types, including Mae West, Marlene Dietrich, Arletty, Danielle Darrieux, Micheline Presle, and Rita Hayworth, to name only actresses. There were blonds, brunettes, and redheads, like the dolls of my childhood. Nevertheless, every couturier has his favorite clients, those he prefers to dress, and who best represent the image of his house. In spring 1945, Marcel Rochas explained to the press that although Danielle Darrieux did not have what is commonly known as a model's figure, she had a perfectly proportioned body, very close to the notion of ideal beauty, with natural curves that were full and slender in all the right places.

The criteria of beauty change with the times. The girls in Rochas's first stable of models in 1925 were short compared to today's standards, and quite curvaceous, almost plump—a far cry from professional models in the twenty-first century. Models' figures changed through the years and also according to couturiers' tastes. In 1945, a Marcel Rochas model had to have a 22.5-inch (59cm) waist, shoulders measuring 14 inches (36cm) wide, and a 16-inch (41cm) bust; Robert Piguet, meanwhile, preferred 60, 47, 46, and Maggy Rouff 60, 42, 50. In couture, a single centimeter can make all the difference! After the war, the Rochas woman had a petite upper body forming a slim and slightly flared rectangle, like an Etruscan vase. My mother had that slim waist, which Rochas accentuated, and a narrow frame.

The *taille de guêpe*, or wasp's waist, was born at Marcel Rochas. In 1946, Rochas invented the *guêpière*—a "waspie" corset or narrow-waisted bodice—coining the word for the purpose. "The whale-boned waist cincher, a Rochas creation, accentuates the feminine line and lends an ideal grace to sequined or floral evening gowns, narrow or full, all of a perfect beauty."[46] Without going back to corsets, which women had at last thrown off, my father designed a female undergarment that slimmed the waist without entirely imprisoning the bust, which he had made by the corset maker Marie-Rose Lebigot, famous designer of corsets, girdles, and women's lingerie. In 1948, she described the process: "Marcel Rochas was the first to launch the idea of the narrow waist two years ago. He is one of those great couturiers whose creative talent and ideas dare to express themselves immediately and powerfully, not in a timid fashion. His whole collection bears the mark of these trends; an extremely slim waist and emphatically long skirts. Using an entirely new design, I made the 'Marcel Rochas *guêpière*' for him, in satin covered with black Chantilly lace, ending in a double flounce in nylon tulle. It gave the wearer an extremely slim waist and freed and shaped the hips, without compressing the body and allowing it to remain completely flexible; in addition to its structural qualities, the rich materials that I use render it a female undergarment of extreme elegance."[47] From chic underwear to shocking top, today it has even inspired a Jean Paul Gaultier perfume bottle.

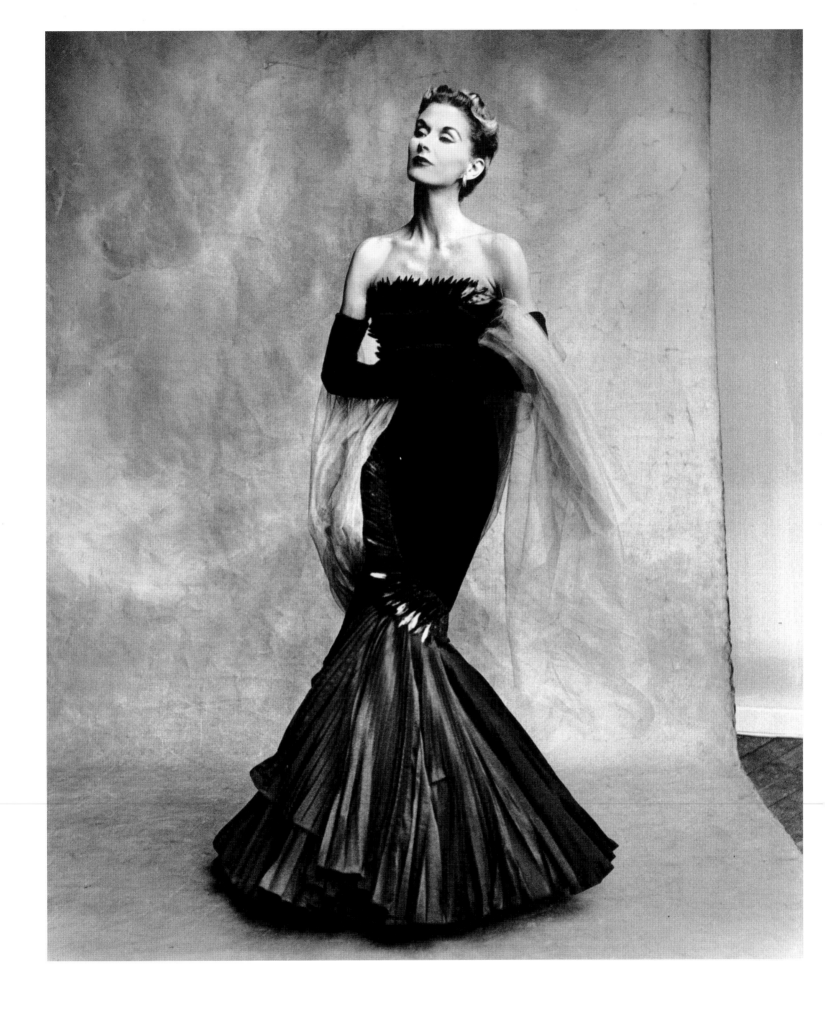

ABOVE Lisa Fonssagrives wearing the black Sirène dress, an iconic design by Marcel Rochas, in a photograph taken by her husband, the American fashion photographer Irving Penn. *Vogue*, September 1950.

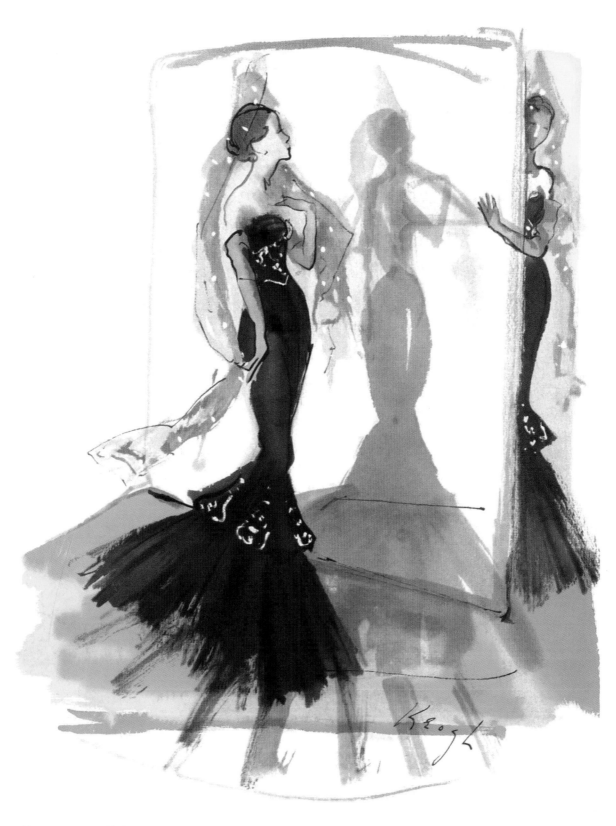

ABOVE Sablier evening gown in black tulle and velvet, embroidered with motifs in jet, 1948.
FACING PAGE Evening gown in tulle named Rose, after the perfume of the same name. "Most of the Winter collections pay tribute to the rose, symbol of femininity. Marcel Rochas has dedicated to it a subtle fragrance, and this tulle dress in a hue echoing its bloom." French *Vogue*, October 1948.

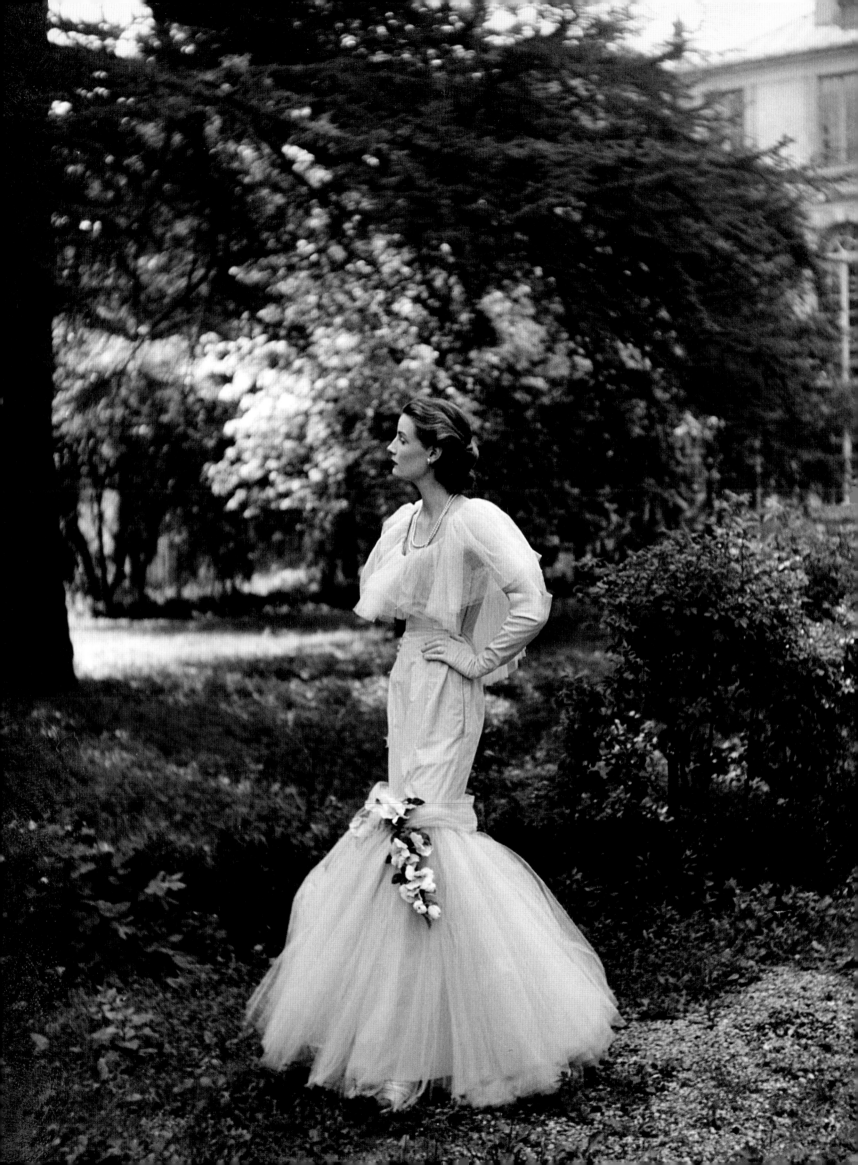

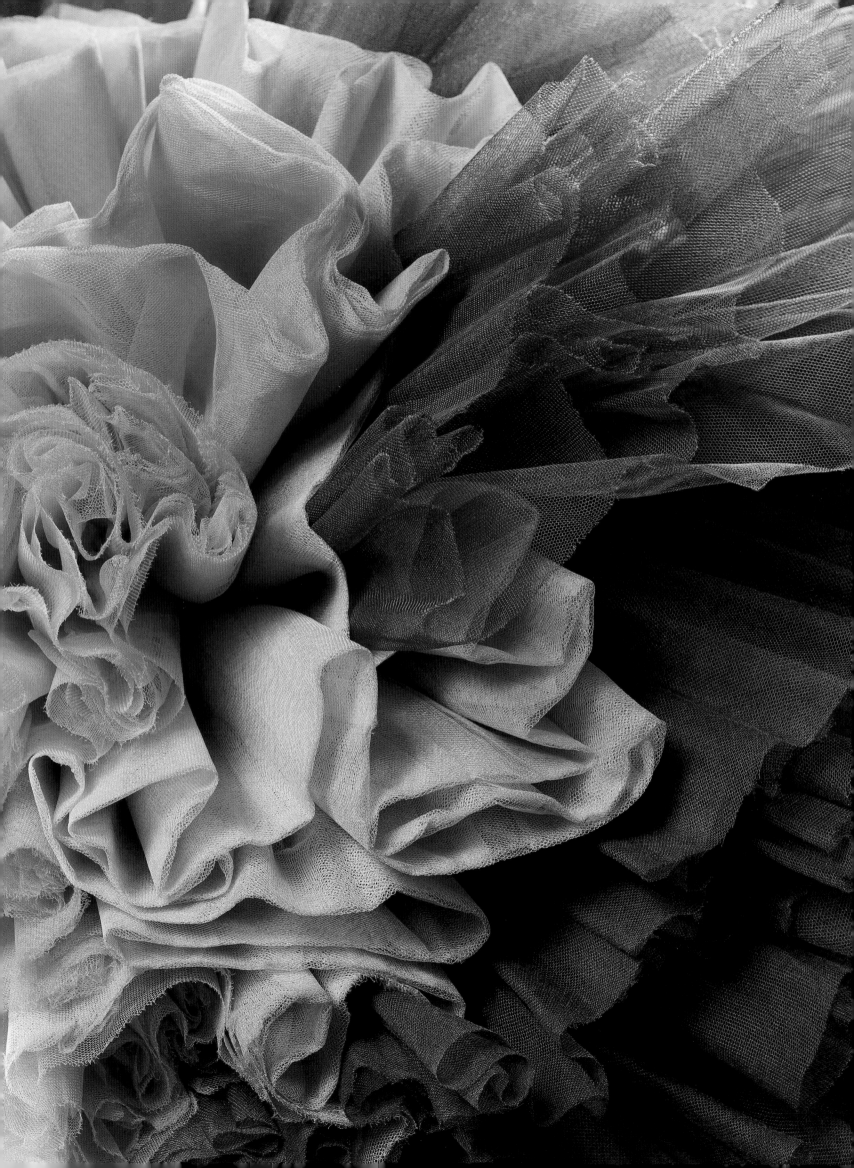

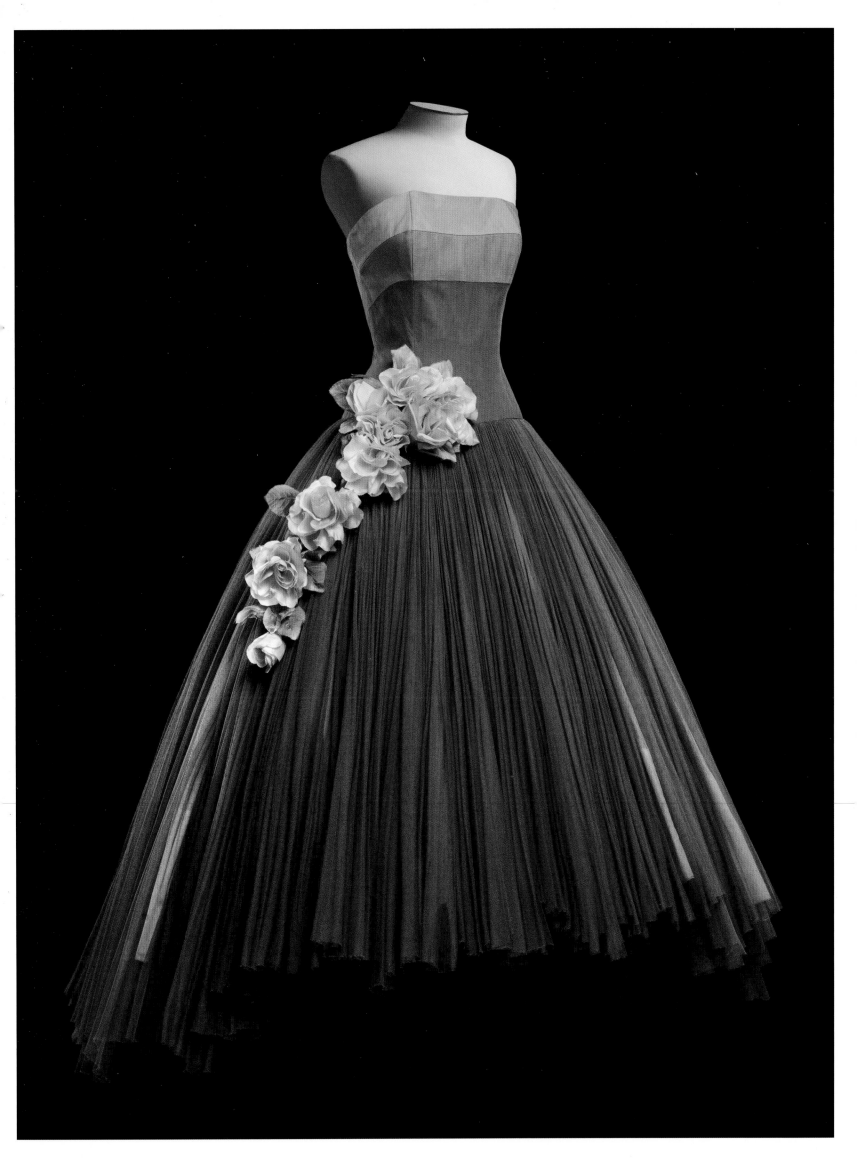

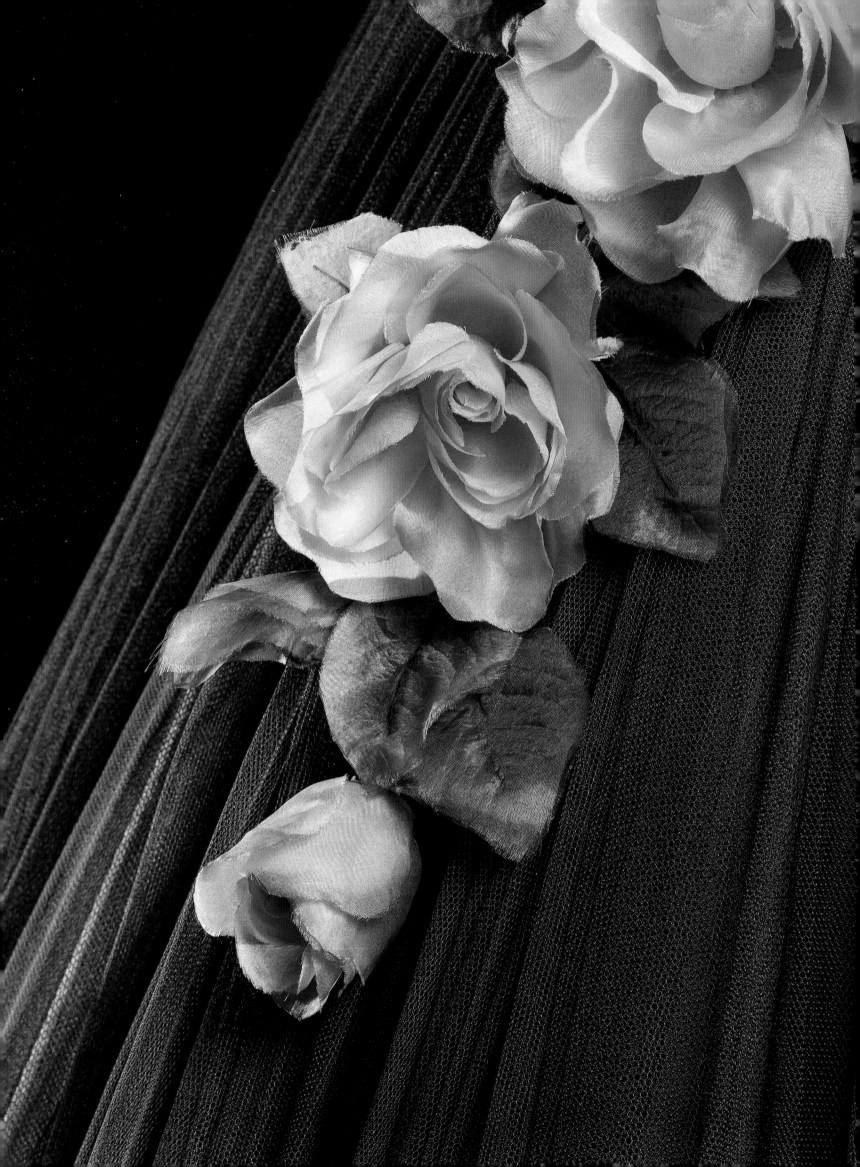

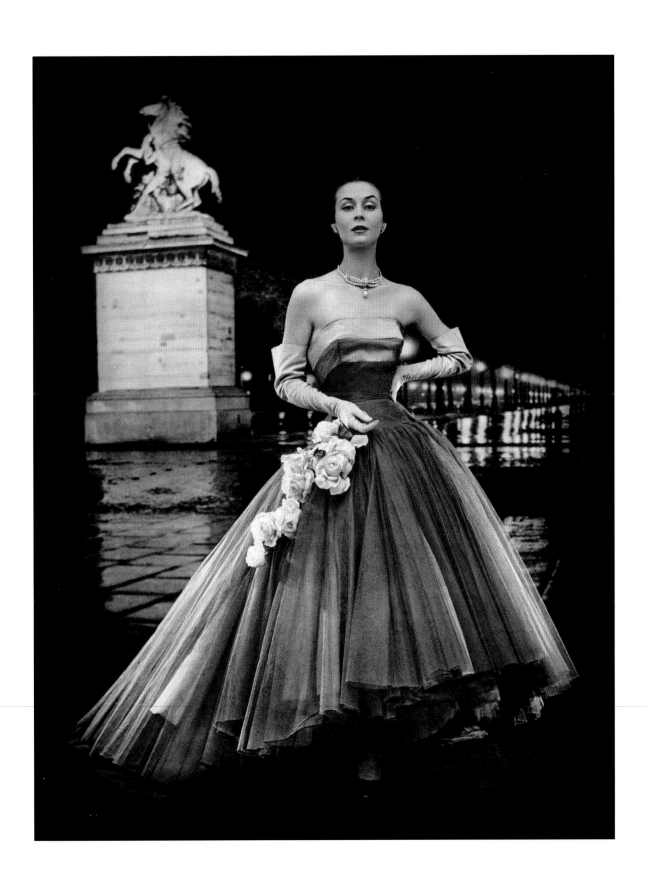

PAGES 232–33 AND FACING PAGE Dress in gray tulle by Dognin,
over a yellow petticoat, 1951. Rita Watnick,
Lily et Cie, Beverly Hills. Courtesy Suzy Kellems Dominik.
ABOVE "Yellow roses cascade gracefully over this dress
by Marcel Rochas in gray tulle by Dognin, over a yellow
petticoat." *L'Officiel de la mode,* nos. 351–52, 1951.

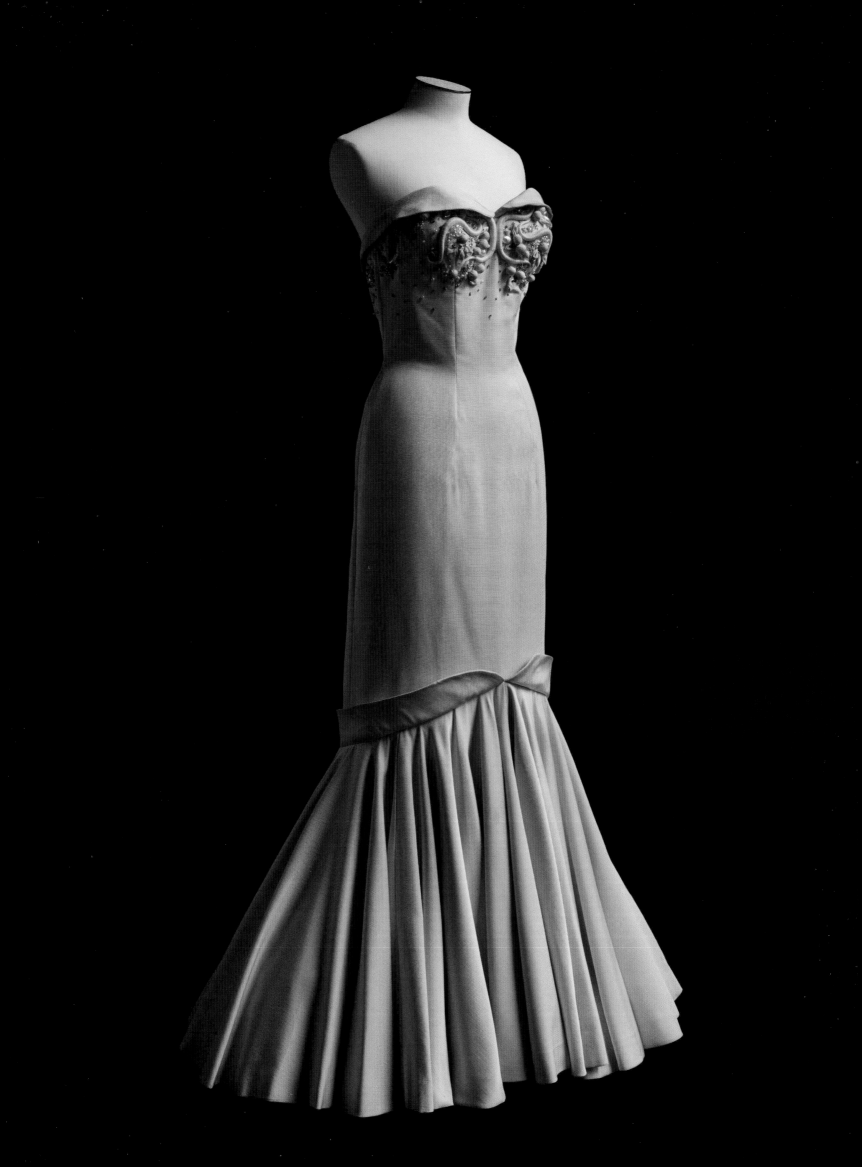

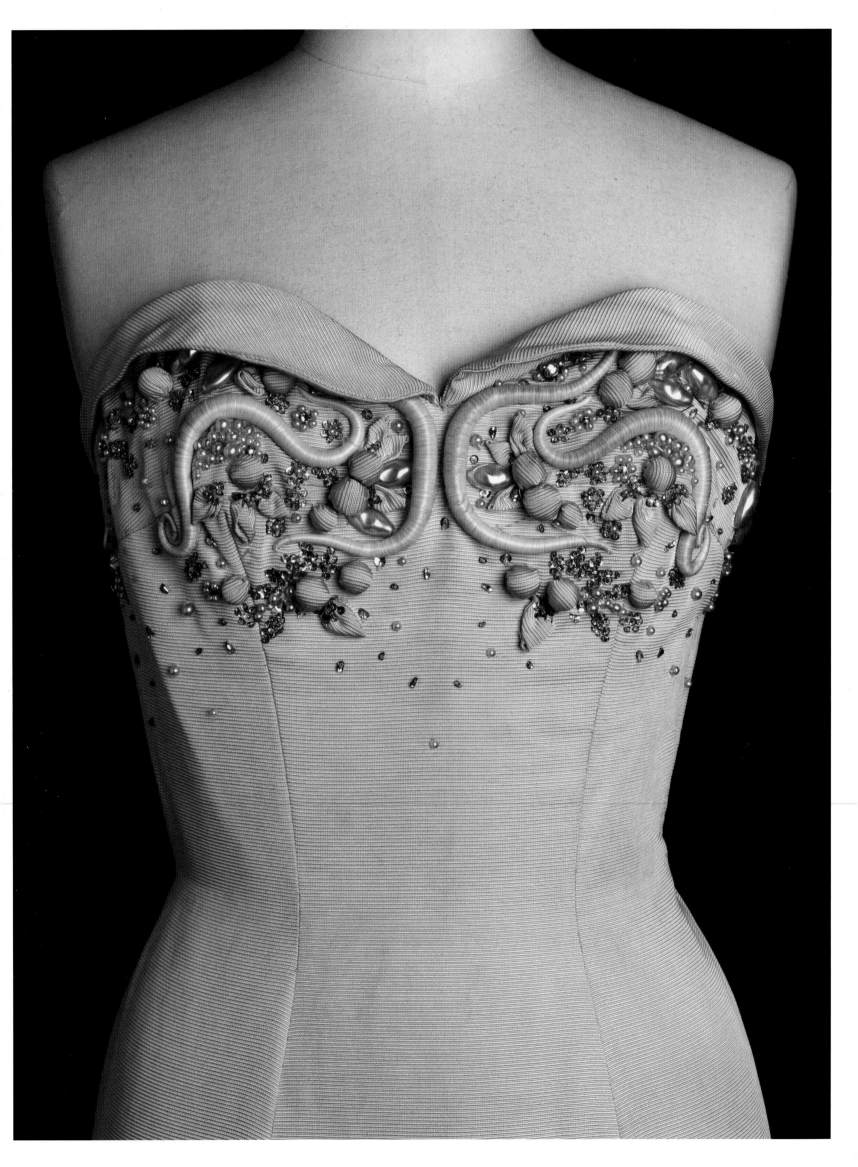

During the second half of the 1940s, Marcel Rochas developed the "amphora" line in all of his designs, with slim shoulders, narrow waist, and healthily full hips seeming to echo the curvaceous forms of the Lalique perfume bottle for Femme. He presented the Femme dress, emblematic of this new line, in 1946. Skirts, which had of necessity been shorter during the war, lengthened again as soon as couturiers could go back to using long lengths of material, sometimes reaching right down to the ankle. "At the outset of spring 1947 we are abandoning dresses that are too short, jackets that are too long, skirts for little girls who don't want to grow up, the style designed for those difficult days of the bicycle. What strikes one most in the couture masters' designs is of course the spectacular lengthening of the dresses. Clinging skirts sheathe the body, while long, pleated models lend a floating grace to a woman's walk."[48] A full skirt was the "nioulouque," as Colette put it, borrowing the expression from an American journalist who praised "such a new look" in Christian Dior's Corolle line. While certain designs filled out, requiring up to forty meters of fabric for a skirt alone, others were based on the straight line. They had in common full hips under a slender bust, especially as couturiers liked to simplify bodices to make the most of these curves. "A new femininity! No retrospective," announced my father for the Fall 1947 collection. His Sonnette line "sounds the death knell for the square shoulder, the short skirt, the classic suit, and the redingote! ... For the evening ... skirts are full, full, full, nothing narrow," with "rustling" fabrics, sloping shoulders, and "always my famous guêpière that I launched two years ago and that everyone is wearing—an ever narrower waist."[49]

In 1948, my father introduced his influential Femme line. "With the guêpière in 1945, I made the girdle old-fashioned by launching the wasp waist. With long and full skirts begins the suggestive poetry of undergarments; so ... to set off woolens, I had to invent the new technique of entaffetage." He went on: "Slim waist, sloping shoulders, long skirts, this is the '48 line that I have called Femme."[50] L'Officiel stressed the highly feminine look of Marcel Rochas's Winter 1948 collection, which "brings fresh success to the career of the couturier of 'La Rose,' his new perfume. Waists are narrower still with the new '49 guêpière, hips strongly emphasized, dresses still long. Silk day dresses in antique colors, coats with a studied fullness, very close-fitting evening gowns that develop their fullness below the knee."[51] The Rose dress, supporting the launch of the eponymous perfume, blossomed in a cloud of tulle, transformed the woman who wore it into a majestic, fairytale mermaid, with a silhouette molded over the hips and thighs, and opening out below into a corolla formed by a flounce of extreme fullness. Created and launched by my father, the mermaid dress was a triumph in the United States. Vogue talked about it in September 1950, publishing Irving Penn's memorable photograph of his wife, Lisa Fonssagrives, in that Marcel Rochas gown.

PAGES 236–37 Mermaid evening gown in ivory gros de Tours, bustier with cannetille embroidery, rhinestones and beads, 1948. Didier Ludot archives, Paris.
FACING PAGE Detail of a Marcel Rochas guêpière (see pages 242–43).
RIGHT, BOTTOM Marcel Rochas with his models, circa 1935.
RIGHT, TOP Marcel Rochas having lunch between two fashion shows, February 1951.

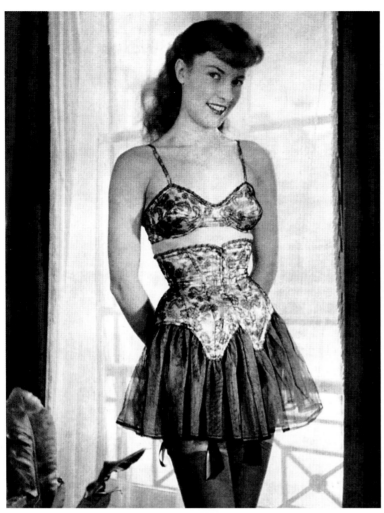
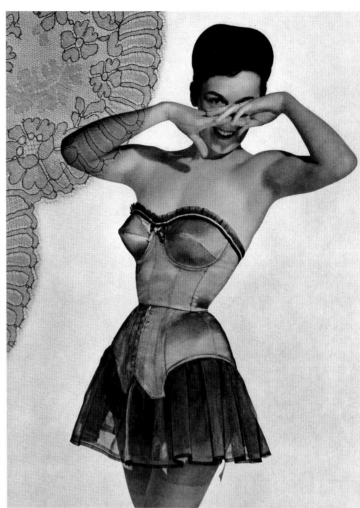

"NO ONE ACHIEVES FRIVOLITY STRAIGHT OFF.
IT IS A PRIVILEGE AND AN ART.....IT IS THE ESCAPE
FAR FROM ONE ABYSS OR ANOTHER WHICH,
BEING BY NATURE BOTTOMLESS, CAN LEAD
NOWHERE." CIORAN, *A SHORT HISTORY OF DECAY*, 1949.

FACING PAGE AND PAGES 242–43 *Guêpière* designed
by Marcel Rochas in 1946 and made
by Marie-Rose Lebigot. House of Rochas archives.
ABOVE, LEFT *Guêpière* made by Marie-Rose
Lebigot for Marcel Rochas, 1947.
ABOVE, RIGHT Marcel Rochas *guêpière*.
L'Officiel de la mode, nos. 319–20, 1948.

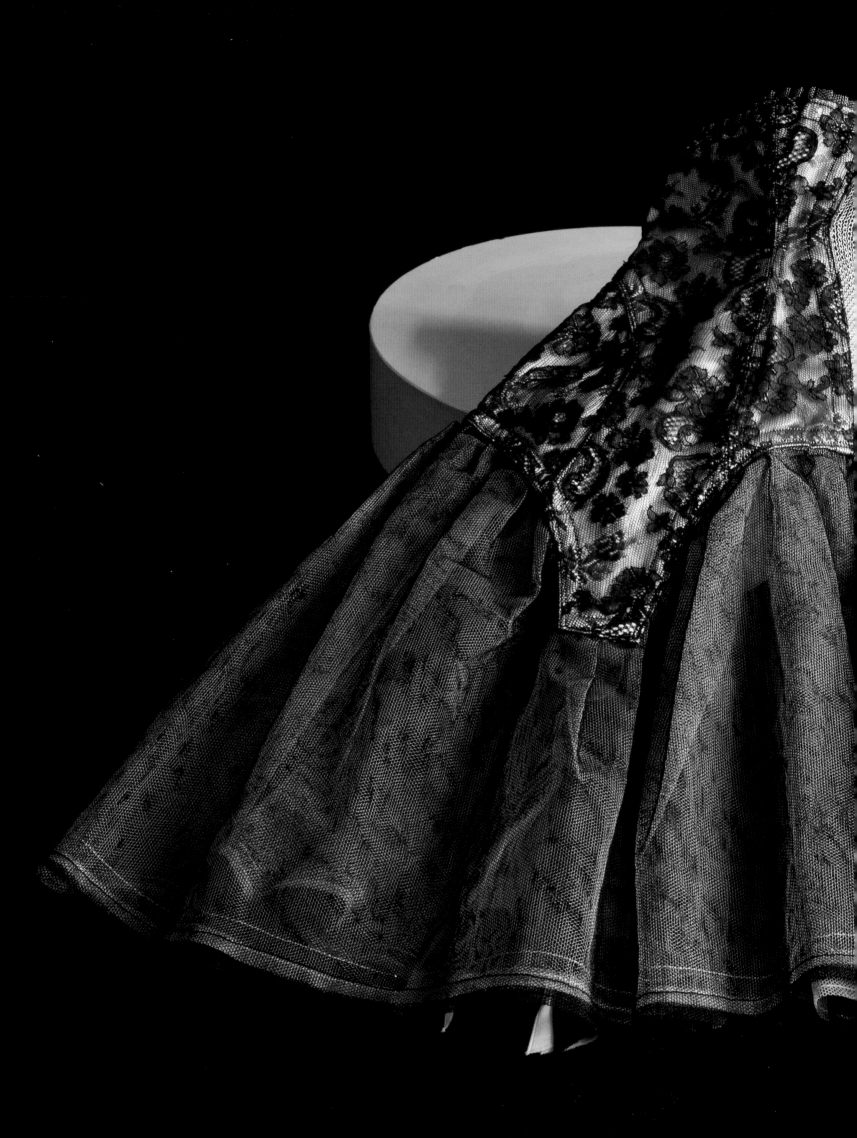

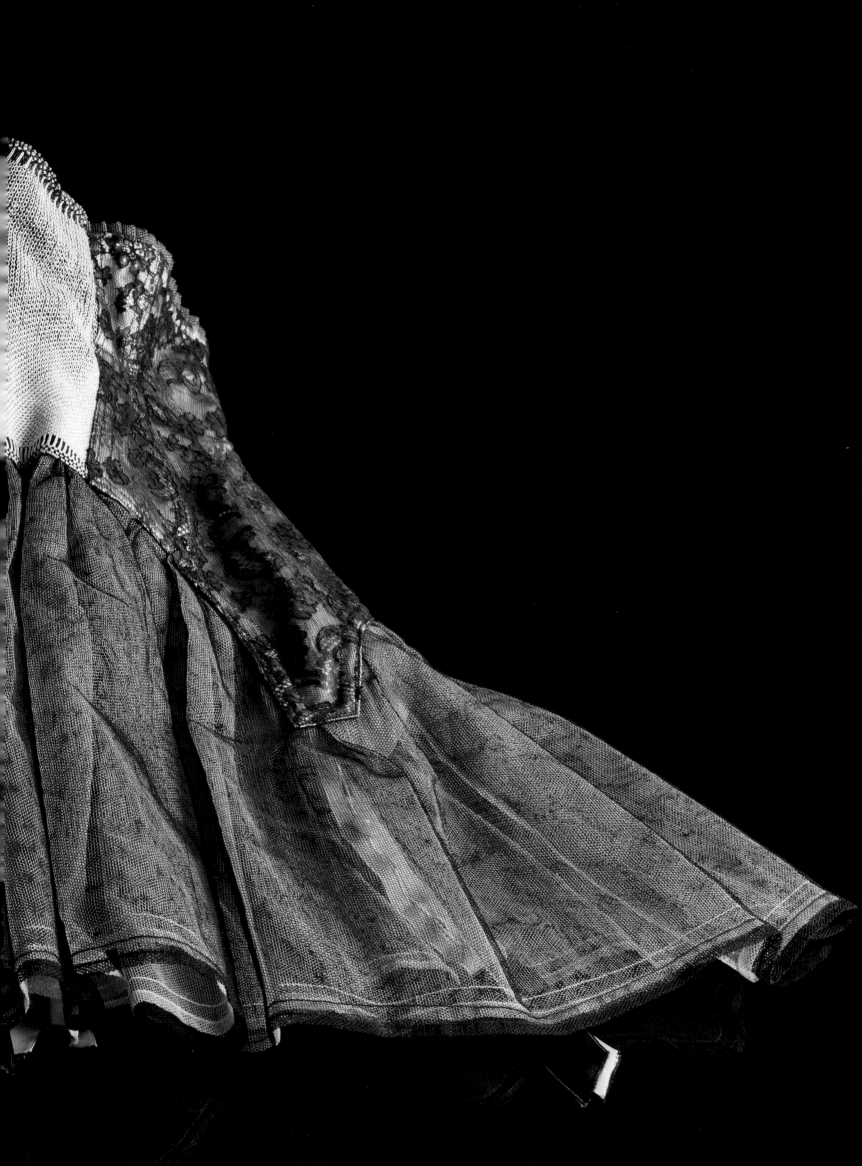

CHANGES OF SCENE The new femininity called for a new decor. In 1949, my father decided to create a complete change of ambience in the salons and store at avenue Matignon. Farewell the 1930s style of the previous interior, farewell the dark blue and white, the great square armchairs and restrained decor. Contemporary tastes were for the eighteenth century and Napoleon III, with walls lined with gray silk moiré, Manet-blue sofas, and cushioned upholstery trimmed with braid and tassels. Reflecting new directions in society, the space was conceived so that the store would serve as a showcase for couture as clients entered. The aim was to display the perfumes and accessories to their advantage, behind a redesigned facade. The man behind these transformations was Georges Geffroy, "a young Palladian architect rightly renowned as the promoter of a new classical order of refined luxury and subtle elegance."[52] The two men knew each other well and had worked together on the Théâtre de la Mode exhibition. They came to an agreement as to how to create an atmosphere conducive to celebrating Rochas designs and feminine beauty, with lighting that flattered the clients' reflections in the mirrors. "What was most striking about the passion of Marcel Rochas…was his personal art of dressing the display windows. He liked to do them himself, gleaning two or three interesting or rare objects at antique dealers or even at flea markets, and composing a theme around them."[53] Before embarking on the work at avenue Matignon, my father tried out Georges Geffroy's talents in his private apartment on rue Barbet-de-Jouy.[54] In 1944, he had rented the ground floor of a private mansion with high windows looking out over a romantic garden, bathed in light—a charming nest in which to settle his family. Flowers dotting the green lawn added a cheerful touch. Through the large trees you could glimpse the dome of Les Invalides and the roofs of the Lycée Victor-Duruy. On my mother's bedroom walls, Geffroy had a neoclassical decor painted after originals by Zuber, the frieze of nymphs and ancient monuments being reflected in the mahogany "Greek" cheval glass. My father's bedroom-cum-office was done in red, black, and green, in imitation of the striped silk imberline fabric of which he was so fond. "Dark and plush, the room has a serious air as if seen through the eyes of a man who might be a couturier," Lise Deharme wrote in an article about the apartment. Jacob chairs and armchairs, a Roentgen desk, Empire pedestal tables: Marcel Rochas chose the furniture with Georges Geffroy, who "proffered the advice of a man of taste and a connoisseur, who required that the most insignificant object should possess elegance." A pair of terracotta busts of women by Carpeaux[55] were quite in keeping in this decor, along with Stanislas Lepri's *Tower of Babel*, a portrait of Hélène and her children by Leonor Fini, and, in my mother's bedroom, a small watercolor of a woman, also by Fini. Perhaps these were more to my father's taste, as he liked contemporary works influenced by Surrealism.

Sometimes, before my parents went out in the evening, I was allowed into their room. The imposing cheval glass reflected the image of the woman that Paris society would admire that night. I no longer recognized my mother, dressed as she was in the gowns and finery that my father had created for her. If I took it into my head to run into her arms I might crease them. So I would stand motionless. She would be handed her gloves and bag. Her lipstick was impeccably applied, and there was no question of her giving her daughter a kiss. So many dresses for cocktail parties and dinners, late-night suppers, evenings at the theater, costume balls, and above all sumptuous evening gowns, every hook and eye fastened with bated breath; what a festival, what a private show for a little girl watching in blissful admiration!

BELOW Marcel Rochas in a salon of the couture house at the beginning of the 1940s.
FACING PAGE, TOP The vestibule at the new Marcel Rochas boutique at 12, avenue Matignon, decorated by Georges Geffroy. Drawing by Alexandre Serebriakoff, 1949.
FACING PAGE, BOTTOM The presentation salon, on the upper floor at the new Marcel Rochas store. Drawing by Alexandre Serebriakoff, 1949.

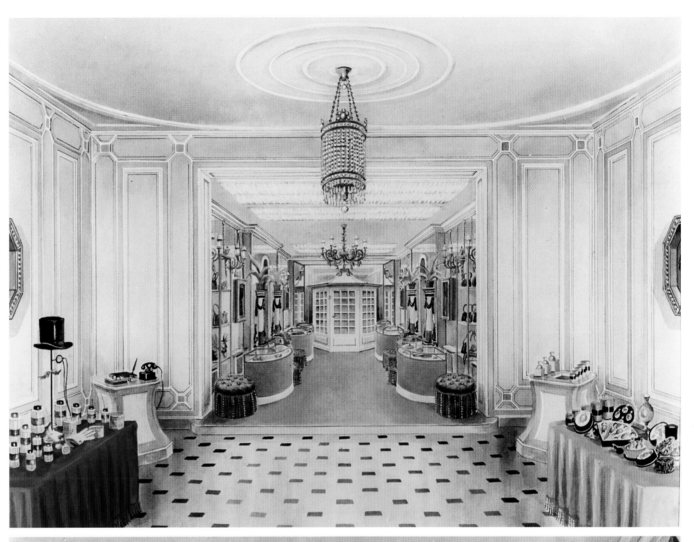

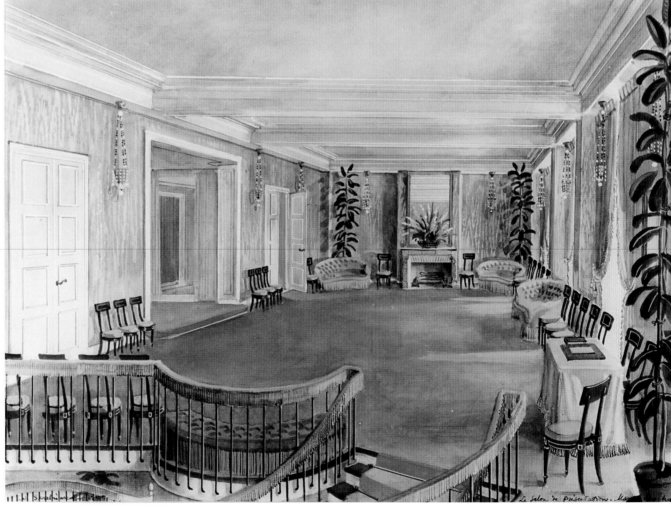

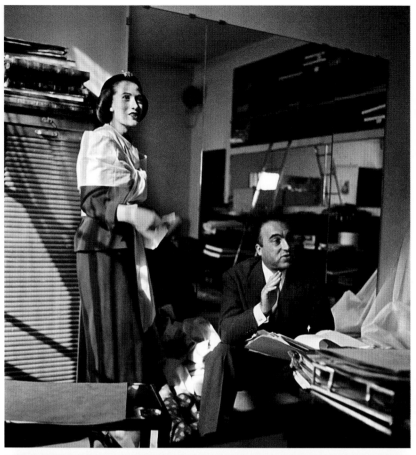
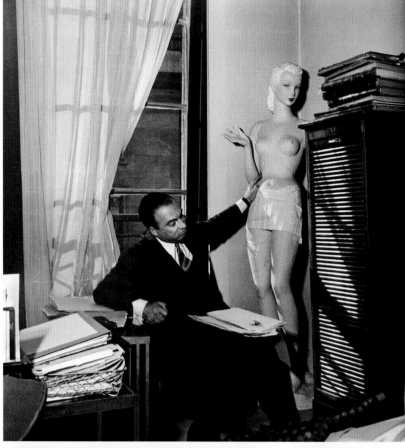
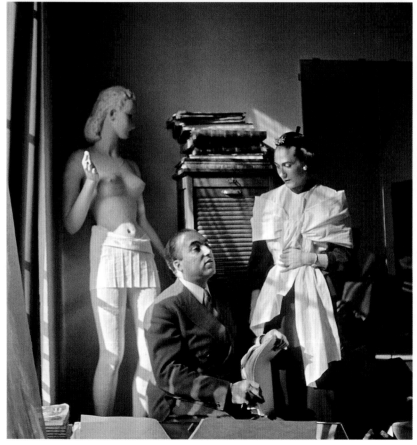
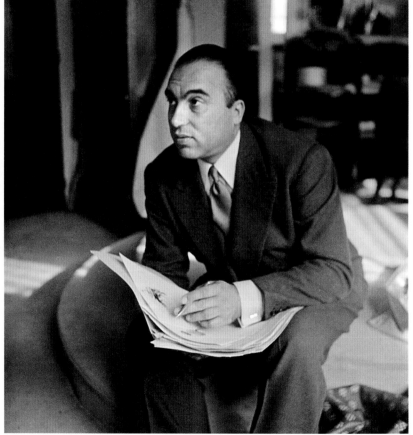

ABOVE Marcel and Hélène Rochas
in their couture house, 1950.
FACING PAGE Two-piece day ensemble in blue jersey,
1950–53. Palais Galliera, Fashion Museum of Paris.
PAGES 248-49 Day dress in beige chiffon with
a floral motif and metallic gold embroidery,
draped bodice and shoulders, 1950.
Renaissance Gallery collection Paris.

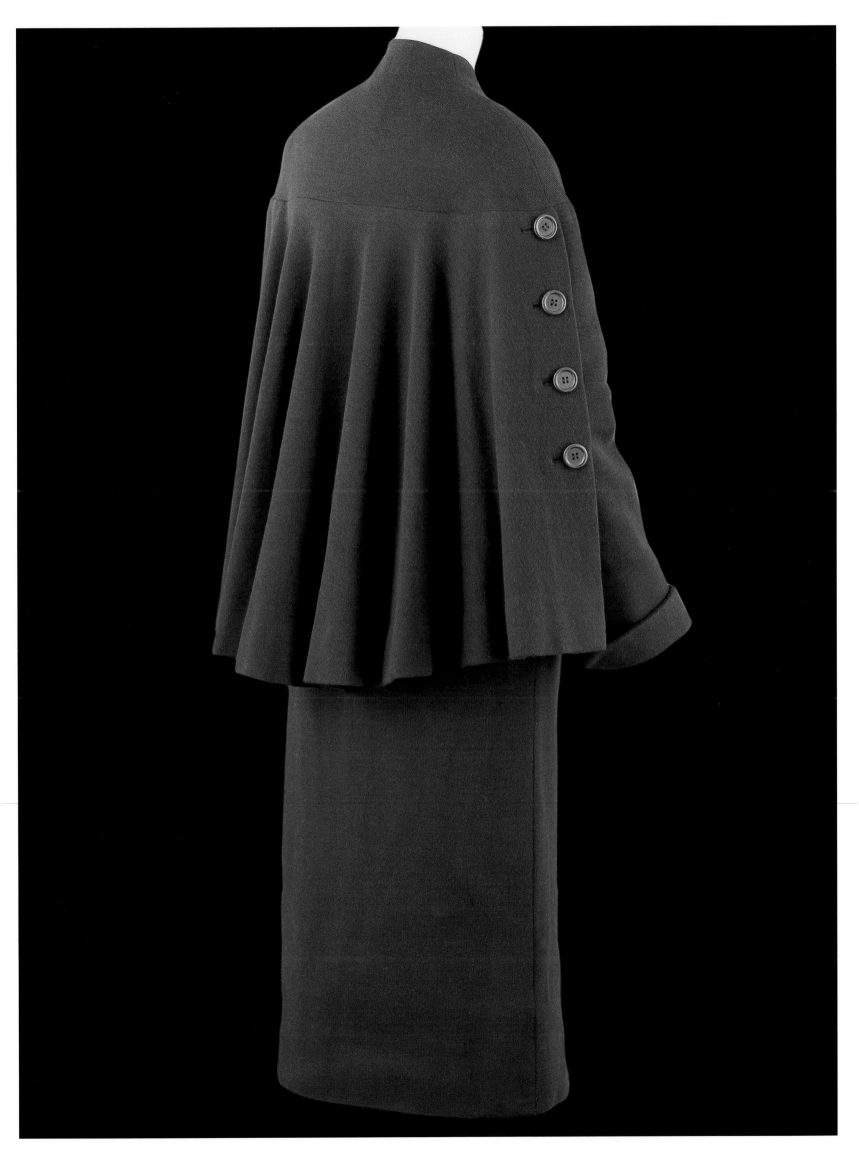

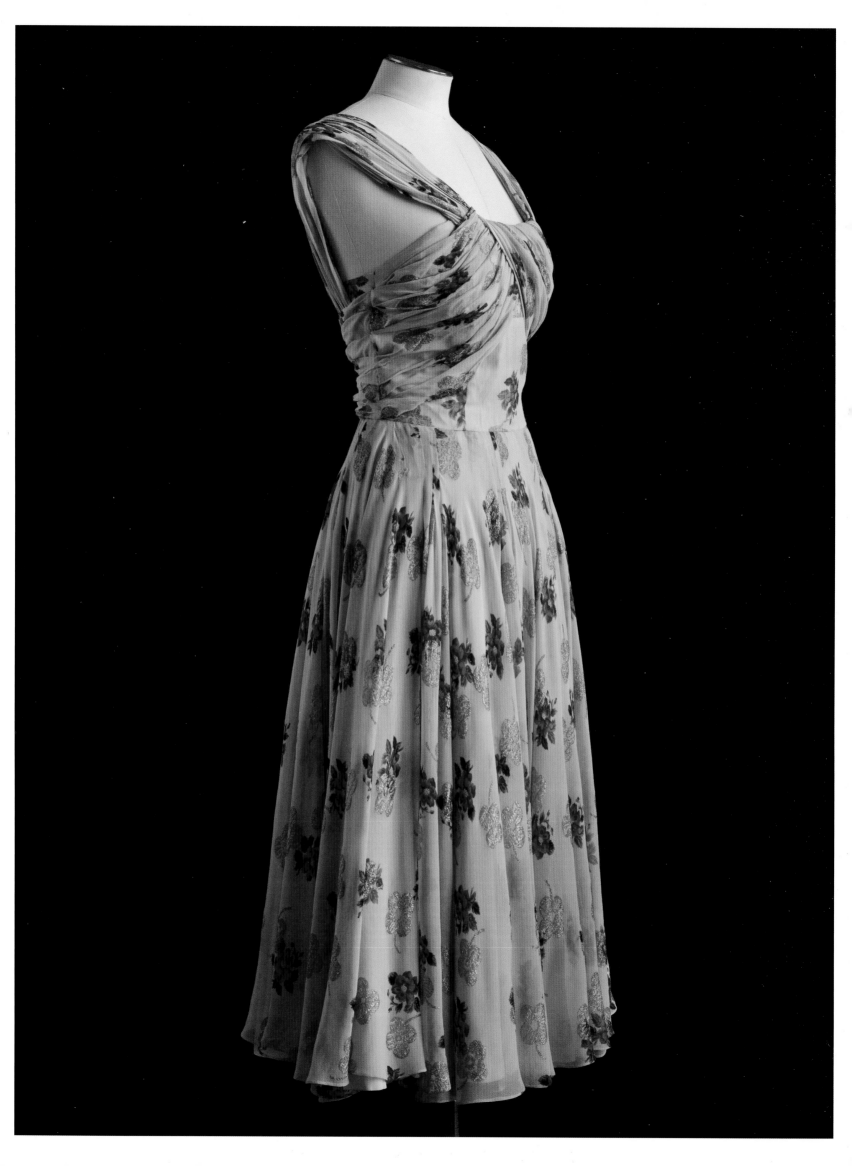

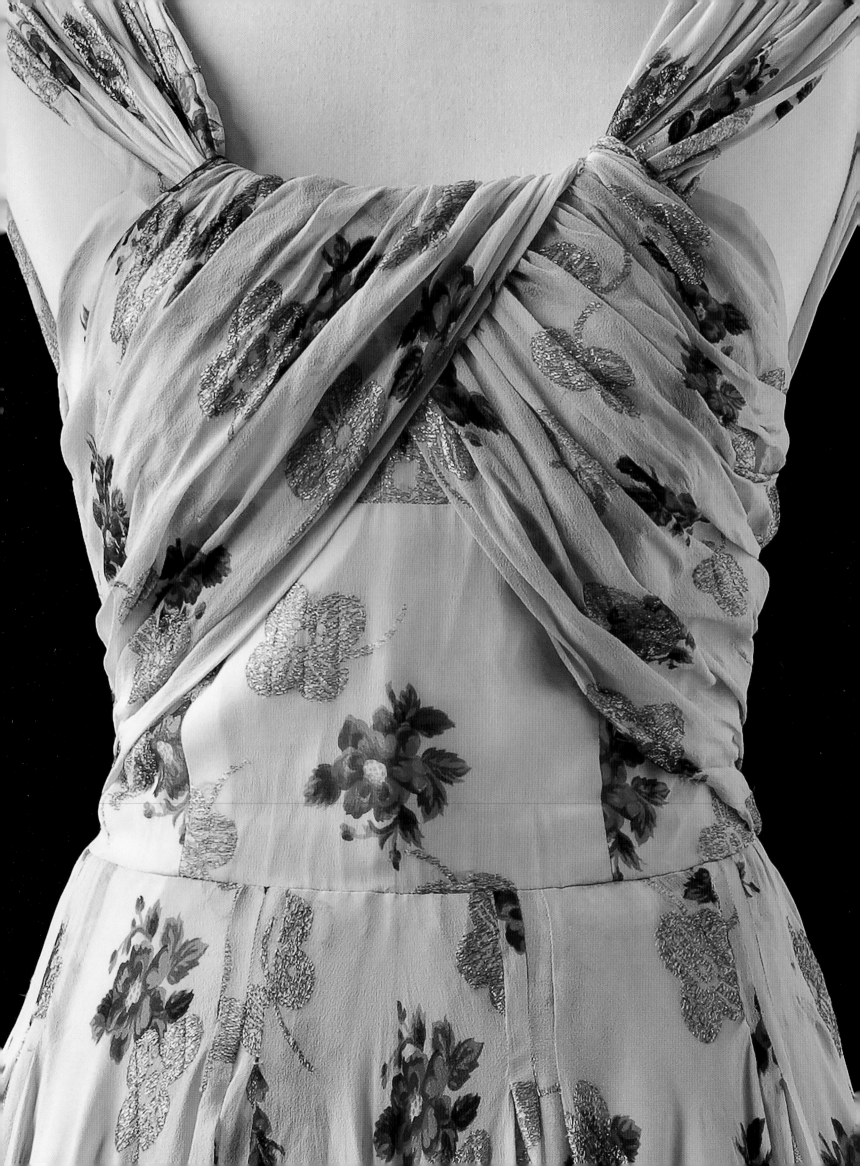

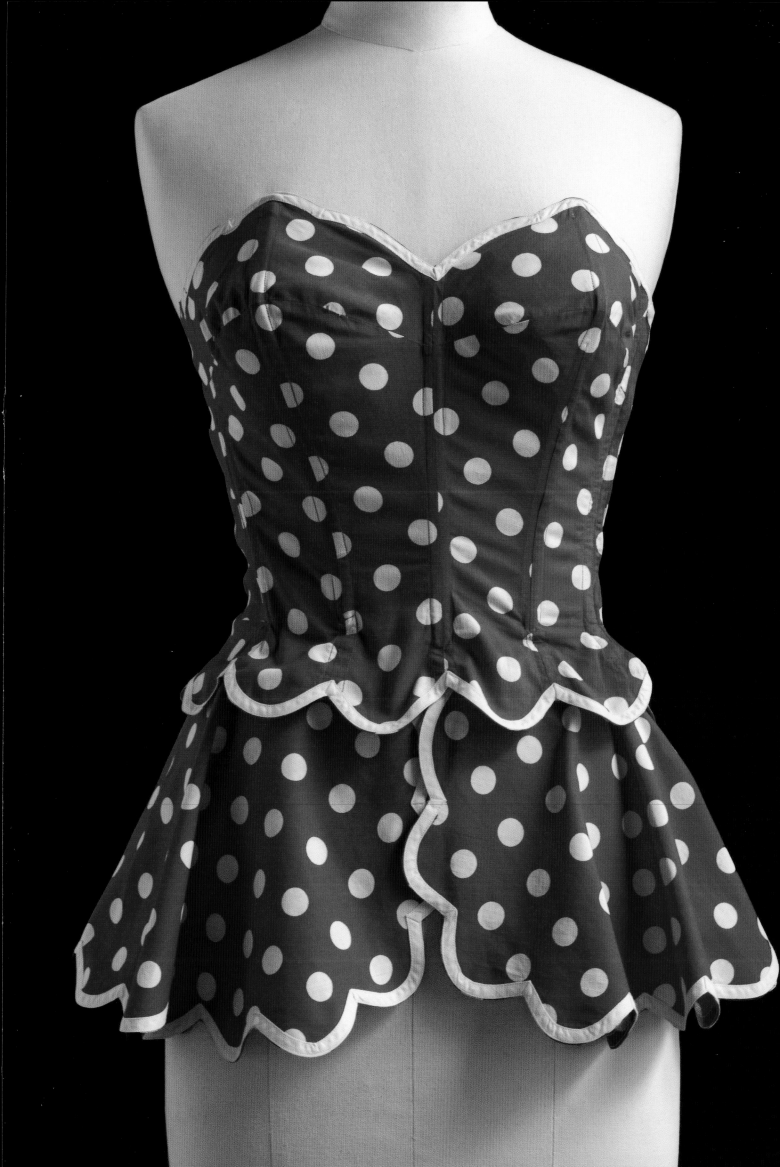

Balls and masks, parades and displays: I was fascinated by those eye masks bordered with lace, those extraordinary animal masks that had me guessing, and discovering the identity of the mysterious stranger added spice to those adult pastimes. While the game lasted, fantasies could run free, before an "Ah, I know who *you* are!" broke the spell, all too soon. After the war, dinners and balls were back on the agenda, often in aid of charity. When an invitation was issued, it was the talk of the town. Either you were on the list, or you weren't. Some people would do anything to be able to say, "I was there!" Unless, like Cocteau, you declined the invitation for the pleasure of being different, or simply because of the "difficulty of being." Balls generally had a theme that gave them a particular ambience. Marcel Rochas was invited to contribute to the great ball hosted by Maurice de Rothschild after the war, at which all the guests would be dressed by the couturier at the baron's expense. In early 1949, just before the death of Christian Bérard, or Bébé, the famous organizer of these balls, the Count and Countess de Beaumont sent out invitations to "all the real or imaginary kings out of mythology or fairy tales. Playing the role of lord chamberlain, the count had invited Christian Bérard and Jacques and Geneviève Fath, escorted by a greyhound, as Henry VIII, Charles IX, and Elizabeth, Empress of Austria. The couturier, reported the magazine *Elle*, had even had his hair cut two centimeters short to resemble his character! Valentine Hugo as the king of rabbits and Leonor Fini as Persephone or Queen of the Underworld also drew attention; Schiaparelli as Queen Bee wore a beehive crown, and Christian Dior donned the fiery mane of the king of the beasts,"[56] (a costume designed by Pierre Cardin). A succession of balls took place in those early months of 1949. The Bal des Oiseaux, hosted at Boni de Castellane's Palais Rose to raise funds for rebuilding clinics, brought together a select gathering including my parents, the Faths, and the Aurics. Marcel Rochas also attended the Bal Tropical, given in January 1950, at Lorraine Dubonnet's home in Neuilly, by the Puerto Rican socialite diplomat Porfirio Rubirosa, with musical entertainment provided by Katherine Dunham's Caribbean orchestra. "Jacques Fath, as a creature of the tropics, was all smiles in an asparagus beard. Marcel Rochas as a Hindu sported the dark skin of a maharaja and a magnificent mustache, miraculously grown, heightening the look of his Oriental nabob character. Mme Fath, all in tulle, as goddess of the rainforest, and Roger Crovetto as Negus, Lion of Judah, bearded and dignified, added to the picturesque charms of this oh-so-Parisian ball."[57] In June 1951, the Faths also gave a memorable party at their country house, the Château de Corbeville: the "*Bal des Tableaux Vivants ou Une Fête à la Cour de France au XVIIIe Siècle*" (A Festive Occasion at the French Court of the Eighteenth Century).

It was the "ball of the century" given by the millionaire Charles de Beistegui at his sumptuous Palazzo Labia in Venice that fired my imagination the most. The theme was "Marco Polo, prodigal son, returns home, bringing Chinese à la Chippendale and Turks à la Liotard across the Adriatic."[58] On September 3, 1951, celebrities from the world over flocked to Venice, vying with each other to be the most creative, bold, and humorous in their choice of costume. "We wanted to be there first, so as to see without being seen," Paul Morand remembered. "The doorman examined our invitation cards as closely as a cashier might inspect a large-denomination bank note, there were so many fake tickets circulating in town."[59] Captured in photographs by Robert Doisneau, Cecil Beaton, and André Ostier, the party hosted some fifteen hundred costumed guests in extraordinarily lavish settings. The guests' arrival alone, as they disembarked from gondolas on to the palazzo steps, was an eye-popping "happening" in its own right. Among the guests who filed by Beistegui, teetering on his high platform-soled shoes in a scarlet robe and a heavy eighteenth-century-style wig, were Orson Welles, in a tuxedo and feathered hat, his costume not having been delivered in time; Gene Tierney as a flower girl; Arturo Lopez Willshaw and his wife as the emperor and empress of China; Salvador and Gala Dalí as tall Venetian ghosts; Alexis de Redé in the Chinese imperial entourage; Leonor Fini as an owl,[60] surrounded by her friends as

PAGES 250–51 Beach outfit in red cotton with white dots and matching shoes, circa 1949. Didier Ludot archives, Paris.
FACING PAGE Leonor Fini at the Panache Ball, 1947. Photograph by André Ostier (top, left). Drawing by Leonor Fini (top, right). Hélène Rochas with the Baronne de Cabrol. Photograph by André Ostier (bottom, left). Hélène Rochas at the Bal des Rois et des Reines hosted by the Count and Countess de Beaumont in 1949. Photograph by André Ostier (bottom, right).
PAGES 254–55 The Mouche and Moustache Ball, Marcel Rochas salons, 1949. Photographs by André Ostier. From left to right, top to bottom: the actor Yul Brynner and Hélène Rochas wearing a heart-shaped beauty spot on her forehead; the Rochas' friend the interior designer Georges Geffroy; the actor Jean-Pierre Aumont dancing with actress Michèle Morgan; the Baronne de Cabrol wearing a Marcel Rochas dress with straps and appliquéd starfish; Marie-Laure de Noailles with a Pointilliste-style decoration on her face; an elegant woman and on her right Monsieur Dastakian, a salesman at Marcel Rochas; Georges Geffroy with his Dalí-mustache eyebrows; the actor and director Jean-Louis Barrault, sporting a dotted mustache; the actor Henri Vidal, friend of Marcel Rochas and husband of Michèle Morgan; the actor Pierre Brasseur and actress Lana Marconi; Madeleine Renaud and the politician Edmond Barrachin, a close friend of Marcel Rochas; Michèle Morgan and Edmond Barrachin. The heroine of *Quai des Brumes* has shed her raincoat and beret and wears a beauty spot at the corner of her beautiful eyes.

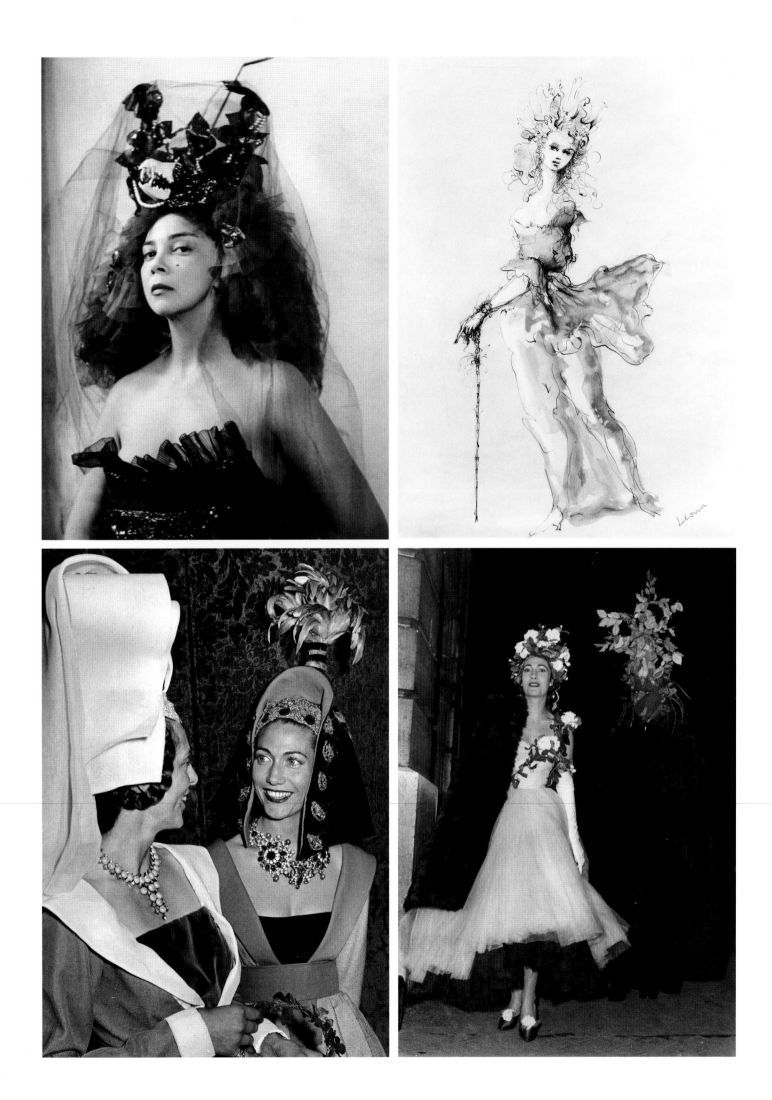

black-feathered crows; Christian Dior; Jacques Fath as the Sun King, whose "insolent luxury offended a fellow haute couturier with golden hair like a comet who was following him around"; the Aga Khan III; Barbara Hutton; "Le Commandant" Paul-Louis Weiller; Lady Churchill, alone, as Winston Churchill had declined the invitation; Lady Diana Cooper as Cleopatra (inspired by the famous Tiepolo frescoes in the Palazzo Labia); and Daisy Fellowes as an African queen, wearing her Cartier Tutti Frutti necklace. My father opted for a simpler outfit, borrowed from Watteau: he was Gilles for the evening, and my mother, on his arm, was Columbine. A Columbine in silk and gold, smiling amid the pomp of the Ancien Régime, next to her sad Pierrot, alone in white. Paul Morand remembered this late summer of 1951 much later: "Like there's no tomorrow, pleasure-seeking Europe, oil-rich Asia, bored America, the kings of *Candide*, jet-setting society, the oceans' ship-owners continued to parade before the local church, where Saint Jeremiah could not help lamenting: 'You are heading straight for the cemetery. Beware of San Michele!'"[61]

My father could not have known then that he had less than four years to live. For the time being, he was thinking about the future of couture. It was a future that looked clouded, owing to the threat of ready-to-wear, among other developments, as we have seen. Thanks to Gosset and to perfume, he had ensured a source of revenue for the house, and he did everything he could to draw attention to the Marcel Rochas name, through exhibitions, receptions, a new decor for avenue Matignon, and his high-profile presence with his pretty wife at society events. But what would become of his profession? There was nothing new about such questions. Besides the changing habits of women, who were now inclined to dress more simply and more affordably, the decline in couture exports and the problem of illicit copying were further causes for concern. After the war, "Le Chasseur d'images" observed that the "volume of 'visible' exports no longer benefits from the advantages formerly offered by exchange rates and domestic pricing. There is therefore an inevitable tendency on the part of foreign buyers, while accepting the supremacy of French fashion designs, to be inspired by them rather than to buy them. This is why, in order to compensate for the probable decline in this export sector, we should not be afraid of taking a new direction, though strewn with difficulties, and looking to conclude commercial agreements based on the reproduction of our models, this reproduction being remunerated through the payment of fair royalties."[62] In 1950, with this in mind,[63] five fashion designers—Piguet, Jacques Fath, Carven, Dessès, and Paquin—entered into partnership with seven clothing manufacturers for the production of seven models per season. These models were designed for wide distribution across provincial France and abroad, at prices ranging from 20,000 to 40,000 francs. In spring 1952, Marcel Rochas joined the "Cinq," replacing Paquin. It was to prove a short-lived collaboration for the house of Rochas, ending in fall 1952,[64] and the venture corroborated my father's decision, taken the previous year, to cease his activities as designer in the company.

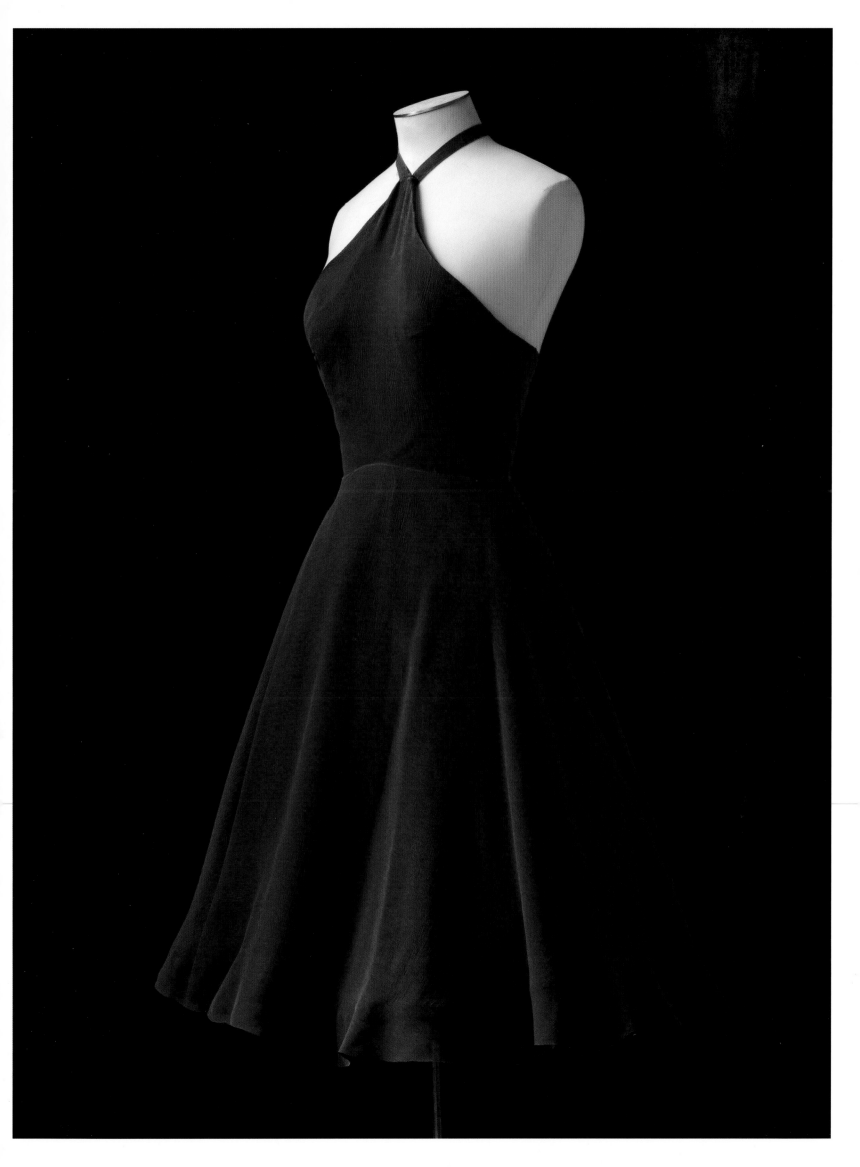

SWAN SONG The year 1951 was the peak of my father's career, crowning twenty-five years of work and creativity. In February, Marcel Rochas recounted these in a rare book, *Vingt-cinq ans d'élégance à Paris, 1925–1950* (*Twenty-five years of elegance in Paris, 1925–1950*), his final contribution to the beauty of the century, which brought the adventure to an end and established a legend. In its pages, the inimitable "*capteur d'ondes*" (trend detector) delivered his final thoughts on the couture of his times. "This book, which I have had the pleasure of writing to celebrate my twenty-five years of couture, is but a modest homage to Paris, to all that I owe it, and for all it has given me. As a Parisian and son of a Parisian, I have simply gathered my most notable memories of a fruitful period that I have lived through and experienced with such passion: 1925–1950. Through my wonderful and beloved profession, I have endeavored in all sincerity to fix a fragile moment in the history of fashion."[65] Published by Éditions Pierre Tisné and printed in a limited edition, the book boasted an elegant typeface and design, high-quality printing and paper, carefully chosen photos and drawings, and quotations from the mischievous Colette and Rochas's friend Cocteau.[66]

After a trip to Brazil and Argentina organized by a Brazilian group, my father returned for his twenty-fifth anniversary as a couturier, which he celebrated in June at the Théâtre Marigny. He took this opportunity to launch his book. "Danielle Delorme was the most applauded of the celebrities who illustrated '*Le Lanterne magique*' at the Marigny theater, presented by Marcel Rochas before an audience of Parisian celebrities. This series of images sums not only up 'twenty-five years of Parisian elegance' but also a quarter of a century of fashion designs since Rochas forsook the Bar for the couturier's studio."[67] Behind the smiles, applause, and acclaim celebrating a creative career, however, serious financial problems were affecting SAGER, the losses this incurred being offset against the profits generated by perfumes and accessories.

A series of talks on French fashion and couture took my father to Egypt. On his return to Paris, he was appointed to the order of the Légion d'Honneur, on July 7, 1951. To celebrate the award, the staff organized a party "on Friday July 13 at 1pm with a cake made by the *petites mains*. They had also created a giant cross-shaped medal for him, made of silver cardboard and hanging on a wide red ribbon. Rochas took this opportunity to announce that he was now handing responsibility for the couture side of the business to his wife, and would henceforth be in charge of the perfumes alone."[68] The women's press was already accustomed to linking Hélène's name with her husband's;[69] the Spring 1950, Fall 1951, and Spring 1952 collections were all presented as four-hand collaborations. And so for Marcel Rochas it was over: twenty-five years of elegance had come to an end.

FACING PAGE Marcel Rochas looking at the book *Vingt-cinq ans d'élégance à Paris, 1925–1950*. **LEFT** On July 7, 1951, Marcel Rochas was made a chevalier of the Légion d'Honneur. To mark the occasion, his staff threw a party at the office the following week and decorated the couturier in their own manner. **ABOVE** Hélène Rochas with Roger Crovetto at the Bal des Oiseaux, hosted at Boni de Castellane's Palais Rose.

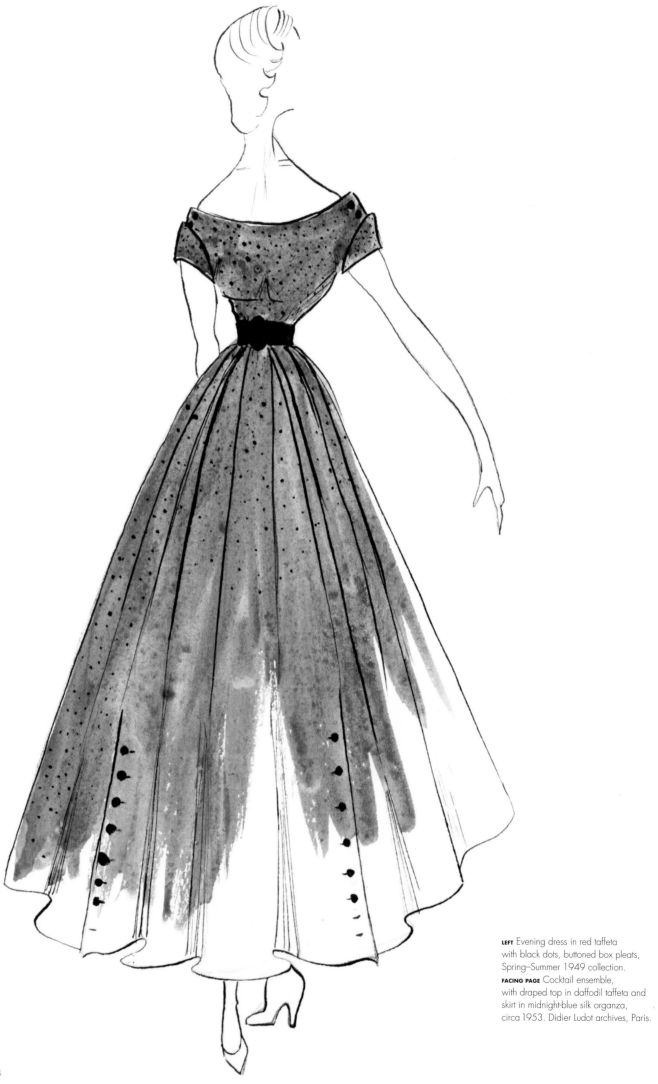

LEFT Evening dress in red taffeta
with black dots, buttoned box pleats,
Spring–Summer 1949 collection.
FACING PAGE Cocktail ensemble,
with draped top in daffodil taffeta and
skirt in midnight-blue silk organza,
circa 1953. Didier Ludot archives, Paris.

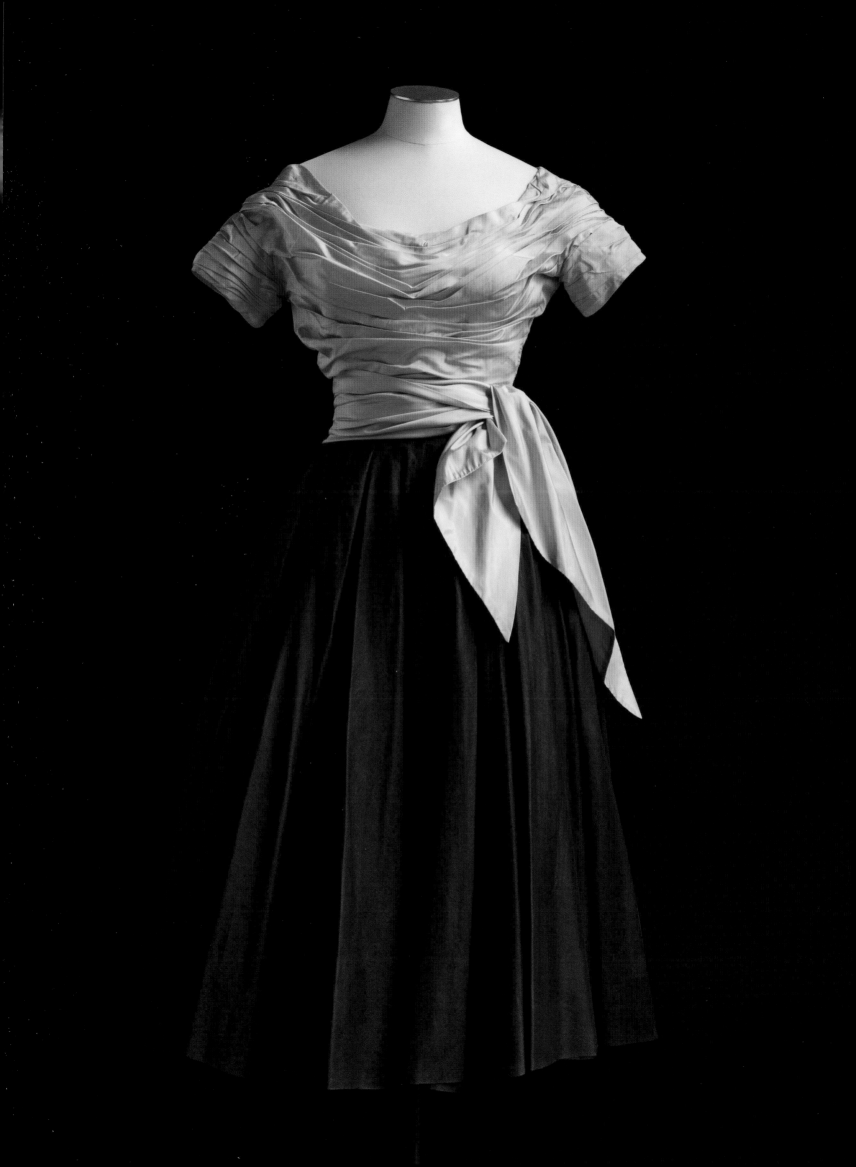

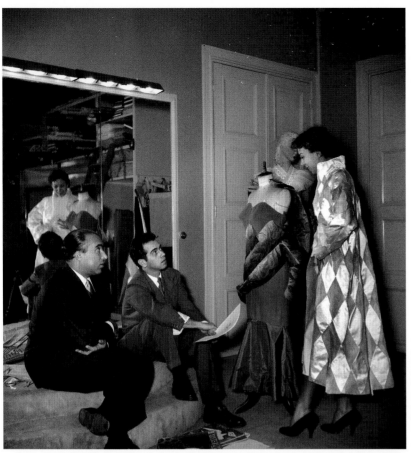
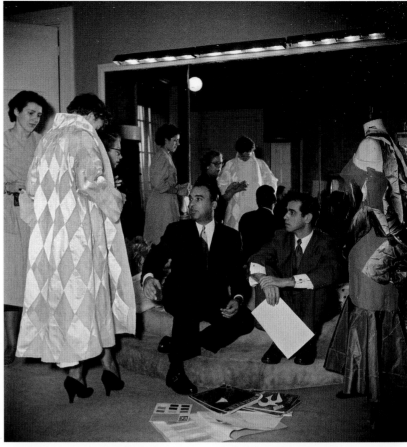
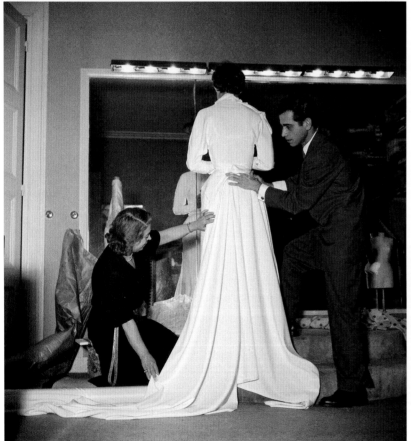
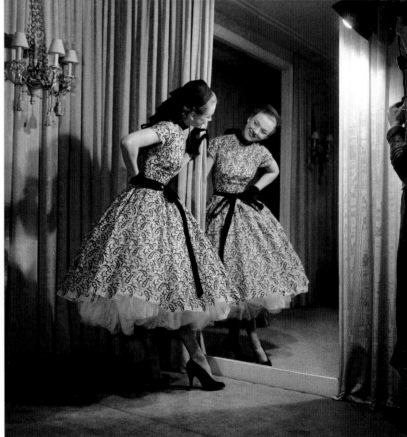

ABOVE Fittings at Marcel Rochas
with the designer Bill Underwood, 1951.
FACING PAGE Batwing dress, 1950.

At a time when couture had become a thorny problem for designers, my father had tried on several occasions to create a new line and a new face for his house. In late 1949, his Looping collection had not convinced the critics. "It's a straight line with turns, bends, loops.... The coats and dresses are of a similar, rather complicated inspiration, more skillful than graceful. There's a perceptible 1920s influence in this collection … which is perhaps not exactly what today's fashionistas are looking for," declared *Le Monde*.[70] With the Spring–Summer 1951 collection, the stylist Bill Underwood, who labeled his designs "Marcel Rochas (Bill)," failed to make an impression with the new Marcel Rochas woman. Despite Hélène Rochas's efforts to promote this different style of femininity, Rochas couture was drawing gently to a close. In early 1953, my father announced the reorganization of his business. "My new formula? A small but very focused collection of twenty-five designs created by my wife, my pupil and collaborator for ten years. These dresses, designed in perfect keeping with haute couture traditions, will be made in my studio by a number of my seamstresses and my '*première*.' This new organization will enable us to maintain quality while reducing prices as far as possible. Without going into the near-insurmountable obstacles that French haute couture is currently encountering, crushed as it is by social legislation, I prefer to 'cut down,' and to do so in style rather than sinking."[71] When its haute couture activities stopped completely in 1953, the house had just forty-four seamstresses left, compared to two hundred in 1951 and one hundred in early 1952.[72] Several other prestigious houses, such as Lucien Lelong, Robert Piguet, Marcelle Dormoy, and Molyneux had recently closed their doors, and Elsa Schiaparelli would close down the following year.[73]

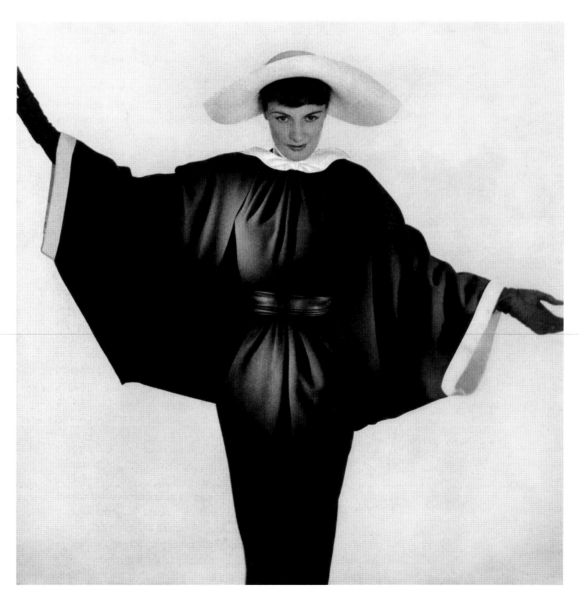

THE MISSED KISS One of my father's last decisions was to sell the building on avenue Matignon. *"Disparition ? Non, évolution"* (Closing? No, changing), he explained in *Le Monde*.[74] While awaiting a change of premises that he would not live to see, the business was refocused on perfumes, accessories, and a variety of fashion items. Perfumes, cosmetics, ties, scarves, bags, belts, stockings, raincoats, umbrellas, and jewelry came together in "the most exquisite magic grotto in Paris," as Lucien François put it. Going into the Marcel Rochas boutique was like going into an art gallery: people went there for the sheer pleasure of the visual feast to be found there, especially at Christmas time. "Marcel Rochas's most illustrious client is Queen Elizabeth of England, who has chosen, among so many other perfumes, Femme, composed as we all know with the most delicate fragrances."[75] Despite his fatigue and weakness, my father remained the best ambassador for his business. He went to all the receptions, in the evening after work; I would catch a glimpse of him when we were having dinner with the nanny, and would kiss him in a haze of Moustache when he came to say goodnight to us in our beds before heading out again.

Tonight he hasn't come to give me a kiss. Yet I've cleaned my teeth conscientiously. My brushed cotton La Chatelaine nightdress is impeccable. I've said my prayers. But…no kiss. For me to go to bed without a kiss from my papa is inconceivable. Nanny scolds us; my brother is obedient and docile, as good as gold in his Old England checkered pajamas. As soon as she shuts the door, I run to the window. He can't have forgotten; perhaps he isn't ready yet? There hasn't been a single evening when he's left without giving me a hug. I am ten years old with only my childish desires, and I am waiting for someone—someone who's not going to come. The shutters to my prettily furnished room, which we've tidied properly (Nanny's orders), are closed. Anxiously, I raise the blind and open the window, shivering with cold and impatience. There! In the still-wintry night, I hear the metallic sound of the garage door, which opens like a can of sardines to expel the black Citroën. His car hasn't left, he hasn't forgotten me! Set in bodywork polished till it gleams by the chauffeur, two yellow crow's eyes blink on. They stare at me in a friendly way. My stubbornness has paid off; I jump for joy: he's there, just a few meters from the car. Lit up in the headlamps, he's impeccably dressed, his jet-black hair smooth and slicked back, a long silk scarf with Persian motifs

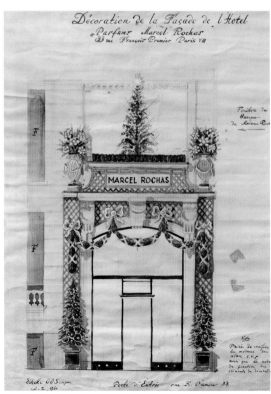

around his neck, his small hands gloved in black leather. I perceive his presence more than I can actually see him, in his midnight-blue cashmere overcoat that's so soft to the touch, and I avidly breathe in a whiff of Moustache. Why hasn't he stopped by my room? He's in a hurry. "I am late my darling, go to sleep. I'll come and give you a kiss when I get back." The car starts up in the night, and I hear it move through the gate and into the street. Silence.

Why do I feel an anxiety pressing down on my chest? The light is out and I'm scared of the dark. I want to talk to my father, but it's late, I have to sleep. I'm alone…I toss and turn in my bed. Those mad, warm kisses are from you, father dear. You are life, my life, a real, flesh-and-blood person—fragile, as such, but so strong for the dreamy child that I was. In my restless sleep, peopled with nightmares, I await my papa's return, as he promised me.

A confusion of noises, whispering, to-ing and fro-ing in the bedroom, footsteps receding, ghostly shadows…is it a child's nightmare? No, I jolt awake and shake the Old England pajamas. What time is it? Daylight is filtering through the closed shutters; we're late for school and nobody has come to wake us up. My brother rings for Nanny. Long minutes pass; we ring, and ring again. Why does no one come? The mischievous little girl freezes like a stone. She has fallen silent and will ask no more questions.

Suddenly Nanny comes in, looking terribly upset, a mixture of stiff starched linen and a mist of tears. What words does she find to tell us the unspeakable? Just these, more cutting than the guillotine: "*Mes pauvres petits*" (My poor little ones). Words that only my mother should have spoken. Maman, it's in your arms that I want to find refuge, to let my grief explode. Our mother appears in the large living room, dressed in a dark Marcel Rochas dress, her usual pearls at her neck. Around her, staff, friends, and acquaintances bustle about. Like a wall between her and us. Without a word, she takes our hands and leads us into the study, where our papa who will never return is lying. I stand before him; he is so pale, so still. The magic of childhood is shattered.

Since that night of Sunday March 13, 1955, I have always hated black Citroëns whenever they have reappeared in my life: those yellow-eyed crows are birds of ill omen for me. On Thursday March 17, a black bier was erected in the courtyard, and a long black hearse laden with flowers took our papa to the Batignolles cemetery at Porte de Clichy.[76] A crowd of elegant Parisian women flocked to his funeral, along with members of the capital's artistic and literary circles. After a career in fashion spanning thirty years, the youngest couturier had died suddenly of a ruptured aneurysm at the age of fifty-three, as he left a reception hosted by the French ambassador and the Academician André François-Poncet.[77] Lucien François paid a final tribute to him in the press: "Here was a turbulent, enterprising, man of passions, suddenly deprived by death of volatility, enterprise, and love…. Fashion designer, interior designer, perfumer, poet, host of memorable parties, *faiseur de riens*, as they used to say in the eighteenth century, a maker of much with little things, Rochas was acclaimed by the multitude. And the multitude was there to escort him to a place where he will never again be warm, he who felt the cold so easily, and who loved nothing more, during his short life, than the warmth of a mink, a perfume, a harmonious room, a female presence."

I am not allowed at the burial of my beloved father. I am forbidden to attend the funeral, and am sent instead with Nanny to the Trianon Palace hotel at Versailles. As if a palace could assuage my grief. From the hotel windows I count Marie-Antoinette's sheep, again and again, until I can't any more; I hate them. When I close my eyes, I can hear the purr of sewing machines, I can feel the silks and velvets, run them between my fingers, I see reels of thread of every color. Here, it all began with bobbins of black thread and ends with white thread. That night when my life changed forever, my father left without leaving me instructions. Long after his death, I understood that he had left me the first letter. After the R, it was up to me to find the rest.

Following the sale of the premises on avenue Matignon and the death of Marcel Rochas, the house of Rochas moved to 33, rue François 1er.
FACING PAGE AND ABOVE Christmas decoration designs for the façade of Parfums Marcel Rochas, 1961. Drawings by Alexandre Serebriakoff.

"IN MY CASE, IT COULDN'T HAVE BEEN A QUESTION OF TECHNIQUE, BECAUSE NEITHER OF US HAD ANY, BUT I BELIEVE WE BOTH HAD A NATURAL FEEL FOR QUALITY." MARCEL ROCHAS, 1943.

Marcel Rochas became a young people's couturier when he opened his first couture house in 1925. Over the next thirty years, he explored the art of creating with audacity. The man who confessed, in 1943, that he was more interested in innovation than in selling proved his ability to combine lines, forms, materials, and colors with a boldness that inspired the name of one of his first perfumes, Audace. My father died too young, in 1955, when French society was in the throes of change, and he did not have time to finish his work. A master craftsman of couture who dreaded the arrival of ready-to-wear, he nevertheless prepared for the future by developing perfume and accessories. The fragrance Femme is still the jewel of the house of Rochas, which celebrates its 90th year of fashion design in 2015: a longevity that is well-deserved for a couturier who loved women and married three: Yvonne, Rina, and Hélène, my mother. Don't they say that behind every great man is a woman?

In the 1930s, women were asserting themselves; by the 1960s, they had picked up the torch. New lifestyles called for new wardrobes. Hélène Rochas, the last Madame Rochas and the first female CEO in France at the age of thirty-three, when she took over at the helm of the house after her husband's sudden death, altered the highly sophisticated look of the line created by Marcel Rochas in the postwar years. Short hair, Chanel suits, sequined tuxedos, day pants and evening pants, designs by Hubert de Givenchy, Guy Laroche, and Yves Saint Laurent: Hélène Rochas shook off her woman-as-object image and freed herself from the hold of her mentor and guide. She seized every opportunity to pay tribute to her master, but in so doing showed that she had learned from him: with the collaboration of Albert Gosset, my mother presided over the launch and marketing of the perfume Madame Rochas, whose fragrance captures an essence and an identity. For nearly sixty years, the beauty and elegance of the famous couturier's widow shaped a new legend, to the point, sometimes, of eclipsing the memory of Marcel Rochas.

Yet Marcel Rochas produced masterpieces. Readers will choose their own favorites among the designs shown in the pages of this tribute. Timeless, unrivaled, and unpredictable, Marcel Rochas continues to haunt the work of his house, which has moved back into ready-to-wear since 1989.

Like a fragrance, the trace of Marcel Rochas runs through the designs of the house, an eternal return for an unknown celebrity.

FACING PAGE Marcel and Sophie Rochas in 1949. "Bike ride in the woods around the house in Villennes-sur-Seine, sitting on my father's knees and ringing the bell. How could I not look to the future? Today, still, my father's loving gaze protects me, his pride has passed the torch to me."
PAGE 268 Box-shaped bag with a gold metal clasp and carrying strap. Scarf in yellow and pale pink silk. House of Rochas archives.

NOTES

PREFACE

1. Lucien François, *L'Officiel*, nos. 295–96, September 1946, p. 45.

2. Paul Morand, *L'Allure de Chanel*, Paris, 1986, p. 139.

3. Gérard-Julien Salvy, *La Mode des années trente*, Paris, Seuil, 1991, Regard, reprint, 2001, p. 79.

4. Françoise Mohrt, *Marcel Rochas. Trente ans d'élégance et de créations*, Paris, Jacques Damase, 1983.

Part I
A BORN COUTURIER
1902–1925

1. Suzanne Henriette Rochas was born on November 19, 1898 in Paris, 11th arrondissement. She married Georges Louis Hiquet on July 6, 1933. She died in 1987.

2. Marcel Louis Jules Rochas was born on February 24, 1902, in Paris, 11th arrondissement. His parents were living at 20, boulevard Voltaire at the time.

3. On May 3, 1897, Alphonse Marius Rochas (1873–1912) married in Paris's 11th arrondissement Jeanne Henriette Damotte (1877–1937), born January 20, 1877 in Paris, rue Saint-Maur.

4. Germaine Blanche Jeanne Rochas, known as Perle, was born on December 6, 1910 in Paris, 1st arrondissement. On April 9, 1934, in Paris, she married Gilles-Marie Ménière de Shacken (1910–1959), a career officer who died in an ambush in Algeria. During World War II, she joined the many women who served as nurses. She died in 2003.

5. Marcel Rochas, "Vingt ans de souvenirs ou Comment je suis devenu couturier," *Revue du vêtement*, June 1943, 2nd year, no. 13, hereafter referred to as Rochas 1943.

6. On April 24, 1913.

7. According to the Lycée Condorcet honor rolls register of 1915–16, my father earned a 16 in literature and a 4 in mathematics. AP, D4T3 336 1914–1923.

8. Rochas 1943.

9. Yvonne Paulette Isabelle Coutanceau was born on January 13, 1900 in Paris, 1st arrondissement. Her second husband was Henri Lugger, whom she married on December 30, 1929. She died in 1987.

10. "One becomes really perplexed and bewildered in one's mind listening to Mr. Marcel Rochas express his tastes. He is so versatile in his talents, so interested in anything and everything that frankly it is difficult to decide which one pastime is his favorite.... He is a curiously interesting artist too, whose work could so ably have ornamented the Autumn Salon of prewar days." "Violons d'Ingres (Their Secret Loves)," *L'Art et la Mode*, no. 2710, 1946, p. 24. No trace can be found of Marcel Rochas in the Salon d'Automne exhibition catalogs between 1919 and 1922.

11. *Album du Figaro*, April–May 1950.

12. The wedding was celebrated on April 7, 1924 at the town hall in Paris's 8th arrondissement.

13. "Mlle Perle Rochas, who has just married M. Gilles-Marie Ménière, wore for her wedding day this fine dress in *peau d'ange* with a long train. Her tulle veil was held in place by a light feather motif and a white bird." "Jeunes mariées," *Femina*, May 1934, unpaginated [p. 19].

14. Among others, Marcel Rochas designed the wedding dresses of Princess Alix of Luxembourg, who married Prince Antoine de Ligne on August 18, 1950, and of Princess Yolande de Ligne, who married Archduke Carl Ludwig of Austria in 1949.

15. Rochas 1943.

Part II
EARLY DESIGNS
1925–1933

1. Jean Cocteau, "La mode meurt jeune," in *Vingt-cinq ans d'élégance à Paris, 1925–1950*, Paris, Pierre Tisné, 1951, p. 58, hereafter referred to as Rochas 1951.

2. Founded in 1910, the Chambre Syndicale de la Haute Couture opened on July 16, 1937 at 102, rue du Faubourg Saint-Honoré. See Didier Grumbach, "Haute couture : Paris, ville modèle," *Historia*, no. 794, February 2013.

3. Registre du Commerce (Trade Register), August 12, 1925, AP, D33U3 1095, no. 220137.

4. Statuts SA Marcel Rochas (articles of association of the Marcel Rochas company), 1925, AP, D31U3 2560.

5. "Un nom – une époque" in Rochas 1951, separate section, unpaginated [p. 8].

6. 9, rue Arsène Houssaye, Paris, 8th arrondissement.

7. Madeleine Ginsburg, *Paris Fashions: The Art Deco Style of the 1920s*, Bracken Books, 1989, p. 158.

8. Conversation with Arletty, 1991.

9. The Groupe des Six was formed during World War I by Georges Auric, Louis Durey, Arthur Honegger, Darius Milhaud, Francis Poulenc, and Germaine Tailleferre.

10. F. Bougon-Colin, "Le couturier Marcel Rochas est mort," *L'Aurore*, March 1955.

11. *Vogue*, October 1, 1926.

12. *Vogue*, April and September 1930.

13. F. Bougon-Colin, "Le couturier Marcel Rochas est mort," *L'Aurore*, March 1955.

14. Élisabeth de Gramont, *Souvenirs du monde de 1890 à 1940*, Paris, Grasset, 1970, p. 380, quoted in *Les Années folles 1919–1929*, Paris, Paris Musées, 2007.

15. Didier Grumbach, *Histoires de la mode*, Paris, Éditions du Regard, [1993] 2008, p. 41.

16. In 1925, it is estimated that one in three French women had her hair cut short. Martin Barnier and Raphaëlle Moine (eds.), *France-Hollywood, échanges cinématographiques et identités nationales*, Paris, L'Harmattan, 2002. The term *garçonne* was taken from the eponymous novel by Victor Margueritte, which caused a stir in 1922 that contributed to its success.

17. Colette, *Le Voyage égoïste* (*Voyage For Myself: Selfish Memories*, Peter Owen, 1971, trans. David Le Vay).

18. *Journal de la femme*, no. 270, January 7, 1938.

19. Ibid.

20. Grumbach, *Histoires de la mode*, p. 41.

21. *Relâche*, with choreography by Jean Börlin for the Swedish Ballets, music by Erik Satie, and decors by Francis Picabia, was first performed at the Théâtre des Champs-Élysées on December 4, 1924.

22. "Marcel Rochas," *L'Officiel de la couture de la mode de Paris*, no. 70, June 1927, p. 44.

23. "Marcel Rochas," ibid., no. 74, October 1927, p. 35.

24. Ibid.

25. "Vogue's Wardrobe for the American Riviera Resorts" exhibition held at Franklin Simon & Co, 1926.

26. "Marcel Rochas," *L'Officiel de la couture de la mode de Paris*, no. 74, October 1927, p. 35.

27. The automobile manufacturer introduced the luxury 8-cylinder Reinastella in 1929. It won prizes in competitions and rallies, was popular with wealthy women drivers, and was even selected as a presidential car.

28. *Vogue*, February 1930.

Part III
A GREAT COUTURIER
IN THE MAKING
1933–1939

1. In 1929, Marcel Rochas married Thérèse Marie Sarah Cassin, known as Rina Rosselli, on November 20, and Yvonne Coutanceau remarried on December 30 (see Part I, note 9).

2. Although it was dated to 1931 in my father's book ("Le sens du décor" in "Un nom – une époque," separate section in Rochas 1951, unpaginated [p. 8]), the move actually took place in 1933. See Statuts de la société anonyme Marcel Rochas (articles of the association of the Marcel Rochas company), 1934, AP, D31U3 3940. See also *L'Officiel de la couture de la mode de Paris*, no. 142, June 1933, p. 19.

3. Registre du Commerce (Trade Register), February 14 1934, AP, D33U3 1227, no. 260585.

4. Letter from Leonor Fini to André-Pierre de Mandiargues, June 1936, in *L'Ombre portée*. *Correspondance 1932–1945, Leonor Fini–André-Pierre de Mandiargues*, Paris, Le Promeneur, 2010. Born in Buenos Aires, raised in Trieste, Leonor Fini settled in Paris in 1931, where she met Rina Rochas and her sister, Elena Cassin. Thérèse Marie Sarah Cassin was born on January 14, 1903 in Ceni (Italy).

5. 34 bis, rue de Longchamp, Neuilly-sur-Seine.

6. Letter from Leonor Fini to André-Pierre de Mandiargues, June 1936, *L'Ombre portée*. *Correspondance 1932–1945, Leonor Fini–André-Pierre de Mandiargues*, 2010.

7. My Aunt Perle, who was very good friends with Rina, gave me a lead in Monaco for her. Alas, that line of research proved fruitless. She had left without leaving an address.

8. "Bravo. Cheerful, youthful, diverse, an attractive and bold use of color, a very sharp silhouette," *Marie Claire*, October 1937.

9. "Le sens du décor" in Rochas 1951, separate section, unpaginated [p. 9].

10. Historique et perspectives de la maison Rochas, report, c. 1950, Gosset archives.

11. "Les collections de demi-saison," *Femina*, [May–June] 1929, p. 29.

12. "It is not possible to obtain accounting figures enabling us to estimate the proportion of sales, at the time, of tailored goods in relation to dressmaking...the proportion must have been around 1,000 suits to 2,000 dresses, about a third.... Rochas's reputation in tailored designs [was thanks] to his remarkable head pattern cutter, Bernard, whose excellent skills were unmatched among competitors." Historique et perspectives de la maison Rochas, report, c. 1950. Gosset archives.

13. Rochas 1943.

14. Gérard-Julien Salvy, *La Mode des années trente*, Paris, Éditions du Regard, 2001, p. 81.

15. "Forget-me-not and rose are flowers that have something to say, but it's silly to love poppies and to love only them." From Marcel Mouloudji's song "Comme un p'tit coquelicot," lyrics by Raymond Asso, music by Claude Valéry, 1951.

16. Rochas 1943.

17. "Un couturier français aux USA. Ce que nous a dit M. Marcel Rochas," *Chantecler Revue*, no. 17, September 8, 1934, p. 1.

18. "Pour la Riviera," *Les Modes*, 1935.

19. "Chapeau. Gaîté, jeunesse, diversité, un emploi heureux et hardi de la couleur, une silhouette très nette," *Marie Claire*, October 1937.

20. *Paris-Couture-Années trente*, exhibition catalog, Paris, Musée de la Mode, 1987, p. 38.

21. Interview with Marcel Rochas, in Henriette Chandet, *Rester jeune*, no. 1, October 1933, p. 21.

22. "Like most of his contemporaries since the years 1935–36, [Jacques Fath] worked on the possibilities offered by optical effects in printed, dotted, striped, or checkered fabrics ... but their research did not attain the technical virtuosities of the likes of Marcel Rochas or Balenciaga." Valérie Guillaume, *Jacques Fath*, Paris, Adam Biro, Paris-Musées, 1993, p. 102.

23. Guillaume Garnier, "Quelques couturiers, quelques modes," *Paris-Couture-Années trente*, 1987, pp. 24–25.

24. Gérard-Julien Salvy, *La Mode des années trente*, 2001, p. 79.

25. Ibid.

26. Ibid.

27. "Les Saisons de Paris. Le dîner du Ciro's," *Femina*, January 1934, p. 8.

28. Rochas 1943.

29. Françoise Mohrt, *Marcel Rochas. Trente ans d'élégance et de créations*, Paris, Jacques Damase, 1983, hereafter referred to as Rochas 1983, p. 51.

30. "Marcel Rochas," *L'Officiel de la couture et de la mode de Paris*, no. 151, March 1934, p. 114.

31. Gérard-Julien Salvy, *La Mode des années trente*, 2001, p. 81.

32. "Nouveautés. La mode des oiseaux," *Femina*, April 1934, p. 1.

33. Michel Déon, *Bagages pour Vancouver*, Paris, Gallimard, Folio, 1985, p. 29.

34. *L'Officiel de la couture et de la mode de Paris*, no. 152, April 1934, p. 21.

35. Rochas 1951, "Un nom – une époque," separate section, unpaginated [p. 3].

36. "La Mode, aperçu sur les premières collections," *L'Européen*, February 8, 1935, p. 12.

37. Ibid.

38. *Les Modes*, March 1935.

39. Ibid.

40. See p. 245.

41. *Jardin des Modes*, July 1931.

42. *Femina*, [1933], p. 16.

43. "La mode est surtout intéressante par la nouveauté de ses details," ibid., p. 5.

44. Rochas 1951, "Un nom – une époque," separate section, unpaginated [p. 11].

45. Rochas 1983, p. 72.

46. *L'Officiel de la couture et de la mode de Paris*, no. 150, February 1934, p. 73.

47. Marcel Rochas, "Les Américains et ma conscience," ibid. no. 133, September 1932, p. 30.

48. Ibid.

49. "Un couturier français aux USA. Ce que nous a dit M. Marcel Rochas," *Chantecler Revue*, no. 17, September 8, 1934, p. 1.

50. Ibid.

51. Adrian Adolph Greenberg (1903–1959) would soon design Dorothy's red shoes in *The Wizard of Oz* for MGM.

52. Travis Banton (1894–1956).

53. "Un couturier français aux USA. Ce que nous a dit M. Marcel Rochas," *Chantecler Revue*, 1934, p. 1.

54. Ibid.

55. "Un jeune couturier français à New York," *L'Officiel de la couture et de la mode de Paris*, no. 196, December 1937, p. 26.

56. Emmanuelle Polle, *Jean Patou: A Fashionable Life*, Paris, Flammarion, 2013.

57. Letter from Leonor Fini to Pierre de Mandiargues, December 5, 1936, *L'Ombre portée*, p. 134.

58. "Un jeune couturier français à New York," *L'Officiel de la couture et de la mode de Paris*, no. 196, December 1937, p. 26.

59. "Autour d'une conference," ibid., no. 196, December 1937, p. 22.

60. Kathleen Cannell, "Paris Styles Cater Little to Berlin, But Its Influence Creeps Into Them," *The New York Times*, December 2, 1940.

61. http://www.vogue.com

62. Rochas 1943.

63. It was during the shooting of *Les Enfants terribles* in September 1949 that Francine Weisweiller met the man with whom she become close friends: "Monsieur Cocteau." Once the film was finished, the poet, accompanied by his adoptive son, Édouard Dermit, known as Doudou, accepted Francine's invitation to spend a few days (it would quickly become long months) at the Weisweillers' property in Cap Ferrat, Villa Santo Sospir. It was in this seaside decor revisited by Jean Cocteau, who endlessly covered the walls with his own frescoes, that these friends became as close as a family, joined by Doudou's youngest sister as well as Carole Weisweiller's childhood hero, Jean Marais. See Carole Weisweiller, *Villa Santo Sospir. Jean Cocteau*, Paris, Michel De Maule, 2012.

64. Hélène Rochas, conversation with Jacques Chancel, *Radioscopie* radio program, France Inter, December 11, 1968.

65. *Two for the Road*, directed by Stanley Donen, 1967, wardrobe coordination by Sophie Issartel-Rochas.

66. "Un couturier français aux US," p. 1.

67. Ibid.

68. Jean Cocteau, *Journal, 1942–1945*, text collected, introduced, and annotated by Jean Touzot, Paris, Gallimard, 1989, pp. 277–78, March 3, 1943.

69. Ibid., p. 289, March 23, 1943.

70. Ibid., p. 374, October 3, 1943.

71. Reminiscences of Geneviève Boyard-Becker recorded by Valérie Vignaux in *Jacques Becker ou l'exercice de la liberté*, Liège, Céfal, 2000, p. 73.

72. Conversation with Claude Boissol, 1992, quoted by Valérie Vignaux, ibid., p. 67.

73. *Le Journal de la Résistance : la Libération de Paris*, INA archives, http://www.ina.fr/video/AFE99000038.

74. Micheline Presle, personal communication, 2008.

75. Micheline Presle, *Di(s)gressions*, Paris, Stock, 2007.

76. *Première étape* by Paul Géraldy, Studio des Champs-Élysées, 1944.

77. *La Nuit du diable* by Jacques Robain, Théâtre de La Potinière, 1946. "Marie Déa a de l'allure dans une jolie robe de Rochas,"

L'Art et la Mode, no. 2709, March–April 1946, p. 67.

78. Lucien François, "L'élégance au théâtre," *L'Art et la Mode*, no. 2694, February 1944, pp. 10–11.

Part IV
DARKNESS IN THE CITY OF LIGHT
1939–1945

1. "Collections d'été. Marcel Rochas," *L'Officiel de la couture et de la mode de Paris*, no. 214, June 1939, p. 66.

2. "Marcel Rochas et la mode," ibid., no. 215, July 1939, p. 90.

3. "Marcel Rochas," ibid., no. 217, September 1939, p. 90.

4. Historique et perspectives de la maison Rochas, report, c.1950, p. 6. Gosset archives. This hypothesis seems the more plausible one, despite a press release issued by the house of Rochas on the death of Marcel Rochas, stipulating that the couturier had "placed the management of his couture house, at the height of its success, in the hands of a group of senior members of his staff" (Marcel Rochas, le célèbre couturier parfumeur, est mort dans la nuit du 13 au 14 mars, à 2 h du matin, press release from the Maison Rochas, March 14, 1955).

5. "Infirmière des hommes," *Marianne*, December 27, 1939.

6. In 1939 the couture industry in Paris provided employment for some 25,000 seamstresses and other workers. See Dominique Veillon, *La Mode sous l'Occupation*, Paris, Payot, 1990, p. 31.

7. "Élégance métropolitaine," *L'Art et la Mode*, no. 2657, January 1941, p. 14.

8. *Fourrures Magazine*, February–March 1940, p. 29, quoted by Dominique Veillon, *La Mode sous l'Occupation*, Paris, Payot, 1990, p. 27.

9. Dominique Veillon, ibid., p. 67.

10. Report by Lucien Lelong, La Couture française de juillet 1940 à août 1944, Archives Nationales, quoted by Dominique Veillon, ibid., p. 142.

11. Ibid., p. 143.

12. Ibid, pp. 149–63.

13. An all-powerful press baron during the Occupation, Jean Luchaire would be shot for collaboration with the enemy in 1946.

14. Corinne Luchaire, *Ma drôle de vie*, Paris, Sun, 1949, quoted by Dominique Veillon, *La Mode sous l'Occupation*, 1990, p. 181.

15. Dominique Veillon, ibid., p. 150.

16. SAGER (Société Anonyme de Gérance des Établissements Rochas) was founded on February 13, 1940. Its business activity was stated as the manufacture and sale of haute couture, and it had a registered capital of 500,000 francs divided into 500 shares, 488 of which were owned by Marcel Rochas, the rest shared between Marc de Laujardière and others. Gosset archives.

17. Ibid., p. 107.

18. Kathleen Cannell, "Paris Styles Cater Little to Berlin, But Its Influence Creeps Into Them," *The New York Times*, December 2, 1940.

19. Rochas 1943.

20. "La mode a decidé," *L'Art et la Mode*, no. 2663, July 1941, p. 10.

21. *Les Nouveaux Temps*, September 25, 1941, and Camille Anbert, "Jacques Fath," *Réalités*, no. 63, April 1951, pp. 47–56, 125, quoted by Valérie Guillaume, *Jacques Fath*, 1993, p. 30.

22. Lucien François, "Les grands couturiers nous révèlent," *Votre beauté*, March 1942.

23. "Les collections," *L'Art et la Mode*, no. 2678, October 1942, p. 10.

24. Dominique Veillon, *La Mode sous l'Occupation*, 1990, p. 188.

25. Anne Vernon, *Hier à la même heure*, Paris, Acropole, 1988.

26. Anne Vernon, personal communication, January 2014.

27. "Notes sur les collections," *L'Art et la Mode*, no. 2684, April 1943, p. 19.

28. Ibid.

29. "Les collections de printemps," *L'Officiel de la couture et de la mode de Paris*, no. 259, April 1943, p. 9.

30. "Aperçus sur les collections," ibid., no. 265, October 1943, p. 5.

31. Lucien François, "L'effort des couturiers de Paris depuis l'armistice," *L'Art et la Mode*, no. 2701, August 1944, pp. 6–11.

32. Edwige Bouttier, "Premières notes sur les collections," ibid., no. 2690, October 1943, p. 4.

33. Lucien François, "L'effort des couturiers de Paris depuis l'armistice," *L'Art et la Mode*, no. 2701, August 1944, pp. 6–11.

34. Ibid.

35. *L'Ombre portée*.

36. I learned much later from my Aunt Perle, who was very close to her, that Rina never got over this loss. See Part III, note 7.

37. Irène Lidova, "Visages de Paris," *L'Officiel de la couture et de la mode de Paris*, nos. 285–86, December 1945, p. 95.

38. Hélène Rochas, conversation with Jacques Chancel, *Radioscopie* radio program, France Inter, December 11, 1968. According to Lucien François, my mother met Marcel Rochas at a reception at his home.

39. Hélène Rochas said that she entered the Opéra at the age of seven. Conversation with Jacques Chancel, 1968, see note 38.

40. Nelly Paulette Jeanne Brignole, born in Montauban-de-Picardie (Somme) on March 24, 1921.

41. Son of Tristan Bernard, Raymond Bernard (1891–1977) was a French film director, famous for his film *Les Croix de bois* (1931).

42. My mother attended the Cours Simon drama school in the late 1930s with François Périer. Hélène Rochas, conversation with Jacques Chancel, 1968, see note 38.

43. Hélène Rochas, conversation with Jacques Chancel, 1968, see note 38.

44. He was born on August 24, 1942. My parents were married on November 20, 1942, in Paris's 8th arrondissement.

45. Letter from Marcel Rochas to Hélène Rochas, November 20, 1947, Sophie Rochas archives.

46. Location unknown. Nora Auric made a pendant portrait of my brother, which remained in his personal collection until it was sold at Christie's in Paris, on September 27, 2012.

47. "Week-end avec…," *L'Officiel de la couture et de la mode de Paris*, nos. 327–28, June 1949, pp. 124–25.

48. Ibid.

49. Cecil Beaton, quoted in *Groussay. Châteaux, folies et familiers de Charles de Beistegui*, Paris, Albin Michel, 2007.

50. Jean-Louis Ricci, their son, born February 22, 1944, was my nursing brother during the months when it was still difficult to obtain formula milk for babies.

51. "Chez les Rochas, au réveillon de Noël, pas d'Aragon, pas d'Éluard, pas de Parrot (Lise toute seule)." Jean Cocteau, *Journal, 1942–1945*, text collected, introduced, and annotated by Jean Touzot, Paris, Gallimard, 1989, pp. 599–600, January 1, 1945.

52. "Le Théâtre de la mode," *L'Officiel de la couture et de la mode de Paris*, nos. 277–78, March–April 1945, p. 49.

53. *Le Théâtre de la Mode*, Paris, Éditions Modernes Parisiennes, 1945.

54. "Le Théâtre de la mode," *L'Officiel de la couture et de la mode de Paris,* nos. 277–78, March–April 1945, p. 49.
55. London, Princes Galleries, from September 12, 1945.
56. *Le Théâtre de la mode,* Paris, Musée des Arts de la Mode, May 10–September 9, 1990, exhibition organized by the Union des Arts Décoratifs; exhibition catalog, Paris, Du May, 1990 (essays by Edmonde Charles-Roux, Herbert R. Lottman, Stanley Garfinkel, and Nadine Gasc). English edition published by Rizzoli, 1991.

Part V
COUTURE AND PERFUME 1945–1955
1. "L'Histoire de la Parfumerie," talk given by Albert Gosset, 1967.
2. Rochas collection.
3. Born into the Gosset family of champagne producers, Albert Gosset (1915–1991) worked in perfumery—another area that called for a good "nose"—before taking over the running of the family company in 1976. "After graduating from the École Supérieure de Commerce in 1936 he was drafted, enabling him to enjoy one of his passions by becoming a pilot, flying a bomber in the Battle of France in 1940. Following his demobilization, he soon started work in what would be his whole life, the luxury industry." (From Albert Gosset's death announcement in 1991.)
4. The company Parfums Marcel Rochas, with a registered capital of 1,000,000 francs, was founded on January 12, 1945. Of the 4,000 shares, 2,230 were held by Marcel Rochas and 1,040 by Albert Gosset. Family members, friends, and other shareholders shared the rest. Marcel Rochas was appointed CEO, and Albert Gosset managing director.
5. Conversation with Edmond Roudnitska, July 18, 1993, http://www.art-et-parfum.com.
6. Unpublished notes by Edmond Roudnitska, October 22, 1986, Sophie Rochas archives.
7. Edmond Roudnitska, *Une vie au service du parfum,* preface by Michel Mosser, Paris, Thérèse Vian, 1991, p. 6. Michel Mosser was president of the Fédération Française de l'Industrie des Produits de Parfumerie, de Beauté et de Toilette.
8. Anne Vernon, *Hier à la même heure,* 1988.
9. Albert Gosset's sons Antoine and Laurent still have this bottle. Albert knew René Lalique, who lived in the same village as the Gossets, Aÿ in Champagne. It was apparently thanks to Lalique that he obtained glass coupons for the manufacture of the Femme bottles. Personal communication from Antoine and Laurent Gosset, October 25, 2013.
10. Conversation with Edmond Roudnitska, July 18, 1993, http://www.art-et-parfum.com.
11. Rochas 1983, p. 128.
12. Lucien François, *Petit Dictionnaire des odeurs suaves,* 1954.
13. Rochas press kit, 1981.
14. Marcel Rochas, preface to the catalog *Les Parfums à travers la mode,* December 1945.
15. Ibid. Born in 1879, Paul Poiret died at the age of sixty-five.
16. Lucien François, *Petit Dictionnaire des odeurs suaves,* 1954.
17. SARL with a registered capital of 1,000,000 francs. Registre du Commerce (Trade Register), January 3, 1949, AP, D33U3 1771.
18. SARL with a registered capital of 1,000,000 francs. Registre du Commerce (Trade Register), January 3, 1949, AP, D33U3 1531.
19. SARL with a registered capital of 750,000 francs. Registre du Commerce (Trade Register), January 7, 1948, AP, D33U3 1501.
20. Catherine Örmen, *Histoire(s) du prêt-à-porter,* text published for the 80th anniversary of the Fédération Française du Prêt-à-Porter Féminin, 2009, http://www.pretaporter.com/ [Présentation –> Publications].
21. Ibid.
22. "Tout Paris en parle," *L'Officiel de la couture et de la mode de Paris,* nos. 331–32, fall 1949, p. 164.
23. Letter from Madeleine Renaud to Marcel Rochas, n.d. [Friday, c.1950], Sophie Rochas archives. *"Merci mon Hélène de nous avoir encore gâtés! Nous étions heureux comme des gosses en découvrant nos parfums préférés! Que ferait Jean-Louis sans 'Moustache'! Tous nos vœux très tendres pour vous tous et je t'embrasse. Madeleine Renaud."* [Thank you dear Hélène for spoiling us once more! We were as happy as kids when we found our favorite perfumes! What would Jean-Louis do without "Moustache"! Fondest wishes and love to all of you. Madeleine Renaud.]
24. Eau de Roche (1947) and Eau de Verveine (1948), both stopped in 1956. Eau de Roche began a new life in 1970, with a composition by Nicholas Mamounas.
25. A perfume designed by Jean Desprez in 1925 for Millot.
26. Unpublished notes by Edmond Roudnitska, October 22, 1986, Sophie Rochas archives.
27. Conversation with Edmond Roudnitska, July 18, 1993, http://www.art-et-parfum.com/. Before it became Mousseline, the perfume Chiffon was called Poupée for a while.
28. Lucien François, *Petit Dictionnaire des odeurs suaves,* 1954.
29. Unpublished notes by Edmond Roudnitska, October 22, 1986, Sophie Rochas archives.
30. Ibid.
31. Ibid.
32. Ibid.
33. "La grande saison de Paris," *L'Officiel de la couture et de la mode de Paris,* nos. 329–30, August 1949, pp. 84–87.
34. Unpublished notes of Edmond Roudnitska, October 22, 1986, Sophie Rochas archives.
35. "Collections de printemps," *L'Art et la Mode,* no. 2703, March–April 1945, p. 15.
36. "De fil en aiguille," *L'Officiel de la couture et de la mode de Paris,* nos. 277–78, March–April 1945, p. 23.
37. Léon-Paul Fargue, "Désirs," ibid., nos. 283–84, October 1945, p. 26.
38. *Le Chasseur d'images,* "Sommes-nous prêts?," ibid., p. 32.
39. *L'Art et la Mode,* no. 2706, October 1945, p. 18.
40. "Tout doux," *L'Officiel de la couture et de la mode de Paris,* nos. 285–86, December 1945, p. 67.
41. Lucien François, "Aux sources de la mode," *L'Art et la Mode,* no. 2709, March–April 1946, p. 55.
42. The private mansion, at 30, avenue Montaigne, was inaugurated on December 16, 1946. See Marie-France Pochna, *Christian Dior,* Paris, Flammarion, 1994, p. 146.
43. Gabrielle C. Berton, "Panorama de haute couture," *L'Art et la Mode,* no. 2709, March–April 1946, p. 17.
44. "À Cannes. Festival du film," *L'Officiel de la couture et de la mode de Paris,* nos. 295–96, October 1946, p. 85.
45. Aliette Marchois, "Les collections d'hiver chez les grands couturiers," *Le Monde,* October 5, 1946.
46. Gabrielle C. Berton, "Panorama de haute couture," *L'Art et la Mode,* no. 2709, March–April 1946, p. 17.
47. "La ligne 1948 dans la haute corsetterie," *L'Officiel de la couture et de la mode de Paris,* nos. 307–8, September–October 1947, p. 70.
48. "De l'élégance, de la ligne, de l'audace," ibid., nos. 301–2, March–April 1947, p. 51.
49. "Premiers interviews de la haute couture," *L'Art et la Mode,* no. 2720, Fall 1947, p. 25.
50. *Air France Revue,* 1948.
51. "Les collections d'hiver," *L'Officiel de la couture et de la mode de Paris,* nos. 319–20, September–October 1948, p. 100.
52. Waldemar-George, "Portraits d'hommes," Moustache. Portraits d'hommes du XVIᵉ siècle à nos jours, exhibition catalog, Marcel Rochas salons, 1949, p. 28.
53. Rochas 1983, p. 11.
54. 40, rue Barbet-de-Jouy, a private mansion built in 1863. My mother lived there until her death in 2011.
55. *Le Printemps nᵒ 1* and *La Rieuse aux roses,* Sophie Rochas archives.
56. Valérie Guillaume, *Jacques Fath,* 1993, p. 83.
57. *L'Officiel de la couture et de la mode de Paris,* nos. 335–36, January–February 1950, p. 47.
58. Paul Morand, *Venises,* Paris, Gallimard, L'imaginaire, 1971, p. 161.
59. Ibid.
60. Jean-Noël Liaut, *Hubert de Givenchy,* Paris, Grasset, 2000.
61. Paul Morand, *Venises,* p. 163.
62. Le Chasseur d'images, "Politique de la présence," *L'Officiel de la couture et de la mode de Paris,* nos. 297–98, p. 60.
63. On the initiative of the outgoing president of the Chambre Syndicale de la Couture Parisienne, Jean Gaumont-Lanvin. See Valérie Guillaume, *Jacques Fath,* p. 43.
64. Valérie Guillaume, ibid., pp. 43–46.
65. Rochas 1951, p. 6.
66. "My dear Marcel Rochas. You know how happy I will be to assist you (if it is within my means). I am overloaded with work. Séverin [?] stopped by at the house. I wasn't there. I was on a shoot. I'll see him. Tell him to stop by one morning at around 10am. All best to you and yours. Jean *" Letter from Jean Cocteau to Marcel Rochas, November 27, 1949. Sophie Rochas archives.
67. "Elles et eux," *Paris Match,* no. 119, June 30, 1951, p. 37.
68. "Elles et eux," ibid., no. 123, July 28, 1951, p. 37.
69. "Couturiers for women, fond of contrasts and new ideas, Marcel Rochas and Hélène Rochas have given us an essentially feminine collection.... This soft style suits their personality: floating backs, white 'Mongolfière' ["hot-air balloon"] sleeves, and natural waists express a *joie de vivre.* In this easy-going style a fashion is expressed," *L'Officiel de la couture et de la mode de Paris,* nos. 337–38, March–April 1950, p. 156.
70. E. de Semont, "Au jour le jour... les collections," *Le Monde,* August 16, 1949.
71. E. de Semont, *"Disparition ? Non, evolution," Le Monde,* January 15, 1953.
72. One hundred employees, including seven pattern cutters, three *premières d'atelier* (head seamstresses) and five models. "Questionnaire relatif à la classification Couture-Création," Chambre Syndicale de la Couture Parisienne, 1952, Rochas archives.
73. Archives of the French Finance Ministry, Chambre Syndicale de la Couture Parisienne file, "Note concernant la situation de la couture parisienne," November 1954, quoted by Valérie Guillaume, *Jacques Fath,* 1993, p. 36.
74. "It is true," Marcel Rochas tells us, "that I have just sold my house on avenue Matignon to the Banque de la Cité, but I have kept my store there and, possibly, some of my workshops." E. de Semont, "Disparition ? Non, evolution," *Le Monde,* January 15, 1953. Marcel Rochas was able to buy the building by exercising a purchase option that he had until end 1952, according to a letter from Marcel Rochas to Albert Gosset, December 12, 1951, Gosset archives.
75. E. de Semont, "Leurs parfums favoris," *Le Monde,* November 27, 1952.
76. The religious ceremony, which was to take place at the church of Saint-François-Xavier, in my father's parish, was refused and cancelled at the last minute, probably because he was twice divorced.
77. *L'Humanité,* March 1955.

KEY DATES

1898
Birth of Marcel Rochas's elder sister, Suzanne Rochas.

1902
February 24 > Birth of Marcel Rochas in Paris.

1903
Paul Poiret opens his couture house.

1907
Pablo Picasso paints *Les Demoiselles d'Avignon*.

1909
Jeanne Lanvin, who opened her first Paris boutique in 1889 on rue Boissy-d'Anglas, Paris, 8th arrondissement, launches a women's collection.

1910
Gabrielle Chanel opens her first boutique at 21, rue Cambon, Paris, 1st arrondissement.
December 6 > Birth of Germaine Rochas, Marcel's younger sister, known as Perle.

1911
Paul Poiret sets up his fragrance house Les Parfums de Rosine.

1912
Death of Marcel's father, Alphonse Rochas.

1914
June 1 > Jean Patou establishes his couture house.
July 31 > Assassination of Jean Jaurès.
August 1 > General mobilization.
August 3 > Germany declares war on France.
November > Marcel Rochas is admitted to the Lycée Condorcet in Paris, where he will stay until 1916.
The Rochas family resides at 7, rue Rouget-de-l'Isle in the 1st arrondissement.

1917
April 3 > The United States joins the war.
May 18 > The ballet *Parade*, commissioned by Serge Diaghilev's Ballets Russes, is performed at the Théâtre du Châtelet. The *"ballet réaliste,"* created by Léonide Massine (choreography), Erik Satie (music), and Jean Cocteau (libretto), also saw the contribution of Picasso, who designed the stage curtain, sets, and costumes.
November 6 > The Bolsheviks take power in Russia, and conclude an armistice with the Central Powers the following month.

1918
November 11 > The Armistice ends World War I.

1922
May > Marcel Rochas is called up for military service.

1923
October 25 > *La Création du monde*, inspired by Cendrars' *Anthologie nègre*, with music by Darius Milhaud and sets designed by Fernand Léger, is performed for the first time by the Swedish Ballets at the Théâtre des Champs-Élysées.
November > Marcel Rochas is demobilized.

1924
April 7 > Marcel Rochas marries Yvonne Coutanceau.
June 4 > Molière's comedy-ballet *Les Fâcheux* is performed at the Théâtre des Champs-Élysées, with choreography by Bronislava Nijinska, music by Georges Auric, and libretto by Boris Kochno. The curtain, sets, and costumes are designed by Georges Braque.

1925
April 28 > Opening of the Exposition Internationale des Arts Décoratifs et Industriels. Paul Poiret presents his collections on three barges named *Amours*, *Délices*, and *Orgues*, moored near Alexandre III Bridge.
Guerlain's new perfume Shalimar is a hit among society women.
Charlie Chaplin's *The Gold Rush* is released.
June 22–July 4 > René Lacoste, "The Crocodile", defeats Jean Borotra at the Wimbledon Championships.
August 12 > Marcel Rochas opens his couture house on the 4th floor of number 100, rue du Faubourg Saint-Honoré in the 8th arrondissement.
October 2 > Josephine Baker triumphs in the *Revue Nègre* at the Théâtre des Champs-Élysées.
November 13 > First group exhibition of the surrealist painters at the Galerie Pierre on rue Bonaparte, showing works by André Masson, Max Ernst, Paul Klee, Hans Arp, Juan Miró, Man Ray, Picasso, Pierre Roy, and Giorgio de Chirico.

1926
August 23 > Rudolf Valentino dies of septicemia, aged 31.
Jeanne Lanvin launches a men's couture line.

M.R. DESIGNS
Matching sweater and skirt ensembles; beach pajamas. The latter were spotted by *Vogue* and put on display alongside original designs by couturiers from Paris and London at the Franklin Simon & Co store in New York, which was hosting *Vogue's Wardrobe For the American Riviera Resorts*.

1927
February 6 > Ten-year-old violin prodigy Yehudi Menuhin makes his debut at the Salle Gaveau, performing Édouard Lalo's *Symphonie espagnole* to an audience of 1,500.
May 20–21 > Aviator Charles Lindbergh makes his non-stop solo Atlantic crossing from New York to Paris in the *Spirit of St. Louis*.
September 14 > Accidental death in Nice of the American dancer Isadora Duncan.

M.R. DESIGNS
A-line slightly flared at the bottom with godet inserts; flowing evening gowns with detached panels and irregular lengths; jersey and wool ensembles; Cubist-style sportswear ensemble.

1928
Elsa Schiaparelli founds her couture house.
June 28 > Igor Stravinsky's *Apollo* is performed in Paris by the Ballets Russes.
August 27 > The Kellogg-Briand Pact or General Treaty for Renunciation of War is signed in Paris by Germany and the Allied forces.

M.R. DESIGNS
Single-breasted coats with half-belt; trompe-l'oeil two-piece dresses; sweaters with colored insets; blouses with Peter Pan collars.

1929
May 16 > The first Academy Awards (Oscars) ceremony is hosted by Douglas Fairbanks at the Hollywood Roosevelt Hotel in Los Angeles.
Jean Cocteau publishes *Les Enfants terribles*.
August 19 > Serge Diaghilev dies in Venice.
October 24 > Black Thursday, first day of the Wall Street Crash.
November > Yvonne and Marcel Rochas divorce.
November 20 > Marcel Rochas marries Rina Rosselli, his second wife.

On the same day, the first Dalí exhibition opens
at the Galerie Goemans in Paris.

M.R. DESIGNS

The line is cut straight, slightly flared at the bottom; skirt lengths drop
and shoulders begin to widen (loose-fitting jackets, capes, etc.)

1930

Marcel and Rina Rochas move to 34 bis, rue de Longchamp in Neuilly.
Georges Auric composes the music for Jean Cocteau's experimental
film *Le Sang d'un poète*.
May 12–13 > Jean Mermoz crosses the South Atlantic non-stop
in 21 hours in the hydroplane *Comte de la Vaulx*.
July 22 > Josef von Sternberg's *The Blue Angel*, starring Marlene Dietrich,
is released in France.
August > Maurice Chevalier returns from a tour of the United States.

M.R. DESIGNS

Winter collection inspired by the Middle Ages: wool or fur jerkins
with flat collars and sleeves in a contrasting color.

1931

Alix Grès opens her fashion house, Alix.
Villa Savoye, the last of the villas designed by Le Corbusier
in the Purist style, is built in Poissy.
May 6 > Opening of the Exposition Coloniale in the Bois de Vincennes.
Josephine Baker sings *J'ai deux amours*.

M.R. DESIGNS

Marcel Rochas launches the fashion for square shoulders
and large white collars.
Bali dress; beach pajamas with wide pants with pleats
for extra fullness; suit-style sports coats.

1932

Nina Ricci opens her couture salons in Paris.
December > The Prix Renaudot is awarded to Céline for *Voyage
au bout de la nuit*.

M.R. DESIGNS

Wide shoulders, slim hips, high waist, short skirts, and narrow belts for
the Summer collection's Egyptienne line, and double-breasted or buttoned
corselet effects in the "era-of-armor"-inspired Winter collection.

1933

The Marcel Rochas store moves to 12, avenue Matignon in the 8th arrondissement.
Marcel Rochas designs the costumes for *Lac aux dames*,
a film by Marc Allégret (released in 1934).

M.R. DESIGNS

Rochas develops his taste for stripes and prints. Directoire-style evening gowns;
sheath dresses with a slit front or sides and a train; surplice.

1934

February 14 > The second Société Marcel Rochas is established.
Marcel and Rina travel to the United States. After New York, they visit
the Hollywood studios and meet American actresses including Joan Crawford,
Carole Lombard, Jean Harlow, Gloria Swanson, and Mae West.

M.R. DESIGNS

Dresses inspired by birds (a favorite Rochas theme, developed over
some fifteen years): Oiseau and Hippocampe dresses; Angkor coat;
"architectural" coats; La Bourrasque swimsuit; Davos ski outfit.

1935

Marcel and Rina reside at 66, avenue d'Iéna, renting a second house
in Behoust (Yvelines).
Marcel Rochas designs costumes for Robert Siodmak's film
La Vie Parisienne (released in 1936).

M.R. DESIGNS

Marcel Rochas develops the color contrasts and mixed materials typical
of his style. The close-fitting line disappears.
Suits with bell skirts; evening gowns flaring into corollas; blouses with original
print motifs; flat flowers placed on the neckline or belt.

1936

May 3 > The Popular Front wins the French general elections.
May 22 > The *Exposition surréaliste d'objets* show opens
at the Charles Ratton gallery in Paris.
June > Following the Matignon Agreements, laws granting paid
vacations are voted in.
July > Outbreak of the Spanish Civil War. Launch of the first Marcel Rochas
perfumes (Air Jeune, Avenue Matignon, and Audace).
December > Marcel Rochas takes another trip to New York.

M.R. DESIGNS

Mixed prints, combinations of houndstooth and plain motifs, and
a new treatment of floral print, cut out and re-appliquéd on plain clothes.
Suits with pockets, ancestors of the safari jacket.

1937

May 25 > Opening of the Exposition Internationale in Paris. Pablo Picasso
exhibits *Guernica* in the Spanish Pavilion.
Jacques Fath presents his first collection, which is sponsored by Marcel Rochas.
September > Opening of the Marcel Rochas store in New York,
32 East 67th Street.

M.R. DESIGNS

Highly imaginative, fanciful use of color and fabric, mixtures of decorative
fabrics, lots of flowers, embroidery, and applied motifs, a very high
waist sometimes marked with a wide horizontal band for a belt,
accentuating the bust.
Gitane dress; Cœur dress; Fleurs bolero; classically cut suits;
masculine-cut pajamas and shorts.

1938

March > Marcel Rochas's New York couture salon is shut down.

M.R. DESIGNS

Lace insets, appliqué flowers, contrasting fabrics on the front and back of a
garment, corselet effects on coats and dresses, in inverted colors and materials.
Beachwear (coats and short, gathered pants, tunics and shorts, pajamas);
suits with fancy jackets; Serpentin evening gown.

1939

Marcel Rochas creates a dedicated space for hats and fancy
accessories on the upper floor of his boutique.
September 3 > France declares war on Germany.
Marcel Rochas is called up.

M.R. DESIGNS

Long or basqued jackets are favored, while dresses feature small gathered
flounces, bows, lace, and trimmings.
Suits with short, bell-shaped skirts; basqued jackets of various lengths,
or long jackets with lapels enlivened by light-colored motifs;
romantic, crinoline-style evening gowns; Marguerites glasses.

1940

February 13 > Founding of SAGER (Société Anonyme de Gérance des Établissements Rochas).
June 22 > The Franco-German armistice ends fighting and lays down the terms of the German occupation of France.
November > Marcel Rochas, who has been demobilized, presents his new collection in Paris.
December 9–12 > The Rochas collection is presented in Lyon, in the unoccupied zone.

M.R. DESIGNS

Jacket and pleated skirt ensembles; very fresh, printed dresses; suits with pockets trimmed with braid.

1941

A "cinema" department opens at Marcel Rochas's couture house.
Marcel Rochas moves to 28, avenue Montaigne.
He meets the model Nelly Brignole, the future Hélène Rochas.
August 27 > Jacques Fath's couture salons move to 48, rue François Ier.

M.R. DESIGNS

Lots of gathers adding fullness to the material (at the waist, on the sleeves, or held in place with insets); suits with long, close-fitting jackets and sleeves narrowing at the wrist, sometimes featuring original trimmings or pockets, over straight skirts flaring in pleats.

1942

March 6 > Presentation of the collections in Lyon, in the unoccupied zone, with Jeanne Lanvin and Jacques Fath.
July > Marcel Rochas and Rina Rosselli divorce.
August 24 > Birth of François Rochas, son of Marcel and Nelly Brignole, known as Hélène de Brignole.
November 11 > The German army invades the unoccupied zone.
November 20 > Marriage of Marcel Rochas and Hélène.

M.R. DESIGNS

Marcel Rochas abandons padding for a natural, rounded shoulder line, sometimes slightly dropped. He lengthens skirt hemlines and accentuates the waist.
An undergarment for the upper body also serving as a bra, the bustier, prefigures the *guêpière* (wasp-waisted corset); loose coats, wide sleeves narrowing at the wrist, or leg-of-mutton sleeves.

1943

March > Marcel Rochas's studio produces the costumes for Jean Delannoy's film *L'Éternel Retour*.
October 13 > Release of *L'Éternel Retour*.

M.R. DESIGNS

The line moves toward the Directoire style, flattering the upper body—high waist, short boleros, square neckline—coats with broad gathers, draped hoods, basqued belts, loosely cut suits, gathered sleeves, pagoda sleeves.

1944

Costume designs for Jacques Becker's *Falbalas*.
March 1 > Start of shooting of *Falbalas*.
April 28 > Death of Paul Poiret.
May 27 > Premiere of Jean-Paul Sartre's play *Huis Clos* at the Théâtre du Vieux-Colombier. Gaby Sylvia wears a Marcel Rochas dress in green jersey.
June 6 > Allied landings in Normandy.
June 9 > Birth of Sophie Rochas, daughter of Marcel and Hélène Rochas, in Barbizon.

December > Launch of a limited luxury edition of the perfume Femme, created by Edmond Roudnitska, Rochas house perfumer.

M.R. DESIGNS

The line, still with a Directoire influence, moves toward a "rustic-elegant," even neo-romantic style: tapered coats, opposite color insets, rounded shoulders still, set off by a capelet, and cinched suits with wide sleeves. Réglisse suit.

1945

January 12 > The company Parfums Marcel Rochas is founded with Albert Gosset. A perfume factory is established on rue La Cigale in Asnières, outside Paris.
March 28 > Opening of the Théâtre de la Mode at the Musée des Arts Décoratifs in Paris.
May 8 > Germany's surrender marks the end of World War II in Europe.
Rochas designs Danielle Darrieux's costumes for Marcel L'Herbier's film *Au Petit Bonheur*, released on May 15, 1946.
June 20 > Release of *Falbalas*.
November 21 > Release of Christian Stengel's *Seul dans la Nuit*, in which Sophie Desmarets wears designs by Marcel Rochas.
December > Public launch of Femme at the exhibition *Les Parfums à travers la mode*, in the couture salons on avenue Matignon.
December 24 and January 1, 1946 > Christmas Eve and New Year at the Rochas' at 40, rue Barbet-de-Jouy, in the company of Jean Cocteau.

M.R. DESIGNS

Designs in the Summer collection have birds' names. Basqued suits and the reappearance of flounces illustrate a return to femininity in Rochas's fashions.

1946

Launch of the perfume Mousseline.
July 6 > Death of Jeanne Lanvin.
July 29–October 15 > Third round of peace conferences in Paris.
September 20 > Opening of the first film festival in Cannes, "the most significant postwar economic event" (*Le Monde*). Marcel and Hélène Rochas host a reception at the Palm Beach for the occasion.
December 16 > Opening of the Christian Dior couture house.

M.R. DESIGNS

Marcel Rochas creates the *guêpière* (wasp-waisted corset) and develops the "amphora" silhouette.
In the same ultra-feminine spirit, he creates the Mermaid silhouette, with an evening gown crossed diagonally and a wide flounce flaring out at the bottom of the dress.
Femme dress.

1947

February 12 > Christian Dior presents his Spring-Summer collection featuring his Corolle designs. The New Look is born.
June > Marcel and Hélène Rochas attend the Bal du Panache.
Marcel Rochas brings out two eaux de toilette, Eau de Roche and Eau de Verveine, created by Edmond Roudnitska.

M.R. DESIGNS

Sonnette line: rounded or kimono-style shoulders, very full skirts; very long evening gowns; close-fitting *guêpière*-style sweaters; the Spahi-Ski.

1948

January 7 > Founding of the Frivolités Marcel Rochas company.
March > Release of Maurice Lehmann's film *Une Jeune Fille Savait*, in which Dany Robin wears Marcel Rochas.
Launch of the perfume Mouche.

Ever-narrower waist with the Guêpière 49.
Femme line: slim waist, rounded shoulders, long skirt; very close-fitting
mermaid-line evening gowns flaring out below the knees; La Rose dress.

1949

January 3 > Two new companies are established:
Produits de Beauté Marcel Rochas and For-Men Parfumerie.
February > The Bal des Rois et des Reines hosted by the Count
and Countess de Beaumont, at their mansion on rue Duroc.
February 13 > Death of Christian Bérard.
Launch of Moustache, Marcel Rochas's first perfume for men,
and first men's beauty care line.
June > *L'Officiel* publishes an article on a Rochas family weekend
at their country house La Tuilerie in Villennes-sur-Seine.
June 10 > Launch of the women's perfume La Rose at the rose garden
in L'Haÿ-les-Roses.
July > Vacation at Port Manech (Brittany) with Michèle Morgan and Henri Vidal.
December > To accompany the launch of Moustache, Marcel Rochas
organizes the exhibition *Moustache. Portraits d'hommes du XVIe siècle à nos
jours*, directed by Waldemar-George, in the salons on avenue Matignon.

M.R. DESIGNS
Claudine line, which suggests a return to the low waist; pleated dresses;
loose-fitting backs; some designs resemble the 1925 silhouette.
Looping line, with its turned-back panels on jackets and skirts.

1950

M.R. DESIGNS
The designs in the Winter collection are named after famous car models:
waffled and cloque fabrics, fastenings set at an angle, dresses with swirling
flat flounces or tiers.
Striped Argentinian Poncho in linen. Moustache collar in starched white piqué.
Moustache fox fur with monkey-hair stitching. Sirène gown in sequined satin
and black velvet.

1951

The young stylist Bill Underwood is hired to lend new momentum to the house.
In the spring, Marcel Rochas undertakes a trip to Brazil and Argentina
at the invitation of a Brazilian group.
April > The Pentagone silhouette, designed by Bill Underwood.
June > In Egypt, Marcel Rochas gives a series of talks on fashion.
Hélène Rochas resumes her activities as designer in the couture house,
assisted by Marcel Rochas.
Launch of Marcel Rochas's book *Vingt-cinq ans d'élégance à Paris,
1925–1950*, published by Pierre Tisné, at the Théâtre Marigny, to mark
his house's twenty-fifth anniversary.
July > Marcel Rochas is awarded the Légion d'Honneur, and announces
his decision to give up his activities as a designer for health reasons.
August > Vacation at La Reine-Jeanne, the villa of "Le Commandant"
Paul-Louis Weiller, on the Var coast in the south of France.
September 3 > Marcel and Hélène Rochas attend the "ball of the century"
given by Charles de Beistegui at the Palazzo Labia in Venice.

M.R. DESIGNS
Bill Underwood designs the Summer collection's Pentagone silhouette.
The Winter collection is designed by Hélène Rochas: a soft, feminine style,
black afternoon dresses, tweed suits.

1952

Spring–fall > Marcel Rochas joins the "Cinq", alongside the houses
of Piguet, Jacques Fath, Carven, and Dessès, with a view to producing
clothing for wide distribution.

M.R. DESIGNS
The Summer collection is designed by Hélène Rochas: dresses
with simple lines, in shantung or alpaca, with large white collars;
tweed suits opening onto a white shirt front.

1953

April 20 > April in Paris Ball, a reception hosted at the Waldorf-Astoria
in New York in aid of French charities. The house of Marcel Rochas produces
the costumes for one of the tableaux presented during the gala dinner.
Closure of the Marcel Rochas couture department.

1954

August 3 > Death of the writer Colette.
November 13 > Death of Jacques Fath.

1955

March 14 > Death of Marcel Rochas, at 4 a.m.,
at his home on rue Barbet-de-Jouy.

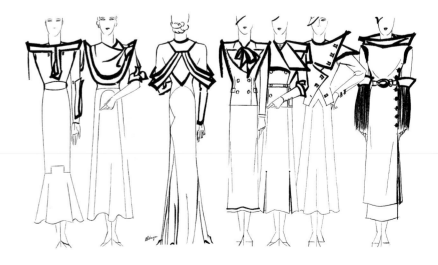

INDEX OF PROPER NAMES

Page numbers in bold refer to captions.

MARCEL ROCHAS TODAY

In 2015, Rochas celebrated its 90th anniversary. For three decades,
from 1925 to 1955, the founding spirit of Marcel Rochas was the lifeblood of the house,
constituting its rich heritage for posterity. This book reveals the principles at its heart
that have kept the story alive, updating it and bringing new inspirations.
After the couture department was closed in 1953 and the death of the founder in 1955,
the house of Rochas flourished from the 1960s to the 1980s thanks to its perfumes,
under the management of Hélène Rochas and Albert Gosset. In 1989, the house
relaunched its fashion business. Since then, four designers have produced their own interpretations
of the Rochas style. Peter O'Brien (1989–2002) worked on sportswear, with brightly colored jersey
designs, and on evening wear, with rustling taffeta dresses and *guêpière* ("waspie") waists.
Olivier Theyskens (2003–2006) updated tiered skirts and flounces, lace,
and roses in his ultra-feminine, romantic silhouettes. Marco Zanini (2008–2013) adopted
a more offbeat couture angle, focusing on textures and large floral motifs as well as accessories.
Since 2014, Alessandro Dell'Acqua has developed his own take on waffled fabrics
and lace insets, drawing notably on the decorative vocabulary of flowers and birds.
Where perfumes are concerned, while Edmond Roudnitska designed all of the Rochas
fragrances in the 1940s, it is to Guy Robert that we owe Madame Rochas (1960)
and Monsieur Rochas (1969). Between 1970 and 1984, Nicolas Mamounas
created several highly successful perfumes for the house, such as Eau de Rochas (1970),
Audace (1972), Mystère (1978), and Lumière (1984). Numerous other fragrance
designers followed in succession until 2008, when the house once more began
working with its own perfumer, Jean-Michel Duriez, who has created seven perfumes to date,
including Eau Sensuelle and the collections Les Cascades de Rochas
and Secret de Rochas. **JG**

The house of Rochas wishes to thank
Julie Aymard, Julien Baulu, François Dunet, Jean-Michel Duriez, Julia Guillon,
Stéphane Lemonnier, Nathalie Perrot, and Nathalie Prévoteau.
Many thanks to Antoine and Laurent Gosset for giving us access
to their family archives, and Alexandra Bosc and Sophie Grossiord for
allowing us access to the collections of the Palais Galliera.

PAGE 275 Drawing by Léon Benigni for
L'Officiel de la mode, no. 139, March 1933.
FACING PAGE Button with a flower motif
between two layers of resin and metal,
circa 1945 (see page 147).

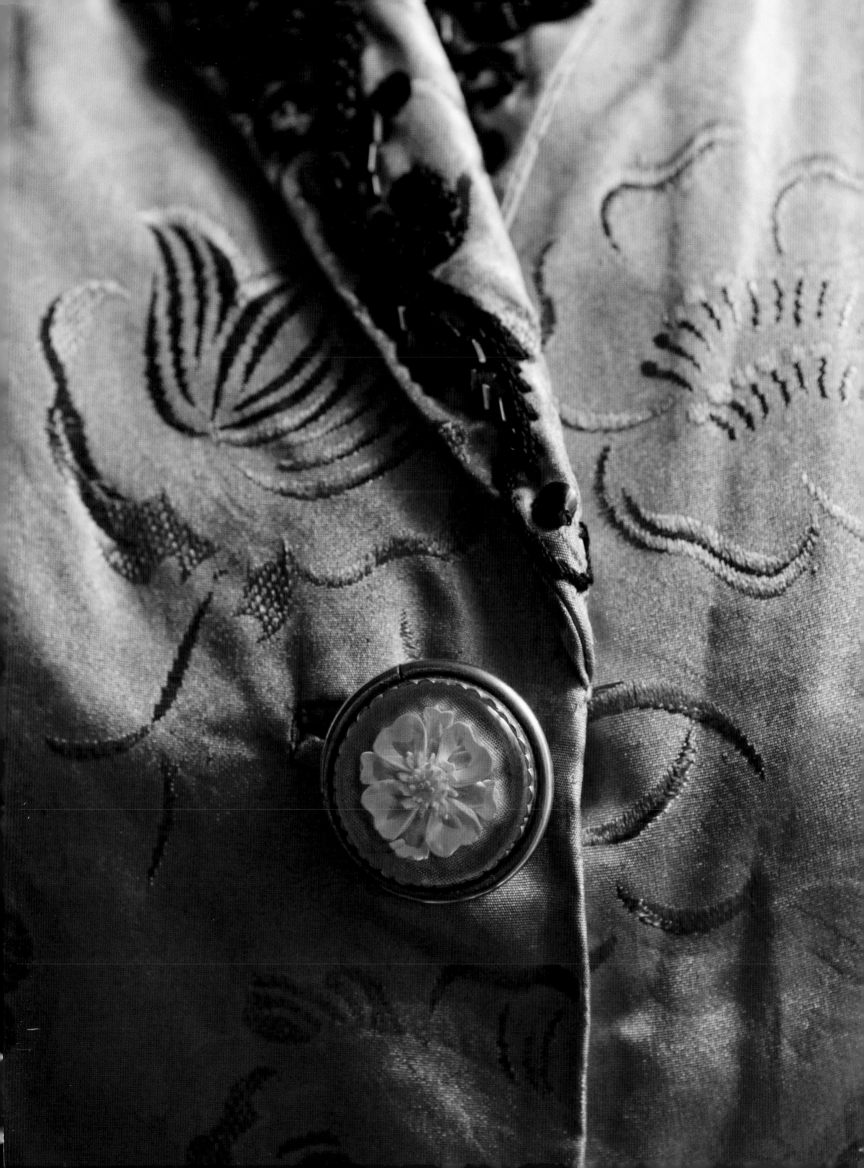

ACKNOWLEDGMENTS

Thanks to all those who supported and contributed to this project, ensuring that
this beautiful book, which bears witness to an era, come to fruition.
Magali Aimée, Françoise Auguet, Camille Coppinger, Olivier Delavault, Bernard Jouanneau,
Agnès Khères, Pierre Lana, Irène Lemasson, Stéphane Lemonnier, Didier Ludot, Marina Miroglio,
Philippe Maille, Perle Ménière de Schacken, Christiane de Nicolay-Mazery, François de Ricqlès,
Olivier Saillard, Gonzague Saint Bris, Delphine Storelli, Eric Suter, Anne Vernon, and Jean-Claude Zylberstein.
Thank you to Suzanne Tise-Isoré, Bernard Lagacé, Sarah Rozelle, Lucie Lurton, and Inès Ferrand.

Éditions Flammarion expresses its deepest gratitude to Sophie Rochas for her commitment
and absolute trust. We are very thankful to the house of Rochas, particularly Stéphane Lemonnier
and Julia Guillon, for their assistance and enthusiasm, and Didier Ludot and Felix Farrington for for their precious
historical and artistic advice. Without them this book would never have been as colorful and elegant.
Thank you to the archives of the house of Rochas who provided invaluable information and documents.
The publisher gives special thanks to Rita Watnick of Lily et Cie, Beverly Hills
and Suzy Kellems Dominick for allowing us to publish the magnificent dress on pages 232–34.
The publisher also wishes to thank Tina Bernachon, Marie-Ange Bernieri, Joseph-Henri Denécheau,
Corinne Dom, Kristina Haugland, Rébecca Léger, Bennett Weinstock, and The Social Trust.

PHOTOGRAPHIC CREDITS

t: top, b: bottom, l: left, r: right, c: center

1: ©Roger-Viollet; 2: ©Francis Hammond/House of Rochas Archives; 4: ©House of Rochas Archives; 6: ©René Gruau; 9: ©Sophie Rochas Archives; 11: ©Harry Meerson/SR Archives; 12, 14, 15, 16 and 17: ©SR Archives; 18: ©House of Rochas Archives; 19 and 20: ©SR Archives; 21l: ©Les Éditions Jalou "L'Officiel, 1934"/Studio Lorelle; 21r: ©Eric Emo/Galliera/Roger-Viollet; 22: ©SR Archives; 23: ©F. Hammond/Galliera; 25: ©Collection Roger-Viollet/Roger-Viollet; 26: ©F. Hammond/SR Archives; 27: ©House of Rochas Archives; 28l: ©Condé Nast/Vogue US/George Hoyningen-Huene; 28tr: ©House of Rochas Archives; 28br: ©Studio Lipnitzki/Roger-Viollet; 29: ©Everett Collection/Rex Features; 30t: ©Library of Congress; 30b: ©Boris Lipnitzki/Roger-Viollet; 31 and 32l: ©Paul Valentin/House of Rochas Archives; 32r: ©Dorland/Condé Nast France/House of Rochas Archives; 33: ©P. Valentin/Condé Nast France/House of Rochas Archives; 35: ©Alban Paris/SR Archives; 36: © Museo Thyssen-Bornemisza/Scala/Art Resource, NY; 37: ©Archives de Paris – August, 8th 1928 – store n°11260, D 12 U 10 325, models 8, 11 and 12; 38: ©House of Rochas Archives; 39l: ©Marc Real/House of Rochas Archives; 39r: ©Éditions Jalou "L'Officiel, 1927"/Alban Paris/SR Archives; 41: ©House of Rochas Archives; 43: Horst P. Horst/Condé Nast France; 44: ©Condé Nast Archive/Corbis/George Hoyningen-Huene; 46l: ©Adagp, Paris 2015/House of Rochas Archives; 46r: ©Les Éditions Jalou "L'Officiel, 1937"; 47: ©Roger Schall; 48–49: ©BnF/Séeberger Collection; 50r: ©Studio Lipnitzki/Roger-Viollet; 50–51: ©Boris Lipnitzki/Roger-Viollet; 52–53: ©R. Schall; 54l: ©BnF/Séeberger Collection; 54r: ©Georges Saad/SR Archives; 55: ©SR Archives; 56–57: ©F. Hammond/Galliera; 58–59: ©G. Saad/SR Archives; 60: ©Boris Lipnitzki/Roger-Viollet; 61: ©Adagp, Paris 2015/Condé Nast France; 62: ©Condé Nast/Vogue US/Horst P. Horst; 63: ©Horst P. Horst/Condé Nast France; 64: ©Philadelphia Museum of Art; 65–66l: ©Les Éditions Jalou "L'Officiel, 1936"/G. Saad; 66r: ©Les Éditions Jalou "L'Officiel, 1938"/Dora Kallmus; 67: ©Condé Nast/Vanity Fair/George Hoyningen-Huene; 68: ©Rue des Archives/collection Grégoire; 69: ©F. Hammond/Archives Didier Ludot Paris; 70: ©Les Éditions Jalou "L'Officiel, 1933"/Collection J.H. Lartigue/Ministère de la Culture – France/AAJHL; 71: ©House of Rochas Archives; 72: ©Dora Kallmus/Ullstein Bild/Roger-Viollet; 73: ©F. Hammond/Archives Didier Ludot Paris; 74: ©Les Éditions Jalou "L'Officiel, 1933"/D. Kallmus; 75: © D'Ora; 76: ©Mary Evans Picture Library; 77: ©F. Hammond/SR Archives; 78: ©Collection J.H. Lartigue/Ministère de la Culture – France/AAJHL; 79: ©Man Ray Trust/Adagp, Paris 2015/Telimage – 2014; 80l: ©Les Éditions Jalou "L'Officiel, 1936"/G. Saad; 80r: ©Les Éditions Jalou "L'Officiel, 1938"/G. Saad; 81: ©George Hoyningen-Huene/Condé Nast France; 82: ©Les Éditions Jalou "L'Officiel, 1937"/G. Saad; 83: ©F. Hammond/SR Archives; 85: Jean-Gabriel Domergue/House of Rochas Archives; 86: ©G. Saad/SR Archives; 87: ©D. Kallmus/SR Archives; 88: ©Boris Lipnitzki/Roger Viollet; 89: ©F. Hammond/SR Archives; 90l: ©Les Éditions Jalou "L'Officiel, 1933"/D. Kallmus; 90r: ©Les Éditions Jalou "L'Officiel, 1933"/G. Saad; 91: ©Modes et Travaux/Léon Benigni; 92g: ©Dora Kallmus/Ullstein Bild/Roger-Viollet; 92r: ©Mary Evans/Rue des Archives; 93: ©F. Hammond/Galliera; 94: ©Les Éditions Jalou "L'Officiel, 1933"/G. Saad; 95: ©F. Hammond/SR Archives; 97: ©Condé Nast/Vogue US/Hahn; 98l: ©Leiris SAS/Adagp, Paris 2015; 98r: ©Les Éditions Jalou "L'Officiel, 1934"/G. Saad; 99: ©Studio Dorvyne/SR Archives; 100: ©H. Meerson/House of Rochas Archives; 101: ©Boris Lipnitzki/Roger-Viollet; 102l: ©BnF/Séeberger Collection/SR Archives; 102r–103: ©Boris Lipnitzki/Roger-Viollet; 104l: ©Condé Nast/Vogue US/R. Schall; 104r: ©Les Éditions Jalou "L'Officiel, 1934"/L. Benigni; 105: ©G. Saad/SR Archives; 106l: ©H. Meerson/House of Rochas Archives; 106c and r: ©Les Éditions Jalou "L'Officiel, 1934"/G. Saad; 107: ©Condé Nast/Vogue US/Horst P. Horst; 109: ©Philadelphia Museum of Art; 110: ©Harper's Bazaar/Hearst; 111–12l: ©Condé Nast Archive/Corbis/George Hoyningen-Huene; 112r: ©House of Rochas Archives; 113: ©Courtesy of Universal Studios Licensing LLC/1935 Paramount Pictures; 114: ©Imagno/Roger-Viollet; 115: ©H. Meerson/House of Rochas Archives; 116, 117, 118l, 119 and 120: ©Cinémathèque française; 118r: ©Rue des Archives/BCA/Aldo Graziati; 121, 122 and 123: ©Studio Canal; 124: ©Cinémathèque française; 125tl and tr: ©Limot/Rue des Archives; 125c and b: ©Cinémathèque française/Guy Rebilly; 127: ©R. Schall; 128: ©SR Archives; 130: ©BHVP/Roger-Viollet; 130r: ©Studio Lavoisier/SR Archives; 131: ©SR Archives; 132: ©R. Schall/Collection Laurent Gosset; 133: ©Boris Lipnitzki/Roger-Viollet; 134: ©SR Archives; 135: ©G. Saad/SR Archives; 136: ©Les Éditions Jalou "L'Officiel, 1950"/BnF/Philippe Pottier; 137: ©Luigi Diaz/SR Archives; 138: ©House of Rochas Archives; 139: ©Boris Lipnitzki/Roger-Viollet; 140t: ©Studio Dorvyne/SR Archives; 140b: ©R. Schall; 141: ©House of Rochas Archives; 142: ©Karsavina/House of Rochas Archives; 143: ©Laure Albin Guillot/Roger-Viollet; 144: ©R. Gruau/Les Éditions Jalou "L'Officiel, 1948"; 145: ©F. Hammond/Galliera; 146: ©Jacques Demachy; 147: ©F. Hammond/House of Rochas Archives; 148 and 149: ©BnF /P. Pottier/Les Éditions Jalou "L'Officiel, 1944"; 150 and 151l: ©SR Archives; 151r: ©H. Meerson/SR Archives; 152: ©André Ostier's copyright owners; 153: ©R. Gruau; 154: ©Robert Doisneau/Rapho; 155: ©André Ostier's copyright owners; 156: ©Rue des Archives/AGIP; 157: ©F. Hammond/Archives Didier Ludot Paris; 158: ©SR Archives; 159: ©Eiwing Krainin/SR Archives; 160l: ©Léonor Fini/SR Archives; 160r: ©SR Archives; 161: ©Condé Nast/Vogue US/Richard Rutledge; 163: ©SR Archives; 164–65: ©Condé Nast/House & Garden; 166: ©Les Éditions Jalou "L'Officiel, 1950"/BnF/P. Pottier; 167: ©Robert Doisneau/Rapho; 168t: ©Serge Lido/SIPA/SR Archives; 168b: ©André Ostier's copyright owners; 169: ©SR Archives; 170: ©Béla Bernand; 171 and 172: ©Adagp, Paris 2015; 173: ©David Seidner; 175: ©Maurice Tabard/SR Archives; 176: ©F. Hammond/House of Rochas Archives; 177: ©House of Rochas Archives; 178, 179 and 180: ©F. Hammond/House of Rochas Archives; 181: ©Jacques Demachy; 182: ©R. Gruau; 183, 184, 185 and 186: ©F. Hammond/House of Rochas Archives; 187: ©Les Éditions Jalou "L'Officiel, 1946"/Arik Nepo; 188: ©F. Hammond/SR Archives; 189: ©F. Hammond/House of Rochas Archives; 190: ©R. Schall; 191: ©F. Hammond/House of Rochas Archives; 192: ©SR Archives; 193c: ©F. Hammond/House of Rochas Archives; 194–95: ©F. Hammond/House of Rochas Archives; 197: ©Les Éditions Jalou "L'Officiel, 1953"/R. Schall; 198, 199 and 200: ©F. Hammond/House of Rochas Archives; 201: ©Collection Laurent Gosset; 202l: ©SR Archives; 202r and 203: ©F. Hammond/House of Rochas Archives; 204l: ©Collection Laurent Gosset; 204r: ©R. Schall; 205 and 206: ©F. Hammond/House of Rochas Archives; 207tl and br: ©Serge Lido/SIPA/SR Archives; 207tr: ©House of Rochas Archives; 207bl: SR Archives; 207c: ©BnF/Séeberger Collection/SR Archives; 208: ©Collection Laurent Gosset; 209: ©BnF/P. Pottier/Les Éditions Jalou "L'Officiel, 1949"; 211: ©SR Archives; 212: ©BnF/P. Pottier/SR Archives; 213l: ©Boris Lipnitzki/Roger-Viollet; 213r: ©BnF/P. Pottier/Les Éditions Jalou "L'Officiel, 1949"; 214: ©R. Gruau; 215: ©Fr. Cochennec and E. Emo/Galliera/Roger-Viollet; 216 and 217: ©BnF/P. Pottier/Les Éditions Jalou "L'Officiel, 1949"; 218l: ©BnF/P. Pottier/Les Éditions Jalou "L'Officiel, 1947"; 218c: ©Roger-Viollet; 218r: ©R. Schall/SR Archives; 219: ©SR Archives; 220: ©F. Hammond/House of Rochas Archives; 221: ©R. Gruau/Les Éditions Jalou "L'Officiel, 1948"; 222: ©R. Gruau; 223: © Jacques Rouchon/akg-images; 224tl: ©Bettmann/Corbis; 224b: ©Philadelphia Museum of Art; 226–27: ©F. Hammond/House of Rochas Archives; 229: ©Condé Nast/Vogue US/Irving Penn; 230: ©Tom Keogh; 231: ©Clifford Coffin / Condé Nast France; 232–34: ©The Social Trust; 235: ©Les Éditions Jalou "L'Officiel 1949"/BnF/P. Pottier; 236 and 237: ©F. Hammond/Archives Didier Ludot Paris; 238: ©F. Hammond/House of Rochas Archives; 239t: ©Nina Leen/The Life Picture Collection/Getty Images; 239b: ©Lucien Aignier/Corbis; 240l: ©Mary Evans/ Rue des Archives; 240r: ©Les Éditions Jalou "L'Officiel, 1948"/BnF/Séeberger Collection; 241, 242 and 243: ©F. Hammond/House of Rochas Archives; 244: ©Studio Carlet/SR Archives; 245: ©Adagp, Paris 2015/Collection Laurent Gosset; 246: ©Sylvia Salmi/Bettmann/Corbis; 247: ©Fr. Cochennec and E. Emo/Galliera/Roger-Viollet; 248 and 249: ©F. Hammond/Corinne Than-Trong, Renaissance, Paris; 250 and 251: ©F. Hammond/Archives Didier Ludot Paris; 253tl: ©André Ostier's copyright owners; 253tr: ©Leonor Fini/SR Archives; 253b: ©André Ostier's copyright owners/SR Archives; 254 and 255: ©SR Archives; 257: ©F. Hammond/Archives Didier Ludot Paris; 258 and 259: ©SR Archives; 260: ©House of Rochas Archives; 261: ©F. Hammond/Archives Didier Ludot Paris; 262tr: ©Studio Lipnitzki/Roger-Viollet; 262tl and bl: ©Boris Lipnitzki/Roger-Viollet; 262br: ©Rue des Archives/AGIP; 263: SR Archives; 264 and 265: ©Adagp, Paris 2015/House of Rochas Archives; 267: SR Archives; 268: F. Hammond/ House of Rochas Archives; 275: ©Les Éditions Jalou "L'Officiel, 1933"/L. Benigni; 279: F. Hammond/ House of Rochas Archives.

The publisher has made every effort to identify and credit the copyright holders of the images reproduced in this book,
and will be glad to correct any inadvertent errors or omissions in future editions.